MAUS
NOW

MAUS
NOW

SELECTED WRITING

Edited by Hillary Chute

PANTHEON BOOKS New York

Library of Congress Cataloging-in-Publication Data
Names: Chute, Hillary L., editor.
Title: Maus now : selected writing / edited by Hillary Chute.
Description: First edition. New York : Pantheon Books, 2022.
Includes bibliographical references.
Identifiers: LCCN 2022007293 (print). LCCN 2022007294 (ebook).
ISBN 9780593315774 (hardcover). ISBN 9780593315781 (ebook).
Subjects: LCSH: Spiegelman, Art. Maus. Spiegelman, Art—Influence.
Graphic novels—History and criticism.
Classification: LCC PN6727.S6 Z73 2022 (print) | LCC PN6727.S6 (ebook) |
DDC 741.5/973—dc23/eng/20220404
LC record available at https://lccn.loc.gov/2022007293
LC ebook record available at https://lccn.loc.gov/2022007294

www.pantheonbooks.com

Printed in the United States of America
First Edition
2 4 6 8 9 7 5 3 1

Contents

Introduction: *Maus* Now

HILLARY CHUTE

1.

In the fall of 2011 I was interviewing Art Spiegelman onstage in a ticketed event at the 92nd Street Y in New York. I asked him, very earnestly, about a musing he had jotted down in a notebook in the early 1970s—which was around the time he started making comics stories about the Holocaust that would eventually lead to creating his two-volume masterpiece, *Maus: A Survivor's Tale*. "Maybe Western civilization has forfeited any right to literature with a big 'L,'" Spiegelman had written. "Maybe Goethe and Mozart were not the patron saints of Germany. . . . Maybe vulgar, semiliterate, unsubtle comic books are an appropriate form for speaking of the unspeakable." Forty years later, onstage, Art quipped back at me, "For one thing the unspeakable gets spoken within ten minutes, by me if nobody else." (This is, I should note, the same event in which he got up in the middle of our interview and went outside to smoke a cigarette, leaving me facing an empty chair, and a sold-out crowd.) Through its creativity and innovation, Spiegelman's *Maus*, coming up on a four-decade anniversary, shifted how people talk about history, trauma, ethnic and racial persecution—and comics.

Maus has profoundly changed cultures of expression in the United States and all over the world. First serialized in the biannual *RAW* magazine beginning in 1980, and published as two book volumes in 1986 and 1991, respectively, it has been translated into almost forty

languages, and Spiegelman is one of our most famous living cartoonists, as well as a globally recognized public intellectual. As the German critic Kurt Scheel writes in his 1989 review of *Maus I*, referring to the celebrated "Todesfuge" ("Death Fugue") poet and onetime labor camp inmate Paul Celan: "Celan and Spiegelman are to be mentioned together because both the cartoonist and the poet invented a language for their subject that did not exist before" (see "Mauschwitz?" in this volume, published here in English for the first time). Spiegelman's approach to "speaking" the unspeakable—the language he invented, as Scheel suggests—is both verbal and visual: comics, with its peculiar, distilled word-and-image grammar. Spiegelman, who spent thirteen years making *Maus*, not only modeled definitively that in fact comics could be remarkably sophisticated, literate, and subtle, but he also blew open about a thousand other clichés and pieties about art and representation, particularly in the expression of the darkest aspects of human history, and the testimony that results from it. (Today the pressure *Maus* places on some of those pieties is itself under pressure, as the book's recent banning by a Tennessee county school board, which cited examples of its supposed impropriety, reveals.)

Unfolding in black line art, *Maus* presents at least two stories: the testimony of Spiegelman's father, Vladek Spiegelman, a Polish Jew who survived the Holocaust (and emigrated to the United States in 1951 with his wife, Anja, also a survivor, and their toddler, Art), and the story of the cartoonist son, as an adult, soliciting his father's testimony in order to understand and visualize his experience on the page for readers. Anja Spiegelman died by suicide in 1968, when Art was twenty, and her absence is a vexing, animating force of the narrative.

Maus toggles back and forth between the 1930s and 1940s in Poland and Germany, during which Spiegelman's parents fight for their lives against the murderous Nazi regime—both ultimately wind up imprisoned in the Auschwitz death camp complex—and the 1970s and 1980s in New York City and the Catskills, during which Spiegelman interviews Vladek, a difficult and often frustrating figure to his son. ("No way—I'd rather feel guilty!" the Spiegelman character remarks when his wife asks, in their SoHo apartment, if he is going to Queens at his father's request to help him fix a drainpipe [*Maus I*, 97].) *Maus* is a powerful story for many reasons, one of which is the propulsive

structure of the book, in which readers, immersed in its pages, on one level know that Vladek survives—after all, Art, his postwar progeny, is its creator—but are also constantly, and harrowingly, in suspense as to how he can escape the succession of terrifying circumstances we witness with him. Readers wait with bated breath for the gap between present and past to close. (Professor Brian Boyd's study *On the Origin of Stories: Evolution, Cognition, and Fiction*, which offers an evolutionary explanation for "supremely successful stories," opens with the line "My first debt is to Art Spiegelman" [389, xi].) Further, *Maus* famously visually articulates its characters as animals throughout—a visual overlay that provides a level of abstraction hard to imagine being effective in any other medium aside from comics. While the characters who populate *Maus* are all drawn with animal heads—and sometimes tails—this figuration is never remarked upon by them in the book (except in rare instances in which Spiegelman reflects, as part of the narrative, on his artistic choices). The characters understand themselves as human, but readers see Jews as mice, Nazis as cats, and Polish gentiles as pigs, among other figurations (Americans are dogs). This animal metaphor—itself borrowed from Nazi propaganda and resignified—is, further, self-reflexively disrupted by the book itself over the course of its pages.

Spiegelman had for some time in the 1980s imagined that he would self-publish *Maus* with the Raw Books & Graphics imprint that he and Françoise Mouly ran out of their living room, and then their basement. (The couple cofounded, and coedited, *RAW* magazine from 1980 to 1991, which offered shifting subtitles with each edition, such as "The Graphix Magazine That Lost Its Faith in Nihilism.") Spiegelman joked to interviewer Stanley Crouch in 1996 that working on a book was like having a long-term disease—to battle, I suppose; this comment also vividly illustrates how Spiegelman approaches the stakes of his work, which is: existentially. I have rarely known anyone as seriously consumed by the act of creation as Art Spiegelman is, whether the project at hand is one page or three hundred pages. But this dedication, particularly as Spiegelman came to *Maus* from an avant-garde comics culture, driven by underground, independent publishing and distribution, was not matched by any expectation for commercial achievement. Spiegelman's three-page 1972 comics story

"Maus," the seed for the longer work (analyzed in this volume by Joshua Brown and Marianne Hirsch, among others), published in the underground anthology *Funny Aminals* (the swapped letters are deliberate), was aesthetically and politically important, but didn't elicit much of a reaction. Spiegelman did not anticipate the enormous critical and commercial success *Maus* would become, particularly after his struggle to find a publisher—Pantheon took it on only after already passing on it once, and Spiegelman had garnered dozens and dozens of rejection letters (a photograph of a thick spread of these appears in our collaborative, interview-driven book, *MetaMaus: A Look Inside a Modern Classic,* Maus).

Maus was an immediate success—a "sensation," to use Michiko Kakutani's phrase in her review of the second volume in *The New York Times*—even as some readers struggled with the perceived glibness of connecting comics and the Holocaust, and still others struggled to understand the valences of its animal conceit. For most readers, actual engagement with the book revealed its complexity, above and beyond the cultural connotations of comics and its "funny animal" tradition. Crouch, in his interview with Spiegelman, notes: "The remarkable thing about it, is when you pick up the book you say, 'Hah . . . This can't work' . . . but he brings it off." As Hirsch suggests in an interview with Martha Kuhlman about *Maus* scholarship—in an important formulation that underscores the book's barrier-breaking—*Maus* teaches you how to read it. "Some of the best strategies are taken from the text," Hirsch points out, "rather than the other way around," namely the standard practice of approaching a book with interpretive frameworks in mind. (Hirsch herself developed the now canonical concept of "postmemory" in relation to *Maus*, as her essay in this volume explains.) Previous frames of reference are inadequate; they might help you a little, but they fail to account for the fullness, and the uniqueness, of what *Maus* accomplishes. While *Maus* is nonfiction, the series was awarded a Special Pulitzer Prize in 1992, because the Pulitzer committee, while bestowing a huge and terrain-shifting honor upon Spiegelman, wasn't sure into which category a comics work about the Holocaust that pictured Jews as mice should fall.

Maus has been received so ecstatically that after researching it for my PhD degree, and subsequently for two of my books, in addition to

MetaMaus, I can count the negative reviews I've encountered on two hands. There have been some holdouts, most notably Hillel Halkin, who wrote in *Commentary* that *Maus* "fails to convince me that comics, no matter how sophisticated, have the slightest potential to vie with either literature or art as a serious medium of expression." (I should note Spiegelman himself, who thrives on debate and intellectual engagement, encouraged me repeatedly to include negative reviews in this volume—his only suggestion for a project for which he had no editorial role. As I explained to him, should any of those pieces, however critical, have merited the "best of" standard with which I approached the book's contents, they would have appeared here.)

Yet for most *Maus* was revelatory, and generative, in profound and long-lasting ways. It is hard to overstate *Maus*'s effect on postwar American culture, and on the collective sense of what art and literature can accomplish (I appreciate how the form of comics puts pressure on the boundaries of these categories—it is a productive awkwardness, as I like to think of it). Not only has *Maus* influenced the fields of literature and history (see Joshua Brown's piece in this volume, first published in *Oral History Review*), but it has refigured contemporary art—Spiegelman, although usually creating comics for print, has yet had exhibits at major museums, including the Museum of Modern Art, as critic and curator Robert Storr addresses here. *Maus* is taught routinely in high school, college, and graduate school, in departments including Sociology and Political Science. It is, in addition, often taught to middle school students—a fact to which its banning in 2022 in Tennessee, for an eighth-grade curriculum, calls attention.

Maus is also a key text in memory studies and trauma studies, connected fields that have emerged, in part, as a response to the Holocaust (a term Spiegelman happens to dislike)—and the idea that its extremity shattered previous interpretive frameworks for understanding subjectivity and history. And within Jewish studies generally, and Holocaust studies specifically, *Maus* has become a signal text, particularly as a work of second-generation literature—that is, created by the child of a survivor. One of the lasting influences of *Maus*, for instance, is its insistence on the fact that, as Spiegelman tells me in *MetaMaus*, "suffering . . . just makes you suffer"—a feature that comes across sharply, sometimes harshly, in a book that avoids the tendency to ennoble the

figure of the survivor (36). Vladek Spiegelman, at the center of the book, is a thorny personality—even one whom Spiegelman captures in an episode toward the end as racist toward Black Americans. (An example of Spiegelman's attention to Othering at all levels.) And Spiegelman himself, the seeker-artist figure, is a thorny personality in *Maus*; Spiegelman the author displays his younger self's selfish character, and rage at his parents. After reading *Maus* probably twenty times, I remain shocked, and moved, every time I read the Spiegelman character, in a perverse formulation, call each of his parents—people who survived the ghastly trial of other people trying to kill them every day for years—"murderers."

Maus succeeds in part because of its rigorous self-reflexivity. Today, due in large part to *Maus*, contemporary culture operates with an expanded sense of modalities of expression, including the idea that drawing, and in particular comics, can express the horizon of history with an accuracy that is not canceled by creative invention. I have long admired a feature in *The Village Voice* that gathered artists, scholars, and critics—including Spiegelman—to debate the value of *Schindler's List*. While it's nominally about Steven Spielberg's 1993 film, which is perhaps, along with *The Diary of Anne Frank* and Elie Wiesel's *Night*, among the best known and most mainstream works of cultural production about the Holocaust, it sheds light on *Maus* by comparison, and, when I first encountered it as a graduate student, it helped give me a language to understand what the book is doing.

In the *Voice* roundtable, Spiegelman discusses what he views as the film's "problem of re-creation for the sake of an audience's recreation"—its staging and replication of violence for the camera and for film viewers (Hoberman, 27). In contradistinction, while *Maus* does depict the death camps and their operations in detail, in comics one avoids the "ersatz verisimilitude" of film (*MetaMaus*, 59). *Maus* is much more like what the avant-garde filmmaker Ken Jacobs, Spiegelman's former mentor and longtime friend, suggests in the *Voice* would be a better approach than Spielberg's: a "Pirandello cinema" in which real survivors would be present instructing actors on-screen, showing the seams of the work and its desire to represent reality. Spiegelman draws "obvious stand-ins for the real thing," to use Jacobs's phrase, with his animal heads (Hoberman, 27). And *Maus*, through its hand-

drawn, juxtaposed frames on the page, which sidestep the realism of film, rather creates Auschwitz as what Spiegelman has called "a mental zone," its own form of accuracy (*MetaMaus,* 166). In a 1995 op-ed in *The New York Times,* Melvin Jules Bukiet declared: "I have more faith in the power of Art Spiegelman's 'Maus' to convey the terror than all the guided tours in the world." For Spiegelman, making the difficulty of visualizing his father's experience in comics part of the narrative we read is an acknowledgment of the impossibility—ethical and practical—of fully representing it. As the acclaimed historian Hayden White affirms, with admiration, in the volume *Probing the Limits of Representation: Nazism and the "Final Solution"*: "*Maus* manages to raise all of the crucial issues regarding the 'limits of representation' in general" (42).

One of the central suggestions of *Maus* is the presence of the past, the inescapability, and uncontainability, of the horrors of history; they are not separate or closed off from the present-tense of lived life in the book. Vladek has survived, but he is damaged (in a *Maus*-era notebook, Spiegelman wrote of his father, in a sentence that captures something of the experience of survivors generally, including his mother: "There's more to survival than bringing the body through its ordeal unscathed"). And in the case of the Spiegelman character in *Maus,* the weight of the past—even a past he did not live himself—bears down upon him. Spiegelman and I were once preparing a *Maus* timeline together for inclusion in *MetaMaus,* as I mention in my book *Why Comics?.* We were on the phone, musing about where it should begin. I think I may have suggested his birthdate, in February 1948, to which he responded: "My chronology would start with: When was Kristallnacht?" This has stuck with me over the years because it indicates so clearly how history—and violent history—is deeply etched into Spiegelman's sense of being and self; for him, his chronology, or story, begins with the November 1938 pogrom in Nazi Germany ("Night of the Broken Glass") that is often seen as the beginning of the Holocaust.

One of the most effective features of comics is its ability—through its unique syntax of balloons and bleeds, gutters and frames—to experiment with time and space on the page. *Maus* does this meaningfully on every single page, each of which has its own narrative and aesthetic

logic. In a poetic formulation, Spiegelman has suggested that comics "choreograph and shape time" ("Ephemera," 4). And in *Maus*, Spiegelman asks readers to encounter the collapse of different temporalities—the imbrication of the past and the present—graphically. *Maus* displays, dramatically, how the past invades the present. In one striking *Maus* episode that I have returned to repeatedly in my teaching and writing (including my essay in this volume), the Spiegelman family—Art, Françoise, and Vladek—drives to a supermarket in the Catskills in the late 1970s, as Art asks his father about a prisoner revolt in Auschwitz. "And the four young girls what sneaked over the ammunitions for this, they hanged them near to my workshop," Vladek says, as the car winds its way on a rural road. At the top of the panel readers see four pairs of legs dangling down from the trees; in this panel the 1940s and the 1970s collide and literally share space as readers cannot help but see how the past wordlessly intertwines the present.

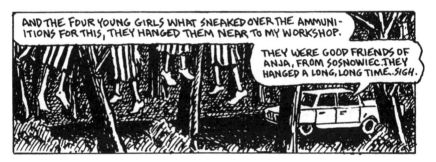

From *Maus II,* page 79

If *Maus* is about the presence of the past, its own timelessness indicates both the dynamic, enduring quality of its structure and execution as a work of art—and also, today, the relevance of the politics and attitudes it anatomizes. "If *Maus* is about anything," Spiegelman once told critic and writer Lawrence Weschler, "it's a critique of the limitations—the sometimes *fatal* limitations—of the caricaturizing impulse" ("Pig Perplex"). To invoke a commonplace, we see these fatal limitations in the 1930s in Nazi Germany, among other times and places—and we also see it today. Spiegelman's point could not be any more urgent right now, during an era of rampant division—during a time, for instance, in which racism and anti-Semitism are

rising both nationally and globally, and in which violence, in the case of America, has been encouraged even at the level of the U.S. government. As the title Maus *Now* indicates, *Maus* is more resonant than ever. One of Spiegelman's longtime catchphrases—Never Again and Again and Again—feels prescient for this moment.

Maus charts fascism and its rise, and insists on the continuation of aspects of the past that so many of us would wish to be over—and which have been conspicuous in recent years. Among a succession of other devastating events, the fatal racist white nationalist Charlottesville rally in 2017 (which included the chant "Jews will not replace us!") and the Tree of Life synagogue shooting in Pittsburgh in 2018—in which a gunman opened fire on congregants during a morning Shabbat service, killing eleven and wounding others, becoming the deadliest attack on Jews in America—gave me the feeling that in its political valences, *Maus* is more vital than ever. Jolted by these events, Spiegelman, an in-demand lecturer, started delivering talks he calls "Maus Now" talks, which inspired this collection's title. After the shock of Charlottesville, despite his long-standing aversion to what he has perceived as the overdetermination of his being received in explicitly Jewish contexts, Spiegelman decided to willingly open up conversations around *Maus* as a Jewish book. I introduced him in 2017, for example, in a lecture at Harvard sponsored by the Center for Jewish Studies called "Comix, Jews, 'n Art—Dun't Esk!!" (the title nodding to his own ambivalence and to the cartoonist Milt Gross's Yiddishy English).

Moved—and horrified—by growing, open anti-Semitism, including in the United States and also in Germany, among other countries, I started, along with my research assistant, a file called "Anti-Semitism Now" in conjunction with thinking about *Maus* now. At this point, examples and news reports are so rampant that it's hard to keep track, but they still feel shocking, whether it is a local detail such as elite students at the Sidwell Friends School projecting swastikas on a wall, or reports of far-right extremism within Germany's Parliament.[1] The attack on the U.S. Capitol on January 6, 2021, was a brutal and traumatic manifestation of the fatal limitations of the caricaturizing impulse, complete with the surreal appearance of a "Camp Auschwitz" sweatshirt worn by an American rioter. Captured in photographs

during the attack, the black sweatshirt also advertises one translation of the famous slogan that hung above the gate of Auschwitz: "Work Brings Freedom" ("Arbeit Macht Frei"), along with a skull and cross-bones. We can note, in 2021, not only proliferating anti-Semitism, but further, and specifically, the public desire for the return of the Nazi death machine.

We can also note how *Maus,* in 2022, emerged as a target in the culture wars, in ways that work to erase histories of racialized violence from being taught and discussed. The banning of *Maus* in an eighth-grade English Language Arts curriculum in McMinn County, Tennessee, by its school board, became a global news story in January, resulting in a huge outpouring of support for the book, including by groups, some led by students, that raised money to distribute it for free.

Part of the outrage the ban provoked has to do with the school board's official, and seemingly flimsy, reasons for removing it from the curriculum: bad language (such as "bitch" and "Goddamn") and nudity (specifically, one small image of Spiegelman's mother Anja, drawn in human form, in the bathtub after taking her own life, a profoundly troubling visual on which to pin the charge of obscenity). These aspects of the book, while debatably not ideal for an eighth-grade audience, feel beside the point in a testimonial narrative that bears witness to the genocide of the Holocaust: a pretext. In one telling comment from the meeting minutes, a school board member comments, "Being in the schools, educators and stuff we don't need to enable or somewhat promote this stuff. It shows people hanging, it shows them killing kids, why does the educational system promote this kind of stuff, it is not wise or healthy." The real reason for the ban seems to lie here. *Maus* is not "promoting" murder by bearing witness to it, and visualizing the horrors of history on its pages. As Spiegelman observed in an event at the University of Tennessee, Knoxville, "They want a kinder, gentler Holocaust they can stand." (*Maus*—clearly not a pro-Nazi text—had earlier been banned in Russia, in 2015, for violating its anti-Nazi propaganda laws, due to the modified swastika on its cover; graphic histories and testimonies ask readers to encounter, in small part, what their subjects and witnesses also encountered, including the malevolent power of this Nazi symbol.)

Maus's role as a signal text for our troubled times has also been marked out in recent popular culture. *Maus*'s contemporary currency really hit home for me when as an unsuspecting viewer in 2018, I encountered *Maus* in a cameo on *The Handmaid's Tale*, the award-winning Hulu television series based on Margaret Atwood's dystopian feminist novel. *The Handmaid's Tale* is set in a theocratic near-future in which a group of powerful, insurrectionary men have staged a coup in the United States—the members of Congress were shot, a detail that now seems especially vivid—and the new state, Gilead, enslaves women as child bearers; it is against the law for women to read or write. In one episode, an enslaved woman named Emily, momentarily alone in her master's library, sneaks a peak at a book—and the camera lingers on an open page of *Maus I*. She risks having her finger chopped off—the punishment for a first offense—to look at *Maus*. The page she and we as viewers see is a striking and painful scene from *Maus I* in which four Jews executed for trading on the black market are shown hanging on a central street in the Polish city of Sosnowiec in 1942. This page, too, entered the Tennessee debates as a flashpoint.

Why *Maus* and this particular page? Within the context of the show, considering the book's owner, *Maus* could be viewed as a playbook for fascism, including its murders; it diagrams fascism and its machinations that closely. But its presence also underscores *Maus* as a text of resistance. While displaying the horror of their deaths, the page additionally, through its word and image form, restores humanity to the hanged men. While a large, unbordered panel in the middle of the page shows their hanging bodies—its size registering the shock and sadness Vladek experienced seeing them—the bottom tier of panels makes the significant move of particularizing the people. The page's last two panels function as literal footnotes, revealing to us their legs and feet and also offering information about the men's identities and personalities. *Maus* is a text of resistance not because it shows us how to survive—Spiegelman emphasized to Stanley Crouch that Vladek survived because of "sheer unmitigated luck"—but rather because it constantly does the work of particularizing victims and survivors alike, working against the caricaturizing impulse despite its prominent animal taxonomy.

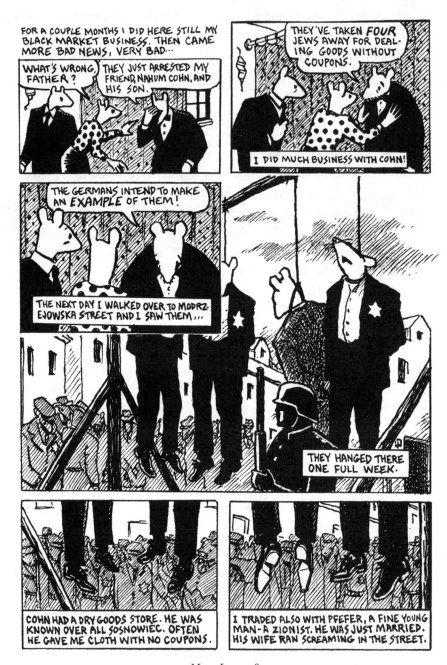

Maus I, page 83

2.

"The impact of what Mr. Spiegelman has done is so complex and self-contradictory that it nearly defies analysis," Christopher Lehmann-Haupt suggested in 1986 in an early review in *The New York Times*. I enjoy this formulation. I have been actively thinking and writing about *Maus* for over twenty years and still—even after now having collaborated on a book about *Maus* closely with its creator—I don't feel like I've definitively "solved" the question of why it works so well. For me *Maus* is a text that keeps on giving; every time I reencounter it, I find something new—the ideas it provokes, and its value, feel inexpendable, ongoing, active. So while one way to capture its stunning mix of intricacy and simplicity is to think of it as practically defying analysis, yet another way to articulate the feat of *Maus* is to examine the range of ways it *has* been analyzed, from the mid-1980s when it first appeared to the current moment. Illustrated throughout with images from the book, Maus *Now: Selected Writing* gathers together many of contemporary culture's leading critics, authors, and academics, who are enlivened by that complexity, approaching *Maus* from a wide range of viewpoints and traditions.

Maus *Now* has several goals. One is simply to collect and make accessible the best writing on *Maus*, whether the original context is a newspaper such as *The Guardian* (see celebrated novelist Philip Pullman's "Behind the Masks"), or an art exhibit publication (as with then-MoMA curator Robert Storr's "Making *Maus*"), or an academic book, or journal like *American Literature* and *Word & Image*. *Maus* has generated reactions from many different corners of culture, and through a dynamic mix of public and academic writing, this book reveals just how profoundly it has preoccupied, and continues to preoccupy, thinkers of all kinds. Maus *Now* aims to be an essential guide to *Maus*. Its essays offer distinct perspectives to help readers understand the project and impact of *Maus*—whether that means placing *Maus* in conversation with prominent fiction, as literary critic Michael Rothberg does in his focus on Philip Roth, or Holocaust scholar Terrence Des Pres does with Leslie Epstein and Tadeusz Borowski, or thinking about *Maus* as a work of oral history, as in historian Joshua Brown's "Of Mice and Memory." Crucially, this book includes writing

on *Maus* translated into English for the first time—one of the central motivations of this collection is to widen the scope of *Maus* criticism by grouping together the perspectives of writers rooted in different global traditions (and languages). Maus *Now* includes two essays translated from German, one from Hebrew, and one from French. All three of these languages and national traditions are significant to the historical context of *Maus* and its aftermath.

The book is organized into three very loosely chronological sections: Contexts, Problems of Representation, and Legacy. The opening section, Contexts, contains some of the earliest critical responses to *Maus*, such as Ken Tucker's consequential "Cats, Mice, and History: The Avant-Garde of the Comic Strip," which appeared in *The New York Times Book Review* in 1985—previous to the book publication of *Maus I*—and played a role in its subsequent publication history. Spiegelman details the significance of this then-quite-anomalous review in our interview in *MetaMaus*: Tucker not only reviewed, in one of the nation's leading literary venues, a work in progress (rare), but further a work in progress serialized by a small-press publisher, *RAW* (very rare), and even further, a *comics* work in progress serialized by a small-press publisher (virtually unheard-of). Tucker's sharp eye, sensitivity, and discernment provoked interest from readers about *Maus* and helped convince Pantheon to issue the work in two volumes (*Maus I* appeared the following year).

Contexts also offers classics of *Maus* criticism focused on frameworks for understanding the book's graphic dimension, from film to caricature. In "Art Spiegelman's *Maus*: Graphic Art and the Holocaust," film scholar Thomas Doherty demonstrates how *Maus* counters Nazi propaganda and aesthetics, contending that through the medium of comics, *Maus* rejects the "erotic energy" of Nazi film and films about Nazis (for this volume, he updated his 1996 essay to include references to Quentin Tarantino's 2009 *Inglourious Basterds*). And in the important essay "Comics and Catastrophe" (1987), current *New Yorker* staff writer Adam Gopnik places *Maus* within a long—and highbrow—history of caricature. Gopnik's *New Republic* piece uncovers a surprising and profound Jewish precedent for Spiegelman's contemporary comics in the Birds' Head Haggadah, one of the earliest surviving illuminated manuscripts of the Haggadah, the ritual text recounting

the story of Passover, in which humans are depicted with bird heads and beaks. Spiegelman's own stated range of influences includes both the highbrow and the putatively lowbrow; this is an artist, after all, whom Stephen Tabachnick, in his contribution, establishes is inspired by a Jewish lineage of creators that includes both Franz Kafka and also *Mad* magazine's Harvey Kurtzman.

The opening Contexts section also presents essays translated from Hebrew and German that offer readers a historical sense of how *Maus* was received in countries in which the Holocaust, the book's central subject, has come to be defining. Dorit Abusch, writing in the art magazine *Studio*, explains that in the early 1990s, when she first gave a talk on *Maus* at an Israeli museum, the book was met with misunderstanding, and even contempt (people walked out as she spoke). In Germany, Kurt Scheel praised *Maus I* in a review essay in the pages of the journal *Merkur*, for which he was an editor (and later editor in chief). Founded in 1947, *Merkur* has published the likes of Hannah Arendt, Theodor Adorno, and Ernst Bloch—as well as Martin Heidegger and Carl Schmitt, members of the Nazi party. Scheel reveals a serious initial German reception of the series ("the secret of *Maus* lies in the shocking and fascinating contrast between the object and the medium of its representation") and significantly, considering *Maus* in *Merkur* places Spiegelman within a distinguished but fraught lineage of intellectuals appearing on the magazine's pages.

The second section tackles what Hayden White, as noted above, deems the limits of representation, examining *Maus*'s aesthetic and ethical strategies. Articulating the problems of—and possible solutions to—representing the violence and suffering of the Holocaust, the six influential scholarly essays here outline different facets of *Maus*, from Andreas Huyssen's focus on Spiegelman's animal faces in "Of Mice and Mimesis: Reading Spiegelman with Adorno" to Terrence Des Pres's exploration of the subversive possibilities of humor in "Holocaust *Laughter?*" to Alan Rosen's examination of Polish-born Vladek Spiegelman's "broken English" in "The Language of Survival: English as Metaphor in Spiegelman's *Maus.*" Spotlighting Vladek's often overlooked accent and syntax, and Spiegelman's representation of his father's speech, Rosen argues that in making English "the most foreign language" in the book, *Maus* uses this fundamental aspect of

the text to convey the foreignness of the Holocaust itself, an event that is radically other to, and affronts, one's sense of normal experience. (Michael Rothberg, whose framework is the commodification of the Holocaust, and Nancy K. Miller, whose framework is identity and autobiography, each also discuss the disconnect between reading and hearing Vladek's voice, as one was able to do at the Storr-curated 1991 MoMA show.)

Problems of Representation also features "My Travels with *Maus*, 1992–2020," by Marianne Hirsch, a literature professor and the former president of the Modern Language Association. Hirsch's "Family Pictures: *Maus*, Mourning, and Postmemory," from 1992, is arguably the most famous academic essay on *Maus*. Hirsch centers her inquiry on the few uses of photographs in *Maus* (as do other essays in the volume here), and she coins the term postmemory, which refers to "a generational structure of transmission": how the children of survivors experience memories belonging to older generations as their own. First developed in conjunction with *Maus*, postmemory is a prominent, guiding concept in trauma and memory studies, and in literary studies widely (see postmemory.net). For Maus *Now*, Hirsch revisited the entirety of her writing of *Maus* over the years, adding new content and grouping together analysis from three separate sources (including her response to a 2020 forum on the significance of her original essay). At the opening of "My Travels with *Maus*," Hirsch cites feminist writer and professor Nancy K. Miller, whose "Cartoons of the Self: Portrait of the Artist as a Young Murderer," appearing next, crucially centers (as Hirsch also does) the figure of the missing mother, Anja Spiegelman, in its evaluation of *Maus*. Miller approaches *Maus* from a long-standing feminist engagement with autobiography, analyzing *Maus* through a feature of its autobiographical creation that is traditionally associated with women writers: how it establishes the identity of the narrator-protagonist in relation to a significant "other"—in this case, the absent mother. Together, these tour-de-force essays offer a feminist perspective (that is not at times uncritical) on the family drama that underpins *Maus*, which is limned by the trauma of the Holocaust.

As with its first, Maus *Now*'s concluding section, Legacy, presents both public and academic writing rooted in distinct contexts. This includes Storr's oft-cited "Making *Maus*," first published to accom-

pany Spiegelman's MoMA show—an exhibit that solidified *Maus*'s art world reception and reveals how the book extends meaningfully into different corners of culture. Storr makes the fascinating (and probably, to some, counterintuitive) claim that *Maus* is "a radically traditional work of art," and his essay creates the case for *Maus* in the museum—a point that critic, dramaturge, and journalism professor Alisa Solomon returns to in the volume's final essay, which takes Spiegelman's traveling "Co-Mix" exhibit, more than twenty years later, as its point of departure.

The Legacy section also presents two translated scholarly essays, revealing that a key part of the ongoing power of *Maus* is its capacity to inspire critical attention across international boundaries. Spiegelman critic Pierre-Alban Delannoy, the author of France's only book-length study of *Maus*, offers a moving reading of the haunting figure of Richieu, Spiegelman's older brother who died as a small child during the war, in order to explain how the concept of survival operates in the text. And Hans Kruschwitz, writing from a German perspective in a 2018 volume of contemporary reflections on the Holocaust, offers an absorbing analysis of how the tension between images and words as different modes of ideation maps onto characters in *Maus*, namely Spiegelman's parents. Both authors closely analyze *Maus*'s brilliant two-page prologue, using its 1950s insult "rotten egg" as a jumping-off point, modeling how a phrase that an English reader might gloss over can be defamiliarizing, and open new avenues of inquiries for non-English speakers. Kruschwitz's essay ends with a call to teach *Maus*, despite its difficulty and complexity, in history and German classes—a notion also at the center of a 2021 newspaper feature in *Frankfurter Allgemeine Sonntagzeitung*, which profiles a German teacher who used *Maus* in the classroom and suggests that *Maus* both expands current German curricula with respect to the Holocaust, and productively focuses on the legacy of the Holocaust for future generations.[2]

Looking back at *Maus* from a contemporary vantage point, critics in this book's final section, each anchored by a different set of interests, articulate its legacy in straightforward terms. In an unusual, unguarded interview with Spiegelman that dives into controversial debates about Jewish identity and Israel, the writer David Samuels claims: "Today it seems clear that *Maus* and *Maus II* are the most pow-

erful and significant works of art produced by any American Jewish writer or artist about the Holocaust." National Book Critics Circle Award winner Ruth Franklin, another prolific and well-known critic, states at the outset of her 2011 assessment, which focuses on *Maus*'s productive unclassifiability, that Spiegelman "has done more than any other writer of the last few decades to change our understanding of the way stories about the Holocaust can be written." And Solomon, in the wide-ranging "The Haus of *Maus*," is incisive in summing up *Maus*'s compelling place in our culture. "Even in a bowdlerized Hollywood or Broadway adaptation," Solomon muses, "one could never imagine Art believing, in spite of everything, that people are really good at heart. Hasn't that always been part of *Maus*'s allure?" Solomon, writing in *The Nation*, brings us full circle, referring to Hirsch's concept of post-memory and noting that *Maus* "became the proof text for academic study of the transgenerational transmission of trauma and its repre-sentation." Throughout Maus *Now*, writers in the volume develop ideas by citing each other. This dynamic enacted across its chapters models a dialogue inspired by *Maus* itself, whose very structure and topic is an ongoing conversation, between father and son, that folds world history into the process. And the book ends with a selected list of fifty further essays on *Maus*; Maus *Now* aims to keep the conversa-tion started by Spiegelman's unique and indispensable book going for at least another forty years.

CONTEXTS

Behind the Masks

PHILIP PULLMAN

Since its first publication in 1986, *Maus* has achieved a celebrity that few other comics have ever done. And yet it's an extremely difficult work to talk about. In the first place, what is it? Is it a comic? Is it biography, or fiction? Is it a literary work, or a graphic one, or both? We use the term graphic novel, but can anything that is literary, like a novel, ever really work in graphic form? Words and pictures work differently: can they work together without pulling in different directions?

In the preface to *The Western Canon*, in his attempt to define "The Books and School of the Ages," Harold Bloom says: "One mark of an originality that can win canonical status for a literary work is a strangeness that we either never altogether assimilate, or that becomes such a given that we are blinded to its idiosyncrasies."

This is an accurate description of my reaction to *Maus*. In one way the work stands squarely in the comics tradition, observing many of the conventions of the form: a story about anthropomorphically depicted animals, told sequentially in a series of square panels six to a page, containing speech balloons and voiceover captions in which all the lettering is in capitals, with onomatopoeic sound effects to represent rifle fire, and so on. So it looks very like a comic.

It also refers to earlier forms. The stark black-and-white drawings, the lines so thick in places as almost to seem as if they belong in a woodcut, hark back to the wordless novels of Frans Masereel, with

their expressionist woodcut prints; and those in turn take their place in an even older Northern European tradition of printmaking that goes back to Holbein and Dürer. In telling a story about Germany, Spiegelman uses a very German technique.

Yet in other ways *Maus* does have a profound and unfailing "strangeness," to use Bloom's term. Part of this is due to the depiction of Jews as mice, Germans as cats, Poles as pigs, and so forth. This is what jolts most people who come to it for the first time, and still jolts me after several readings. It is such a risky artistic strategy, because it implies a form of essentialism that many readers will find suspect. Cats kill mice because they are cats, and that's what cats do. But is it in the nature of Germans, as Germans, to kill Jews?

The question hangs over the whole work, and is never answered directly. Instead we are reminded by the plot itself that this classification into different species was precisely how the human race was then regarded by those who had the power to order things; and the question is finally dispelled by the gradual gentle insistence that these characters might look like mice, or cats, or pigs, but what they are is people. They have the complexity and the surprisingness of human beings, and human beings are capable of anything.

At the heart of the story is the tormented relationship between Art and his father, Vladek, a survivor of Auschwitz, an obsessive, mean, doting, helpless, cantankerous, altogether impossible old man, whom we come to know in two different worlds: the present-day world of penny-pinching retirement in New York and the Catskill Mountains (names signify), and the remembered world of occupied Poland and the extermination camps. The work as a whole takes the form of a memoir by Art in which he tells us of his interviews with his father about Vladek's experiences under the Nazis. As Vladek tells his story, the first-person-past-tense captions in Art's voice give way to those in Vladek's, so the bulk of the narrative is technically a flashback.

Names signify. Is the Art of the story the Art of the title page? Art Spiegelman is a man, but the Art in the story looks like a mouse. In one extraordinary passage about two-thirds of the way through, Art is worrying about art—about his art, and what it's doing to himself and to its subject matter.

But the Art shown here is not a mouse but a man in a mouse mask,

and the journalists who come to pester and interview him are people in cat or dog masks, but men and women, not cats and dogs. This Art is the author, as distinct from the Art who is the narrator. So for six pages, as we follow the man-Art's anxiety about his art, we are in a different kind of world from either of the story-worlds, and in this sequence alone the words are not drawn in capitals.

What shape things have, and in what kind of letters the words are printed, and how a picture is set against its background, are matters we have to think about when we look at comics. A comic is not exactly a novel in pictures—it's something else. But the presence of pictures is not a new thing in printed narrative: William Caxton included woodcuts in the first books he printed in English, and some of the greatest novels in the language were conceived from the beginning as being accompanied by pictures. *Vanity Fair* is incomplete without Thackeray's own illustrations, which often extend and comment on the implications of the text; and in a sense the entire career of Dickens as a novelist began when he was commissioned to provide a text for a series of engravings of Cockney sporting life by the artist Robert Seymour. This grew into *The Pickwick Papers*. Our experience of Dickens is also an experience of "Phiz," his most prolific illustrator Hablot K. Browne, just as our sense of the world of Sherlock Holmes comes from the drawings by Sidney Paget as much as from the words by Conan Doyle.

So a criticism that was able to deal adequately with comics as a form would have to abandon the unspoken assumption that pictures aren't quite grown-up, or that they're only for people who don't read properly, and that clever and serious people need only consider the words. In order to have anything to say about comics, where the pictures generate a large part of the meaning, it would have to take the shape of things into account. For example, take the full-moon shape against which the characters are silhouetted at important points in the story of *Maus*, as if on a movie poster.

This echoes the claim old Vladek makes to young Vladek near the very beginning of the story, that he was romantic and dashing; but we know that movies are make-believe, and so the full-moon shape is bitter as well as sweet. It indicates something wished-for, not something true. There was no happy ever after; Anja was haunted by her

IN THE EVENINGS WE WENT EITHER TO THE THEATER OR TO DANCE IN THE CAFE.

DID I TELL YOU THE TRAGEDY ABOUT THE PILLOW MY FAMILY LOST AT THE START OF THE 1914 WAR!

I WAS SEVEN... WE LIVED TOO CLOSE TO THE BORDER... IT WASN'T SAFE...

I TOLD HER MANY JOKES AND STORIES TO KEEP HER BUSY...

...SO WE TOOK WHAT WE COULD ON A WAGON PULLED BY FOUR HORSES AND WENT TO MY GRANDFATHER'S HOME IN RADOMSKO.

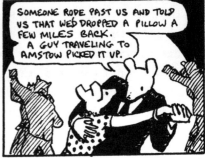

SOMEONE RODE PAST US AND TOLD US THAT WE'D DROPPED A PILLOW A FEW MILES BACK.

A GUY TRAVELING TO AMSTOW PICKED IT UP.

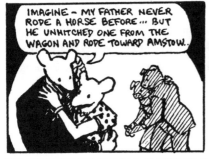

IMAGINE — MY FATHER NEVER RODE A HORSE BEFORE... BUT HE UNHITCHED ONE FROM THE WAGON AND RODE TOWARD AMSTOW..

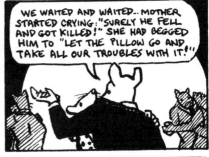

WE WAITED AND WAITED... MOTHER STARTED CRYING: "SURELY HE FELL AND GOT KILLED!" SHE HAD BEGGED HIM TO "LET THE PILLOW GO AND TAKE ALL OUR TROUBLES WITH IT!"

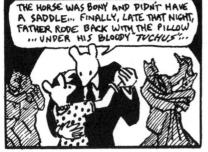

THE HORSE WAS BONY AND DIDN'T HAVE A SADDLE... FINALLY, LATE THAT NIGHT, FATHER RODE BACK WITH THE PILLOW ...UNDER HIS BLOODY *TUCHUS*"...

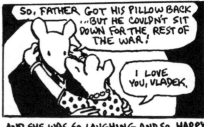

SO, FATHER GOT HIS PILLOW BACK ..."BUT HE COULDN'T SIT DOWN FOR THE REST OF THE WAR!

I LOVE YOU, VLADEK.

AND SHE WAS SO LAUGHING AND SO HAPPY, SO HAPPY, THAT SHE APPROACHED EACH TIME AND KISSED ME, SO HAPPY SHE WAS.

Maus I, page 35

experiences, and committed suicide in 1968. The shape carries a charge of irony: we see it and feel it in a glance.

Perhaps the most powerful moment comes very close to the end, and it could only come by means of a picture. Vladek, after Auschwitz, is making his way home to Anja, and one day Anja receives a letter telling her that he's on his way. And in the envelope there's a photograph. Old Vladek explains to Art: "I passed once a photo place what had a camp uniform—a new and clean one—to make souvenir photos . . ."

And there is the photograph. Here on the page is the character we have come, with Art, to hate and love and despair over in his old age, not a mouse any longer, but a man: a handsome man, a strong man, a proud and wary man in the prime of life who has survived appalling suffering, and survived in part because of the very qualities that make him so difficult to like and to live with: in short, a human being in all his urgent and demanding complexity. As Anja says when she opens the letter and finds the photograph, "And here's a picture of him! My God—Vladek is really alive!"

He's really alive. This story is really true. The impact of that photograph is astonishing.

Comics are a modern form, but this story has ancient echoes. At one point early in the war, the young Vladek, having been drafted into the Polish army and then captured by the Germans, escapes and finds his way home, and when he tries to pick up his young son, Richieu, the boy is frightened and cries out. In the *Iliad*, Homer relates a little episode on the walls of Troy:

> . . . *Shining Hector reached down*
> *for his son—but the boy recoiled*
> *cringing against his nurse's full breast,*
> *screaming out at the sight of his own father,*
> *terrified by the flashing bronze, the horsehair crest* . . .
> (translation by Robert Fagles)

Men in uniform have been terrifying their own children for thousands of years.

At the very end, little Richieu's name appears again, although he died forty years before. Vladek, ill and near the end of his own life,

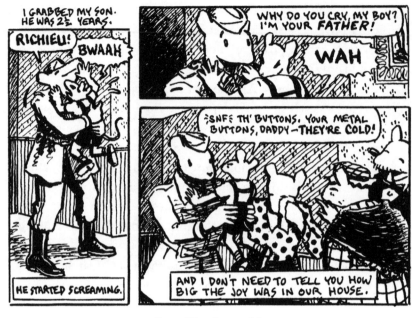

From *Maus I*, page 66

is talking to Art, and he says: "So . . . let's stop, please, your tape recorder . . . I'm tired from talking, Richieu, and it's enough stories for now . . ." Art stands by the bedside, silent, because art has been subsumed under a larger heading, namely life. There's nothing more for him to say. I began with a series of questions, and I'm not sure they can ever be completely answered; *Maus* is a masterpiece, and it's in the nature of such things to generate mysteries, and pose more questions than they answer. But if the notion of a canon means anything, *Maus* is there at the heart of it. Like all great stories, it tells us more about ourselves than we could ever suspect.

(2003)

Of Mice and Memory

JOSHUA BROWN

Art Spiegelman's *Maus: A Survivor's Tale* is a digest-sized comic book using mice, cats, pigs, and other animals to portray a history of the Holocaust. It has received adulation in newspaper and magazine reviews, was nominated for the 1986 National Book Critics Circle prize in biography, and received the *Present Tense*/Joel H. Cavior Book Award sponsored by that journal and the American Jewish Committee. But the award *Maus* won was in the category of fiction, and in that designation one may discern an uneasiness, largely unaddressed in the press, that greeted the book even as it was lauded. I have not seen many criticisms of *Maus* in print, but I have heard them expressed in casual conversations: "Okay, *Maus* is an ingenious work of art, it's a good story as well and, certainly, it's better than the run-of-the-mill comic book. But, history? No way."

Maus is not a fictional comic strip, nor is it an illustrated novel: however unusual the form, it is an important historical work that offers historians, and oral historians in particular, a unique approach to narrative construction and interpretation. *Maus* also provides us with the unique opportunity to evaluate simultaneously a finished work and a work in progress. The present book, subtitled *My Father Bleeds History (Mid-1930s to Winter 1944)*, is the first half of a planned two-volume work. The six chapters comprising the first volume originally appeared from 1980 to 1985, in somewhat different form, as installments in *RAW*, an art comics/graphics magazine edited by

Spiegelman and Françoise Mouly. The chapters of the second volume will appear sequentially in subsequent issues. Chapter 7 has already been published in *RAW* number eight, picking up where the first volume ended, at the gates of Auschwitz.

Much of the power of Spiegelman's book lies in his discourse with the reader, a discourse that exists "between the panels," beneath the narration and the dialogue. To understand this relationship between *Maus* and the reader we must consider first how Spiegelman approached oral history techniques and the problem of remembrance, then how he worked to visualize the past, and finally his use of the central metaphor of mice. Spiegelman's reflections, recorded in an interview I conducted with him in early 1987, run throughout this review. They make clear how much the book's impact is grounded in his explicit intention.

1.

Maus is the story of two survivors of the Holocaust. The first is Vladek Spiegelman, a Polish Jew who, along with his wife, Anja, survived Auschwitz and came to live in Queens, New York. There, Vladek and Anja raised their second son, Art, their post-Holocaust child (their first son died during the early stages of the Final Solution). Art grew into adulthood under the shadows of his parents' past, the darkest appearing in 1968 when Anja committed suicide. Art himself is the second survivor, although at first his torment seems self-indulgent compared to the elemental horror of his parents' experience.

The accounts of these two survivors run through *Maus* as Art records his father's memories in a series of oral interviews: Vladek's courtship of the wealthy Anja, the marriage that facilitated his rise in the business world of the secularized Jewish community of Sosnowiec, his induction into the Polish army and capture by the Nazis in 1939, his release and return to the area of Poland "annexed" by the Reich. Vladek relates the steady tightening of the Nazi noose around the Jews as the policies of extermination were put into practice, detailing how, as the concentration camps filled, he and Anja managed to survive through cunning strategies and blind luck, until they were caught and sent to Auschwitz.

Throughout *Maus*, Vladek's story is paralleled by Art's attempts to come to terms with the opinionated, tight-fisted, and self-involved father whose personality was formed in a world and through an experience so completely divorced from his own. The ghosts of this past swirl around Art, who is haunted by the irretrievable experiences of the dead, their residue found in familial relationships characterized by guilt and manipulation. The first volume closes with dual betrayals: Vladek describes how he paid two Poles to smuggle Anja and him to Hungary only to be turned over to the Nazis; minutes later he reveals to his son that, after Anja's suicide, he destroyed her diaries, her account of the Holocaust for which Art has been frantically searching.

It is logical to approach the book first as a work of oral history, because of its sources and Spiegelman's decisions about the structure of its text. The absence of footnotes or bibliography should not be mistaken for indifference to the importance of research. "Essentially, the root source of the whole thing is my father's conversations with me," Spiegelman explained when I asked him about the sources he consulted. "Sixty percent of those are on tape and the rest of it's during phone conversations or while I was at his house without a tape recorder, taking notes. Now, my father's not necessarily a reliable witness and I never presumed that he was. So, as far as I could corroborate anything he said, I did—which meant, on occasion, talking to friends and to relatives and also doing as much reading as I could."

Although *Maus* focuses on the particularity of Vladek's story, Spiegelman succeeds, through succinct narration and dialogue, in keeping us aware of the changing social and political climate of Sosnowiec, and from there the context of Poland and the Third Reich. "This is a bottomless pit of reading if one falls into the area," Spiegelman said. "There's building after building of books and documents. I don't pretend to [have read them all]. On the other hand . . . I read as many survivors' accounts as I could get hold of that touched on the specific geographical locations [depicted in the book]." In his effort to place Vladek on the particular map of Sosnowiec, Spiegelman was also aided by a Polish pamphlet published after the war that chronicled the fate of the Jews of that city. "Every region had its own booklet. . . . [The Sosnowiec pamphlet] was really important for the things that

take place in the last half of the first volume because it has very, very specific information."

Spiegelman's sources are relevant, but oral history is more than a verbatim transcript propped up by corroborative facts and context. The structuring of an account—how a recorder shapes his or her sources, how he or she organizes the materials into an interpretive narrative—are equally a concern. In his choices and the critical considerations behind those choices, Spiegelman worked as a skilled oral historian. He presented his father's story as a chronologically linked chain of events, restructuring Vladek's testimony to strengthen the clarity of the account. But, the way one chooses to tell a story is a kind of censorship, and Spiegelman conscientiously had to weigh the impact of one narrative decision over the effects of others:

> This is my father's tale. I've tried to change as little as possible. But it's almost impossible not to [change it] because as soon as you apply any kind of structure to material, you're in trouble—as probably every historian learns from History 101 or whatever. Shaping means [that] things that came out [in an interview] as shotgun facts about events that happened in 1939, facts about things that happened in 1945, they all have to be organized. As a result, this tends to make my father seem more organized than he was. For a while I thought maybe I should do the book in a more Joycean way. Then I realized that, ultimately, that was a literary fabrication just as much as using a more nineteenth-century approach to telling a story, and that it would actually get more in the way of getting things across than a more linear approach.

Or, as Spiegelman shows more concisely in *Maus*:

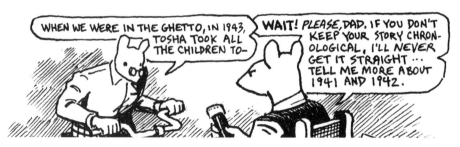

From *Maus I*, page 82

However, Spiegelman was after more than "telling a story" or creating a comprehensible biographical account. He also strove to depict the process of remembering and relating, one that included the incidental breaks and digressions that occur between two people whose relationship exists outside of the roles of interviewer and interviewee. In the interstices of the testimony we learn more and more about both Vladek and Art. The breaks and digressions convey the sense of an interview shaped by a relationship. They also remind the reader that Vladek's account is not a chronicle of undefiled fact but a constitutive process, that remembering is a construction of the past.

Spiegelman telegraphs information about events or insight into character or a relationship through inflection, carefully chosen words, or the structuring of their order. Spiegelman's use of language is remarkable in its exactitude and lack of bravado. The language has the peculiar mix of confusion and clarity of spoken words—because, indeed, the dialogue is based on Spiegelman's interviews with his father. But we are not provided with verbatim transcriptions of conversations. "It's impossible in a comic strip to record verbatim conversation," Spiegelman explained,

> because the balloons would be about twelve inches high for every two-inch picture. . . . Comics are an art of indication. And it's a matter of, after reading Vladek's three or four different accounts of the same story with different language, trying to distill them, to keep the phrases that are most telling for me and rewrite a lot of that in a kind of telegram that catches the cadence of the way he talked. And because I grew up hearing him talk, it was easy enough for me to do.

Beyond presenting a comprehensible account of events while subtly depicting characterization and the composition of a relationship, *Maus* makes an even greater contribution as a work of oral history by interrogating the limitations of our techniques for recording experience, and by engaging the problematic of memory as evidence. As Art records Vladek's story, the reader follows a course of events and, yet, revelation is accompanied by a feeling

of constraint, expressed concretely in Art's persistent and finally frustrated search for his mother's diaries. Spiegelman confronts the perennial obstacle facing any oral historian, the problem of one person's account, the reliance on one memory to record an event. But, there is an added dimension to this problem in *Maus*: the survivor is not only one person with one memory; the fact of his survival lends a delusory authenticity to his recollections: "It's a built-in problem," Spiegelman observed:

> As soon as you tell a story of a survivor and how they survived, you're not telling a story of what happened. Somehow, it becomes a how-to manual. Because there's a natural desire and tendency on the reader's part to identify with a character in a book someplace, you identify with the one who survived. You pick a winner and you ride through with him. And, yet, there was such a large amount of luck involved. There might have been certain personality traits or mechanisms that would help a person increase the odds of surviving, but—no matter what Terrence Des Pres's or Bruno Bettelheim's theories of survivors are—within a situation where ninety percent died that's not enough and, therefore, isn't reason to identify with the survivors rather than to try to understand the situation.

Confronted with that dilemma, Spiegelman considered broadening Vladek's story to include others. Instead, however, he decided to confront the problem head-on. The dilemma of *not knowing* pervades the book. At one point, as Art endeavors to tell Vladek's story, all he seems to come up with is a distorted stereotype; speaking with Mala, Vladek's second wife, he reflects:

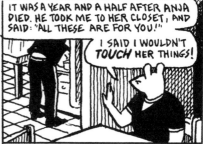

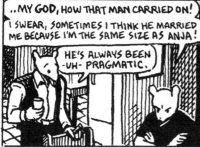

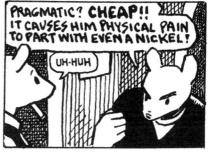

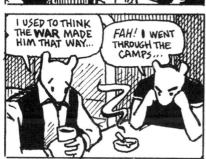

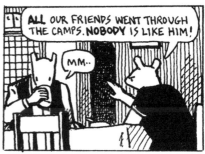

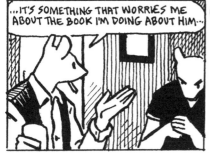

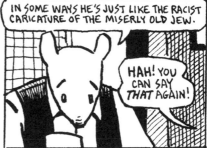

Maus I, page 131

The book ends with Vladek's revelation that he has destroyed Anja's diaries. Spiegelman presents the reader with the terrible realization that Vladek's account is what we are left with. The issue escalates in the second volume:

> In the second book, I'm now introducing another survivor who is giving me a little bit of a vantage point that I would have liked to have from my mother but isn't in any way available to me anymore from that source. And, yet, it seemed important to indicate ways in which Vladek was not the archetypal survivor, but a survivor.

So, the second volume of *Maus—From Mauschwitz to the Catskills (Winter 1944 to the Present)*—will overtly grapple with the limitations of oral technique, in part by presenting contradictions to Vladek's testimony through other survivors. Yet, it is the achievement of *Maus* that Spiegelman refuses to fill in the picture, leaving the reader with the terrible knowledge that we cannot know. "I was obviously angry that my father had done this [destroyed Anja's diaries]," he said.

> On the other hand . . . if I had access to my mother's diaries, perhaps I'd have to find yet another way of trying to indicate that, okay, I have those two stories but I don't have the other five or six or seven million stories that could have gone alongside it. . . . In spite of the fact that everything's so concretely portrayed box-by-box, it's not what happened. It's what my father tells me of what happened and it's based on what my father remembers and is willing to tell and, therefore, is not the same as some kind of omniscient camera that sat on his shoulder between the years 1939 and 1945. So, essentially, the number of layers between an event and somebody trying to apprehend that event through time and intermediaries is like working with flickering shadows. It's all you can hope for.

"There persists this illusion that everything can be resolved," John Berger said in a recent *New York Times* interview, "and the great tragedies have been a result of this impatience with contradiction." The

"unknowableness" that ends the first volume of *Maus* (and promises to characterize the second) leaves the reader uneasy. *Maus* is a successful work of history because it fails to provide the reader with a catharsis, with the release of tension gained through the complacent construct of "knowing" all.

<div align="center">

2.

</div>

Maus may be a biography, but it is a comic strip biography, and a comic strip biography that uses mice to depict the victims of the Holocaust. I suspect that the caution with which many readers have approached *Maus*, and the reasoning behind the *Present Tense*/Joel H. Cavior Award in the category of fiction, lies not in the text but in the interaction of the written word with images. Beneath that interaction lurks a myriad of issues about the presentation of history and, more particularly, the structuring of an efficient yet nuanced visual narrative.

Consider the challenge Spiegelman faced. He had to "materialize" Vladek's words and descriptions, transforming them into comprehensible images. "My problem," Spiegelman remembered, "was when my father said, 'I was walking down the street,' I'd start picturing 14th Street and 8th Avenue and, of course, it's not that. It's in Eastern Europe." Spiegelman consulted photograph books, from Roman Vishniac's pictures of the Jewish ghetto in *A Vanished World* (1983) to Lucjan Dobroszycki and Barbara Kirshenblatt-Gimblett's photographic history of Jewish life in Poland, *Image Before My Eyes* (1977). He consulted the few remaining family photographs and, for the second volume, has pored over *The Book of Alfred Kantor* (1971), the artist's "visual diary" of his internment in the concentration camps Terezín, Auschwitz, and Schwarzheide. He has viewed films such as *Shoah*, *Night and Fog*, and *Image Before My Eyes*, wearing out the heads on his VCR as he gazed at particular images on freeze-frame. And he traveled to Eastern Europe, to his father's hometown, to Auschwitz, taking photographs.

Working on the second volume of *Maus*, Spiegelman has run into formidable obstacles:

For instance, I'm trying now to figure out what a tinshop looked like in Auschwitz because my father worked in one. There's no documentation whatsoever of that, it's hard to even find out what kind of equipment people used. I happen to be lucky enough to have met somebody who worked in a tinshop in Czechoslovakia in 1930 and so he knows approximately what it was like. And he's trying to describe equipment to me but I have a very poor head for mechanical objects and things like that. It's not something I understand well. So I sort of make little doodles and he'd say, "Oh no, a little bit smaller with a kind of electric motor that attaches to a belt to a ceiling thing." So I'm getting some sense of it.

The intensity of Spiegelman's search for visual sources shouldn't be ascribed to a fetish for visual representation. Indeed, Spiegelman shuns the ubiquitous comic book "splash panel" displaying sweeping action or filled with minute details that are calculated to impress the reader, preferring instead to convey a sense of time and place through "incidentals." To Spiegelman, however, exhaustive research still is necessary if he is to distill the images for his readers. Referring to the machinery in the tinshop, Spiegelman noted:

The final drawing will not reflect any of this stuff because it's going to be a two-inch-high drawing with a little line representing an electrical cable or something. But, somehow, I don't feel comfortable until I know what it is that I'm [drawing], where it's situated. Even if it's ultimately a rather fictionalized space, I have to believe in that space enough so that it can be there, even though what finally represents that space is so modest that somebody can project a whole other space onto what I've drawn. . . . It's just steeping myself in enough stuff so that I know what it is. And once I know what it is, I assume that I can get some of it over.

Yet, the "unknowableness" remains a problem: "It's becoming harder and harder as I go on in the book. For instance, the stuff in the camps that I'm working on now is very, very difficult because I just can't get a clear sense of movement through Auschwitz. None of

the accounts are sufficient to let me feel that." Not knowing presents Spiegelman as a cartoonist with several choices in representation. How much is the artist willing to invent to fill out the incomplete record? When parts of the past are cloaked in silence, how can the artist lend visual coherence to the images without producing pictures that merely provide an illusion of knowledge? "I'm proceeding very, very carefully," Spiegelman answered, "and it means that, in some places here, I'm even more circumspect than I was before in terms of showing something. Unless I *need* to show it, I try not to speculate on what might be happening in the background."

Spiegelman's strategy for visualizing the past suggests how profoundly his role as a biographer is rooted in years of work as a cartoonist and his persistent experimentation with the comic strip form. In *Maus*, Spiegelman has used the strengths of the conventions of the comic strip, stretching and rearranging text and image into a coherent presentation. This may seem a long way from listened-to words and transcribed language. But if we accept the idea that history is a construct and not facts existing in a natural state, the aspects of *Maus* that at first sight seem removed from biography will emerge as critical constitutive parts.

Maus was published in a digest-sized book format. That size is, of course, unusual for a comic book. Within this format, Spiegelman designed panels that average about two inches in height. The veteran cartoonist has used this dimension to his advantage, creating emphases and effects through sudden changes in an otherwise more uniform presentation. When Vladek and Anja, for the first time, confront Nazism in Czechoslovakia, its impact upon them and their accompanying fear emerge through the abruptly changed dimension of the panel. The effect is heightened by Spiegelman's unusual method of cartooning. The standard approach is to draw a page twice the size of the published version, permitting the artist to tackle detail more easily. The reduced finished product appears tighter and sharper to the reader's eye (and, practically, obscures mistakes). An illusion, in effect, is produced for the reader, a "naturalized" image divorced from its production. Spiegelman decided, instead, to draw *Maus* in the constricted format in which it would be

finally published. "I didn't want the drawing to get tighter," Spiegelman said,

> I wanted it to be more vulnerable as drawing so that it wouldn't be the master talking down to whoever was reading. And this sort of leaves me without as many intermediaries between me and somebody reading *Maus*. It's a little more like reading somebody's handwriting or a journal if it's the same size as you're writing.

The visual language of the images underscores this artistic point. The style of *Maus* is as concise and direct as the writing in the captions. As with the size of the panels, there is a uniformity of characterization throughout: the mice are not particularly individualized by expression or facial appearance. Other than distinctive clothing and different linguistic constructions in the captions, individual expressiveness is rendered through imaginative use of gestures and simple comic book symbols for emotions: embarrassment . . . desperation.

This quieter style is not due to lack of skill, as one can see by comparing the images in the book with those in Spiegelman's first attempt at *Maus*, a three-page strip published in *Funny Aminals* [sic] in 1972 (or by looking at "Prisoner on the Hell Planet," a 1973 strip included in its entirety within *Maus*).

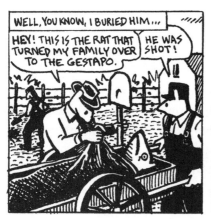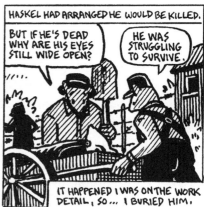

Two panels from page 117 of *Maus I*

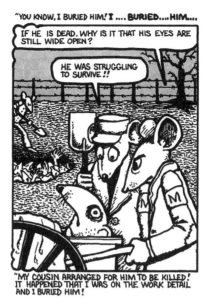

Panel from "Maus," 1972

Through careful observation of comics (his loft apartment contains one of the largest collections of comic art I've seen) and through "progressive self-revision," to use Michael Baxandall's phrase, in rough sketch after rough sketch of *Maus*'s images, Spiegelman sought to reduce the gap between words and pictures.

> I didn't want people to get too interested in the drawings. I wanted them to be there, but the story operates somewhere else. It operates somewhere between the words and the idea that's in the pictures and in the movement between the pictures, which is the essence of what happens in a comic. So, by not focusing you too hard on these people you're forced back into your role as reader rather than looker. . . . One analogy I've used before is that these faces are a little bit like Little Orphan Annie's eyes. If you look at those blank disks you see a lot of expression, but it's taking place somewhere other than on that piece of paper. And by keeping the faces relatively blank, relatively similar to each other, you end up entering into and participating more in bringing this thing to life as a reader. In that sense it's a little more like reading.

Perhaps this explains why, as we read, the simplified images none-theless magnify the visual impact of character, and the telegraphing of emotions and relationships. This effect is particularly powerful when *Maus* is read cover to cover. The story of the Holocaust grows as we follow Vladek's chronology, as we stumble over the ruts and holes in the pitted roadway of his memory, and as the slights and misplaced affections of Art and Vladek's brittle relationship come fully to life. Perhaps, by isolating a two-page spread, the experience of reading *Maus*—and the nature of the discourse it elicits—may be suggested. In this episode, shown on pages 74–75, Vladek has returned after being released from a prisoner of war camp. He returns to the demonstra-bly straitened circumstances of the Sosnowiec Jewish community, evident even in the comparatively sumptuous circumstances of his in-laws' dinner table.

The simple rendering of the mice, their very lack of individuality, heightens the captions' power to convey information. At the same time, we are not left with mere stick figures to ignore as we pore through the text. The interchanges take place over a dinner table, and the actions and gestures bespeak the peregrinations and little bits of chaos in a family thrown together under the intensification of Nazi policy. The sketched-out activity gives the reader a sense of time and circumstance, drawing the information out within a spe-cific context.

"Historical understanding," Johan Huizinga once wrote, "is like a vision, or rather like an evocation of images." To understand oral testimony we must imagine the narrative, reconstructing it into pic-tures in our imagination. Spiegelman, in the guise of a cartoonist, renders the intellectual work of the oral historian as a palpable act: he presents us with the images that Vladek's testimony created in his mind, carefully exploiting conventions of the comics form in a manner that does not subsume the reader's imagination but stim-ulates it. It is a finely wrought balance: while so many contempo-rary comics lull the reader—whether through a "naturalism" of style that suggests authenticity or through visual pyrotechnics calcu-lated to leave us in awe—*Maus* engages him or her in filling out the experience.

3.

Which finally brings me to the subject of mice. I've saved for last the most controversial aspect of *Maus*, the metaphor of mice representing Jews. I haven't been neglecting the issue of Spiegelman's use of Hitler's vermin metaphor because I think the subject is unimportant—how can it be unimportant when Spiegelman places in the epigraph Hitler's statement, "The Jews are undoubtedly a race, but they are not human"? But Spiegelman's use of the metaphor must be placed within the overall concept and construction of *Maus*. The obvious question to ask, the question that has been repeatedly posed to me on the occasions *Maus* has come up in conversation, is: why use the metaphor at all? Why not portray the Jews, the Poles, and the Germans as human beings? It has not often been noticed that in fact Spiegelman has done just that: the Jews are *not* mice, the Poles are *not* pigs, the Germans are *not* cats. The anthropomorphic presentation of the characters should make that eminently clear, and were there any doubts, Spiegelman dispels them. When Anja and Vladek hide in the cellar of a Polish house:

From *Maus I*, unpaginated (page 147)

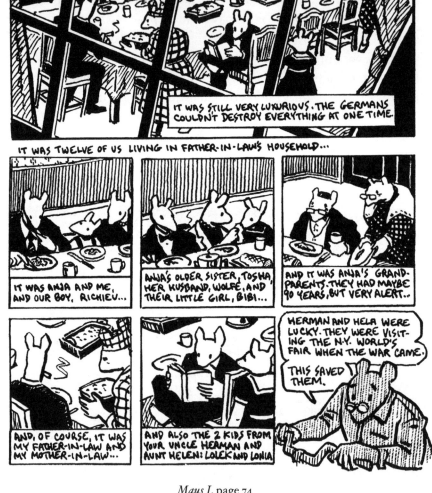

Maus I, page 74

In fact, we are not really confronted by animals playing people's roles but by humans who wear animal masks (indeed, when the Jews try to pass as Poles, they wear pig masks). Through the metaphor *Maus* palpably confronts the reader with the social relations of Eastern Europe, of nations divided by nationalities and by culturally constructed, politically exploited stereotypes. By drawing people as animals, Spiegelman evokes the stratification of European society that had seemed dormant but soon exploded into an orgy of racism. When you read *Maus*, you don't tend to identify the characters as animals. You decipher human beings, and then the metaphor takes hold. You are disrupted, upset. That is the effect Spiegelman hoped for:

> You can't help when you're reading to try to erase those animals. You go back, saying: no, no, that's a person, and that's a person there, and they're in the same room together, and why do you see them as somehow a different species? And, obviously, they can't be and aren't, and there's this residual problem you're always left with.

Spiegelman tackled Hitler's metaphor to undermine it. The horror of racial theory is not rationalized or supported by the metaphor; it is brought to its fullest, tense realization.

Spiegelman's rendering of the mice, or rather (as he has put it) "masks of mice," elicits that awful realization. But the metaphor does more than that. Spiegelman explicitly created his "masks of mice" to confront a tendency implicit in Holocaust historiography:

> If I had just written a précis of what *Maus* was, somebody would say, "Oh God, he's doing a comic strip about the Holocaust with cats and mice," and the first thing they'd imagine was cute little Disney mice running around. So I didn't want to make the mice too cute, too sweet. Which brings me to a thing that has disturbed me in the literature on the subject of the Holocaust, the occasional unnecessary plea for sympathy for the victim. There's a lot of literature in which certain demands are being made on you that I feel should be a given and, therefore, it's actually demeaning to ask. Using that kind of cute, pudgy little mouse character with big, round, soulful eyes would've been, well, would've been all wrong.

Maus captures the terrible relationship between the lost world of European Jewry and the present. It portrays the frustration of a son who grew up in a different setting, trying so hard to understand the world that shaped his father, to grasp the stunning dimensions of an unfathomable experience. "Unknowableness" is the void separating the two generations, and the awareness of the limitations of under-standing, of how remembering and telling captures and, yet, fails to capture the experience of the past, permeates *Maus*. Through the structuring of his narrative, sensitive use of language, and a decep-tively simple visual strategy, Spiegelman has created a history that is compelling in its portrayal of the Holocaust and in its consistent analysis of the hazards and holes in the reconstruction of history. No short summary delineation of elements can adequately convey *Maus*'s achievement. But the difficult endeavor Art Spiegelman set out for himself is worth reiterating one more time. In her short story "Rosa," Cynthia Ozick suggested the challenge in a passage where she, too, played off of the metaphor of animals:

> ". . . in America cats have nine lives, but we—we're less than cats, so we got three. The life before, the life during, the life after." She saw that Persky did not follow. She said, "The life after is now. The life before is our real life, at home, where we was born."
> "And during?"
> "This was Hitler."

(1988)

Cats, Mice, and History

The Avant-Garde of the Comic Strip

KEN TUCKER

Since 1980, a self-described "graphix magazine" called *RAW* has published six installments of "Maus," a comic strip written and drawn by Art Spiegelman. In "Maus," Mr. Spiegelman re-creates the experiences of his parents, Polish Jews who were persecuted by the Nazis during World War II. A remarkable feat of documentary detail and novelistic vividness, the strip is also striking in another way: its protagonists are drawn as mice; their Nazi captors are represented as cats.

Coedited by Mr. Spiegelman and Françoise Mouly, the magazine's publisher, *RAW* is usually published twice a year in New York. Its twelve thousand copies are sold mainly in bookstores around the country. Perhaps because of *RAW*'s limited circulation, few people are aware of the unfolding literary event "Maus" represents. Bernard Riley, curator of popular and applied graphic art for the Library of Congress, says the strip's narrative structure and its social and political themes make it comparable to nineteenth-century literature. "It's good, serious work," Mr. Riley says. "'Maus' brings back an excitement that has been lost in comic art. You get the feeling reading him that you're on the cutting edge of graphics, a field that has been stagnant for a long time now."

Mr. Spiegelman tells the story of his parents as he first heard it,

through a series of conversations with his father. The artist himself appears in the strip as a laconic narrator-mouse in jeans and a rumpled shirt, perennially puffing on a cigarette. He and his father take aimless walks through the latter's Rego Park, Queens, neighborhood or sit around a small kitchen table while Art coaxes the stoic Vladek Spiegelman to tell the story of his life: Vladek's early career in Poland as a textile salesman; his courtship of and marriage to Art's mother, Anja, in 1937; the couple's internment in a Nazi concentration camp and their escape in 1945. Mr. Spiegelman explores the legacy of that period. Most of the Spiegelman family—grandparents, aunts, uncles, cousins—either died or disappeared. His mother eventually committed suicide and Vladek subsequently married Mala, a Polish concentration camp survivor. Running through the story is Vladek's unrelenting obsession with his experience at the hands of the Nazis.

This is an epic story told in tiny pictures. The drawing in "Maus" is blunt and unadorned. Characters are sketched with a few lines in black-and-white panels and shaded with the most elementary crosshatching. As art, Mr. Spiegelman says, "Maus" is intentionally simple: "seeing these small pages of doodle drawings—rough, quick drawings—makes it seem like we found someone's diary and are publishing facsimiles of it." The cartoonist Jules Feiffer, the author of *The Great Comic Book Heroes,* observes that Mr. Spiegelman has "found a new way to express a unique and personal view of life. He is by no means pretentious and yet absolutely true to the form."

Mr. Spiegelman's characters stand, dress, and speak as humans; they just happen to have long, narrow, white mouse faces. Why mice? "A few years ago I was looking at a lot of animated cartoons from the 1920s and '30s, and I was struck by the fact that, in many of them, there was virtually no difference between the way mice and Black people were drawn. This got me thinking about drawing a comic strip that used mice in a metaphor for the Black experience in America. Well, two minutes into it, I realized that I didn't know the first thing about being Black, but I was Jewish, and I was very aware of the experiences of my parents in World War II, so that pushed me in that direction.

"What amazed me was that I have continued to find parallels, some of them painfully ironic, to this artistic metaphor. For example,

Title page for chapter six, *Maus I,* page 129

in *Mein Kampf,* Hitler refers to Jews as 'vermin.' I saw a Nazi propaganda film in which shots of crowds of Jews in a busy marketplace were contrasted with shots of scurrying rats. There is also a short story by Kafka called 'Josephine the Singer, or the Mouse Folk' which portrays Jews as mice.

"All of these things served as buttresses for what I was attempting," Mr. Spiegelman says. "Then too, I needed to deal with the characters as animals to have some distance from the materials—in an early version of the story I started out doing portraits of my parents, but it became too sentimental. Comics is a language of signs, and by using these masklike faces on top of what are real people, the metaphor remains useful, and adds to the story a resonance it wouldn't have otherwise."

This is Mr. Spiegelman's triumph in "Maus": he tempts sentimentality by suggesting a pop-culture cliché—wide-eyed mice menaced by hissing cats—and then thoroughly denies that sentimentality with the sharp, cutting lines of his drawing and the terse realism of his dialogue. Six chapters of "Maus"—119 pages of a work expected to number about

250 pages—have appeared in *RAW*. When the strip is completed—in about two years, Mr. Spiegelman estimates—Pantheon will publish it in book form. In the meantime, it will continue to be serialized in *RAW*, where Mr. Spiegelman and Miss Mouly try to present the comic strip as a narrative form as capable of telling enthralling stories as the novel or the movies, as a medium for the discussion of political issues and social causes, and as an experimental, often abstract art form.

Does it sound odd to speak of comic strips in such serious terms? Can a medium whose most persuasive representatives are the perennial bestsellers Snoopy the dog and Garfield the cat possibly interest serious readers? Only in America would these questions even arise. Comic strips—prized as a fresh, even radical variation on fine art throughout the world, particularly in Europe and Japan—are in America widely reviled as the lowest of the low arts, aimed, most adults assume, at young children or immature eccentrics. Few Americans who are otherwise well informed and open-minded in cultural matters seem aware of the excellent, sometimes innovative work being done by a small but prolific number of comic strip artists. This group includes Dave Stevens, the West Coast writer and illustrator of *The Rocketeer*, a super-hero parody that offers lovely, meticulous color drawings of 1930s Los Angeles; Gary Panter, a Texan, whose intentionally primitive comic book version of *Art Brut* has made him a cult favorite of both art gallery owners and punk-rockers; and Sue Coe, an English artist whose harshly drawn, highly polemical *How to Commit Suicide in South Africa,* was published by Mr. Spiegelman's Raw Books last year. Mr. Riley, of the Library of Congress, says "the collective efforts of Art Spiegelman, Sue Coe, and other new artists will change political satire in our time."

Comic strips with political or avant-garde aesthetics, with intentions beyond mere entertainment, are not new; if anything, challenging cartoonists had more exposure early in this century, when Winsor McCay's hallucinatory *Dreams of the Rarebit Fiend* and George Herriman's proto–Abstract Expressionist *Krazy Kat* first came into millions of innocent American homes as part of the Sunday newspaper. By the 1960s, however, the newspaper comic strip and its companion format, the comic book, had become so tediously familiar, so segregated

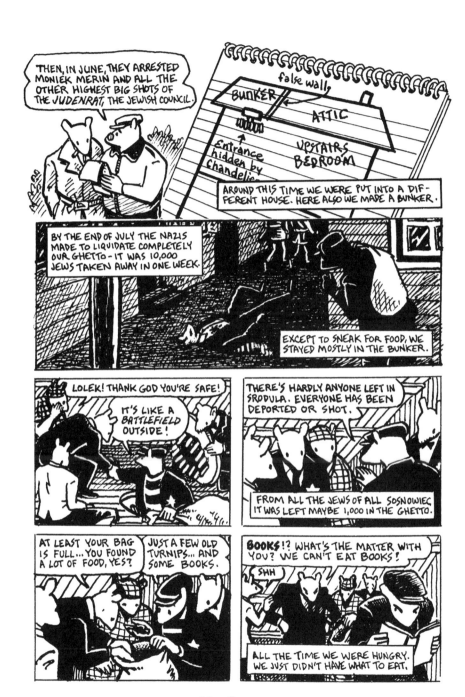

Maus I, page 112

as a diversion created solely for children, that a rebellion was almost inevitable.

By the end of the decade, "underground comics" had appeared. They reveled in colorful tales of drug consumption and explicit sex, and unleased at least one genius—the savagely misanthropic and witty Robert Crumb—and a whole generation of original artists. Mr. Feiffer notes that "'Maus' is not a 60's work—it's not countercultural at all. There is no reason why a much larger audience than the one that usually reads comics could not become engrossed in 'Maus.'"

With the fading of the 1960s counterculture, many artists have moved away from the sex-and-drug excesses of the underground-comic era. Their new goal is to expand the very notion of what a comic strip can do, to make intelligent readers reconsider—and reject—the widespread notion of, in Mr. Spiegelman's phrase, "comics-as-kid-culture."

There is disagreement about the value of such efforts. Bill Blackbeard, director of the San Francisco Academy of Comic Art, says that "Comics are usually read by an audience that reads for excitement or amusement alone. It's an audience that doesn't want to read for serious purposes. Spiegelman's work challenges those assumptions." Bernard Riley says Mr. Spiegelman "takes underground comics into new territory, making comics over into a kind of psycho-history, with highly literary and meticulously observed autobiography."

(1985)

Comics and Catastrophe

Art Spiegelman's *Maus* and the History of the Cartoon

ADAM GOPNIK

If you ask educated people to tell you everything they know about the history and psychology of cartooning, they will probably offer something like this: cartoons (taking caricature, political cartooning, and comic strips all together as a single form) are a relic of the infancy of art, one of the earliest forms of visual communication (and therefore, by implication, especially well suited to children); they are naturally funny and popular; and their gift is above all for the diminutive.

But these beliefs about cartooning are not merely incomplete; they are in almost every respect the direct reverse of the truth. Cartoons are not a primordial form. They are the relatively novel offspring of an extremely sophisticated visual culture. The caricature, from which all other kinds of cartooning descend, first appears around 1600 in Italy, within the circle of Bernini and the Carracci—and then not as a popular form, a visual slang, but as an in-group dialect, an aristocratic code.

Some of the devices that belong to cartoon and caricature might seem to be very ancient. There may appear to be precedents in Egyptian and Assyrian art for the device of combining human and animal elements in one figure; and we find distorted or grotesque human faces on everything from Greek pots to Gothic cathedrals. But these ancient practices have essentially nothing in common with apparently similar devices in modern cartoon and caricature. Before 1600 the

tradition of combining human and animal elements in a single figure was a tradition of splicing—usually placing an animal head on a human body in order to symbolize reverence (as in Egyptian art) or contempt (as in certain Roman graffiti). It was only around 1600 that the tradition of splicing human and animal elements was replaced by a tradition of melding those elements together in such a way that the abstract likeness of man and animal was made into an animated visual fusion.

Similarly, grotesques before 1600 were never portraits: Roman and Gothic grotesques are meant to depict sub- or transhuman types. They are not meant to be striking, much less affectionate, likenesses of individuals. Distortion of the human face for the purposes of caricature, rather than the creation of monsters or satyrs, and the device of melding, as against splicing, human and animal features together are unique to the cartoon tradition, and are at most three hundred years old (though, inevitably, certain kinds of simple caricature and cartoon are haunted by earlier "grotesque" traditions).

It took more than a century before the caricature was reimagined, in England in the late eighteenth century, as a form of popular political and social satire. And the "diminutive" cartoon, the kind of cartoon we associate in this country with the work of Walt Disney, is not a simple extension of the cartoon tradition, but a real departure from it, an American invention of the same vintage as contract bridge or the NFL.

Our mistaken beliefs about cartooning testify to the cartoon's near magical ability, whatever its real history, to persuade us of its innocence. Even though cartoons are in fact recent and cosmopolitan, we respond to them as if they were primordial. If we could understand why this happens, we might begin to understand the special cognitive and even biological basis of our response to the form. That educated people don't know very much about cartooning just shows that we don't usually think it worthwhile to educate people about it. But this situation is changing. That, for the first time, educated people are coming to have an opinion about cartoons is largely due to the influence of one remarkable work, Art Spiegelman's book *Maus: A Survivor's Tale*.

By now everyone has heard something about *Maus*. It has been widely and enthusiastically reviewed, has sold a surprisingly large number of copies, has been nominated for a National Book Critics

Circle award. And by now everyone knows what *Maus* is: the Holocaust Comic Book. This label is one of those oxymorons—like "nonfiction novel" and "rock opera"—that put reviewers into a kind of hypnotic trance. Rising from their baskets and swaying back and forth, they worry ponderously about categories rather than values. *Maus* is a work in progress, a serial that has appeared in installments in Spiegelman's magazine *RAW,* a magazine of what used to be called "underground" cartooning. (*RAW* is to New York painting in the 1980s, which often draws heavily on cartoon imagery, what *Minotaure* was to Paris painting in the 1930s—a kind of *prêt-à-porter* catalogue of avant-garde form.)

On one level, *Maus* is an autobiographical documentary about Vladek Spiegelman, the artist's father, and his experiences in Poland as a Jew during the Second World War. *Maus* begins with Art visiting Vladek today in Rego Park, Queens. "We weren't very close," Art admits. (We learn later that the two men had been torn apart by the suicide of Art's mother, Anja, a few years before.) In part to encourage a warmer relationship with his father, in part because it seems important for its own sake, in part because it offers a new avenue for Art's work, Art decides to write a book about Vladek's experiences during the war, experiences that, we discover early on, took him into Auschwitz. The story then moves freely from Rego Park today to Poland during the horror, as we both follow the track of Art's inquisition of his father and move back into the lost world Vladek's memories evoke.

Vladek, we are informed, came from a family of well-off Polish Jewish merchants. As a young man he married the plain and troubled daughter of a much wealthier family. (It is a measure of Spiegelman's extraordinary intelligence and delicacy as a kind of novelist that he manages to make his father's mixed motives in this marriage perfectly apparent without seeming censorious.) When the war breaks out, Vladek joins the army. (There is a hilarious flashback to the Spiegelman family's distinguished history of draft evasion.) Vladek participates in a single, doomed battle with the Polish army, in which, quite unremorsefully, he kills a wounded German soldier ("I was glad to do something"). He is sent to a prison camp, where, interestingly enough, his Jewishness doesn't seem to single him out for especially sadistic treatment. Then he is released, and returns to his family. Practical and exceptionally enterprising, he begins to build up his business

again—and then, in its oddly impersonal way, the Nazi "noose begins to tighten" around the throats of Vladek and his family.

Spiegelman makes the bureaucratic sadism of the Germans uncannily vivid—all the steps and reroutings and sortings and resortings that preceded mass murder. *Maus* is a work of hyperrealist detail. Nobody could have anticipated that a comic book about the Holocaust could have told so much about the way this particular endgame was played out: precisely how the black market worked within the ghettos; exactly what happened, in sequence, when the Germans occupied a town; why in 1943 a Jew would have thought Hungary a haven, and how he would have tried to get his family there. The book version of *Maus I: A Survivor's Tale,* published by Pantheon in 1986, ends with Vladek and Anja in Auschwitz, and the latest installment in *RAW* picks up their story again in the camp.

At the same time, we see Vladek as he tells his story today. Vladek is not exactly Elie Wiesel. He is a pinched, mean-spirited, and hilariously miserly old man. In the middle of telling Art how Anja's parents were the first among the family to be sent off to Auschwitz and the ovens, he breaks off the conversation to pick something up from the street. Art: "What did you pick up?" Vladek: "Telephone wire. This it's very hard to find. Inside it's *little* wires. It's good for tying things." Art: "You *always* pick up trash! Can't you just *buy* wire?" Vladek: "Pssh. Why always you want to *buy* when you can find!? Anyway, this wire they don't have it in any stores. I'll give to you some wire. You'll see how useful it is." Art: "No thanks! Just tell me what happened with Haskell." And then we are back in Poland.

No summary can do justice to Spiegelman's narrative skill—his feeling for the dramatic juxtaposition of hideous and comic material; his rendering of the exasperated love of a son for his inadequate, persecuted father; above all his ear for voices. No writer in any genre since the young Philip Roth has managed to make the Jewish speech of several generations sound so fresh or uncannily convincing, an achievement that's all the more impressive since it has been done within the incredibly tight confines of comic strip balloons.

But none of this is what has made *Maus* famous in its time. That notoriety is due to a simple, hallucinatory device: all the characters in *Maus* are drawn as animals—the Jews as mice, the Poles as pigs, the

Germans as cats, and the Americans as dogs. It's extremely important to understand that *Maus* is in no way an animal fable or an allegory like Aesop or *Animal Farm*. The Jews are Jews who just happen to be depicted as mice, in a peculiar, idiosyncratic convention. There isn't any allegorical dimension in *Maus,* just a convention of representation. In fact, at one key moment in the book real mice, animal mice, appear, and the Anja and Vladek characters, though drawn as mice, respond exactly as real people would respond to real rodents.

But the cartoon device in *Maus* has been widely seen not as a way of organizing the horror vividly and effectively, but as a way of denying the horror altogether, of turning remembrance into folktale. It's even been said that *Maus* marks the end of real Holocaust literature, the moment when, in the hands of the survivors' children, the horror settles into folktale and fable. Or else, in the hands of those few reviewers committed to the "underground" cartoon as a form, Spiegelman is seen not as an artist working within the best traditions of the cartoon, but as the Spartacus of the underground comic strip, the hero of a movement that has emancipated the cartoon from mere cuteness—liberated the seven dwarfs from the Disney mines, so to speak, and turned them into underground men of a better and different kind.

Both these views are fundamentally ahistorical. Working not against the grain of the cartoon but within its richest inheritance, and exploring the deepest possibilities unique to the form, Spiegelman has reminded us what the cartoon is capable of: *Maus* is an act not of invention, but of restoration. And in rediscovering the serious and even tragic possibilities of the comic strip and the fable. Or else, in the cartoon, Spiegelman has found another way to do what all artists who have made the Holocaust their subject have tried to do: to stylize horror without aestheticizing it.

Mostly we think about the problems of art about the Holocaust in literary terms, and not sufficiently about how the problem has been addressed in the visual arts. It is in the visual arts, after all, that memorials to national disasters and martyrdoms have traditionally been made. Some of the terms and concepts evolved in art criticism and art history may help us to understand what is, after all, an iconoclastic dispute, a debate about the legitimacy of images. To borrow a distinction from Meyer Schapiro, we want art about the Holocaust to be both nar-

rative and iconic. We want to be told or shown exactly what happened, but because we know in advance that what we're going to see is more horrible than anything we can imagine, we want the style of the depiction to be elevated and even a little mysterious, like great religious art.

Even the few inarguably great public statements about suffering in our time seem inadequate to the events of the Holocaust. If we were told, for instance, that Picasso's *Guernica* is a memorial to, say, Lublin, I think we would feel a little disgusted. *Guernica,* after all, is an elegy to the losing side in a conflict: the painting takes sides, and has a point. But the uniquely horrible thing about what happened to the Jews in Europe is that the "sides" existed only in the paranoid fantasies of their persecutors. (And in *Guernica,* as in *The Charnel House* of 1945, we can't help but feel that we're being had a little. Picasso's great achievement in art was to ask us to read "distortions" of human form not merely as horrific, but as capable of expressing an enormous range of emotion. In their way these pictures are too beautiful.)

Of course, the notion that modern warfare has brought with it a new kind of evil—not merely cruel, but senseless—does not begin with what happened in Europe in the 1940s, and neither does the corresponding notion that the traditional forms of elegiac art are in some sense inadequate. Goya saw clearly that the traditional forms of ennobled suffering were utterly incapable of dealing with a new kind of horror—and he was the first to see, too, that it was the tradition of the cartoon, of all things, that might offer a solution. What may strike us most about Goya's etchings in *The Disasters of War* or *The Third of May* is their documentary realism, but, as E. H. Gombrich has pointed out, it wasn't firsthand experience that gave form to Goya's art; rather, it was the tradition of popular imagery, of caricature and political cartoon, that Goya borrowed and reimagined as the appropriate armature on which to hang his indignation.

One of the most frightening and memorable of Goya's devices in *The Disasters of War* is borrowed from the popular tradition of making men look like animals and animals look like men—the tradition of "physiognomic comparison." What's most striking about the major examples of the tradition, even before Goya, is how fascinatingly ambiguous they are, and how essentially humorless. If we look at, say, Charles Le Brun's *Comparisons* of 1671, the most encyclopedic of

all the essays in physiognomy, we seem to be seeing something proto-Darwinian in its vision. Are these images of the bestiality latent in man, or of the humanity latent in beasts? Even those animal types that have become, in our time, stock instances of the diminutive cartoon (rabbits and mice) have in Le Brun's drawings an utter gravity and melancholy. The faces of Le Brun's little humanized rodents not only look uncannily like the faces in *Maus;* they also look like us. They seem, for all their obvious grotesqueness, so much more modern than any of the portraits Le Brun painted precisely because of their ambivalence—not man secure in a social role but man staring into the abyss of his own possible bestiality.

Thus the tradition of the cartoon, far from being essentially diminutive and escapist, has been from its beginnings well suited to expressing certain kinds of high seriousness. Again and again throughout the history of the cartoon, serious artists have drawn not just on the satiric

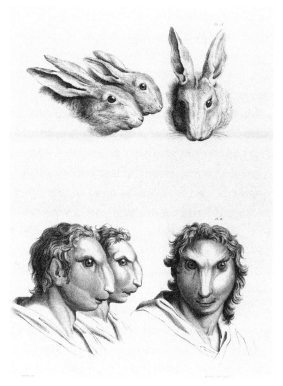

From *Comparisons* (1671) by Charles Le Brun.
Courtesy of the Wellcome Collection, London.

potential of the form, but on its ability to stylize a certain kind of horror as well, the horror that occurs not when human beings behave wickedly but when they lose (or are robbed of) their humanity altogether. This is a tradition Le Brun articulated and Goya ennobled. (It is also the tradition of cartoon that Picasso drew on in his political comic strip of the 1930s, *The Dream and Lie of Franco*.)

What needs explaining, then, isn't the emancipation of the cartoon tradition by Spiegelman and the *RAW* stable of artists, but its previous domestication. Stephen Jay Gould has explained the essential psychological device that allowed the artists of the Disney studios, in particular, to transform humanized animals from totemic beasts into pets. Gould demonstrates that Mickey gradually became more and more "neotenic" as time went on; that is, he came to have more and more of the features of human infants: large forehead, floppy joints, head out of proportion to body size, and so on. Mickey, in short, came increasingly to look like a human baby, and, as Gould goes on to suggest, this transformation turned the cartoon mouse into a kind of red flag waved at the most basic of human instincts. We are prewired, it seems, to respond with passionate affection to anything that has a certain set of infantile features; the anonymous artists of the Disney studio had forged a key that fit a primal lock in the human mind.

What Gould didn't point out (and had no need to) was how utterly discontinuous this discovery was with the rest of the history of cartooning. Disney's invention was so astonishingly successful that in some respects it effectively expunged any other kind of cartooning, or any other potential for the cartoon, from the memory of educated people. We see here the source of the paradox with which we began: the neotenic cartoon has overwhelmed not just all other kinds of cartoons, but our memory of all other kinds of cartoons.

This was possible, in part, because at a deeper level cartoons and caricature have always had more direct access to basic types of human cognition than almost any other kind of drawing. Some cognitive psychologists theorize that caricatures and cartoons are so memorable because their external forms in some way mirror the internal structure of our mental representations, the idealized and schematized mental imagery that our minds use to presort and structure perception. The

mind's eye, they argue, in effect sees caricatures when it looks at the world and sees cartoons when it tries to remember what it has seen. The discovery of caricature, on this view, is as much an episode in the history of psychology—a fundamental discovery about the way the mind works—as it is an episode in the history of art.

I do not invoke Goya and Picasso to provide *Maus* with a tony pedigree. *Maus* is, by comparison, visually timid and even a little crude. In fact, *Maus* is considerably less daring, as drawing and design, than almost anything else in *RAW,* and less daring than much of Spiegelman's own earlier work. (An episode of an earlier Spiegelman strip, "Prisoner on the Hell Planet," is inserted into *Maus* to make this plain.) The drawing here is, even by Spiegelman's own standards, deliberately folklike, stiff and unvaried.

If *Maus* depended for its effect only on the cartoon device, it would not be much more than an interesting curiosity. But *Maus* draws its power not from its visual style alone, but rather from the tension between its words and pictures, between the detail of its narration and dialogue and the hallucinatory fantasy of its images. At the heart of our understanding (or our lack of understanding) of the Holocaust is our sense that this is both a human and an inhuman experience. We know that it happened to people like us, but we also know that what happened to them is not what happens to people, that what happened was not just discontinuous with the rest of human history, but also with our notion of what it is to be a person, and of how people behave. In order to show that these events are in some way sacred to us, we have to indicate, in art, that they are at once part of human history and outside it.

This overlay of the human and the inhuman is exactly what *Maus,* with its odd form, is extraordinarily able to depict. On the one hand this is entirely a history of the motives and desires of particular people, the story of Vladek's and Anja's hundred individual decisions, failures, betrayals, and disappointments. On the other hand it is a history in which all human intention has been reduced to the hunted animal's instinct for self-preservation, in which all will and motive has been degraded to reflex. The heart-wrenching pathos of *Maus* lies in its retrospective, historical sense: Art, drawing *Maus,* knows that Vladek

and Anja are finally as helpless and doomed as mice fleeing cats—but *they* still think that they are people, with the normal human capacity for devising schemes and making bargains.

Maus thus gives form to something essential to our understanding of the Holocaust. It is both loving documentary and brutal fable, a mix of compassion and stoicism. This is the consequence of its strange form, which pays perfect and unerring respect to the fate of particular people caught up in the horror, and at the same time makes it plain that the horror cannot really be understood or explained as a sum of individual actions and desires. Our fear about the depiction of the Holocaust is not only that it will be trivialized, but also that it will be assimilated to the Western tradition of tragedy, that organizing it will allow us in some sense to dismiss it—to leave the theater of history, purged. But with its seemingly bizarre juxtaposition of visual and literary struggles, *Maus* manages to give dignity to the sufferers without suggesting that their suffering had any "meaning" in a sense that in some way ennobled the sufferers, or that their agony has a transcendent element because it provides some catharsis for those of us who are told about, or are shown, their suffering.

Spiegelman's animal metaphor captures something crucial about the psychology of Holocaust survivors. Those few I have met are

Early Spiegelman self-portrait with mouse head

remarkably articulate about their story, but they are interestingly uncurious about the motives of their persecutors. They do indeed seem to see them as cats, as natural and unthinking predators who simply do what they are born to do. But the Germans weren't cats. They didn't have to do what they did. The cartoon form can supply a perfect mix of literary and visual metaphor, but metaphors aren't explanations.

If *Maus* is a nearly magical description of what happened—if it manages to sum up the experience of the Holocaust, for the survivors and their children, with as much power and as little pretension as any other work I can think of—it still must be said that the book succeeds so well in part because it evades the central *moral* issue of the Holocaust: how could people do such things to other people? The problem with the animal metaphor is not that it is demeaning to the mice, but that it lets the cats off too easily.

There is also a deeper level of image magic at work in *Maus,* which accounts for both its power and its extraordinary fit with its subject. I have mentioned earlier that a tradition of "spliced" animal and human forms precedes the "melded" forms of caricature. The image of a human body with an animal head is one of the very oldest in art, and it occurs frequently for the same reason: not, as in the physiognomic tradition, to compare man and animal, but to symbolize the presence of the sacred. In a way that I am almost certain is completely unconscious, *Maus* is also haunted by the older tradition, and, particularly and strangely, by a peculiar Jewish variant of the older tradition.

Spiegelman's animal heads are, purposefully, much more uniform and masklike than those of almost any other modern cartoonist. His mice, while they have distinct human expressions, all have essentially the same face. As a consequence, they suggest not just the condition of human beings forced to behave like animals, but also our sense that this story is too horrible to be presented unmasked. The particular animal "masks" Spiegelman has chosen uncannily recall and evoke one of the few masterpieces of Jewish religious art—*The Birds' Head Haggadah* of thirteenth-century Ashkenazi art. In this and related manuscripts, the Passover story is depicted using figures with the bodies of humans and heads of animals—small, common animals, usually birds.

Now, in one sense the problems that confronted the medieval Jewish illuminator and the modern Jewish artist of the Holocaust

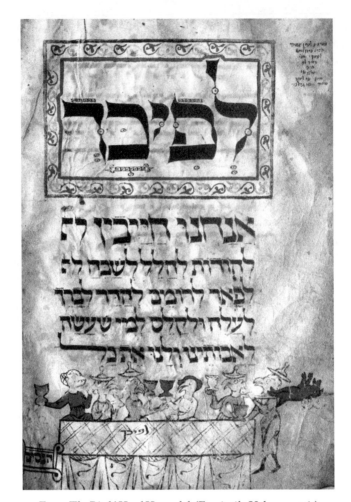

From *The Birds' Head Haggadah* (Facsimile Volume, 1965)
by Moshe Spitzer, Bezalel National Art Museum in
Jerusalem. Courtesy of the David M. Rubenstein Rare
Book & Manuscript Library at Duke University.

are entirely different. The medieval artist had a subject too holy to be depicted; the modern artist has a subject too horrible to be depicted. For the traditional illuminator, it is the ultimate sacred mystery that must somehow be shown without being shown; for the contemporary artist, it is the ultimate obscenity, the ultimate profanity, that must somehow be shown without being shown. But this obscenity, this profanity, has become our sacred subject, in the sense that our contemplation of it has become nearly liturgical.

Yet still we want a sacred art that isn't a transcendent art. We want an art whose stylizations are as much a declaration of inadequacy to their subject as they are of mystical transcendence. And this is the quality that *Maus* and *The Birds' Head Haggadah,* for all their differences, share: in both these Jewish works, the homely animal device is able to depict the sacred by a kind of comic indirection. The device is so potent precisely because it seems, at first, so disarming.

So the self-conscious element of primitivism in Spiegelman's drawing has the deepest affinity with the very small body of important Jewish art. It is an affinity that may help lead us to a better understanding of what a modern Jewish art can be, a Jewish art that leads away from Chagall and his levitating Hassidim, away from banal affinities rooted in sentimental imagery, from ersatz connections between ancient form and modern abstraction such as those made by modern Israeli artists who draw on Hebrew calligraphic traditions. The affinity between the medieval Jewish illuminators and Art Spiegelman may be rooted in a much more profound set of solutions—solutions that turn deliberately to the homely and the unpretentious, rather than to the transcendent and mystical, in order to depict the sacred.

One of the platitudes about modern art is that it exists in the face of the failure and dissolution of religious art. In some sense, of course, this is true. And yet the human need to see depicted all those things that used to be the province of religious art—the geography of good and evil, of heaven and hell—remains constant. The deeper preoccupation of modern art, from Matisse's Arcadia to Francis Bacon's infernal interiors, has been to find some secular visual language to fulfill that need. Cartoons reflect this preoccupation too, and have been surprisingly successful in making these images for us: images of Eden in the work of George Herriman and Winsor McCay, and now potent images of extreme horror in *Maus.* If all the old forms of religious art have gone into diaspora, there seem to be moments in heaven, and circles in hell, that have taken shelter in the comic strip.

(1987)

Mauschwitz?

Art Spiegelman's "A Survivor's Tale"

KURT SCHEEL

Translated from the German by Elizabeth Nijdam

This is the story of Vladek Spiegelman, told to us by his son Art, in which Art narrates how his father recounted it to him. Vladek's story begins in Poland, in Częstochowa and Sosnowiec; it provisionally ends in 1944 in Oświęcim, called Auschwitz in German, where Vladek and his wife, Anja, are taken—because they are Jews—to a camp, the gate of which reads "Work Makes One Free" (*Arbeit Macht Frei*).

Art Spiegelman's book is admittedly different from all other accounts of the Holocaust: because *Maus* portrays it not as the persecution and extermination of Jews by Germans, but of mice by cats. And as if that were not disturbing enough, Spiegelman takes the provocation to the extreme by using the most undignified and inappropriate form imaginable to tell the world's most terrible story: that of the cartoon; *Maus* is a comic strip.[1]

"Is the comics medium an acceptable form of depicting the German murder of the Jews?" (*taz*, January 2, 1988). The answer seems simple; puns on Auschwitz—the second volume will be subtitled *From Mauschwitz to the Catskills*—are certainly, if not blasphemous, then more than distasteful. There is no question that this topic cannot be presented in this way—until one has read Art Spiegelman's book. This is to say that *Maus* is one of those rare works of art, the impossibility

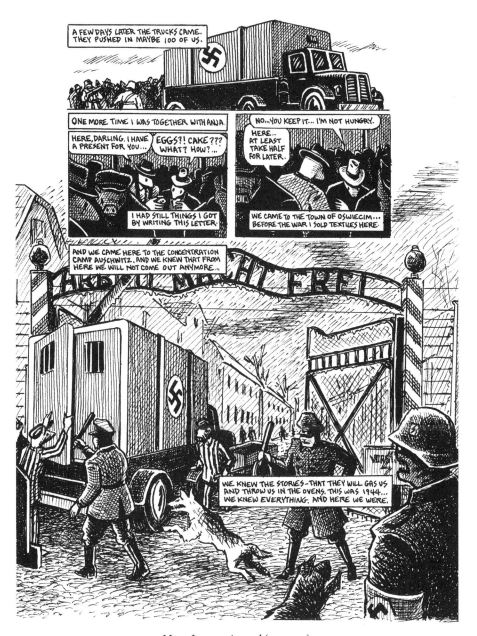

Maus I, unpaginated (page 157)

of which one is only no longer convinced when it is physically placed in front of them. This needs to be stated before even asking how Spiegelman succeeds in doing what can hardly be done: bringing to life what eludes even the imagination.

Sometime after 1968, the year of his mother's suicide, cartoonist Art Spiegelman visits his father in the New York borough of Queens. "I hadn't seen him in a long time—we weren't that close." Art wants to publish his father's life story as a comic book, so Vladek tells him how he lived in Poland in the 1930s (not the "mid-1930s," as the German edition mistakenly translates it) as a small textile merchant, a handsome young man whom his friends compare to Rudolph Valentino. But then the carefree bachelorhood is over—his longtime love interest Lucia is exchanged for Anja Zylberberg, the honorable daughter of a hosiery manufacturer. She is certainly not as pretty as Lucia, but she is smart, tidy, and wealthy. They marry in 1937. But, as Vladek requests at the end of the first chapter, the affair with Lucia should be left out of the book, since it has nothing to do with Hitler and the Holocaust—it is too private and "isn't so proper." "Okay, okay—I promise," is Art's answer, and this broken promise thus becomes an assurance of the book's truthfulness.

This chapter, like the other five, begins and ends in New York. Vladek's story, the flashbacks to the events in Poland, make up three quarters of the volume, but it is only a part of the book and is not only integrated and distanced by the frame narrative, but also interrupted every two or three pages by individual images that show Vladek and Art in the circumstances of the New York storytelling—the father pedaling on his exercise bike, for example. And next to this image we see that of a mass execution. A repulsive and inappropriate connection? More than that. For here inappropriateness as such becomes the subject. *Maus* is, what every Holocaust depiction has to be, also a reflection on the inappropriate.

The perpetual change of narrative perspective is one of the methods Spiegelman uses to try to prevent what most well-intentioned descriptions à la *Holocaust* already fail at: that one makes oneself so comfortable in the terrible, that this history also becomes a subject for entertainment in its telling. To quote Goethe's *Faust*: "On holidays

there's nothing I like better / Than talking about war and war's display, / When in Turkey far away, / People one another batter."

A second reason why *Maus* is successful is the dubious nature of the main character (which we learn, according to Art). Vladek is the hero of the story, but not a shining light. As victim, he is not automatically a good person, as the common well-meaning error in thinking would suppose. Vladek Spiegelman is a materialistic pedant: "He's more attached to things than to people!" Mala—his second wife and also a concentration camp survivor—lashes out angrily at one point. Moreover, Mala also rejects the pastoral explanation that victims are rendered stingy and shabby, like Vladek, because of their fate: "All our friends went through the camps. Nobody is like him!" And wasn't Vladek's behavior toward his beloved in that first chapter, before there was any mention of cats—of Nazis—downright brazen? And the way he then secretly checks Anja's closets for neatness . . .

Vladek Spiegelman is not a particularly likable fellow. A comfortable New Yorker who takes paper towels from restrooms in order not to have to buy napkins is no longer just curious; he is repugnant. And yet he moves us—because his stinginess is also the depressing reflex of that experience that one needs possessions in order to bribe another so that they may perhaps escape annihilation after all . . .

Art Spiegelman does not glorify the victim, his father. In this obviously autobiographical story, insistent on truth, he depicts him with crude realism, not concealing the negative; for *Maus* is also the ambivalent reckoning of a son with his father, filled with love and hate. It is the truthfulness of the depiction, which needs no embellishment; it is the credible brokenness of Vladek that grips us, his defenseless shabbiness—a mouse in which every person can recognize themselves. This questionable figure, however, does not invite simple identification; and that is a good thing with regards to this subject and in a country where the reconciliation of the perpetrators and their children with the victims and their children tends to accompany "coming to terms with the past" (*Vergangenheitsbewältigung*) like a shadow. Spiegelman rushes the reader back and forth between the poles of identification and alienation, leaving little time for sentimental fraternization.

A third reason for *Maus*'s success lies, of course, not in the message,

but in the medium. It's not another one of the many Holocaust memoirs. "Horribly, we've become inured to the horror," according to a conversation with Art Spiegelman: "People being gassed in showers and shoveled into ovens—it's a story we've already heard" (*Rolling Stone*, November 20, 1986). That the Holocaust cannot be talked about like other subjects was central to Paul Celan's work. In a way, Spiegelman provided the absolute countermodel to the poet's pursuits: the most precious, traditionally highest genre of art on the one hand—the shabbiest, barely perceived as art on the other; the hermeticism of Celan's language, reaching into silence, referring to sacred texts—the mainstream of cartoons, the infantilism of funnies, seen as trash of the culture industry, relating to Mickey Mouse . . .

In bringing Celan and Spiegelman into conversation here, it is not so that the cartoonist might be ennobled by the poet. Whether comics can be art is a question that those who know nothing about comics like to ask; and even the question's enthusiastic affirmation is of no significance for the mercurial medium. Official museum art is abundant, and the fact that *Maus* has nothing to do with the calculated Holocaust images of an Anselm Kiefer is nothing to be lamented. Instead, Celan and Spiegelman are to be mentioned together because both the cartoonist and the poet invented a language for their subject that did not exist before. One cannot invent the same thing twice. Regardless of the specific nature and quality of Spiegelman's cartoons, after *Maus*, this theme could only be taken up *as a comic* at the price of turning a stroke of genius into a trick, the shock of the unbelievable into the thrill of the original.

At first glance, *Maus*'s black-and-white drawings seem almost crude, drawn with a heavy hand: rigid faces, little differentiation, expressing emotions only schematically in the simplest of comics techniques—commercial comics are much smoother in terms of craftsmanship, to say nothing of the mastery of a cartoonist like Robert Crumb. That this has nothing to do with Spiegelman's ability to draw becomes apparent at the latest during the fifth chapter's interlude "Prisoner on the Hell Planet," Spiegelman's confrontation with his mother's suicide. Spiegelman teaches at New York's School of Visual Arts, has won several awards for his work, and is the editor of the avant-garde comics magazine *RAW*.

Fortunately, *Maus* is neither an avant-garde nor a virtuoso comic; Spiegelman does not betray his subject to "art," nor does he exploit it to demonstrate his drawing skills. That he is a master of his craft can be seen in his use of perspective, composition, and background—not to mention the realistic, sardonic comments and speech balloons: "Acch, Mala!" grumbles Vladek (whose accent may have been exaggerated a bit in the German translation). "A wire hanger you give him! I haven't seen Artie in almost two years . . . We have plenty wooden hangers." And fortunately, Spiegelman does not make an ideology out of his graphic restraint: the lackluster nature of the images does not extend into the overbearing modesty of Arte Povera, the radical Italian art movement of the 1960s and 1970s.

The fact that the characters of *Maus* are animals—more precisely: human bodies with animal faces—plays a comparatively minor role in the reading. One forgets quite quickly that the Jews actually have mouse faces, cats stand for Germans, pigs for Poles, dogs for Americans (in one scene there are also rabbits, moose, goats . . .). This does not surprise a comic book reader, since they never read stories about Donald Duck out of interest in poultry. Spiegelman himself states that the transformation of the protagonists, his parents, into animal figures was necessary for him not to be overwhelmed by emotions; and through the minimally differentiated, masklike faces, he wanted to emphasize the allegorical character of the story (*New York Times*, May 26, 1985).

The tendency toward distantiation (change of perspective, fractured hero) finds its counterpart on the formal level (comics, animals). And alongside the de-differentiation, the—at least graphic—de-individualization of the figures, Spiegelman avoids a fundamental issue in every depiction of the Holocaust: that it concerns a collective and not primarily an individual story. And furthermore, by portraying this story on a formal level in a way it has never been portrayed before, Spiegelman avoids the need to make the plot artificially interesting: Spiegelman does not have to invent goodhearted SS officers for narrative reasons in order to avoid the accusation that his evil Nazis are cliché . . .

Spiegelman thus also avoids driving the already overwhelming nature of any narrative of the Holocaust into totality, forcing the

reader's emotional involvement or exposing them as an inhumane spectator. There is no need to justify the fact that no mercy is shown over such extorted "work of mourning" (*Trauerarbeit*), which gladly takes place in front of running cameras.

Through his narrative and artistic techniques, Spiegelman gives *Maus*'s readers latitude; they can either lean into his story, Vladek's story, or they can distance themselves from it. More important than the manner of execution, however, is Spiegelman's idea to portray the atavistic extermination of the Jews by the Germans in the form of the archaic, inhuman enmity between Cat and Mouse—and to be precise, as a comic strip. The secret of *Maus* lies in the shocking and fascinating contrast between the object and the medium of its representation: in the shabby image of the cartoon, the artistic inadequacy par excellence, Art Spiegelman succeeds in painfully forcing together that which must elude all art.

(1989)

"The Holocaust in Comics?"

DORIT ABUSCH

Translated from the Hebrew by Yardenne Greenspan

Introduction

For me and the rest of my generation of Israelis, the Jewish Holo-
caust is a re-created memory stamped into our psyche by the edu-
cation system and the media. In Israel, Holocaust Remembrance Day
begins with a siren, at the sound of which pedestrians and drivers
pause in their tracks and stand at attention for a moment of silence.
The night before, upon sunset, TV and radio broadcasts cease their
regularly scheduled programming and focus exclusively on Holocaust-
related content. Restaurants and entertainment centers shut down,
and everything returns to normal only as the stars come out on the
following evening.

The first part of this essay appeared in Hebrew in 1997 in the
art journal *Studio* and is based on a longer talk given at the Tel Aviv
Museum of Art. My talk at the museum was met with cries of pro-
test from the mostly older audience. Some even walked out halfway
through. My point was missed and negated by the title of the talk,
which merged the Holocaust with entertainment. In Israel at the
time, and to some extent even to this day, there was hardly any tra-
dition of comics, not for children and certainly not for adults. I was
lucky enough to have some slight exposure as a child through the
frightening *Max und Moritz* and *Struwwelpeter*, as well as comic books
that starred Donald Duck and his cohort, which my grandparents,

who couldn't speak Hebrew, read to me in German. They even added superfluous interpretations as they showed me the wordless cartoon *Vater und Sohn*. It is possible that this early exposure to the genre was what led me later on, in my twenties, to the St. Mark's Bookshop in the East Village in New York City, where I made one of my first independent comics purchases: *RAW* magazine, edited by Art Spiegelman and Françoise Mouly, which contained serialized chapters from *Maus*. Like the audience at the museum, I recoiled at what I perceived as a vulgar combination between the Holocaust and comics, and didn't even bother to separate the *Maus* insert from the magazine. I only read *Maus* after it came out in book form, the Penguin logo acting as a kosher seal.

As I've mentioned, the first part of this essay is composed of my original *Studio* piece. The second part contains some later insights regarding *Maus* in light of Spiegelman's other works. I named this essay after my talk, though the title has since lost its dissonance. Responsible for this is Spiegelman himself, who revolutionized the genre's status in the world of art and literature.

1.

The quality of a work of art is measured, among other means, by the originality with which it combines form and content. An original combination might be achieved, for instance, by introducing familiar subject matter and themes into an unexpected genre. Until the 1950s, the sexual perversions of Nabokov's Humbert Humbert had only been affiliated with pulp fiction, the artistic virtues of which were mirrored in the low-grade paper on which it was shoddily printed. *Lolita* offered a fresh use of the archetype in a novel rife with brilliant stylistic choices and literary parodies. Similarly, art lovers would have expected Manet's bed to have supported the reclined body of Venus rather than the defiant nudity of *Olympia*. These two brilliant works of art created scandals in their respective time periods, rattling bourgeois society, which included critics.

But is it still possible in the 1980s and 1990s, when form and content are known to merge in every possible combination, blurring the lines between genres, mixing high- and low-brow, sentimental and sci-

entific, documentary with fiction, giving birth to new mutations, to find a merging of subject and genre that would make an erudite reader uncomfortable? I believe the combination of the Jewish Holocaust and comics is one example.

This pairing was made into a masterpiece by Art Spiegelman, the son of a Holocaust survivor, who composed two volumes of comics documenting his father's memories, starting in the Polish town of Sosnowiec, through the Środula Ghetto and Auschwitz, and ending in the Queens neighborhood of Rego Park. *Maus* is based on conversations between Art and his father, recorded over more than eight years, from 1972 to 1981. Its writing and drawing took approximately thirteen years. Before being published by Pantheon to great commercial and critical acclaim, it was serialized, as mentioned, in small inserts in the comics magazine *RAW*.

The source of the fluster caused by *Maus* was in the collision of two sets of emotions and associations. The Holocaust is a historical atrocity which typically inspires anxiety, confusion, and bewilderment, while the immediate association of the comics genre is lowbrow pop culture drawing from the fantastical, the romantic, and the satirical, and starring protagonists such as Batman and Blondie, not the Jewish People. We expect this loaded topic to be addressed by a genre with more gravitas, be it fiction or nonfiction, but most of these iterations are disappointing. There is almost no great art that deals with the Holocaust. It's easy to offer up explanations such as the rarity of great artists and the incidental or nonincidental nature of their choice of subject matter. But I believe the problem is more complicated. The Holocaust evades any artistic attempt to look at it, to understand it, or to confront it. The intensified feelings it inspires become the central experience of interacting with it, and the sense of horror at its foundation often translates into artistic kitsch, gothic fantasy, and pathos.

The problem of Holocaust documentation is no less severe. Photographs and documentary materials arouse the predictable emotional response: horror. We've all experienced this when faced with documents or photographs in historical institutions or while watching documentaries: the closing eyes, the turned head trying to shake away the harrowing image. The central experience is shock rather than observation. This confrontation with disturbing materials is lethal to the

scrutinizing gaze: the emotion responds to Goya's *Disasters of War*, but the eye remains calm when looking at a self-portrait of Rembrandt.

The central difficulty in Holocaust representations stems from the fact that familiar reality has been twisted so badly that we can no longer continue to recognize it as our own. We don't perceive the wandering *muselmanns* as actual human beings, but rather as silhouettes from a horrifying B movie. The crematoriums seem to be taken straight from Bosch's hellscapes. The prisoners' uniforms seem to have been forced on human captives by their alien abductors. We watch a terrifying fantasy, a surreal vision, not a historical event. This creates a constant danger of veering into the realm of kitsch, sentimentalism, surrealism, and pathos, which threatens the artistic representation of the Holocaust.

But these very qualities, which are common in popular comics, are entirely missing from *Maus*. And this is the source of its major achievement: its success in offering disturbing panels that don't push the viewers' eyes away, allowing their gazes the space to linger on documentary details and follow the drawn plot.

The main experience of reading *Maus* is the sense that it frames a solid reality, as horrific as it may be. We come closer to understanding the material, an understanding which relies on a sense of identification, which is only available when the subject is a real possibility, something that could happen to us. How does Spiegelman succeed where others have failed, and in a comic book, no less? Spiegelman is not in dialogue with the comics genre, as are artists like Roy Lichtenstein, Andy Warhol, and Jasper Johns. He does not reference it, stylize it, parody it, or strip it of its elements. He uses comics as comics, a serious genre in the tradition of George Herriman, Winsor McCay, and others.

A Cat, a Mouse, and a Polish Pig

In *Maus*, the members of different nations are represented by animals. Jews are mice, Germans are cats, Americans are dogs, and the Polish are pigs. This is a scheme familiar from the song "Chad Gadya" in the Passover Haggadah: the American dog chases the German cat, who tries to hunt the Jewish mouse. The Polish gentile is a mere pig. The prototype of this sort of representation is Aesop's Fables, in which animals reflect human character. But in Spiegelman's work, whole nations

are bestialized. The choice of a negative self-representation, the depiction of Jews as mice—weak and persecuted but also pests—is intentional. The outcast who chooses to reappropriate his own derogatory term takes the sting out of the negative portrayal. The quote included on the copyright page of the second volume, from a 1930s German Nazi propaganda newspaper, attests to Spiegelman's intentions:

> Mickey Mouse is the most miserable ideal ever revealed.... Healthy emotions tell every independent young man and every honorable youth that the dirty and filth-covered vermin, the greatest bacteria carrier in the animal kingdom, cannot be the ideal type of animal, ... Away with Jewish brutalization of the people! Down with Mickey Mouse! Wear the Swastika Cross!

Cat and mouse are popular comic book figures. In Herriman's classic comic series, *Krazy Kat*, cat, mouse, and dog appear in a reversal of roles: Ignatz the mouse represents human evil and inflicts suffering upon Krazy Kat, who is in love with him and accepts the persecution passively. The dog, Officer Bull Pupp, who is in love with Krazy Kat, tries to subdue Ignatz. Hanna-Barbera's *Tom and Jerry* also features a mouse abusing a cat. This theme of David beating Goliath recurs in other comics and animated shows made for children, who identify with the weaker character who outsmarts the stronger one through crafty ploys.

But such a reversal of roles does not exist in Spiegelman's *Maus*. The mice are persecuted, but rather than embodying absolute "good," they contain a wide array of human qualities. Vladek, the author's father, is a resourceful Holocaust survivor whose tragic life story does not immunize him from possessing racist views (both against Black people, whom he refers to as "shvartsers," and against gentiles). He is also a pathological miser. Spiegelman does not glorify the survivor or build him into a superhero. His father's story of survival and his ability to continue living illustrate the power of David, but his human weaknesses prevent him from becoming a mythical figure, imbuing him with emotional and psychological profundity, making the story real.

The animal imagery is a convenient visual solution for signifying national identity. The facial features are schematic and members of

the same nation are distinguished from each other through elements such as glasses, hats, or fashion sense. This schematic representation according to nationality makes concealed, subversive use of racial ideology as a means of mocking it. Satirical representation is typically the weapon of caricaturists drawing familiar political figures, for instance Scarfe's political cartoon of U.S. president Reagan as a dilapidated horse, speculating whether he should run for reelection. But while caricaturists hone a visual or character stereotype through their images, Spiegelman grants his characters psychological depth through the dialogue he puts in their mouths, a fullness absent from Aesop's Fables.

Every chapter in *Maus* begins with a meeting between Art and his father in Rego Park, lingers on the friction between them and the father's petty character, then moves on to the father's remembrances of the Holocaust, veering back and forth into the frame story, with which every chapter ends. This prosaic sliding into the frame story softens the experience of reading difficult biographical materials, with settings such as the ghetto, the camps, and the crematoriums, helping anchor this nightmarish reality within everyday life. This swinging between the past "impossible" and the present-time prosaic creates balance and contributes characteristics and observations that break apart every cliché or formula of Holocaust stories. The story becomes personal and real. Vladek's language also helps the cause—rather than being laden with pathos and cliché, it is the American dialect of Polish Jews with the grammatical errors prevalent among nonnative speakers and peppered with Yiddish terms such as "gevalt," "meshugah," and "pfui." The dialogue appears inside speech bubbles, while narration and commentary appear in rectangles.

The Gaze Can Bear the Images

Spiegelman demonstrates his narrative's horrifying reality through the small details that make up any nightmarish or prosaic existence. At one point, he complains to his therapist that he has no idea what the tools from his father's Auschwitz tin shop looked like because there is no documentation and he therefore doesn't know how to draw them in the book. He illustrates the guestroom of a wealthy Jewish-Polish family in Sosnowiec, a Baroque high-end sanatorium in Czechoslovakia, a map of Auschwitz, a diagram of a method for shoe repair in the

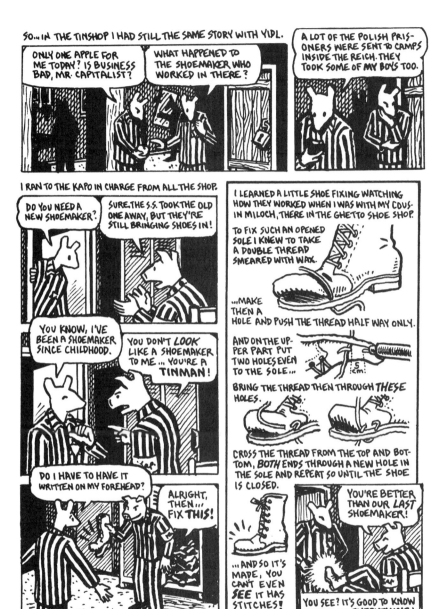

Maus II, page 60

work camp, and a blueprint of the crematorium. This is the language of *Maus*: drawing objects, structures, and occurrences in an accurate, factual fashion, using a clean, efficient, and restrained line to soothe the eye.

The choice of this accessible realism—as much as any comic book can be referred to as "realistic"—is not guided by aesthetic considerations. Spiegelman wants us to look at his panels as framing a solid reality, and in order to achieve this he must entice the eye to take in scenes of horror, process the terror while keeping anxiety at bay, never allowing it to swallow us whole, leading us toward understanding. The clean, restrained line creates a sense of distance in readers, allowing them to focus their gaze on the heart of horror.

One of the most difficult scenes in *Maus* depicts four Jewish men who were hanged as punishment for shopping at the black market. The scene is shown from the point of view of the audience standing below the gallows. In spite of this close-up on death and the outsized figures, our gaze can bear the images. It is illuminating to compare this panel to an earlier comic strip by Spiegelman, "Prisoner on the Hell Planet," which is included within *Maus* as an embedded narrative, describing his mental state around the time of his mother's suicide in

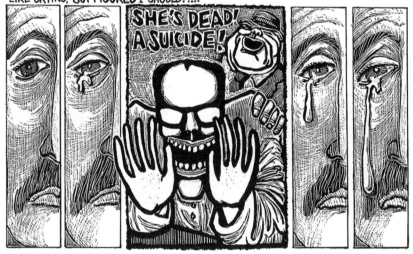

Panels from the second page of "Prisoner on the Hell Planet," 1972, in *Maus I*

1968. The style is expressionistic, the perspective is exaggerated and distorted, the black lines are thickened, the pages are dark, and its style is hallucinatory, the visual equilibrium unstable. Note the sentimentally emphasized tear, the bespectacled man's enlarged hands, accentuated with thick black lines in the foreground of the panel, and the grotesque face in the back. The visual restlessness makes reading the four pages of the story difficult. The anxiety and emotional turmoil with which the images are imbued blur psychological nuances and factual details. Viewers are carried away in a whirlpool of anxiety. Horror is the central experience, not a processing of information. Had this expressionistic style prevailed over *Maus*, the reading of the three-hundred-page tome would have been an agonizing experience. *Maus* would have become a surreal narrative bordering on the horror genre and destined to veer into kitsch.

Maus is a drawn plot whose content is historical and biographical, and in which creator Spiegelman appears as one of the characters. This is similar to Giotto, Simone Martini, and Filippo Lippi, who commemorated their self-portraits as part of the painted stories that they created on the walls of churches, chapels, and palaces. Art Spiegelman points readers' attention to himself as the maker of *Maus*. Renaissance painters who placed themselves within the painted plot typically showed their portrait to viewers at a forty-five-degree angle, their gaze slanted and focused. Spiegelman, on the other hand, presents us with human ears, hair, and stubble that peek through the mouse-mask covering his face.

Maus is a tribute to and commemoration of the artist's parents, whose photographs are included and whose graves are the image with which the book ends. But *Maus* is also a commemoration of the Jewish Holocaust. It is an impressive monument, in spite of the author's lament in the book:

> I feel so inadequate trying to reconstruct a reality that was worse than my darkest dreams. And trying to do it as *a comic strip*! I guess I bit off more than I can chew. Maybe I ought to forget the whole thing. There's so much I'll never be able to understand or visualize. I mean, reality is too *complex* for comics . . . so much has to be left out or distorted. (*Maus II*, 16)

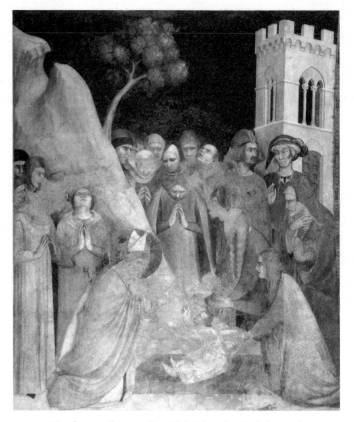

The figure who stands with his hand raised, beneath
the tower on the right-hand side of the fresco, is believed to be a
self-portrait of the artist. His downcast gaze directs our eye to the
central spectacle of the child. Scene 5 from *Saint Martin and the
Miracle of the Resurrected Child* (between 1312 and 1317) by Simone
Martini. Fresco, Lower Church, S. Francesco, Assisi, Italy.
Courtesy of Scala / Art Resource, NY.

2. Meta Comics Devices

The Spiegelman collections *Breakdowns* (a 1977 volume reprinted in
2008), *In the Shadow of No Towers* (2004), and *Co-Mix* (2013) offer an
opportunity to examine some characteristics of Spiegelman's comics
that are also prominent in *Maus*. Across his work, Spiegelman plays
around with metafictional devices. He reveals his identity as the
author in the frame story and intervenes in the drawn plot, inserts
characters from classic comics and children's books, references and
paraphrases other artists and writers, and shares his musings about his

genre. He also includes caricatures, photographs, and paintings inside his panels. Spiegelman bursts into the fictional world of his comics like Laurence Sterne, who makes appearances in his own novel, *The Life and Opinions of Tristram Shandy*, interjecting with theological and philosophical arguments, quotes, and commentary about names, noses, and other obscurities. Much like Sterne, who challenged the conventions of narrative in his eighteenth-century tome, Spiegelman delineates new boundaries for the playground of comics.

Spiegelman's comics are populated with dozens of characters from classic comic strips. We encounter Dick Tracy, Ignatz and Krazy Kat, Little Nemo, Betty Boop, the Yellow Kid, Little Orphan Annie, the twins Hans and Fritz, and more forgotten characters such as Jiggs and Maggie and Happy Hooligan. The list of characters in Spiegelman's comics is as long as the mouse's tail in the Lewis Carroll poem. Often they are pertinent to the plot, such as the monsters from *Where the Wild Things Are*, who appear in the background of Spiegelman's visit to Maurice Sendak's home, as seen in *Co-Mix*. Another strip re-creates a conversation between the artist and Charles M. Schulz, in which Spiegelman draws himself as a boy with the head of a mouse while Schulz is drawn as a child with the head of Snoopy.[1]

Spiegelman reveals his love affair with classic comics across his work. His passion for older comics haunts him, invading his panels. In one page of *In the Shadow of No Towers*, he retraces his steps on 9/11. Not far from the smoking towers, he runs into Mama from *The Katzenjammer Kids*, who hysterically cries, "*Gott in Himmel!*" Spiegelman as protagonist swapping a random woman on the street for Mama is reminiscent of Proust's hero Swann, who experiences the people he comes across as characters from paintings. Art connoisseur Swann suffers from an incurable, obsessive love for vulgar trollop Odette, all due to her resemblance to one of Jethro's daughters in Botticelli's fresco *Youth of Moses*. At a party at the home of the Marquise de Villeparisis he places a muscular servant in a painting by Mantegna, just as Spiegelman plants Mama in his own work. Such substitutions can even be seen as naturalistic. In "Portrait of the Artist as a Young %@&*!," the new introduction to the reissued collection *Breakdowns*, Spiegelman the child, enamored with *Mad* magazine, suffers from a congenital vision flaw that damages his depth perception. He com-

ments that because of his lazy left eye, "confusing 2D comics with reality seems natural to me."[2]

In his work, Spiegelman references political cartoons, photographs, and paintings. Political cartoons appear in a comics essay in *Co-Mix* about the Jewish refugee ship MS *St. Louis,* which was barred entry to the United States. The comic presents seven contemporary political cartoons that responded to the event. The ghost of the father of caricature, Francisco Goya, creator of the series of etchings *The Disasters of War* and *Los Caprichos*, peeps out from Spiegelman's sketches and drawings. Another Goya print appears in a comic in *Breakdowns*, along with its original title. Old photographs are also included in Spiegelman's work—such as a photo of the MS *St. Louis*.[3]

Paintings make a furtive cameo. One panel in *Breakdowns* includes Picasso's *Guernica* and another features a Cubist woman as one of the characters. There is also a drawing of *The Birth of Venus* and an allusion to the Ingres painting *The Source* in the image of a nude model carrying a clay urn on her shoulder. Guston's head with a Cyclopean eye also makes several appearances. In Spiegelman's collection of sketches *Be a Nose!*, Dick Tracy's profile replaces that of the Duke of Urbino from the Piero della Francesca's portrait, the two men's crooked noses strikingly similar.[4]

Alongside visual quotes from comics, political cartoons, caricatures, photographs, and artworks, Spiegelman references and paraphrases writers, thinkers, and artists. Cartoonist Harvey Kurtzman enters the discussion alongside Picasso, Mark Twain, and the Russian formalist Viktor Shklovsky. He reflects on his genre, drawing a fistfight between words and images, comparing in a four-panel strip the immediacy of speech balloons and captions.[5]

Where are these metacomical devices in *Maus*? Spiegelman appears as author several times. In chapter 2 of *Maus II* and again in the spot normally reserved for an author photo, Spiegelman is shown leaning over his drafting table and wearing a mouse mask, with his human ears, hair, and neck peeking from behind, and fountain pens, ink, brushes in a paint can, and a pack of cigarettes by his side. These images identify him as the artist of the graphic novel *Maus*. The purpose of the mask in this case is not to conceal, as when a mouse disguises his Jewish ethnicity behind the mask of a Polish pig. Rather,

Maus II, page 11

its purpose is the opposite, to expose. The mouse mask distinguishes Spiegelman as author from Spiegelman the son with a mouse head in the frame story. It reveals to readers an extratextual flesh-and-blood person, the artist.[6]

In the frame story, which takes place in the book's present time, and consists mostly of meetings with his father, Spiegelman appears with the head of a mouse and the body of a human. He appears in the same fashion in some other scenes that present him as the artist, for instance, when he shows sketches for *Maus* to his father. He shares with the reader the process of creation, showing a page from his sketchbook, containing the heads of a reindeer, a sheep, a frog, a mouse, and a rabbit. An image of Spiegelman with a human body and a mouse's head appears again in later comics, sometimes in panels that refer to the Holocaust and to *Maus*. Just as Spiegelman transplants characters from classic strips into his panels, he inserts the chimera he invented in *Maus*.[7]

In *MetaMaus: A Look Inside a Modern Classic*, which revolves around interviews conducted by Hillary Chute, the creator of *Maus* reveals secrets of his trade. An introductory strip shows him struggling to remove a mouse mask, which clings to his head. When it finally comes off, a skeleton's skull is exposed. The strip laments the mask that conceals his presence as man and artist, as well as readers' common questions about the animal images in the book, thus justifying the need for *MetaMaus*. But the skeleton's skull might also allude to doubts regarding the validity of Spiegelman's existence outside of his masterpiece.[8]

Unlike other work, *Maus* features no cameos by the protagonists of classic comics. But classic comics are featured in *Maus* in other, subtle, insinuated ways. I already mentioned the metaphoric use of the food chain as an allusion to *Krazy Kat*, in which the inborn enmity of dog, cat, and mouse undergo a reversal. Herriman's work sneaks into *Maus* through the back door, taking over the representation of characters. Similarly, in *MetaMaus*, Spiegelman explains that the pig heads drew inspiration, in part, from Porky Pig of *Looney Tunes* fame.

Grotesque painting that adorns the ceilings and walls of churches and palaces in Italy features fantastical creatures born as hybrids among the animal, the mineral, and the vegetable. Political cartoons and caricatures often portray people as animals in order to high-

light certain physical or behavioral qualities. But in *Maus*, the cross between human and animal is neither a grotesque nor a caricature. Once we internalize the convention of people as half animals, we cease to be aware of the animal characteristics. The singular appearance of a fortune-teller as a moth or of two Englishmen as fish elicits a laugh, but this is not the case for the established cast of the story. None of the visuals in *Maus* are caricatures. When Spiegelman depicts Vladek's pathological miserliness, he expresses his concerns to his wife: ". . . It's something that worries me about the book I'm doing about him . . . In some ways he's just like the racist caricature of the miserly old Jew" (*Maus I*, 131). But this comes from the content of the narrative, not from exaggerated and distorted visual depiction of the character Vladek.[9]

Spiegelman is a fan of metamorphoses. In his children's book *Open Me . . . I'm a Dog!*, a dog is transformed by wizards into a shepherd, then a frog, until finally, in a last transformation, the dog turns into a book. In a comic for children, a prince who believes he is a rooster starts behaving like one. In a parodic sketch included in *Co-Mix*, Gregor Samsa from Kafka's *The Metamorphosis* wakes up in his bed to find himself a human being, surrounded by his appalled insect family. In one section of *In the Shadow of No Towers*, Spiegelman and Françoise reincarnate as Jiggs and Maggie from *Bringing Up Father*, and in another section Spiegelman appears as Happy Hooligan and Françoise perhaps as Hooligan's girlfriend Suzanne. The concept of metamorphoses also is thematized in *Maus*, when Spiegelman and his wife—who converted to Judaism—discuss possible ways she might be portrayed in the book. It is remarked that Vladek would have doubted the power of a rabbi's magic words to turn her from a frog into a mouse.[10]

Maus contains three photographs: one of Spiegelman's older brother, who died in the Holocaust; of Spiegelman's mother, wearing a swimsuit, with ten-year-old Art crouching at her side; and of his father, wearing a clean camp uniform in a picture taken after he was liberated from Auschwitz. These photographs attest to the fact that the characters in the book exist outside of the narrative as well as for the purpose of commemoration.

Spiegelman's signature is scrawled on the final page of *Maus*, along with the years of its writing, 1978–1991. The signature is placed below an image of the tombstone on his parents' grave, engraved with their

dates of birth and death. *Maus* is a monument to the Holocaust and to the artist's parents, documenting his father's story of survival, just as the Bayeux Tapestry describes and commemorates the victory of William the Conqueror over the English army in the Battle of Hastings in 1066, in woolen words and images embroidered on seventy meters of linen. The identity of the designer is unknown, as are those of the embroiderers. Like the tapestry, comics such as Carl Barks's *Donald Duck* and C. C. Beck's *Captain Marvel* were unsigned. The role of the hand signature at the end of the *Maus* books is twofold. Signing his name on the final page, much like painters do in the corners of canvases, identifies Spiegelman as the original creator of the drawings and the text, while equating his comic with "high art." The second role of the signature is to witness. It confirms that the author was an ear-witness to Vladek's spoken description of his experiences in the Holocaust. It serves a similar function to Jan van Eyck's signature on his oil painting *The Arnolfini Portrait*. The signature, situated between the curved mirror and the chandelier, states, "Jan van Eyck was here." It attests to the painter's presence at the wedding ceremony of Arnolfini and his bride, as one of two witnesses necessary for proving the legality of the marriage agreement, with all its financial clauses. The Flemish painter's signature makes the painting the document of a witness, as well as identifying the artist. Spiegelman's signature identifies him as an ear-witness, as well the creator of *Maus*.

I would like to thank Sarah Breitberg, the past editor of Israeli art magazine Studio, *who kindly let me republish my original Hebrew article. Thanks also to the philosopher Asa Kasher who invited me to speak on the subject at the Tel Aviv Museum of Art, as part of talk series hosted by him in the mid-1990s. And finally, special thanks to Yardenne Greenspan for her careful and insightful translation of my article from Hebrew to English. All faults and mistakes are mine.*

(1997 and 2021)

Art Spiegelman's *Maus*

Graphic Art and the Holocaust

THOMAS DOHERTY

n presenting a "Special Award" to Art Spiegelman's *Maus* in 1992, the Pulitzer Prize committee decided to finesse the issue of genre. The members were apparently befuddled by a project whose merit they could not deny but whose medium they could not quite categorize. The obvious rubric (Biography) seemed ill-suited for a comic book in an age when ever-larger tomes and ever-denser footnoting define that enterprise. Editorial cartooning didn't quite fit either, for *Maus* illustrated not the news of the day but events of the past. The classification problem had earlier bedeviled *The New York Times Book Review,* where the work had crisscrossed the Fiction and Non-Fiction Best Seller Lists. Originally, *Maus* was placed on the Fiction List, a decision Spiegelman protested in a wry letter to the editor: "If your list were divided into literature and non-literature, I could gracefully accept the compliment as intended, but to the extent that 'fiction' indicates a work isn't factual, I feel a bit queasy. As an author, I believe I might have lopped several years off the thirteen I devoted to my two-volume project if I could have taken a novelist's license while searching for a novelist's structure."[1] In a tiny but telling blip on the cultural radar, the *Times* obligingly moved the volume from the Fiction to Non-Fiction Best Seller List. The veracity of the image—even the comic book image—had attained parity with the word.

From its first appearance in 1980 in the comic magazine *RAW* ("High Culture for Lowbrows") to the complete two-volume edition issued in 1991, *Maus* presented an unsettling aesthetic and scholarly challenge, not least to print-oriented purists who scoffed at the notion of comic book artistry and bewailed the incursion of pop culture into the undergraduate curriculum. In the hands of cartoonist Spiegelman, a conceit obscene on its face—a Holocaust comic book—became solemn and moving, absorbing and enlightening. Occupying a landscape that crossed George Orwell with Max Fleischer, where Nazis were snarling cats, Jews forlorn mice, and Poles stupid pigs, *Maus* redrew the contractual terms for depictions of the Holocaust in popular art. As a graphic reaction to the aesthetics of Nazism and a new mode of inquiry into the past, it offered a media-wise vision whose rough images put traumatic history into sharp focus.

Spiegelman issued his cartoon biography in two volumes published in 1986 and 1991 respectively.[2] *Maus I: A Survivor's Tale: My Father Bleeds History* tracks Vladek, the artist's aged father and *oedipal* muse, from the thriving Jewish culture of prewar Poland to the gates of Auschwitz. Prodded by his cartoonist son, Artie, Vladek flashes back to a young manhood in which his experiences are alternately mundane (work and courtship) and monstrous (mass executions and casual brutality). *Maus II: A Survivor's Tale: And Here My Troubles Began* finds the old man sicker and crankier as he divulges his struggle for survival to Artie, himself now given to spasms of guilt (natch) over the critical and commercial success of the first volume of *Maus*.

In good postmodern fashion, the interview sessions between father and son—and the artist's behind-the-scenes scaffolding— are incorporated into Vladek's narrative. Parallel lines intersect as Artie determines to make Vladek's memory speak and to depict his own entanglements as son and artist. Yet the conflations—writer/ illustrator Art Spiegelman drawing mice Artie and Vladek for a comic book biography of his real-life father called *Maus*—never get too cute or convoluted. Nor does Spiegelman allow the kvetching of an American baby boomer to detract from or compare with his father's passage through hell. As the artist confides to his shrink, "no matter what I accomplish, it doesn't seem like much compared to surviving Auschwitz" (*Maus II*, 44). Finally, though theirs is a father-son relationship

of unusual bitterness and anguish (Artie's wife, Françoise, seems the only nonneurotic in Vladek's contemporary orbit), the artist is faithful to his father's life and memory. To the real Vladek, who died in 1982, Artie is a good son.

The inherent audacity of the project earned *Maus* an extraordinary amount of popular attention in the press, and, by and large, the response was rhapsodic. In addition to the Pulitzer Prize, the work garnered dozens of laudatory reviews and inspired op-ed pieces in the pages of the major metropolitan dailies, a sure sign of its status as a cultural as well as a literary event. By the time a consumer-friendly packaged edition of both volumes appeared in stores for the 1991 Christmas season, *Maus* had entered the national lexicon. In February 1994 the Voyager Company issued a multimedia CD-ROM version entitled *The Complete Maus*, an elaborate hypertext that includes preliminary drawings, journal entries, home movies, and tape recordings from the interview sessions between Spiegelman and his father.[3] Though denied by the artist, rumors of a forthcoming feature-length, animated motion picture version (not by Walt Disney) persist.

Significantly, though, the tentacles of corporate synergy have thus far stopped short of the manufacture of a line of *Maus*-inspired toys for children. Even the forces of commerce recognize that when the Holocaust is the subject, neither the market nor expression is free. No matter how austere and reverent the tone, no matter how traditional the format, any representation of the Holocaust attracts a special measure of critical scrutiny and, if judged lacking, earns a severe measure of opprobrium. The usual criteria for literary and cinematic excellence—originality, wit, formal innovation, and the sundry "pleasures of the text"—are suspended for depictions of the Holocaust. Saul Friedländer expresses a consensus suspicion of "the trap of self-feeding rhetoric or of sheer camera virtuosity" in literary and cinematic treatments of the destruction of European Jewry. "The issue is one of *indiscriminate word and image overload on topics that call for so much restraint, hesitation, groping,* on events we are so far from understanding."[4] It remains one event in twentieth-century history in which poetic license and tolerant forbearance are not granted automatically.

From a traditionalist vantage point, the readily accessible, easy-on-the-eye comic book format of *Maus* would in itself disqualify and

indict the work. Spiegelman's medium is associated with the madcap, the childish, the trivial. By its very nature it seems ill-equipped for the moral seriousness and tonal restraint that have been demanded of Holocaust art. But—also by its very nature—the cartoon medium possesses a graphic quality well suited to a confrontation with Nazism and the Holocaust. The medium is not the message, but in the case of *Maus*, the medium is bound up with the message, with the ideology of Nazism and the artist's critique of it. Spiegelman's artistic style and animating purpose are shaped by the two graphic media whose images make up the visual memory of the twelve-year Reich—cartoons and cinema. Both arts are intimately linked to the aesthetic vision and historical legacy of Nazism. From this perspective, cartoons become not just an appropriate medium to render the Holocaust but a peculiarly apt response to a genocidal vision.

Following a line of inquiry first marked off by Hans-Jürgen Syberberg's *Our Hitler* (1978), Spiegelman sees Nazism not only as a force of history but also as an aesthetic stance. To the Nazis, art was more than an expression of a totalitarian ethos; it was the rationale for it. The Nazi aesthetic celebrated perfection in form just as Nazi ideology demanded purity of bloodlines. Official pronouncements condemned abstract impressionism and other modernist expressions as *Entartete Kunst* ("degenerate art") sprung from diseased minds and foisted on Germany by Bolshevik art critics and Jewish gallery owners. Adolf Hitler, the Reich's most powerful art critic, inveighed constantly against modernist expressions of all sort—"Dadaist sensationalists, Cubist plasterers, and Futurist canvas smearers."[5]

For the Nazis, matters of aesthetics were not the esoteric domain of a small coterie of artistes and buffs but a compelling state interest to be overseen and regulated by the full-blown Reich Ministry for Public Enlightenment and Propaganda headed by Joseph Goebbels. In Munich on July 18, 1937, an officially sponsored twin bill of Nazi-approved and Nazi-forbidden museum shows put the Reich Ministry's aesthetics on full display: the Great German Art Exhibition of 1937 and its ostensible doppelgänger, an exhibition of "Degenerate Art" which opened the next day in the same city (to much larger crowds). The exhibitions' guidebooks condemned the misshapen visages and contorted physiques of abstract impressionist portraiture and

African-influenced sculpture as a defilement of the Aryan ideal; the Reich was threatened by an "endless supply of Jewish trash."[6] Forbidden to envision the human body in any way short of perfection, artists no less than administrators expunged the sick, the infirm, and the mentally disabled from their sight. As Susan Sontag observed: "Fascist art displays a utopian aesthetics—that of physical beauty and perfection. Painters and sculptors under the Nazis often depicted the nude, but they were forbidden to show any physical imperfections. . . . They have the perfection of a fantasy."[7] Always, the theoreticians of Kunst and Kultur abetted the thugs.

The vision of physical perfection was expressed most vividly in film, the high-definition medium of choice. If the posters, portraits, and sculptures that comprise the kitsch of the Nazi era today accrue value only as collectible artifacts, the cinematic legacy has endured both as archival material and dramatic inspiration. Tellingly, the occasion of Sontag's remarks on fascist aesthetics—her famous essay "Fascinating Fascism"—was a review of a collection of photographs by Nazi filmmaker Leni Riefenstahl. Riefenstahl's screen images of muscular bodies and flawless, chiseled faces, her celebration of the grace and power of the (perfect) human form, projected the aesthetic ideal with all the impact of tour-de-force filmmaking. *Triumph of the Will* (1935), Riefenstahl's documentary record of the 1934 Nazi Party Congress at Nuremberg, worshipfully frames the hallowed faces of beatific *Hitler-iugend* and fanatic Labor Service workers, while the superhumans in *Olympia* (1938) defy gravity itself, as sinewy marathon runners strain over roadways and high divers fly through the air. In Nazi art, the Greek ideal of human perfection lived—literally so in the opening of *Olympia,* when Greek statues come alive, the marble men of the classical age incarnated as athletes in the Berlin Games of 1936.

No wonder that, on film, the Nazis continue to exert a perverse fascination and seductive attraction. The visual pleasure of the gaze, the scopophilic voyeurism that makes moviegoing so hypnotic and enticing, is an erotically charged experience.[8] For the moviegoer, physical perfection and bodily beauty are likely to arouse more than disinterested contemplation. Famed as an exemplary specimen of gorgeous humanity, bathed in shimmering chiaroscuro, shot from adoring camera angles, the big screen star is a model human being and a sexually

A scene from Leni Riefenstahl's *Triumph of the Will* (1935), her chronicle
of the 1934 Nazi Party Congress at Nuremberg, the touchstone source
for motion picture images of the Nazis in full dudgeon

alluring object of the gaze.[9] Yet where Hollywood harnesses the erotic
energy of its stars for commercial exploitation, Goebbels's Reichsfilm-
kammer sought to transfer the sexual energy into a "spiritual force for
the benefit of the community."[10]

Of course eroticism is not so easily expunged from the tantalizing
spectacle of beauty and youth. So magnetic and alluring is the Nazi
celebration of the perfect human form that the attractions—especially
on the big screen—are at least as powerful as the revulsions. In con-
temporary films that re-create the set design and resurrect the model
humans of the Nazi era, the erotic energy nascent in Nazi aesthetics
is more likely to be ecstatically released than spiritually repressed.
Think of Luchino Visconti's *The Damned* (1969), Bob Fosse's *Caba-
ret* (1972), Liliana Cavani's *The Night Porter* (1974), Lina Wertmüller's
Seven Beauties (1975), Sam Peckinpah's *Cross of Iron* (1977), or Rainer
Werner Fassbinder's *Lili Marleen* (1981).[11] The most elaborate and self-
reflexive of the subgenre is doubtless Quentin Tarantino's *Inglouri-*

The fetishistic attractions of Nazi imagery in Quentin Tarantino's
Inglourious Basterds (2009)

ous Basterds (2009), a feature-length, high-definition, counterfactual
romp through wartime France that luxuriates in the hypnotic allure
of Nazi iconography and character types, especially the charismatic,
deliciously evil scene-stealing SS officers who have enlivened Holly-
wood cinema from Conrad Veidt's Major Strasser in *Casablanca* (1942)
to Ralph Fiennes's Amon Göth in *Schindler's List* (1993), and beyond.

Cartoons partake of none of this sexual power. A medium of rough
edges and broad caricature, of presexual creatures and anthropomor-
phic animals, it evokes rather than records the human form. Cartoons
define themselves against the aesthetics of photographic reproduction
or realist representation. Unlike film, they offer few scopophilic plea-
sures and little chance of complicity with the aesthetics of Nazism, of
the spectator-reader assuming an adoring gaze at Nazi spectacle and
Wehrmacht specimens.

Not that the cinema-obsessed Third Reich was oblivious to the
propagandistic power of the cartoon medium. Just as the Nazis took
to the screen to celebrate themselves in a high-definition, cinematic
format, the Jews were consigned to a lower-definition medium better
suited to their status in the aesthetic hierarchy. Comic art—"low defi-
nition, deep involvement" in Marshall McLuhan's terms—is the visual
medium most congenial to caricature and low blows. The pivotal inspi-
ration for Spiegelman's cat and mouse gambit was the visual stereo-
types of Third Reich symbology, the hackwork from the mephistoes
at Goebbels's Reich Ministry and Julius Streicher's venomous weekly

Der Stürmer—the anti-Semitic broadsheets and editorial cartoons depicting Jews as hook-nosed, beady-eyed *Untermenschen*, creatures whose ferret faces and rodent snouts marked them as human vermin. Hence, Spiegelman's ironic boast that *Maus* "was made in *collaboration* with Hitler. . . . My anthropomorphized mice carry trace elements of [editorial cartoonist] Fips's anti-Semitic Jew-as-rat cartoons for *Der Stürmer*, but by being particularized they are invested with person-hood; they stand upright and affirm their humanity. Cartoons person-alize; they give *specific* form to stereotypes."[12] But again it is film that generated the iconic image of anti-Semitism under the Third Reich: the notorious sequence from Fritz Hippler's *Der ewige Jude* (1940) that crosscuts between rabbinical ghetto dwellers and swarming sewer rats. From subhumans to nonhumans, the Jews are linked with ver-min, to be eradicated, like plague bearers, from the Fatherland.

Pushing against that deep background is the animation legacy of American popular culture. Like any mass-mediated American, Spiegelman's own cartoon memories are of Saturday mornings filled by Krazy Kat, Mickey Mouse, and Tom and Jerry. Because Vladek's past and his son's present encompass a graphic aesthetic bound by *Der Stürmer* and *Steamboat Willie,* Joseph Goebbels and Walt Disney, the

Cartoons from *Der Stürmer* (March 1937) reproduced from microfilm copies on file at the Jewish Division of the New York Public Library

cartoon world is an apt if disjointed re-creation of their shared experi-
ence. The gulf in time and space bridged by Vladek's life alone—from
the unspeakable horrors of the Auschwitz past to the serene banality
of a Catskills present, from death camps to holiday camps—is a dis-
placement for which surrealist technique is redundant.[13]

Above all, though—more than the supermen in Riefenstahl's films
or the cartoon rodents in Streicher's periodicals—the pertinent and
indelible visual backdrop to *Maus* is the Holocaust itself. As much as
any milestone in history, the Holocaust is made real and vivid by its
motion picture documentation. Recorded on 16mm film by the Army
Signal Corps, the Soviet Army, and the Nazis' own photographic
units, the newsreel footage of the Nazi death camps—which first
stunned American moviegoers in late April 1945 and which has been
a staple of wartime documentaries and archival compilations ever
since—is a permanent presence in the popular memory bank. Doc-
umentaries such as the War Department's *Death Mills* (1946), Alain
Renais's *Night and Fog* (1955), and the "Genocide" episode of Thames
Television's the *World at War* series (1975) have bequeathed a fright-
ful montage: emaciated survivors staring blankly from behind barbed
wire fences; bulldozers corralling and burying heaps of corpses; moun-
tains of hair, eyeglasses, and suitcases; and children unrolling their
sleeves to expose serial numbers tattooed on their arms. The aesthetic
strategy infusing Claude Lanzmann's epic nine-hour documentary
Shoah (1985), a meticulous chronicle of the bureaucracy of genocide,
presumed an intimate acquaintance with this filmic legacy. Reason-
ing that the Holocaust footage was already in the mind's eye of any
sentient spectator, Lanzmann elected not to show a single frame of
archival footage. Similarly, the cinematography in Steven Spielberg's
Schindler's List (1993) imitated the black-and-white film grain of the
archival footage, rather than incorporating it, to evoke the celluloid
memory of Holocaust history.

For the graphic artist grappling with the visual legacy of 1939–1945,
the photographic immediacy of the Holocaust presents something of
an aesthetic quandary. Against the horrific photorealism of the death
camps, impressionist illustrations of existential torment seem lame
and self-indulgent. What representational artist can match the scale
of Hitler's project or his cold eye for detail? Unable to compete with

the real-life horror shows recorded in the newsreels and documentary meditations, artists facing the Holocaust seek to create a picture of reality that though not photographic is still a good likeness. In a literal return of the repressed, the impressionist techniques censored by the Nazis are resurrected to delineate the full horror of Nazism.

Working from a lowbrow rung of the ladder of art, Spiegelman sketched a low-definition revision of the high-definition detail of the newsreel Nazis and the Holocaust footage. Relying mainly on sparse black lines and the shadings of the monochromatic scale, the cartoonist conjures the survivor's landscape with rough sketches, black silhouettes, and white space. The pictures lack detail but not depth, the low-definition medium enhancing the deep involvement of the reader. "The mouse heads are masks, virtually blank," commented Spiegelman, "like Little Orphan Annie's eyeballs—a white screen the reader can project on."[14] In *Maus*, cartoons are not just a shield against the visual pleasures of big screen Nazism but a medium that reverses the process of projection.

The reference to Harold Gray's *Little Orphan Annie* is a clue to the care with which Spiegelman deploys his medium's peculiar advantages. Besides Nazism, *Maus* is invested with the history and aesthetics of the cartoon. In a purely comic book composition, Vladek and his

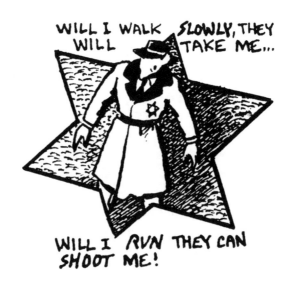

From *Maus I*, page 80

first wife, Anja, confront a series of dead-end roads zigzagging like a swastika across the page, the couple trapped in the frame of the comic and of history. Another frame assumes the shape of the Star of David and seems to pin Vladek under a spotlight of anti-Semitism. Among the low-definition renderings, a highlighted detail directs attention to itself—the telltale tail of Anja, Vladek's unmistakably Jewish wife, for example, or the tattooed serial number on Vladek's forearm as he pedals his exercise bike. Throughout *Maus*, comic-specific associations and tropes dot the cartoon landscape, as when free-floating, Chester Gould–like arrows signpost points of information ("Zyklon B, a pesticide, dropped into hollow columns," reads one) or when, in an audacious interlude of true comic relief, the exclamatory typography of the Sunday funnies lightens things up.[15]

The differences in media dialectics notwithstanding, the grammar of cinema translates readily into comic book terms. In a mosaic presentation akin to cinematic montage, panels and maps splash across the page, figures bleed out of and break across rectangular frames, and elaborately designed layouts greet the eye before a close-in inspection of the individual panels. When a triptych of panels zooms in from a medium shot to a close-up, the sequence of still images duplicates the dynamic telescoping of the camera lens. Unlike the height-to-width aspect ratio of a film screen, however, the comic frame has a malleability and elasticity that can heighten dramatic effect and visual impact, as when the dimensions of the comic book screen expand lengthwise to accentuate the horizontal movement of the transport trains.

Perhaps to balance the high-risk gamble of the imagery, the language and tone of Spiegelman's comic book work is tempered and austere. In Holocaust literature, the language of low melodrama or high adventure, the reliance on generic machinations and literary flourish is deemed blasphemous or at least bad form. A studied, unadorned understatement is the approved style. The title and tone of one of the most moving Holocaust autobiographies captures the reigning aesthetic: Nechama Tec's *Dry Tears*. A searing memoir of Tec's life in Poland as a young girl, the work renders everything from the perspective of a child who knows only horror and witnesses it with a detached, numb acceptance.[16]

Verbally if not visually, *Maus* is very much in line with this con-

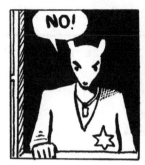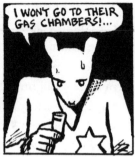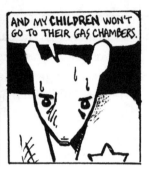

From *Maus I*, page 109

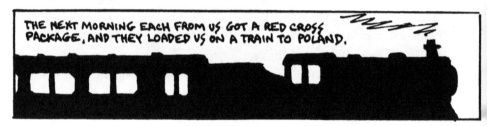

From *Maus I*, page 59

vention. After all, sparseness of expression is a sine qua non for the cartoon medium, a format that severely rations the space available for wordplay. Save for the free-floating exclamation or sound effect, the two main devices of comic book narration are the dialogue balloon and the boxed commentary positioned at the top of the frame; these set strict limits on exposition and dialogue. The narrative craft of the cartoonist is to prune away excess verbiage to accommodate the limited space available. Claiming a dual kinship with the narrative voice of the novel and the narrative voiceover of cinema, cartoon exposition must be concise and elliptical lest it bleed over into—and overpower—the image.

The forced economy inspires Spiegelman's most impressive literary achievement: his unobtrusive modulation of Vladek's voice. Infused with the music of second-language English and Yiddish syntax, Vladek's first-person voiceover is devoid of oratorical flourish or self-pity. "All such things of the war, I tried to put out from my mind once for all," Vladek tells Artie, "until you rebuild me all this from your questions" (*Maus II*, 98). Or: "And we came here to the concentration

camp Auschwitz. And we knew that from here we will not come out anymore . . ." (*Maus I*, 157).

Just as the tone of *Maus* conforms to expectations, Spiegelman's research method is traditional enough: probe the subject, master the historical record, "reality test" the testimony, and organize all into a coherent vision of the individual caught in the web of history. Maps and diagrams of wartime Europe and the gas chambers at Auschwitz are testimony to the scrupulous scholarship that invests the book with historical authority as well as emotional power. The first injunction of Holocaust literature is to get the facts straight—to master the details and maintain an utter fidelity to the known record.[17] At one point Artie disputes his father's memory on a matter of fact; at another he solemnly pledges to conceal an anecdote the old man relates in confidence, a sequence he has already illustrated. Rather than conceal the truth from the reader, he exposes himself as a liar to his father in service to a greater truth and higher trust.

Spiegelman's fidelity to the unvarnished truth is apparent in his unsparing portrait of Artie as a (sometimes) petulant son and his father as a (usually) insufferable human being. Indeed the maddeningly self-absorbed and thoroughly unpleasant Vladek comes off as something of an ethnic stereotype himself. "In some ways he's just like the racist caricature of the miserly old Jew," Artie worries (*Maus I*, 131). As a working artist in a culture whose own sensitivities to ethnic portraits can be exquisite, Spiegelman challenges the real comic book mentalities. Rendering the truth in stereotype (ethnic group members can be quite true to form) and the lie (that the group image defines the individual), the artist refuses to flinch from a literal illustration of the complexity of being human, of being both an ethnic type and a unique individual, a cartoon character and a fully realized human. Artie's father forthrightly defies one stereotype: the stereotype of the Holocaust survivor. Neither saintly sufferer nor guilt-ravaged witness, he is most appealing at his most annoying. Vladek seems pretty much the same irascible SOB before Auschwitz as after. Preternaturally self-interested (he's the kind of romantic suitor who checks out his girlfriend's medicine cabinet to make sure she has no hidden ailments) and resourceful (at various points he works as salesman, soldier, laborer, tinsmith, shoemaker, and translator), Vladek is a born

survivor but not a born Survivor. Stubbornly, gallantly, he refuses to be ennobled. When Françoise berates him for his own bigotries ("You talk about blacks the way the Nazis talked about the Jews!"), his reply is unrepentant: "Ach," snorts Vladek. "It's not even to *compare*. The shvartzers and the Jews!" (*Maus II*, 99).

Near the end of the book, the end of Vladek's nightmare in history, Spiegelman pastes a photograph of his father into the *Maus* layout, a real photograph, sharp and clear, of a handsome and healthy young man who looks almost natty in the gray stripes of a camp inmate's uniform. The picture was taken shortly after the war, Vladek explains, at a souvenir photo shop. Amid the rough lines of Spiegelman's comic book art, the snapshot on film seems pallid and duplicitous. The true picture of this survivor's tale is in the cartoons.

(1996 and 2020)

Of *Maus* and Memory

The Structure of Art Spiegelman's Graphic Novel of the Holocaust

STEPHEN E. TABACHNICK

1. The Graphic Novel and *Maus*

In 1986, Lawrence Abbott concluded that "Comic art does possess the potential for the most serious and sophisticated literary and artistic expression, and we can only hope that future artists will bring the art form to full fruition" (176). Even as he was writing that, the movement toward a serious comic book art had already gained momentum. One of the most exciting developments in all contemporary literature is the emergence during the past ten years of the "graphic novel"—the comic book that has outgrown limited popular conventions of size, format, and content and become a vehicle for the subtle discussion of important issues.[1] Owing to the graphic novel's freedom from the typically brief duration, flat surfaces, standardized panels, constricted techniques, stereotyped characters, and simplified plots and attitudes of the conventional comic book, the graphic novel "reader" experiences a richer sense of time and space and a deeper involvement of the senses than are available from any other novelistic or sequential art medium.[2]

Prime examples of this new art form are Alan Moore and Dave Gibbons's *Watchmen* (1986), which mingles long texts and flat comic book panels in an investigation of the psyches of superheroes; George Pratt's *Enemy Ace: War Idyll* (1990), which sensitively explores the

emotional aftermath of war; Neil Gaiman and Dave McKean's *Black Orchid* (1991), which speculates on the possibility of a human-botanical hybrid, possibly under the influence of Hawthorne's "Rappacini's Daughter"; Robert Crumb's anarchical oeuvre, including *Fritz the Cat*, which deliberately violates every public taboo; and Harvey Pekar's *American Splendor* collection (1986), an autobiographical account of Pekar's life as a proletarian gadfly in Cleveland, including telephone wires and garbage cans drawn to life.

Behind these recent exemplars stands the influence of such pioneering popular comic strips as Lyonel Feininger's *Wee Willie Winkie's World*, Winsor McCay's *Little Nemo*, Al Capp's *Li'l Abner*, and Walt Kelly's *Pogo*. More direct influences on the graphic novel are the eventually banned William M. Gaines's EC Comics of the 1950s, the seminal success of Gaines's and Harvey Kurtzman's *Mad* magazine, and the 1960s radical underground "comix." The graphic novel has broken free from the oppressive, homogenizing comic book self-censorship code that began in 1954 (and which was the industry's frightened response to Fredric Wertham's anti-comics tract *The Seduction of the Innocent* and Senator Estes Kefauver's investigatory commission). The new form frequently displays an antiauthoritarianism, ethnic expression, philosophical depth, and serious aesthetic power that are glimpsed but not fully exploited in these precursors.

Among his other endearing qualities (such as the principled stance against censorship seen in his interview with Stephen Ringgenberg), William Gaines had a penchant for hiring very talented international political refugees of all kinds, as Maria Reidelbach points out. As a result, he involved many Holocaust survivors in *Mad* from its inception in 1952. Thus, through its influence on *Mad*, the Holocaust may in some sense be credited with making the comic book a more important artistic form soon after the Second World War. Indeed, one of *Mad*'s most notorious early parodies involved a concentration camp sequence, and Philologos, the linguistic writer for the English-language edition of the Yiddish newspaper the New York *Forward*, recently devoted a long discussion to the *Mad* word "furshlugginer," coming to the tentative conclusion that it was born of Yiddish and German in the concentration camps and means "stinking." Revealing the influence that *Mad* had on his own work as well as his esteem for

that publication, writer-cartoonist Art Spiegelman (in his interview with Jonathan Rosen of the *Forward*) comments that he hopes that his own children will be "exposed to the great holy Jewish writings of Harvey Kurtzman and Franz Kafka if nothing else."

Holocaust background becomes foreground in Spiegelman's *Maus*, the most exciting graphic novel of all, and the first and only one to have been awarded the Pulitzer Prize. "Spiegelman" (as Art must know) means mirror-maker or seller in German, and *Maus*, an autobiography, holds the mirror up to the lives of Spiegelman's parents, Vladek and Anja, during the Holocaust, and to his own spinoff problems as their son growing up in placid Rego Park, Queens. By focusing intensely on his family's past and present, Spiegelman manages to encapsulate the history of the Holocaust as a whole, including its influence on survivors' children. I hope to explain how and why Spiegelman, using an unexpected and hitherto despised medium, succeeds in uniting the public and private aspects of the Holocaust so well that many reviewers have found *Maus* the most compelling representation of this subject ever devised in any literary or pictorial genre.

2. Influences on *Maus*

How did Spiegelman develop the strikingly original idea of using a comic book as an autobiographical *cri de coeur* about the Holocaust? The most obvious answer is that he is a cartoonist by trade (and is presently the coeditor with his wife, Françoise Mouly, of the avant-garde comics journal *RAW*), and so naturally used the tools he had at hand to exorcise his personal anguish. But he may also have felt that the other ways of dealing with the Holocaust had already been exhausted. Novels, plays, poems, and films abound. But few of them any longer generate the interest that they deserve, even when they are by first-rate writers like Elie Wiesel, Aharon Appelfeld, and Jerzy Kosinski. The documentary horror films remain, but they are already half a century old and have lost their immediacy for a later generation, especially since they must compete with more recent horrors shown in full color on the TV screen every night. Moreover, they lack the redeeming quality of art, namely, the attempt to derive meaning from the atrocities depicted.

Perhaps Spiegelman felt that *Maus* could succeed precisely because it would arouse readerly expectations completely dissimilar to those raised by other artistic treatments of the Holocaust on the one hand and by Disney-style popular comics, with their focus on harmless talking animals, on the other. Paul Buhle explains that "More than a few readers have described [*Maus*] as the most compelling of any [Holocaust] depiction, perhaps because only the caricatured quality of comic art is equal to the seeming unreality of an experience beyond all sane reason" (16). This explanation assumes that *Maus* succeeds because it does what popular comics usually have done—portray unreal situations in an unreal way. Another explanation, which has the long tradition of the newspaper political cartoon behind it, is that *Maus* works because it depicts what was all too real, however unbelievable, in a tightly controlled and brutally stark manner.[3] The black-and-white quality of *Maus*'s graphics reminds one of newsprint (as Norman Spinrad has pointed out), and the story presented has a strong political as well as moral dimension.

All of these forces may have been operating on Spiegelman in the background, but he has cited other immediate influences in his *Forward* interview:

> The real origin of "Maus" was being invited, 20 years ago, to do a three-page comic strip for an underground comic book called "Funny Aminals," the only requirement being that I use anthropomorphic characters. Fishing around for something led me toward my center. A number of things helped. One of them was sitting in on Ken Jacobs' film classes at SUNY Binghamton where he was showing racist cartoons and at the same time showing cat-and-mouse chase cartoons. They conflated for me and originally steered me toward possibly doing something about racism against Blacks in America. Shortly thereafter, [Kafka's] Josephine the Singer began humming to me and told me that there was something closer to deal with and I began pursuing the logic and possibilities that that metaphoric device opened up. (11)

That cinematic cartoons have influenced the creation of *Maus* comes as no surprise: one has only to think of a Tom and Jerry chase,

for instance. Franz Kafka is a perhaps more unexpected but at the same time very apt influence.

An interesting speculation is that Kafka, in writing about beetle-man Gregor Samsa in *Metamorphosis* as well as about Josephine and the mouse folk, not to mention the clever mole in "The Burrow," was influenced by the comics and cartoons of his own time and earlier. Wilhelm Busch, the innovative nineteenth-century German artist, published in the magazine *Bilderbogen* a cartoon story entitled "The Transformation" in which a boy is transformed into a pig before our eyes (Clark, 93). Could Kafka have run across a reprint of this, perhaps while a child? Lyonel Feininger, who went on to do *Wee Willie Winkie* and to become a famous American artist, was the cartoonist for several German-language magazines and newspapers from 1895 onward. Could Kafka as a German speaker in Prague have seen some of his or other European cartoonists' equally exciting work? If so, Kafka's influence on *Maus* and possibly on other American comics would bring us full circle. We should take Spiegelman's words about Kafka's influence on him seriously. Certainly we find in Spiegelman's work some of the same literary structures that we find in Kafka and in other fictionists.

3. Narrative Layers in *Maus*

As a narrative, Spiegelman's autobiographical graphic novel contains three separate genres usually found in fiction, which form distinct but interwoven narrative layers: the *künstlerroman*, the *bildungsroman*, and the epic.

The *künstlerroman* layer tells the story of Art's development as the angst-ridden artist making *Maus*. Spiegelman meditates about his worries concerning the creation of this graphic novel, and particularly about whether or not he can make it authentic, since he has not witnessed the Holocaust himself. Although he refers more than once to the problem of truth in autobiography, pointing out jocularly, for instance, that in real life his wife would not let him talk as much as he does in *Maus,* Spiegelman seems driven to prove that we are reading an authentic story. Mala, Vladek's second wife, tells Art in *Maus* that Art's "Prisoner on the Hell Planet" (a *Maus* precursor employing human figures and telling the story of his mother, Anja's, suicide,

which is included in volume I of *Maus* itself) is "so personal! But very accurate . . . objective. I spent a lot of time helping out here after Anja's funeral. It was just as you said" (104).

But this accuracy is hard-won, as Spiegelman admits in *Maus* itself: "I feel so inadequate trying to reconstruct a reality that was worse than my darkest dreams. And trying to do it as *a comic strip*! I guess I bit off more than I can chew. Maybe I ought to forget the whole thing. There's so much I'll never be able to understand or visualize. I mean, reality is too *complex* for comics . . . So much has to be left out or distorted" (*Maus II,* 16). To which his wife, Françoise, replies, "Just keep it honest, honey." He shows himself agonizing over whether by showing his father's cheapness he might not be reinforcing anti-Semitic stereotypes, and exposing his father to ridicule. He responds, as Françoise advises, with the ruthless honesty of the artist, by portraying his father as he sees him, come what may.

On the positive side, Spiegelman has said that the process of interviewing his father for *Maus* "gave me a relationship with Vladek that I probably wouldn't be able to have otherwise" (*Forward*, 9). This leads us to Spiegelman's second role, as Art the son rather than the artist.

The *bildungsroman* layer centers on an Art who wrestles with his relationship with his parents, Vladek and Anja, and with what the Holocaust, through them, has done to him. As he tells his wife, Françoise, "I know this is insane, but I somehow wish I had been in Auschwitz *with* my parents so I could really know what they lived through! . . . I guess it's *some* kind of guilt about having had an easier life than they did" (*Maus II,* 16). Rather than any son facing any father, Art is a son confronting a very powerful, epic, amazing, if cranky and alien father to whose experience he can never rise; and who fills him with awe and guilt as a result. It is the Oedipal conflict written large indeed.

Achieving an objective view of one's own parents is difficult in any case. This task is even harder for the children of Holocaust survivors. In her book *Children of the Holocaust*, Helen Epstein quotes psychiatrists who have studied the survivors. Survivors' posttraumatic symptoms include depression, nightmares, withdrawal and isolation, changes in identity, anxiety, and genuine as well as psychosomatic physical problems. *Maus* shows Vladek experiencing nightmares, and

Art comments to his wife, Françoise, that he thought everyone's parents screamed every night in their sleep. The children of survivors, it has been found, also frequently suffer from depression and an inability to function well. Spiegelman will forever remain the child of survivors; and his heroic attempt to understand this imposed and perpetually inescapable role of his, and to present his parents as they really seem to be, is largely what the *bildungsroman* aspect of *Maus* is all about.

In the dialogue between Art and his psychiatrist, Vladek is portrayed as the father who knows some dirty secret—not sex but Auschwitz—beyond Art's ability to know; and as if to underline this point, Art shrinks to child's size in this episode. In a real sense, the middle-aged Art is always a child next to Vladek, because any American growing up under usual circumstances is perpetually like a child before the terrible knowledge of the Holocaust survivor.[4]

At the very end of volume II, Vladek is tired and tells Art, "I'm tired from talking, Richieu, and it's enough stories for now . . ." (unpaginated [136]). Calling Art by the name of his dead five-year-old brother, Richieu (poisoned by a relative to save him from the Nazis long before Art was born), Vladek reduces Art to the status of child again. On one hand, Vladek is like any father telling a child a bedtime story. On the other, Vladek's tale has not been a normal bedtime story and Art's life has been changed forever by it, even before he heard it.

Even apart from the survivor aspect, Art's relationship with his father is problematic. The aging father retains his prerogatives at the same time that he is increasingly dependent upon the middle-aged son's help. Art is impatient with his father's cheapness, embarrassed by Vladek's quarrelsome relationship with his second wife, Mala, and unable to bear living with him. He feels that both Vladek and Anja have imprisoned him with their Holocaust-derived behavior and obsessions. With an artist's ruthlessness, Spiegelman shows us not only his own limitations as a son, but that Vladek is hard to live with, and that he was not an extraordinarily noble man before the war, either. There are no saints among the main characters in *Maus*.

This brings us to the third genre embedded in *Maus*, the epic story of Vladek, the incredible Sinbad the Sailor who has passed through the most perilous straits and lived to tell the tale, like a monstrous *Odyssey*, to his only surviving son.[5]

One of the recurring questions about the Holocaust is how it could have transpired at all. Another is why the Jews did not escape before it was too late. No one can answer the first question, but Vladek's narrative answers the second. Using the diagrammatic quality of sequential art, *Maus* shows in great detail the progression of one Jewish family from disbelief to shocked belief to horror to numbness.

At least as Vladek tells it (which is all we can know), he always kept his head and managed to help his friends and relatives throughout the Nazi trauma. Perhaps the reason that he is ready to talk to Art is that, unlike many others, he does not appear to have done anything disreputable or betrayed anyone. He tells us that he always tried to be in touch with Anja, and reports that Mancie, a woman who served as a go-between for them in the camps, said that she had to do it however much she risked her own life, because of the depth of Vladek and Anja's love.

Vladek emerges as admirable, no less a lover than Petrarch, no less resourceful a hero than Odysseus. But as Art's wife, Françoise, comments when Vladek returns his opened but uneaten food to the supermarket, part of him did not survive. Unlike Odysseus's decisive reclamation of his patrimony following more or less honorable battles on the plains of Troy, Vladek's is a particularly ambiguous kind of heroism, born of a complete lack of power to defend oneself and of survival in impossible conditions, and leaving a mixed and unpleasant aftermath, including humiliating memories. Suffering does not necessarily ennoble, and so it is with Vladek. While we pay tribute to his courage and tenacity during the Holocaust, we also find much to question about his life in the present. Watching Vladek develop from a rather usual young man engaged in love affairs and the textile business, into a smart survivor and great lover, and finally into a sick, tired, cranky, unhappy old man with a second wife who doesn't love him, is an incredible journey for the reader.

The aesthetic, personal, and epic narrative layers interact to raise unanswerable questions ranging from the local to the cosmological: Was Art's own stint in a mental institution (referred to in "Prisoner on the Hell Planet") caused by his parents' experiences? How could anyone have devised the Holocaust in the first place? Is there indeed a God who watched over Vladek and Anja at Auschwitz and enabled

them to survive while others perished? As Spiegelman tells the journalists asking what his "message" is, "I dunno" (*Maus II*, 42). Unlike a political cartoonist, he cannot tell us what to think because he doesn't know himself. Not knowing, however, is a hell, and Art will forever be a prisoner on the hell planet precisely because he doesn't know if he himself, Vladek, or Hitler is responsible for his mother's suicide.

4. Visual and Verbal Devices in *Maus*

What is the nature of *Maus*'s art and how does it influence the reader? In a negative review of Spiegelman's work, the usually perceptive Hillel Halkin writes that "Language may indeed be tyrannically word-bound, but the visual arts are no less tyrannically space-bound, and yoking two tyrannies together in such a way that there is a minimum of room for maneuver within either is a poor strategy for overcoming them. All that happens in the comic strip is that one ends up more bound and chained than ever. The division into small boxes limits all utterances to the shortest and pithiest statements, ruling out nearly all verbal subtlety or complexity, while the need to fill each box with a drawing has a similar effect on the illustrations" (56).

In response to this clever but superficial comment, one wonders if Halkin has considered the sonnet, which works precisely because of the tension between its constricted form and its content? Or if he has pondered Robert Frost's statement that writing poetry without rhyme and meter is like playing tennis without a net? To a lesser artist and writer than Spiegelman, any kind of formal restraint is a limitation and a disaster; to someone as good as Spiegelman, the very restraint imposed by the graphic panel format becomes a challenge and an opportunity to say a lot in a little.

Moreover, Halkin has not paid attention to the number and complexity of devices that Spiegelman uses to expand the clichéd, popular comic book format into something completely original and new. Abbott points out that the panel is the basic unit in sequential art, and that the panel usually has visual and verbal devices in it. Among the visual devices in sequential art are the control of the viewer's eye movement, and the time duration shown in each panel. Among the verbal devices we have narration, dialogue, and sound effects. In addi-

tion to these considerations, there is the sequential aspect: how one panel leads to another and how the panels function together throughout the work. I want to look at some visual devices in *Maus*, and to explore the ways in which Spiegelman uses them to support and sometimes to undercut his text.

Spiegelman's own unique visual devices include the use of black-and-white drawing; the use of diagrams; the use of different animals for different nationalities; the adroit manipulation of the reader's perspective via eye movement and various sizes of panels; and the use of photographs interspersed with the drawings.

The thread that unites all of these disparate techniques is Spiegelman's brilliant exploitation of sequential art's capacity for juxtaposition, to which he himself calls attention in his interview with Rosen:

> One of the themes important to the book has to do not only with the juxtaposition of personal and global history, but the juxtaposition of past and present, and that informs "Maus," quite literally, in that a comic strip is made up of units of time placed next to each other so that one sees past and present simultaneously, before decoding the moments that are being depicted in any given box. So there is a kind of visual overlapping and interweaving of Vladek on an Exercycle and a moment in Poland in the '40s. In one panel, it's made even more condensed, where we're driving through the Catskills and there's a forest with prisoners hanging from the branches. That mixture is reflected throughout the book in one way or another, and certainly in the dedications as well. (9)

On the back cover of both volumes, we see how effective Spiegelman's visual devices, unaided by many words, can be, owing to his use of the telling juxtaposition. On the back cover of volume I, a small colored map of Rego Park is set into a larger colored map of Poland, alongside a black-and-white drawing of Vladek talking to Art. We have the old world, with its "Mauschwitzes" clearly marked in skeletons, juxtaposed with the new, supposedly safe world—Vladek speaking from an armchair in Queens, and Art, on the floor, like a child, trying to understand his father's fantastic but all too true tale.

On the back cover of volume II, we see a neat, greenish diagram

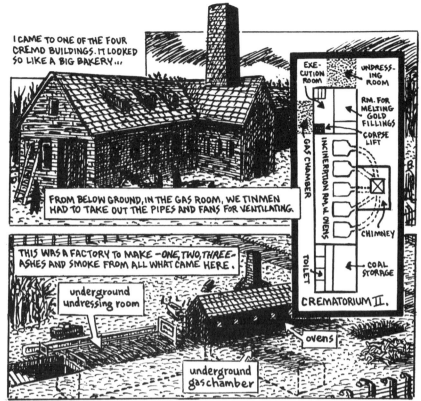

I CAME TO ONE OF THE FOUR CREMD BUILDINGS. IT LOOKED SO LIKE A BIG BAKERY...

FROM BELOW GROUND, IN THE GAS ROOM, WE TINMEN HAD TO TAKE OUT THE PIPES AND FANS FOR VENTILATING.

THIS WAS A FACTORY TO MAKE – ONE, TWO, THREE – ASHES AND SMOKE FROM ALL WHAT CAME HERE.

underground undressing room

ovens

underground gaschamber

EXE-CUTION ROOM

UNDRESS-ING ROOM

RM. FOR MELTING GOLD FILLINGS

GAS CHAMBER

INCINERATION RM. W. OVENS

CORPSE LIFT

CHIMNEY

COAL STORAGE

TOILET

CREMATORIUM II.

SPECIAL PRISONERS WORKED HERE SEPARATE. THEY GOT BETTER BREAD, BUT EACH FEW MONTHS THEY ALSO WERE SENT UP THE CHIMNEY. ONE FROM THEM SHOWED ME EVERYTHING HOW IT WAS.

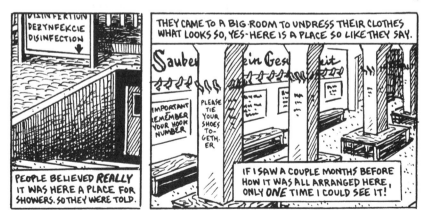

DISINFEKTION DEZYNFEKCIE DISINFECTION

PEOPLE BELIEVED REALLY IT WAS HERE A PLACE FOR SHOWERS. SO THEY WERE TOLD.

THEY CAME TO A BIG ROOM TO UNDRESS THEIR CLOTHES WHAT LOOKS SO, YES – HERE IS A PLACE SO LIKE THEY SAY.

Sauber ein Ges it

IMPORTANT REMEMBER YOUR HOOK NUMBER

PLEASE TIE YOUR SHOES TO-GETH-ER

IF I SAW A COUPLE MONTHS BEFORE HOW IT WAS ALL ARRANGED HERE, ONLY ONE TIME I COULD SEE IT!

Maus II, page 70

of Auschwitz and Birkenau in whose foreground is a dark, ugly column of smoke, while off to the side there is a pretty yellow map of the Catskills, where Vladek goes for the summer and where much of the action takes place. Once again, the whole point of the book is summed up visually in one gestalt. The new American world of Ellenville and Monticello (represented by a friendly AAA map) is literally overshadowed by the old dark tragedy of Auschwitz represented by a precise, neat khaki-colored diagram and threatening smoke. We take in at a glance the irreconcilability of the old world and the new; and yet the superimposed black-and-white portrait of Vladek in a prison uniform set over both worlds forces us to recognize that they have somehow been bridged, and that we cannot escape the past.[6]

Spiegelman's choice of black-and-white drawings for his whole work (apart from the covers) is very appropriate, because it matches the concentration camp uniform of Vladek, because it resembles a stark newspaper or medieval woodcut style, and because it recalls the black-and-white films of the Second World War and the Holocaust, but even more because it does not allow the reader to evade the stark, salient import of Spiegelman's story.

The black-and-white format is also very appropriate for Spiegelman's diagrams, as on page 60 of volume II when Vladek explains how to sew a boot, or when on page 70 of that volume, he explains the layout of the crematoria. The boot diagram prepares us for the crematorium diagram; the first explains a technical process that most people simply do not know about while the second describes a technical process that most people cannot even imagine. The juxtaposition of the two diagrams ten pages apart reinforces the cold, technical nature of what the Nazis did. But this icy, distanced diagrammatic feeling is immediately undercut by the frames on page 71 in which a man who worked clearing out the gas room explains its results to Vladek in graphic detail, so that even in his hardened state he shouts, "Enough!" and comments, "I didn't want more to hear, but anyway he told me." This is just one example of how pictures and words work together inseparably throughout this book, the text supporting or undercutting the reader's reaction to the pictures.

One reason that we can bear the horror in *Maus* is that Spiegelman's use of talking animals distances us from the story to some degree. As

Adam Gopnik comments, Spiegelman's animals "suggest not just the condition of human beings forced to behave like animals, but also our sense that this story is too horrible to be presented unmasked." Nonetheless, Hillel Halkin is a severe critic of Spiegelman's decision to use animals, claiming that it is an evasion of the truth, because having cats chase mice gives children the idea that such a pursuit is an entirely natural function instead of a terrible, unnatural condition inflicted by one group of human beings upon another. Moreover, Spiegelman's decision to assign animals according to nationality has aroused controversy. His Jews are mice, the Germans cats, the Poles pigs, the Americans dogs, the Swedes reindeer, the French frogs, and in a witty touch, the Roma are moths (referring to the insect species then called "gypsy moths" and now renamed "spongy moths"). In response to a query in *Maus*, Spiegelman replies that he might draw Israelis as porcupines were they to figure in the story.[7]

But Spiegelman has already answered the objections to his use of animals. In his brilliant chapter on *Maus*, Joseph Witek quotes Spiegelman as an artist faced with practical problems saying that:

> If one draws this kind of stuff with people it comes out wrong. And the way it comes out wrong is, first of all, I've never lived through anything like that . . . and it would be counterfeit to try to pretend that the drawings are representations of something that's actually happening. I don't know what a German looked like who was in a small town doing a specific thing. My notions are born of a few score of photographs and a couple of movies. I'm bound to do something inauthentic.

> Also I'm afraid that if I did it with people, it would be very corny. It would come out as some kind of odd plea for sympathy or "Remember the Six Million," and that wasn't my point exactly, either. To use these ciphers, the cats and mice, is actually a way to allow you past the cipher at the people who are experiencing it. So it's really a much more direct way of dealing with the material. (102)

So for Spiegelman, the use of animals, paradoxically, limits sentimentality and makes it possible for authenticity and realism to predominate.

Another answer to Halkin's objections to the use of talking animals is that the Holocaust turned the world upside down, so that people became animals and showed their humanity only on exceptional occasions. Volume I begins with an epigram quoted from Hitler, "The Jews are undoubtedly a race, but they are not human," and *Maus* literally shows us what happened when that dictum was acted on. During the Holocaust, the Jews' Jewishness rather than their humanity became foregrounded for most Germans, who hunted men down only because of that Jewishness. Each national and ethnic group, moreover, acted like a separate species because of the Nazis' racial laws. During the Holocaust, nationality and ethnicity became matters of life and death.

Another justification for Spiegelman's use of animals is its subtlety. His drawings of cats emphasize their sharp teeth and hooded eyes, except when he shows a German prisoner in the camps, as on page 50 of volume II: here the cat becomes gentle and frightened, too. As Witek comments, all of Spiegelman's main characters, whether cats, mice, or other animals, have unique facial expressions, clothing, or other marks of individuality. Angst, terror, despair, sadism, all are clearly written in miniature on these faces. But Spiegelman is even more subtle than that: his wife, Françoise, who converted to Judaism, is shown as a mouse, but only after he gives us a discussion about how he arrived at that decision (*Maus II*, 11–12). When he shows an intermarried German-Jewish family, the children are shown as mice with cat stripes (*Maus II*, 131).

The fact that the animals can speak to one another despite their different species—even the German cats talk to the Jewish mice—shows that this is really a tale about people, not animals. As Spiegelman himself has pointed out, his use of talking animals is only a mask to be shucked off immediately; no reader for a moment thinks that he's reading about animals rather than about people, perhaps because the mice wear recognizable human clothing. While it will remain controversial, for Spiegelman the deployment of animals to represent human groups probably had the virtue of graphically illustrating his view of the relationships between these groups: the Americans are shown to be friendly and generous like dogs and chase the German cats; the Poles are portrayed as pigs because their eating of pork was a major

I THOUGHT ONLY HOW HAPPY IT WOULD BE TO HAVE ANJA SO NEAR TO ME IN THESE NEW BARRACKS.

IT COULD BE "ARRANGED" FOR 100 CIGARETTES AND A BOTTLE VODKA, BUT THIS WAS A FORTUNE.

one day's bread. = 3 cigarettes

200 cigarettes = 1 bottle of vodka

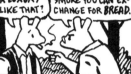

HOW COULD YOU GET CIGARETTES?

EACH WEEK TO THE WORKERS, THEY GAVE US THREE.

THEY ISSUED A LUXURY LIKE THAT!

YA. AND IF YOU DON'T SMOKE YOU CAN EXCHANGE FOR BREAD.

I STARVED A LITTLE TO PAY TO BRING ANJA OVER.

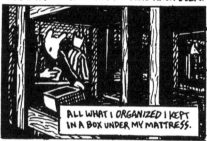

ALL WHAT I ORGANIZED I KEPT IN A BOX UNDER MY MATTRESS.

BUT, WHEN I CAME BACK ONE TIME FROM WORK...

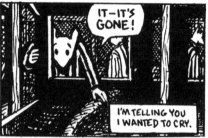

IT—IT'S GONE!

I'M TELLING YOU I WANTED TO CRY.

YOU LEFT THE BOX IN THE BARRACK? HOW COULD IT NOT BE TAKEN?

I DIDN'T THINK ON IT...

BUT EVERYONE WAS STARVING TO DEATH! SIGH-I GUESS I JUST DON'T UNDERSTAND.

YES...ABOUT AUSCHWITZ, NOBODY CAN UNDERSTAND.

SO... I SAVED A SECOND TIME A FORTUNE, AND GAVE OVER BRIBES TO BRING ANJA CLOSE TO ME. AND IN THE START OF OCTOBER, 1944, I SAW A FEW THOUSAND WOMEN IN THESE NEW BARRACKS...

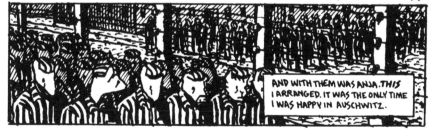

AND WITH THEM WAS ANJA. *THIS* I ARRANGED. IT WAS THE ONLY TIME I WAS HAPPY IN AUSCHWITZ.

Maus II, page 64

difference between them and the Jews who lived among them, and pigs do not hunt mice; the reindeer, the frog, and the moth are only clever strokes, since they do not figure prominently in the story.[8]

A final justification of Spiegelman's use of animals is that it carries more than a hint of the degradation of all of the people involved in the Holocaust; all reverted to animal status and are denied human form by Spiegelman.

The manipulation of perspective, partially by means of panel size, also allows Spiegelman to control the reader's distance from the story. In the first panel on page 64 of volume II, we see Vladek's face from close up in a moment of despair, circumscribed both by a window pane that looks like bars, and by the narrow frame of the panel. Vladek's narration tells us that he wanted Anja to be near him, but the bars seem to prevent this outcome. In the final, wide panel on the same page, we watch from in front of a line of advancing male prisoners (including, incidentally, one pig and one cat), and from a point slightly above them. The narration tells us that Anja is among the indistinguishable women prisoners on the other side of the electric fence in the panel, but we cannot see her because the women are too far away. Vladek himself is distinguishable from the other prisoners only because his head is turned to the left in order to look at the women. His comment that "It was the only time I was happy in Auschwitz" is lost in the bleak sameness and the wide-angle size of the panel; moreover, a fence separates him from Anja as the window panes did in the first panel. In the distant juxtaposition of first and last panels, Spiegelman has moved us from an intense sense of Vladek's individuality and personal pain to a view of Vladek as one of a gray, sad crowd whose idea of happiness is so minimal as to be incomprehensible from a usual perspective. This final panel underlines the point Vladek makes to Art in the panel immediately above it: "About Auschwitz, *nobody* can understand."

The use of perspective is never better rendered, however, than on page 32 of *Maus I*. Here we have three sizes of panel—a long one showing the train in which Vladek is riding into Czechoslovakia, two small ones showing the friends looking out of the train windows, and then a very large one in which they glimpse the Nazi flag for the first time. We first see the train from a comfortable, neutral point far from it, then witness the friends' shocked facial expressions from a much

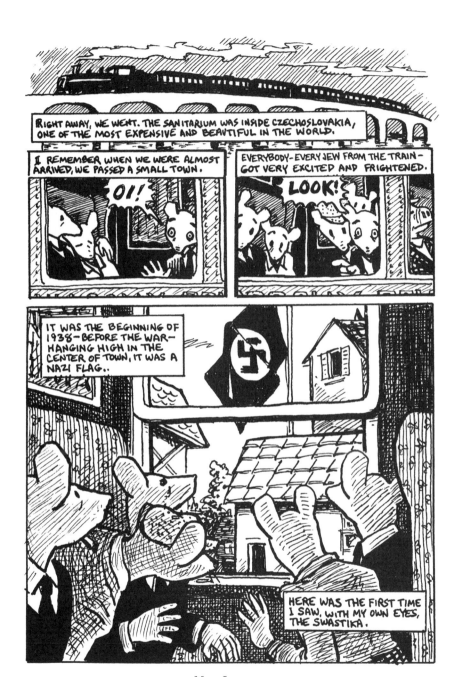

Maus I, page 32

closer perspective outside one train car, and only at last look out from inside the car containing them to see the Nazi flag, experiencing the reason for their shock as well as that shock itself as we do so.

Finally, Spiegelman uses actual photographs of his dead brother, Richieu, himself and his mother, and his father in souvenir concentration camp uniform, and intersperses them in the text with drawn photographs. The real photos give autobiographical authenticity and even nostalgia to the narrative by forcing us, with a mild sense of shock, to step outside of it completely and to acknowledge the main characters' real, human (rather than mouse) faces. These genuine photographs say that this story, like the Holocaust itself, actually happened; that this is autobiography, not fiction. Moreover, like other family photographs, they add nostalgia to the story, particularly when in "Prisoner on the Hell Planet," in *Maus I*, we juxtapose Art's timeless photographic happiness as a boy next to Anja at Trojan Lake, New York, with the relentless sequence of black-and-white drawings depicting her suicide and its aftermath.

The drawn photos of dead or dispersed family members on pages 114–116 of *Maus II* fit the black-and-white style of the usual *Maus* panels. But Spiegelman's device of superimposing them on and interspersing with usual panels showing Art and Vladek talking makes them dominate these panels. Art and Vladek alike will be ruled by these photos that flutter across the page and lie on the floor like dead leaves, finally burying the present (113). The survivors are buried under the weight of the past, and the suggestion of leaves implies that the survivors will not, finally, survive, and will be reduced to dead leaves and old, faded photos themselves in the end. In a subtle visual lead-in, Spiegelman hints that these photos, superimposed at odd angles on the usual square panels, will follow when on page 110 one panel seems to shake loose because of the artillery explosion it depicts.

Spiegelman's verbal devices are equally varied and complex, and include the realistic use of dialogue and dialect, the combination of dialogue and Vladek's commentary on the action, comic book sound indications, "black" humor, and terse, poetic comment.

On pages 28–34 of the Auschwitz episode in *Maus II*, we see many of these verbal devices juxtaposed with the visuals to create subtle effects and implications. When a priest incarcerated at Auschwitz

asks him why he is crying, Vladek answers "Should I be happy? Am I at a carnival?" (28). The priest goes on to interpret Vladek's camp tattoo in a numerological way that "proves" that Vladek will survive. Art and Vladek both scrutinize the tattoo in the present to ascertain that it does indeed add up to the number "18," which stands for "life" in Hebrew, and that it does contain other lucky numbers seen by the priest. The black humor here is not only contained in Vladek's sarcastic remark about a carnival, but in the fact that the priest is performing, albeit for free, a carnival act, the interpretation of lucky numbers on Vladek's arm.

This theme of numerological luck is raised to a higher power a few pages later. Vladek, right after narrating his life at Auschwitz, jerks Art into the Pines Hotel, where Vladek frequently goes to act like a guest and to receive guest services for free. Vladek recounts that once he won a bingo game but could not collect any winnings because they send the prize to one's room, and he didn't have one. But "Behind me sat a young lady what got so disappointed that she lost—she had just one number away . . . So I gave to her my card and said: 'I don't care for such prizes—You go up to be the winner.' . . . Was she happy." As he speaks this mundane, broken but warm English, we see Vladek's tattoo, the number of which the priest at Auschwitz called lucky (37). The lesson that seems to come through the juxtaposed and jumbled words and pictures of this entire incident is that Vladek's life has been like bingo, with his salvation depending largely on chance.

But was it? Earlier, as a Polish prisoner of war, he has been called a *Ro-eh Hanoled*, or seer, by a rabbi because in a dream he correctly saw the day of his release (*Maus I*, 60). During that incident, the Hebrew prayer "How goodly are your tents O Jacob, your dwelling, O Israel" is ironically set into a panel showing the praying mice in miserable prisoner-of-war tents. Is there a God, and does that God mock men or help them?

If there is a God, was He present during the Holocaust? While talking about Auschwitz, Vladek comments tersely, "But here God didn't come. We were all on our own" (*Maus II*, 29). Rendered in Vladek's usual matter-of-fact manner, this comment is probably the starkest statement in all of *Maus*, recalling Dante's "Abandon hope, all ye who enter here." Yet the fact is that Vladek has survived, and

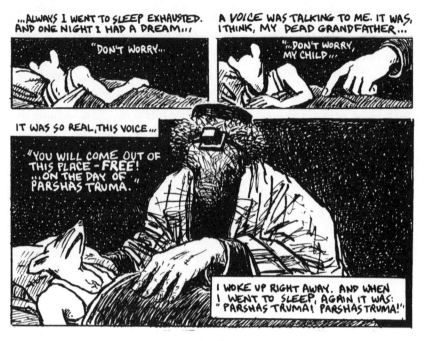

From *Maus I*, page 57

the message that there is something supernatural about this has been delivered on two separate occasions by a rabbi and a priest.

The seriousness of Spiegelman's material, including Vladek's stark narration rendered in broken English, and the sobering pictures of his tattoo and of the many unspeakable brutalities in the book, is made even more striking by Spiegelman's use of comic book sound effects. On page 59 of *Maus II*, the use of such effects to render the mortal fear of a man awaiting death, "AAWOOWWAH!," brings out in one word the complete contrast between the brash American comic book and what Spiegelman is doing in *Maus*. This sound comes back to haunt Vladek and therefore the reader on page 74 of the same volume, when Vladek moans in his sleep, possibly remembering this incident in his dreams. This is yet another juxtaposition, pages apart, that has the effect of a discordant musical motif.

Similarly, Spiegelman ends each section of volume II with an understated but ironic and unpleasant verbal and visual commentary on what has come before in that section. In "Auschwitz (Time Flies)" we are told that Zyklon-B was a pesticide. At the end of the section,

Art unthinkingly kills a bug with a pesticide as Françoise comments that "It's so peaceful here at night. It's almost impossible to believe Auschwitz ever happened" (*Maus II*, 74). The implication is that Jews were killed as unthinkingly as Art kills bugs, but there is also the hint that Art himself is capable of unthinking extermination. There are also verbal and visual puns involved here: the chapter subheading, "Time Flies," reminds us of death and decay as we see flies buzzing on page 41 around the dead mouse bodies near Art's drawing table. The presence of these imagined bodies from the past reveals that time never flies as long as memory functions.

Also, Vladek calls Kellogg's Special K cereal "poison" (*Maus II*, 78), setting up another juxtaposition between the present, in which even Vladek uses words unthinkingly, and the genuine Zyklon-B poison of the past. In another section, Art unthinkingly uses the Americanism "I'm starving" to describe his hunger for one meal, and this is juxtaposed with Vladek's tale of real hunger. On page 35, Vladek describes how guards would make prisoners chase their own hats and then shoot them for allegedly attempting to escape, and the panels show this happening. On the same page, he describes himself as looking like a "BIG SHOT" because of the protection offered him by a kapo. Perhaps Spiegelman's most effective visual/verbal juxtaposition is forcing these ironic double meanings out of innocuous, everyday expressions, which forever lose their innocence for the reader of *Maus*.

5. The Potential Influence of *Maus*

There have been some important mice in comic book history—Jerry of Tom and Jerry; Mighty Mouse; and of course, Mickey. Then there are Kafka's "Josephine the Singer, or the Mouse Folk," Steinbeck's *Of Mice and Men*, and the film *The Mouse That Roared*. More recently, and possibly influenced by *Maus* itself, we have the Steven Spielberg–produced *An American Tail* and *Fievel Goes West*. These mice always win against the cats. Spiegelman's mice don't really win—but then they're not really mice, either.

In two major ways, however, Art and Vladek, at least, have triumphed: Vladek has lived and Art has told Vladek's tale. By exploiting the magical power of juxtaposition inherent in sequential art, Spiegel-

man has conflated the past and present, modern America and Second World War Europe, and has succeeded in making the Holocaust a permanent part of the contemporary reader's historical memory.

Maus is a masterpiece because, in it, highly significant content is being expressed in a new form. As Judith O'Sullivan writes, *Maus* "was to forever transform the nature of the comics" (136). Spiegelman has destroyed all assumptions about what can and cannot be done with sequential art; indeed, because of his masterly use of his personal history and the visual and verbal devices that comprise *Maus*, it may become one of the predominant artistic (as opposed to archival) experiences through which the Holocaust will be remembered. In the words of Wallace Stevens, "Death is the mother of beauty," and as Yeats said of the Irish rebellion of 1916, "A terrible beauty is born." In Spiegelman's *Maus*, the Holocaust has given birth to a new form of art that will help insure that it is never forgotten.

(1993)

PROBLEMS OF REPRESENTATION

My Travels with *Maus*, 1992–2020

MARIANNE HIRSCH

Beginnings[1]

had begun to teach Art Spiegelman's *Maus* in 1987. I was not teach-
ing it in a course on the Holocaust—that would come later—but I
thought it the perfect work to use in an introductory Comparative
Literature course and in my first-year seminars. In fact, I soon found
myself teaching *Maus* every year, no matter what I was teaching.
Spiegelman's foregrounding of the structures of mediation and repre-
sentation was enormously useful pedagogically. But there was some-
thing else that drew me in as well: Artie's persona, the son who did
not live through the war but whose life, whose very self, was shaped by
it. I identified with him profoundly, without fully realizing what that
meant. In class, I was focusing on aesthetic and narratological ques-
tions of representation and I was also interested in discussing the gen-
der issues in *Maus*, the way it was structured as a transaction between
men who were mourning the wife and mother who had committed
suicide, whose diaries had been burned and whose voice would never
be heard.

How is trauma transmitted across generations? I began to wonder.
How is it remembered by those who did not live it or know it in their
own bodies? This is the story of Spiegelman's Artie. In some ways, I
began to acknowledge, it is my story as well.

In 1991, Art Spiegelman's *Maus II* appeared. In the midst of the
drawings of mice and cats there were two photographs of people, one

of his lost brother, Richieu, on the dedication page, the other of his
father, Vladek, at the end. With the photograph of his mother, Anja,
and himself as a young boy in the first volume, Spiegelman had allowed
photography to reconstitute his nuclear family, a family destroyed by
the Holocaust and its traumatic aftereffects. An analysis of the use of
photographs in the graphic pages of *Maus* became the first chapter
of my book *Family Frames*, my book on family photographs, and the
inspiration for the idea of postmemory.

Mourning and Postmemory[2]

All photographs are *memento mori*.
—SUSAN SONTAG

All such things of the war, I tried to put out from my mind once for
all . . . until you rebuild me all this from your questions.
—ART SPIEGELMAN

In order to represent himself completely, the son must represent his
mother, his other, without omitting a word.
—NANCY K. MILLER

Family Pictures

When my parents and I immigrated to the United States in the early
1960s, we rented our first apartment in Providence, Rhode Island, from
the Jakubowiczs, a Polish- and Yiddish-speaking family of Ausch-
witz survivors. Although we shared their hard-earned duplex for four
years, I felt I never came to know this tired elderly couple nor their
pale and otherworldly daughter, Chana, who was only ten, though her
parents were in their late fifties. We might have been neighbors in dis-
tant Eastern Europe—Poland and Rumania did not seem so far apart
from the vantage point of Providence—and were neighbors on Sum-
mit Avenue, but worlds separated us. They were Orthodox Jews and
kept kosher; they would not even drink a glass of water in our house.
We were eager to furnish our first American apartment with the lat-
est in what we considered modern and cosmopolitan—Danish walnut

furniture and tasteful Rya rugs—while their flat, with its haphazard mixture of secondhand furniture and Sears Formica, topped with doilies and fringes, had a distinct old-world look about it. Of course I was simultaneously fascinated and repulsed by the numbers tattooed on their pale arms, and could not stop asking my mother for details of their survival in Auschwitz, the loss of their spouses and children, how they met each other after the liberation, how they decided to marry, to have Chana, to start a new life all on the traces of such inconceivable pain and loss. I well remember going to their apartment and staring at the few framed photos on a small, round doily-covered living room table. These were pictures of Mr. and Mrs. Jakubowicz's first families—Mrs. Jakubowicz, her first husband and three sons, Mr. Jakubowicz, his first wife and three daughters. I can't remember these photos visually—in my memory they have acquired a generic status of old-looking studio family portraits. Perhaps one was a wedding photo, others might have depicted the parents and children. I just don't know anymore. But there was something distinctly discomforting about them which made me both want to keep staring at them and to look away, to get away from them. What I most remember is how unrecognizable Mr. and Mrs. Jakubowicz seemed in the photos, and how hard I thought it must be for Chana to live in the shadow of these legendary "siblings" whom she had already outlived in age, whom, because she never knew them, she could not mourn, whom her parents could never stop mourning. I thought that their ghostly presence might explain Chana's pallor, her hushed speech, her decidedly unchildlike behavior. I spent a lot of time wondering how these photos had survived. Had the Jakubowiczs left them with Polish neighbors or friends? Had they perhaps mailed them to family abroad? Had they been able to keep them through their time in Auschwitz, and, if so, how?

I had forgotten the Jakubowiczs and their photos until I saw another photo that seemed to me, as much as those, to be hovering between life and death—a photo of Frieda Wolfinger, my husband, Leo's, aunt, a survivor of the Riga ghetto and concentration camp. Rose, my mother-in-law, who had survived the war as a refugee in Bolivia, had this picture in her collection, and later we found another copy among the photos of another aunt, Käthe, who had survived the war in England. In one of his most vivid childhood memories,

Leo recalls the moment—in 1945—when this photo arrived in a letter announcing Frieda's survival and detailing the death of the rest of her family. I can picture the family sitting around their kitchen table in La Paz, reading Frieda's letter, crying and studying the picture which had crossed the ocean as proof of life and continuity. I can picture Käthe receiving the identical picture in England at nearly the identical moment, and I can imagine her relief to see Frieda, at least, alive. How many copies of the picture did Frieda have printed, I wonder, and to how many relatives did she send it? And how could those relatives just get up from their kitchen tables, how could they integrate into their lives Frieda's image and the knowledge it brought?

I am fascinated with this multiple dissemination of the same image, by the weight of its message in relation to its own unassuming character. There is nothing in the picture that indicates its connection to the Holocaust: Frieda does not look emaciated or death-like. On the contrary, she looks very much alive and "normal." She is firmly situated in an ordinary domestic setting—seated on a bench in front of a pretty house surrounded by flowering trees, she is holding a newspaper and smiling, a bit sadly it seems to me, at the camera. Alone, she seems to be asking something of the onlooker, beckoning to be recognized, to be helped perhaps, although, at the same time, she wears a distinctly self-sufficient expression. Her posture articulates some of these contradictions: her body is twisted in on itself, uncomfortable at the edge of the seat. For me, this picture has become an emblem of the survivor who is at once set apart from the normalcy of postwar life and who eagerly awaits to rejoin it: in the picture, Frieda remains outside the garden fence, she seems to inhabit neither house nor garden. She is the survivor who announces that she has literally "survived," lived too long, outlived her intended destruction. She is the survivor who has a story to tell, but who has neither the time to do so in the instant of the photograph, nor the audience to receive it.

Holocaust Photographs

As much as the pictures in the Jakubowicz living room represented death for me, so Frieda's picture says "I am alive," or perhaps, "I have survived"—a message so simple and, at the same time, so overlaid with meaning, that it seems to beg for a narrative and for a listener, for a

survivor's tale. Theorists of photography have often pointed out this simultaneous presence of death and life in the photograph: "Photographs state the innocence, the vulnerability of lives heading toward their own destruction and this link between photography and death haunts all photos of people," says Susan Sontag in *On Photography*.[3] Roland Barthes agrees but points out the reverse as well when he connects photography to life: "The photograph is literally an emanation of the referent," he says, "light, though impalpable, is here a carnal medium, a skin I share with anyone who has been photographed."[4]

But it is precisely the indexical nature of the photo, its status as relic, or trace, or fetish—its "direct" connection with the material presence of the photographed person—that at once intensifies its status as harbinger of death and, at the same time and concomitantly, its capacity to signify life. With the image of the umbilical cord, Barthes connects photography not just to life, but to life-giving, to maternity. Life is the presence of the object before the camera and the "carnal medium" of light which produces its image; death is the "having-been-there" of the object—the radical break, the finality introduced by the past tense. For Barthes, it is the mother's death and the son's desire to bring her back. The "ça a été" of the photograph creates the scene of mourning shared by those who are left to look at the picture. More than memory is at stake here: Barthes insists that "the photograph does not call up the past"; photography, he implies, does not facilitate the work of mourning.[5] Going further, Marguerite Duras writes that "photographs promote forgetting. . . . It's a confirmation of death" and Barthes agrees: "not only is the photograph never, in essence a memory . . . but it blocks memory, quickly becomes a counter-memory."[6] Photography's relation to loss and death is not to mediate the process of individual and collective memory but to bring the past back in the form of a ghostly revenant, emphasizing, at the same time, its immutable and irreversible pastness and irretrievability.

Sontag elaborates on what she calls the photograph's "posthumous irony," describing Roman Vishniac's pictures of the vanished world of Eastern European Jewish life which are particularly affecting, she argues, because as we look at them we know how soon these people are going to die.[7] We also know, I would add, that they will all die (have all died), that their world will be (has been) destroyed, and that the

future's (our) only access to it will be (is) through those pictures and through the stories they have left behind. The Holocaust photograph is uniquely able to bring out this particular capacity of photographs to hover between life and death, to capture only that which no longer exists, to suggest both the desire and the necessity and, at the same time, the difficulty, the impossibility, of mourning.

In the broad category of "Holocaust photograph," I include the Jakubowiczs' family portraits, Frieda's picture, Roman Vishniac's pictures of Jewish shtetl life as well as the many pictures of atrocities from the concentration and extermination camps that have come down to us. I include those pictures which are connected for us to total death and to public mourning—pictures of horror and also ordinary snapshots and portraits, family pictures connected to the Holocaust by their context and not by their content. I recognize, of course, that there are differences between the picture of Frieda and the documentary images of mass graves, especially in the work of reading that they require. Confronted with the latter image, we respond with horror, even before reading the caption or knowing its context. The context, then, increases the horror as we add to the bodies, or the hair, or the shoes depicted, all those others we know about but which are not in the picture. Confronted with the former image—the portrait or family picture—we need to know its context, but then, I would argue, we respond with a similar sense of disbelief.

These two photographs are complementary: it is precisely the displacement of the bodies depicted in the pictures of horror from their domestic settings, along with their disfigurement, that brings home the enormity of Holocaust destruction. And it is precisely the utter conventionality of the domestic family picture that makes it impossible for us to comprehend how the person in the picture was, or could have been, annihilated. In both cases, the viewer fills in what the picture leaves out: the horror of looking is not necessarily in the image but in the story the viewer provides to fill in what has been omitted. For each image we provide the other complementary one. "There was no stone that marked their passage," says Helen Epstein about her deceased relatives. "All that was left were the fading photographs that my father kept in a yellow envelope underneath his desk. Those photographs were not the usual kind of snapshots displayed in albums and

shown to strangers. They were documents, evidence of our part in a history so powerful that whenever I tried to read about it in the books my father gave me or see it in the films he took me to, I could not take it in."[8]

Epstein's statement defines the process of reading the Holocaust photograph: looking at the family pictures, placing them in context through reading and seeing films, being unable to understand or to name that context—note how Epstein repeats the indeterminate "it." Epstein's inability "to take *it* in" is perhaps the distinguishing feature of the Holocaust photograph.

I started thinking about the connection between the Jakubowiczs' family pictures and the photograph Frieda sent to her relatives— pictures I saw twenty-five years apart—when I read *Maus II*, the second volume of Art Spiegelman's controversial cartoon representation of his father, Vladek's, survival in Auschwitz. Volume I of *Maus* contained one photograph of Art Spiegelman and his mother which, emerging among the drawings of mice and cats, I had found particularly moving. But *Maus II* complicates the levels of representation and mediation of its predecessor. The photo on the first page, of Artie's dead brother, Richieu, and, on the last page, the picture of the survivor Vladek Spiegelman in a starched camp uniform, came to focus for me the oscillation between life and death that defines the photograph. These photographs connect the two levels of Spiegelman's text, the past and the present, the story of the father and the story of the son, because these family photographs are documents both of memory (the survivor's) and of "postmemory" (that of the child of survivors). As such, the photographs included in the text of *Maus*, and, through them, *Maus* itself, become sites of remembrance, what Pierre Nora has termed *lieux de mémoire*. "Created by a play of memory and history," *lieux de mémoire* are "mixed, hybrid, mutant, bound intimately with life and death, with time and eternity, enveloped in a Möbius strip of the collective and the individual, the sacred and the profane, the immutable and the mobile." Invested with "a symbolic aura" *lieux de mémoire* can function to "block the work of forgetting."[9]

Although I find Nora's reified distinction between history and memory and its organistic distinctions between life and death troubling, his notion of *lieux de mémoire* does usefully describe the status

with which Holocaust photographs are often invested. The spatiality of memory mapped onto its temporality, its visual combined with its verbal dimension, makes memory, as W. J. T. Mitchell suggests, in itself an "imagetext, a double-coded system of mental storage and retrieval."[10]

Images and narratives thus constitute its instruments and its very medium, extending well into subsequent generations. Photographs, ghostly revenants, are very particular instruments of remembrance, since they are perched at the edge between memory and postmemory, and also, though differently, between memory and forgetting.

I propose the term "postmemory" with some hesitation, conscious that the prefix "post" could imply that we are beyond memory and therefore perhaps, as Nora fears, purely in history. In my reading, postmemory is distinguished from memory by generational distance and from history by deep personal connection. Postmemory is a powerful and very particular form of memory precisely because its connection to its object or source is mediated not through recollection but through an imaginative investment and creation. This is not to say that memory itself is unmediated, but that it is more directly connected to the past. Postmemory characterizes the experience of those who grow up dominated by narratives that preceded their birth, whose own belated stories are evacuated by the stories of the previous generation shaped by traumatic events that can be neither understood nor re-created. I have developed this notion in relation to children of Holocaust survivors, but I believe it may usefully describe other second-generation memories of cultural or collective traumatic events and experiences.[11]

I prefer the term "postmemory" to "absent memory," or "hole of memory," also derived in Nadine Fresco's illuminating work with children of survivors.[12] Postmemory—often obsessive and relentless—need not be absent or evacuated: it is as full and as empty, certainly as constructed, as memory itself. My notion of postmemory is certainly connected to Henri Raczymow's *mémoire trouée,* his "memory shot through with holes," defining also the indirect and fragmentary nature of second-generation memory.[13]

Photographs in their enduring "umbilical" connection to life are precisely the medium connecting first- and second-generation remem-

brance, memory and postmemory. They are the leftovers, the fragmentary sources and building blocks, shot through with holes, of the work of postmemory. They affirm the past's existence and, in their flat two-dimensionality, they signal its unbridgeable distance.

Like all pictures, the photos in *Maus* represent what no longer is. But they also represent what has been and, in this case, what has been violently destroyed. And they represent the life that was no longer to be and that, against all odds, nevertheless continues to be. If anything throws this contradictory and ultimately unassimilable dimension of photography—perched between life and death—into full relief, it has to be the possibility, the reality, of survival in the face of the complete annihilation that is the Holocaust. Holocaust photographs, as much as their subjects, are themselves stubborn survivors of the intended destruction of an entire culture, its people as well as all their records, documents, and cultural artifacts.[14]

The photographs in *Maus* are indeed defined by their inclusion in Spiegelman's very particular imagetext, his provocative generic choice of an animal fable comic book to represent his father's story of survival and his own life as a child of survivors. If Holocaust representation has been determined by Theodor Adorno's suggestion in his 1949 essay "After Auschwitz," that "after Auschwitz you could no longer write poems," then what can we say of Spiegelman's comics and of the photographs embedded in them?[15]

Despite his own careful reconsideration and restatement, Adorno's radical suspicion has haunted writing for the last fifty years. One of its consequences has been the effort to distinguish between the documentary and the aesthetic. Most theoretical writing about Holocaust representation, whether historical or literary, by necessity debates questions such as truth and fact, reference and representation, realism and modernism, history and fiction, ethics and politics—questions that may seem dated in theoretical thought, but that revisionist histories have brought to the fore with great urgency. Peter Haidu summarized this preoccupation: "Our grasp of the Event must inevitably be mediated by representations, with their baggage of indeterminacy. But this is a context in which theory is forced to reckon with reference—as unsatisfactory as contemporary accounts of reference may be—as a necessary function of language and all forms of representation."[16]

The consequent validation of the documentary makes the archival photograph—along with the spoken survivor testimony—an especially powerful medium, due to their incontrovertible connection to reference. Julia Kristeva has even argued that film is the "supreme art of the apocalyptic" and that the profusion of visual images in which we have been immersed since the Holocaust in their extraordinary power to evoke its horror, has silenced us verbally, impairing the symbolic instruments that might have enabled us to process the apocalyptic events of our century: "For these monstrous and painful spectacles disturb our mechanisms of perception and representation. Our symbolic modes are emptied, petrified, nearly annihilated, as if they were overwhelmed or destroyed by an all too powerful force. . . . That new apocalyptic rhetoric has been realized in two extremes, which seem to be opposites but which often complement each other: the profusion of images and the withholding of the word."[17]

John E. Frohnmayer, former chairman of the National Endowment of the Arts, goes farther than Kristeva in endowing all documentary visual representation with awesome power. He has claimed, for example, that Holocaust photographs are so upsetting that their public display needs to be strictly controlled: "Likewise, a photograph, for example of Holocaust victims, might be inappropriate for display in the entrance of a museum where all would have to confront it, whether they chose to or not, but would be appropriate in a show which was properly labeled and hung so that only those who chose to confront the photographs would be required to do so."[18]

To Frohnmayer, documentary images are a form of evidence. They affirm the "having-been-there" of the victim and the victimizer, of the horror. They remove doubt, they can be held up as proof to the revisionists. In contrast, the aesthetic is said to introduce agency, control, structure and, therefore, distance from the real, a distance which might leave space for doubt. Art Spiegelman seems to confirm such a distinction when, contrary to his earlier ambition to write the "Great American Comic Book Novel," he subsequently insisted that *Maus* be classified as "nonfiction."[19]

But some have questioned this distinction between the documentary and the aesthetic highlighting the aestheticizing tendencies

present in all visual representation and therefore presumably its diminished power truly to represent horror. Christina von Braun, for example, decries the way in which the image—the image in general—can "transform horror into the aesthetic," suggesting that "film and the photograph have inserted themselves like a protective barrier between us and the real" becoming what she has aptly termed a "photo morgana."[20]

The immobilizing quality of the still photograph—its death-like fixing of one moment in time—clearly contributes to this perceived incapacity of the photo to maintain its initial power. After looking repeatedly at any image, the viewer builds up sufficient psychological resistance so as to become desensitized, just in order to survive the horror of looking. In von Braun's reading, this would be as true of a picture of atrocities as of the family picture of a child who later died in the gas chambers. For her, the photograph—in itself—can no more evoke horror than it can promote memory or facilitate the work of mourning. In contrast, Spiegelman's text maintains the photographs' visual power through their sparse use and through their placement.

By placing three photographs into his graphic narrative, Art Spiegelman raises not only the question of how, forty years after Adorno's dictum, the Holocaust can be represented, but also how different media—comics, photographs, narrative, testimony—can interact with each other to produce a more permeable and multiple text that may recast the problematics of Holocaust representation and definitively eradicate any clear-cut distinction between documentary and aesthetic.[21] In moving us from documentary photographs—perhaps the most referential representational medium—to cartoon drawings of mice and cats, Spiegelman lays bare the levels of mediation that underlie all visual representational forms. But confronting these visual media with his father's spoken testimony adds yet another axis to the oppositions between documentary and aesthetic, on the one hand, testimony and fiction, on the other. Considering these two axes in relation to one another might enable us to come back to the Holocaust photo—and, through it, to photography more generally—and to look at its particular articulation of life and death, representation and mourning.

A Survivor's Tale

Maus, the title Spiegelman has chosen for his "survivor's tale," illustrates well the interplay between those visual and aural codes that structure his text. *Maus* sounds like the English word "mouse" but its German spelling echoes visually the recurring Nazi command "Juden raus" ("Jews out"—come out or get out) as well as the first three letters of "Auschwitz"—a word that in itself has become an icon of the Holocaust. Spiegelman reinforces this association when, in the second volume, he refers to the camp as "Mauschwitz" and boldly entitles the first chapter: "From Mauschwitz to the Catskills and Beyond." Similarly, the subtitle of volume I plays with the visual and aural dimensions of the word "tale"—when we see it, we know it means "story" but when we hear it after hearing "mouse" we might think that it is spelled t-a-i-l. Furthermore, on the cover and title imprint, the author includes his own name without capitals thereby making himself a visual construct able to bring out the tensions between aesthetic and documentary, figural and mimetic: "art," on the one hand, and "Spiegelman" or "mirror-man," on the other. Spiegelman's audacious visual/verbal punning not only lays bare the self-consciousness of his textual production—a self-reflexivity that disarmingly pervades his text—it also defines from the beginning the two primary elements of his representational choices, the visual and the aural. These work together in the text in complex interaction.

On one level, *Maus* tells the story of Spiegelman's father, Vladek, from the 1930s in Poland to his liberation from Auschwitz in 1945; on another level, *Maus* recounts the story of father and son in 1980s Queens and the Catskills, the story of the father's testimony and the son's attempt to transmit that testimony in the comics genre which has become his profession, and the story of Art Spiegelman's own life dominated by memories which are not his own. When Art visits Vladek at his home, in his workshop, or on his vacations, as they sit, or walk, or work, or argue, Vladek talks into a tape recorder and Art asks him questions, follows up on details, demands more minute descriptions. The testimony is contained in Vladek's voice, but we receive both more and less than that voice: we receive Art's graphic interpretation of Vladek's narrative. This is a "survivor's

tale"—a testimony—mediated by the survivor's child through his idio-syncratic representational and aesthetic choices.[22]

And these choices are based on an almost obsessive desire for accu-racy and, at the same time, clearly abandon (or refigure) that desire by choosing to set the story in an animal fable. On the one hand, then, the tape recorder captures Vladek's story as he tells it, and the text gives us the impression that Art has transcribed the testimony verbatim, getting the accent, the rhythm, the intonation just right. On the other hand, he has not provided the visual counterpart of the tape recorder—the camera. Instead, he has drawn the Jews as mice, the Poles as pigs, the Germans as cats, the French as frogs, the Americans as dogs, the Roma as spongy moths (formerly called gypsy moths). While in the visual realm, Spiegelman chooses multiple mediations, in the aural, by contrast, he seems to seek absolute unmediated authenticity. But the three family photos that are reproduced in the text complicate consid-erably this apparent disjunction between the visual and aural dimen-sions of Spiegelman's imagetext.[23]

At first glance, Spiegelman's animal fable is a literalization of Hit-ler's line which serves as its epigram: "The Jews are undoubtedly a race, but they are not human." If indeed, Jews are not human, Spiegel-man seems to ask, what are they, and, more importantly, what are the Germans? In response, he draws schematic mice and cat heads resting on human-looking bodies. But these are mice and cats who perceive themselves as human, who in all respects except one—their heads—are human. When Anja Spiegelman discovers a rat in the basement where she is hiding she is terrified, and Art is amused when he finds a framed photo of a pet cat on the desk of his survivor psychiatrist. On the one hand, Spiegelman would like to make it clear throughout his books that his representational choices are just that—choices—and that iden-tities are assumed rather than given. When Vladek gets out of hiding to walk through Sosnowiec, he wears a pig mask, trying to pass for Polish. Some children call him a Jew but the adults believe the mask and apologize. Art has trouble deciding how to draw his French wife—should she be a frog because she is French, or a mouse because she con-verted to Judaism? On the other hand, however, Spiegelman seems to come close to duplicating the Nazis' racist refusal of the possibility of assimilation or cultural integration when he represents different

nationalities as different animal species. But in the second volume these oppositions blur as Art often represents himself not as a mouse but as a human wearing a mouse mask. Eventually, as he starts to draw and gets into his father's story, the mouse head becomes his own head. If Jews are mice and Germans are cats, then, they seem to be so not immutably but only in relation to each other and in relation to the Holocaust and its memory. They are human except for the predator/victim relationships between them. Yet Art and Françoise's Vermont friends are dogs, even in the 1980s. Obviously, Spiegelman's reflections on "race," ethnicity, and nationality, as essential (natural) or as socially and ideologically constructed contain a number of contradictions and incongruities, and during the years of the two books' production, they have evolved. That evolution can be traced by the differences between his original self-portrait and the one he adopted upon the publication of *Maus II*. In *Maus I*, the cartoonist is a hybrid creature, with a schematically drawn man's body and a mouse head, a lonely artist at his drawing table, with his back to the viewer. In the second, the artist is a more fully drawn cartoon man wearing over his own head a large mouse mask which he anxiously holds in his hands as, facing out, he contemplates his work. No longer isolated, he is surrounded both by the world of his imagination (a Nazi guard is shooting outside his window) and of his craft (a picture of *RAW* and the cover of *Maus* are on the wall). For him to enter his book has become more problematic and overlaid, the access to his mouse identity more mediated. Spiegelman's animal fable is both more and less than an analysis of national and ethnic relations: it is his aesthetic strategy, his affirmation of identity as construction.

At the same time, readers and viewers raised on Mickey Mouse, Tom and Jerry, and, Spiegelman's favorite, *Mad* magazine, quickly accept the convention of the animal fable and learn to discern subtle facial and bodily expressions among the characters of *Maus* even though the figures' faces rarely vary. Even the breaks in illusion that multiply in *Maus II* do not interfere. We appreciate Art's self-consciousness, his questions about the validity of his enterprise and his capacity to carry it out, and we sympathize with his discomfort at the success of *Maus*. Art, drawn as a mouse, or wearing his mouse mask, is a figure to whom we have become accustomed. Even the incongruity, the uneasy

fit, between the characters' heads and their bodies, the book's confusions about the nature of racial and ethnic difference, the monumental and pervasive dissonance between the past and present levels of the narrative (Vladek describing his deportation while riding his exercise bicycle in Queens, for example) all ultimately come to be normalized, even erased, in the reading process.

The truly shocking and disturbing breaks in the visual narrative—the points that fail to blend in—are the section called "Prisoner on the Hell Planet" in *Maus* in which an actual photograph appears, and the two photos in *Maus II*. These three moments protrude from the narrative like unassimilated and unassimilable memories. The "Prisoner" section stands out powerfully not only because of the picture of mother and son, but also because of its different drawing style and the black-bordered pages which disturb the otherwise uniformly white edging of the closed book. In *Maus II*, Spiegelman sets off the two photos through contrast: they emerge through their difference not only from the narrative itself, but also from several pages where "photographs"— schematic representations of framed mice—are shown and discussed by Vladek: "Anja's parents, the grandparents, her big sister Tosha, little Bibi and our Richieu . . . All what is left, it's the photos" (*Maus II*, 113–116). They emerge also in contrast to the lack of photos: Vladek, deploring the absent photos of his own side of the family, sadly stands in for them, filling up an entire page with his own body: "It's nothing left, not even a snapshot" (*Maus II*, 116). When we get to the actual photographs of Richieu and Vladek they break out of the framework of Spiegelman's book as much as the black pages of the "Prisoner" section did and thus they bring into relief a tension that is present on every level of the text.

"Breaking the framework" is a term Shoshana Felman uses in her book, with Dori Laub, on *Testimony*, where she recounts how in a course on the literature of testimony, the screening of videotaped interviews with Holocaust survivors broke "the very framework of the class" just as all the writers of testimony ended up breaking through the framework of the books they had initially set out to write.[24]

Felman sees what she calls this "dissonance" as essential to her pedagogical experience in the age of testimony. "Breaking through the framework" is a form of "dissonance": visual and verbal images are

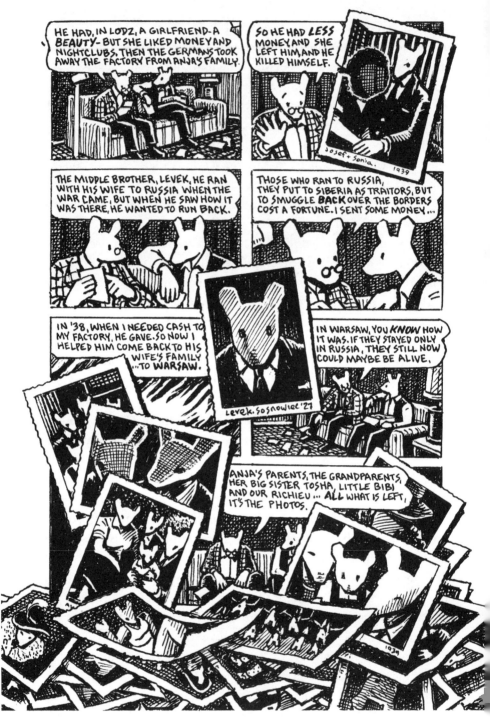

Page 115 of *Maus II*. See sketch of this page on page 245.

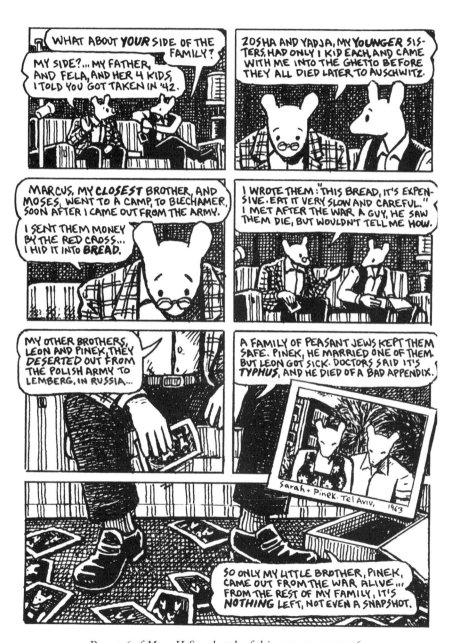

Page 116 of *Maus II*. See sketch of this page on page 246.

used to describe an incongruity necessary to any writing or teaching about the Holocaust. How are we to read the radical breaks in the representational continuity of *Maus*? How do Spiegelman's family pictures mediate his narrative of loss? What alternate story—in the margins of the central narrative of *Maus*—is told by the family pictures?

Breaking the Frame

Taken together, the three photographs in *Maus I* and *II* reassemble a family violently fractured and destroyed by the Shoah: they include, at different times, in different places and in different guises, all the Spiegelmans—Art and his mother, Art's brother, Richieu, and the father, Vladek. Sparsely distributed over the space of the two volumes, these three pictures tell their own narrative of loss, mourning and desire, one that inflects obliquely, that both supports and undercuts the story of *Maus*.

But these three images are not equal. The first, the picture of mother and son, has a unique generative power in his text, a power that comes from the "double dying" and the double survival in which it is embedded.[25] The photograph clarifies the importance of the mother's suicide twenty-three years after her liberation from Auschwitz in the story the father and son construct, reinforcing the work of memory and postmemory that generates their text.

The photograph of Artie and his mother, labeled "Trojan Lake, N.Y. 1958," introduces "Prisoner on the Hell Planet," the account of Anja Spiegelman's suicide. In the picture, the family is obviously vacationing—the ten-year-old Art is squatting in a field, smiling at the camera, and Anja is standing above him, wearing a bathing suit, one hand on his head, staring into space. Presumably the picture is taken by the invisible father, a conventional division of labor in 1950s family pictures. But the very next frame immediately announces the destruction of this interconnected family group: "In 1968, when I was 20, my mother killed herself. She left no note." Poignantly, Spiegelman juxtaposes the archival photograph with the message of death which, through the presence of the photo's "having-been-there," is strengthened, made even more unbearable. This echoes an earlier moment in the text when Art, holding his mother's photograph, tries to engage his father in the project of testimony: "Start with Mom" (*Maus I*, 12).

The drawings in the "Hell Planet" section are completely different from the rest of the volume: drawings of humans rather than mice and cats, they express grief, pain, and mourning in much more direct, melodramatic, expressionist fashion—tears running down faces, skulls, Vladek lying on top of the casket screaming "Anna." Art, dressed in the striped concentration camp uniform that has come down to him through his parents' stories, metaphorically equates his own confinement in his guilt and mourning with their imprisonment in the concentration camp. "Hell Planet" is both Auschwitz and Art's own psyche. "Left alone with [his] thoughts," Art connects "MENOPAUSAL DEPRESSION, HITLER DID IT!, MOMMY!, and BITCH"—memory is unbearable and, in his representational choices, Spiegelman tries to convey just how unbearable it is (*Maus I*, 103). "Hell Planet" demonstrates how immediately present their war memories have remained for Art and his parents in their subsequent life, and how unassimilated. But the grieving Art does not actually remember the concentration camp whose uniform he wears—mediated through his parents' memories, his is a postmemory. Art remains imprisoned in his camp uniform and in the black-bordered spaces of his psyche. Drawing *Maus*, it is implied, represents both his attempt to get deeper into his postmemory and to find a way out. In "Hell Planet" the two

From "Prisoner on the Hell Planet," 1972, which appears in *Maus I*

chronological levels of *Maus* merge and in this convergence between past and present, destruction and survival, primary and secondary trauma—incarnated by Anja's suicide—lies the root of Art's (perhaps temporary) insanity. But in this merging, this segment merely exacerbates what occurs at every level of *Maus*; Art's stay at the mental institution in "Hell Planet" is a more pronounced version of the insanity he lives through every day of his postmemory.

The other characters attest to the power of "Hell Planet"—Mala, Vladek's second wife, insists it is unlike other comics because it is "so personal" but "very accurate . . . objective" too. Vladek says he only read it because it contained Anja's picture and he says that he cried when he read it because it brought back memories of his wife (*Maus I*, 104). Vladek keeps his wife's memory alive through the pictures of her he has all over his desk which, as his second wife complains, is "like a shrine." The photo of mother and son sets the stage for the personal, as well as the objective, realistic and accurate—it legitimizes "Hell Planet" as a document of life and death, of death in life. In the photo, mother and son are connected by her hand which touches the top of his head; but the photo itself is, in Barthes's terms, a carnal medium, connecting all those who look at it (Art, Mala, and Vladek, as well as the reader of *Maus*) with the living Anja who stood in front of the camera in 1958, touching her son. In each case, hands become the media of interconnection: Anja places her hand on Art's head, a hand (presumably Art's) is holding the photo at an angle at the top of the page, and Art's hand is holding the pages of "Hell Planet" as they are represented in *Maus*. The reader's access to Anja and her story is multiply mediated by Art's hands and hers—his drawing hand which stands in stark contrast to her arm where the photograph does not reveal what, in another text, Spiegelman says she was always intent on hiding: her tattooed Auschwitz number.

Anja left no note—all that remains is her picture—her hand on Art's head, their visible bodily attachment, and his memories of her transformed into drawings. It is a picture modulated by other memories, such as the one in "Hell Planet" of Anja asking Artie, in the only speech of hers he remembers directly (the others are all reported by his father), whether he still loves her. He turns away, refuses to look at

her, "resentful of the way she tightened the umbilical cord," and says "sure, Ma!" In guilty recollection all Art can say is "Agh!" (*Maus I*, 103).

But *Maus* is dominated by this absence of Anja's voice, the destruction of her diaries, her missing note.[26] Anja is recollected by others, she remains a visual and not an aural presence. She speaks in sentences imagined by her son or recollected by her husband. In their memory she is mystified, objectified, shaped to the needs and desires of the one who remembers—whether it be Vladek or Art. Her actual voice could have been in the text, but it isn't: "These notebooks, and other really nice things of mother," Vladek explains to Art, ". . . One time I had a very bad day . . . and all of these things I destroyed." "You what?" Art exclaims. And Vladek replies: "After Anja died I had to make an order with everything . . . these papers had too many memories, so I burned them" (*Maus I*, 158–159). Vladek did not read the papers Anja left behind, he only knows that she said: "I wish my son, when he grows up, he will be interested by this" (*Maus I*, 159). Her legacy was destroyed and *Maus* itself can be seen as an attempt to reconstruct it, an attempt by father and son to provide the missing perspective of the mother. Much of the *Maus* text rests on her absence and the destruction of her papers, deriving from her silence its momentum and much of its energy. Through her picture and her missing voice Anja haunts the story told in both volumes, a ghostly presence shaping familial interaction—the personal and the collective story of death and survival.

"Prisoner on the Hell Planet" was initially published in an underground journal, and in *Maus* Art says he never intended for his father to see it. "Prisoner" is Art's own recollection, but *Maus* is the collaborative narrative of father and son: one provides most of the verbal narrative, the other the visual; one gives testimony while the other receives and transmits it. In the process of testimony they establish their own uneasy bonding. In his analysis of the process of testimony, the psychoanalyst Dori Laub says: "For lack of a better term, I will propose that there is a need for a tremendous libidinal investment in those interview situations: there is so much destruction recounted, so much death, so much loss, so much hopelessness, that there has to be an abundance of holding and of emotional investment in the encounter, to keep alive the witnessing narration."[27] Art and Vladek share one

monumental loss, Anja's, and on that basis, they build the "libidinal investment" demanded by the "witnessing narration" they undertake.

The absence of the mother, the masculine collaboration between father and son, are crucial to the power of *Maus* and the mother-son photograph, a record of a "double dying," reinforces this gendered narration.

Anja's role in their familial construction makes Art and Vladek's collaboration a process of masculine, Orphic creation, in the terms of Klaus Theweleit's *Buch der Könige*.[28] Art and Vladek do indeed sing an Orphic song—a song about the internal workings of a Hades which few have survived, and about which fewer even have been able to speak. In Theweleit's terms, Orphic creation—the birth of human art forms, social institutions, and technological inventions—results from just such a descent into and a reemergence from Hades: a masculine process facilitated by the encounter with the beautiful dead woman who may not herself come out or sing her own song. Orphic creation is thus an artificial "birth" produced by men: by male couples who can bypass the generativity of women, whose bonding depends on the tragic absence of women. In this process, women are relegated to the role of "media," of intermediaries; they are not the primary creators or witnesses. In *Maus*, father and son together attempt to reconstruct the missing story of the mother. They do not go to Mala, Vladek's second wife for assistance, even though she, too, is a survivor. Mala, in fact, is also disturbingly absent as a voice and even as a listener. When she tries once to tell parts of her own story of survival, Art interrupts her to go to check on his father. Her role is only to care for the aging Vladek and to put up with his litany of complaints. Moreover, Mala brings us face-to-face with the limitations of the book's fairy-tale mode, with its polarization of mice and cats, good guys and bad: her name "Mala" emphasizes her position as foil to the idealized deceased Anja and sets her up, at least symbolically, as the evil stepmother. And Art leaves her in that role even when he seems to consult with her about Vladek. Françoise, Art's French wife, is at best a sounding board, an enabling presence, for the confused cartoonist. In his acknowledgments, Spiegelman thanks both women for their roles as "media": Mala was his translator from Polish and Françoise his editor. Art's hostile comments about dating Jewish women complete the banishment of female

voices from his narrative and show that his story, in Orphic fashion, depends on female absence and death. Art and Vladek perform the collaboration of the creative male couple: the difficulties that structure their relationship only serve to strengthen the ties which bind them to each other and to the labor they have undertaken.

In the Orpheus story, Orpheus may not turn around to look at Eurydice's face. In "Hell Planet," Spiegelman draws Anja and even hands us her photograph—Anja's face and body, connected to the body of her son, is there for everyone to see. Seeing her photograph is a "memento mori"—a sign of the "having been," of Anja's onetime presence and of her subsequent, perpetual, and devastating absence. The photograph thus becomes the visual equivalent of the Orphic song which, through the intermediary of a cultural artifact—*Maus*—can bring Eurydice out of Hades, even as it actually needs to leave her behind. Thus the photograph—the product of both the aesthetic and the documentary/technological—signals this dual presence and absence, in Barthes's terms, this "anterior future of which death is the stake." It figures the son's desire for his mother, for her bodily presence, the touch of her hand and for her look of recognition.

This is no simple Orphic or Oedipal conflict echoing classical mythic patterns. Familial conflict based on gender and generation is there, but is refocused by those violent historical forces that have rewritten family plots in the twentieth century. Psychoanalytic and mythic paradigms need to be qualified by the extreme historical circumstances in which they take shape. Thus father and son transcend their roles when they become witness and listener; son and mother become historian and the object of historical quest. Brothers are divided by war and Holocaust, inhabitants of different worlds and of different families. The photographs included in *Maus*, reassembling a nuclear family violently fractured by circumstance, point both to the power of the familial mythos in the face of external threat, and to the powerlessness of the family as institution to act in any way as a protection. Just as these photographs are embedded, however uneasily, in the squares of Spiegelman's graphics, so the familial gaze of *Maus* is shaped by these overwhelming historical circumstances, encircling and refocusing the exchange of familial looks.

While "Prisoner on the Hell Planet" is the work of memory, *Maus*

itself is the creation of postmemory. In fact, that is the status of the two photographs in *Maus II*. The second volume carries two dedications: "For Richieu and for Nadja." Richieu is the brother Art never knew because he died during the war, before Art's birth; Nadja is Spiegelman's daughter. The volume is dedicated to two children, one dead, the other alive, one who is the object of postmemory, the other who will herself carry on her father's postmemory. Whose picture, in fact, illustrates the dedication page? I have assumed that it is Richieu's: a serious, about three-year-old child with parted hair, and wearing what looks like knit overalls. But upon reflection the picture is quite indeterminate. Could it be Nadja? Could it be a childhood image of Vladek, I wonder, noting the resemblance between the two pictures which frame *Maus II*? Or could it be Art himself? A few pages into *Maus II*, Art alludes to a photograph of his "ghost-brother" wondering if they would have gotten along: "He was mainly a large blurry photograph hanging in my parents' bedroom." Françoise is surprised: "I thought that was a picture of you, though it didn't look like you" (*Maus II*, 15). Based on appearance alone, the picture could be Art or Vladek or Nadja or Richieu and Spiegelman does not specify. But in terms of function, the picture in the bedroom and the one on the dedication page clearly has to be Richieu: "That's the point. They didn't need photos of me in their room . . . I was alive! The photo never threw tantrums or got in any kind of trouble . . . It was an ideal kid, and I was a pain in the ass . . . I couldn't compete" (*Maus II*, 15). This photograph signifies death and loss, even while, as a kind of "fetish object," it disavows loss. The parents keep it in their bedroom to live with; Art competes with it; and we take it as the ultimately unassimilable fact that it was a child who died unnaturally, before he had the chance to live. The child who could not survive to live his own life—especially in his equivalence with Art and Nadja—becomes the emblem of the incomprehensibility of Holocaust destruction. In her book *Children with a Star*, Debórah Dwork provides a chilling statistic: in Nazi-occupied Europe, only 11 percent of Jewish children survived the war years.[29]

Richieu was poisoned by the aunt who hid him so that he might be saved; she poisoned him so that he might not suffer in the death camps. Art reports, "After the war my parents traced down the vaguest rumors, and went to orphanages all over Europe. They couldn't

believe he was dead" (*Maus II*, 15). We cannot believe it either: the indeterminacy of the dedication photograph means that this child could be any of us. Because of its anonymity, this photograph, and many others like it, refers to the anonymity of the victims and corpses represented in photographs of concentration and extermination camps. At the end of the volume, Art becomes Richieu and Richieu takes on the role of listener and addressee of Vladek's testimony, a testimony addressed to the dead and the living: "So," Vladek says as he turns over in his bed, "let's stop, please, your tape recorder . . . I'm tired from talking, Richieu, and it's enough stories for now . . ." (*Maus II*, 136). Richieu is both a visual presence and a listener—and, as he and Art merge to transmit the tale, he is neither. The child's photograph, visible in other frames portraying Vladek's bedroom, itself becomes the ultimate witness to the survivor's tale. In this role, Richieu, or his photograph, confirms the interminable nature of the mourning in *Maus*, and the endlessness of Vladek's tale, a tale subtitled "And here my troubles began." This is a phrase Spiegelman takes from Vladek's narrative, an ironic aside about Dachau. Reading *Maus II* we realize not only that his troubles began long before, but that his troubles (and his son's) never end.

If the child's photograph at the beginning of this volume is the emblem of incomprehensible and unacceptable death, Vladek's photograph at the end works as a sign of life that reconnects Vladek and Anja after the liberation. "Anja! Guess what! A letter from your husband just came." "He's in Germany . . . He's had typhus! . . . And here's a picture of him! My God—Vladek is really alive!" (*Maus II*, 134). Reproduced in the next frame, but at a slant, jumping out of the frame, is a photograph of the young Vladek, serious but pleasant, standing in front of a curtain, wearing a starched, striped camp uniform and hat. He explains the picture: "I passed once a photo place what had a camp uniform—a new and clean one—to make souvenir photos." Just as Vladek keeps pictures of the deceased Anja on his desk, he asserts that "Anja kept this picture always." The photograph which signifies life and survival is as important, as cherished, as the one signaling loss and death. But this photograph is particularly disturbing in that it stages, performs the identity of the camp inmate. Vladek wears a uniform in a souvenir shop in front of what looks like a stage curtain;

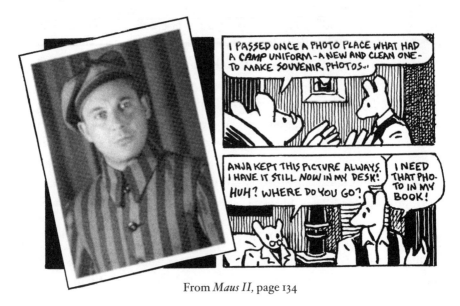

From *Maus II*, page 134

he is no longer in the camp but he reenacts his inmate self even as he is trying to prove—through his ability to pose—that he survived the inmate's usual fate.

In Anja's eyes the uniform would not call into question the picture's message: "I am alive, I have survived." She last saw Vladek in Auschwitz and would certainly have noticed the difference between this clean uniform and the one he actually must have worn. The uniform would signal to her their common past, their survival, perhaps their hope for a future. It is a picture Vladek could have sent only to her—someone else might have misunderstood its performative aspect. For readers of *Maus* this picture plays a different role: it situates itself on a continuum of representational choices, from the authenticity of the photos, to the drawings of humans in "Hell Planet," to the mice masks, to the drawings of mice themselves. This photograph is both documentary evidence (Vladek was in Auschwitz) and it isn't (the picture was taken in a souvenir shop). This picture may look like a documentary photograph of the inmate—it may have the appearance of authenticity—but it is merely, and admittedly, a simulation, a dress-up game. The identity of Vladek, the camp survivor with the man wearing the camp uniform in the picture is purely coincidental—anyone could have had this picture taken in the same souvenir shop—any of

us could have, just as perhaps any of us could be wearing uniforms in our dreams, as Art is. Certainly, any of us can wear the horizontally striped shirts Françoise seems to favor (another visual pun?) only further to blur the lines between document and performance. Yet, like Helen Epstein's family pictures, Vladek's photo is also a very particular kind of document, appropriate to a history we cannot "take in."

Breaking the frame, looking intently at the viewer/reader, Vladek's picture dangerously relativizes the identity of the survivor. As listeners of his testimony, as viewers of Art's translation and transmission of that testimony, we are invited to imagine ourselves inside that picture. Like Frieda's picture, Vladek's photo, with all its incongruous elements, suggests a story and *Maus* is that story. With Art and with Vladek, but without Anja, the reader is in what Dori Laub calls "the testimonial chain": "Because trauma returns in disjointed fragments in the memory of the survivor, the listener has to let these trauma fragments make their impact both on him and on the witness. Testimony is the narrative's address to hearing. . . . As one comes to know the survivor, one really comes to know oneself; and that is no simple task. . . . In the center of this massive dedicated effort remains a danger, a nightmare, a fragility, a woundedness that defies all healing" (71–73).

Maus represents the aesthetic of the trauma fragment, the aesthetic of the testimonial chain—an aesthetic that is indistinguishable from the documentary. It is composed of individually framed fragments, each like a still picture imbricated in a border that is closed off from the others. These frames are nevertheless connected to one another in the very testimonial chain that relates the two separate chronological levels, the past and the present, that structure the narrative of *Maus* relating teller to listener. But, once in a while, something breaks out of the rows of frames, or out of the frames themselves, upsetting and disturbing the structure of the entire work. The fragments that break out of the frames are details functioning like Barthes's "punctum"; they have the power of the "fetish" to signal and to disavow an essential loss. Anja Spiegelman, because of her missing voice and her violently destroyed diary, is herself one such point of disturbance, made more so by the photograph that is included among the stylized drawings. And embedded in those fragments—in spite of the conventional fairy tale ending of the second volume where Vladek and Anja are reunited and

Vladek insists that "we were both very happy and lived happy, happy ever after," in spite of the tombstone that enshrines their togetherness in the book's last frame and establishes a seemingly normalized closure—the nightmare, the fragility, the woundedness remain. The power of the photographs Spiegelman includes in *Maus* lies not in their evocation of memory, in the connection they can establish between present and past, but in their status as fragments of a history we cannot take in. Utterly familiar, especially in the context of the defamiliarizing images of mice and cat drawings, these photographs forge an affiliative look that enables identification: they could be any of ours. At the same time, this same context—both the story of the Holocaust and the cartoon drawings in which they are embedded—make them strangely unfamiliar, opaque.

Maus I, subtitled "My father bleeds history," shows us that this bleeding, in Laub's terms, "defies all healing," and the subtitle to volume II, "And here my troubles began," shows that they are never absorbed. The three photographs in *Maus* and the complicated marginal narrative of unassimilable loss that they tell, perpetuate what remains in the two volumes as an incongruity appropriate to the aesthetic of the child of survivors, the aesthetic of postmemory. Like those ghostly images of the former Jakubowicz families, of Chana's lost siblings, they reinforce at once incomprehensibility and presence, a past that will neither fade away, nor be integrated into the present.

Familial Postmemories and Beyond[30]

When Art Spiegelman first began to draw his father's story of survival in Auschwitz, and his own childhood reception of that story, he relied on familiar visual archives and narrative traditions that he then transformed in radical and surprising ways. The three-page "Maus," published in 1972, begins as a bedtime story "about life in the old country during the war."[31] Visually, a small drawing of the house in Rego Park opens out to a larger frame of the child's bedroom, where the partially pulled shade, the toy figure holding up the lamp, the polka-dot pajamas, the checkered blanket, and the cozy hug create a seemingly safe scene in which the father can evoke for his son the most brutal stories of wartime violence and persecution, fear and terror.

The mice and cats in the flashback images have not yet achieved

the visual economy they will eventually find in the subsequent *Maus* volumes, but the condensed account of the liquidation of the unnamed ghetto, the attempts at hiding, and the murders, betrayals, and deportation to Auschwitz already connect personal and public memory, present and past, in paradigmatic ways. The window shade is only partially pulled down, after all, and the postwar childhood is not protected from the history it has inherited. Indeed, that history is absorbed in the most vulnerable moments of childhood: the intimate exchange of the bedtime story. As Spiegelman will say later, in the subtitle of *Maus I*, "My father bleeds history."

And indeed, blood flows on this page, off the title letters spelling *MAUS* that bleed into the large, half-page title image that will remain foundational for Spiegelman, serving as the cover image of the second volume and appearing in a number of other frames. It is a drawing of a widely circulated 1945 photograph by Margaret Bourke-White of liberated male prisoners in Buchenwald, standing behind a barbed wire fence and all facing the photographer, huddled in blankets and torn uniforms, some holding on to the fence. Spiegelman's early drawn version of the photograph is distinct from its later incarnations not only in its drawing style, but also in the photo corners on the edges that show how this public image has been adopted into the private family album. Indeed, the arrow pointing to a mouse figure in the back row and identifying him as "Poppa" clarifies that the son can only imagine his father's experience in Auschwitz by way of a well-known image from the public archive. Even the most intimate familial transmission of the past is, it seems, mediated by public images and narratives.

But if the scene of narration in the first "Maus" takes place between father and son in the striking absence of the mother, it is the powerful image of her loss that will mediate the adult father/son relationship and the narrative of the second generation developed in the later volumes. Maternal abandonment and the fantasy of maternal recognition, announced by implication in the first "Maus," are paradigmatic tropes for the psychology and aesthetic of the postgeneration, and for the workings of postmemory. "Mickey's" mother appears in the early drawings, led along by her husband from one hiding place to another. But it is the father who is the narrator of her story, as well as his own. When *Die Katzen* capture the couple and send them off

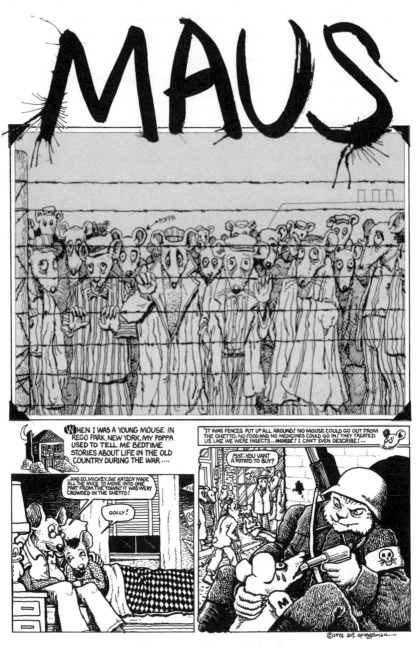

First page of the 1972 "Maus"

to "Mauschwitz," the father hugs his wife, who covers her eyes with her hands. Like the silent women in *Shoah*, she has no voice, but she provides a mute emotional backdrop to the horrific tale in which she is inscribed. Her absence from the bedroom, her inability to modulate her child's reception of the father's history lesson, leave him exposed and undefended.

Do children of survivors, like Artie in *Maus*, have "memories" of their parents' suffering? The bedtime scene of childhood transmission that Spiegelman draws suggests how the father's violent experiences can acquire the status of fairy tale, nightmare, and myth. It suggests some of the transactive, transferential processes—cognitive and affective—through which the past is internalized without fully being understood. These "acts of transfer," to use Paul Connerton's term, not only transform history into memory, but enable memories to be shared across individuals and generations.[32]

Eva Hoffman describes what was passed down to her as a fairy tale: "The memories—not memories but emanations—of wartime experiences kept erupting in flashes of imagery; in abrupt but broken refrains" (*After Such Knowledge*, 6, 9). These "not memories," communicated in "flashes of imagery," and these "broken refrains," transmitted through "the language of the body," are precisely the stuff of the *postmemory* of trauma, and of its return.

Jan and Aleida Assmann's work on the transmission of memory clarifies precisely what Hoffman refers to as the "living connection" between proximate generations and accounts for the complex lines of transmission encompassed in the inter- and transgenerational umbrella term "memory" (*After Such Knowledge*, 126). The Assmanns have devoted themselves to elucidating, systematically, Maurice Halbwachs's enormously influential notion of *collective* memory. I turn to their work here to scrutinize the lines of transmission between individual and collective remembrance and to specify how the break in transmission resulting from traumatic historical events necessitates forms of remembrance that reconnect and reembody an intergenerational memorial fabric that is severed by catastrophe.

In his book *Das kulturelle Gedächtnis*, Jan Assmann distinguishes between two kinds of collective remembrance, "communicative" memory and what he calls "cultural" memory.[33] Communicative mem-

ory is "biographical" and "factual," and is located within a generation of contemporaries who witness an event as adults and who can pass on their bodily and affective connection to that event to their descendants. In the normal succession of generations (and the family is a crucial unit of transmission for Jan Assmann), this embodied form of memory is transmitted across three to four generations—across eighty to one hundred years. At the same time, as its direct bearers enter old age, they increasingly wish to institutionalize memory, whether in traditional archives or books, or through ritual, commemoration, or performance. Jan Assmann terms this institutionalized archival memory "kulturelles Gedächtnis."

In her elaboration of this typology, Aleida Assmann extends this bimodal distinction into four memory "formats": the first two, "individual" memory and "social" memory, correspond to Jan Assmann's "communicative" remembrance, while "political" memory and "cultural" memory form part of his "cultural" memory.[34] A fundamental assumption driving this schema is, indeed, that "memories are linked between individuals." "Once verbalized," Aleida Assmann insists, "the individual's memories are fused with the inter-subjective symbolic system of language and are, strictly speaking, no longer a purely exclusive and unalienable property. . . . They can be exchanged, shared, corroborated, confirmed, corrected, disputed—and, last not least, written down" ("Re-framing Memory," 36). And even individual memory "include[s] much more than we, as individuals, have ourselves experienced" (40). Individuals are part of social groups with shared belief systems that frame memories and shape them into narratives and scenarios. For Aleida Assmann, the family is a privileged site of memorial transmission. The "social memory" in her schema is based on the familial transfer of embodied experience to the next generation: it is intergenerational. "Political" and "cultural" memory, in contrast, is not inter- but transgenerational; it is no longer mediated through embodied practice but solely through symbolic systems.

Jan and Aleida Assmann's typological distinctions do not specifically account for the ruptures introduced by collective historical trauma, by war, Holocaust, exile, and refugeehood: these ruptures would certainly inflect these schemas of transmission. Both embodied communicative memory and institutionalized cultural memory

would be severely impaired by traumatic experience. They would be compromised as well by the erasures of records, such as those perpetrated by totalitarian regimes. Under the Nazis, cultural archives were destroyed, records burned, possessions lost, histories suppressed and eradicated.

The structure of postmemory clarifies how the multiple ruptures and radical breaks introduced by trauma and catastrophe inflect intra-, inter-, and transgenerational inheritance. It breaks through and complicates the line the Assmanns draw connecting individual to family, to social group, to institutionalized historical archive. That archive, in the case of traumatic interruption, exile, and diaspora, has lost its direct link to the past, has forfeited the embodied connections that forge community and society. And yet the Assmanns' typology explains why and how the postgeneration could and does work to counteract or to repair this loss. Postmemorial work, I want to suggest, strives to *reactivate* and *reembody* more distant political and cultural memorial structures by reinvesting them with resonant individual and familial forms of mediation and aesthetic expression. In these ways, less directly affected participants can become engaged in the generation of postmemory that can persist even after all participants and even their familial descendants are gone.

It is this presence of embodied and affective experience in the process of transmission that is best described by the notion of memory as opposed to history. Memory signals an affective link to the past—a sense, precisely, of a material "living connection"—and it is powerfully mediated by technologies like literature, photography, and testimony.

The growth of our memory culture may indeed be a symptom of a need for individual and group inclusion in a collective membrane forged by a shared inheritance of multiple traumatic histories and the individual and social responsibility we feel toward a persistent and traumatic past. As Aleida Assmann writes, "the memory boom reflects a general desire to reclaim the past as an indispensable part of the present," and she suggests that the idea of "collective memory" has become an umbrella term that has replaced the notion of "ideology," prevalent in the discourses of the 1960s, 1970s, and 1980s ("Reframing Memory," 39).

Maus locates the scene of transmission in the bedtime connec-

tion between parent and child. The language of family, the language of the body: nonverbal and precognitive acts of transfer occur most clearly within a familial space, often taking the form of symptoms. It is perhaps the descriptions of this symptomatology that have made it appear as though the postgeneration wanted to assert its own victimhood, alongside that of the parents, and to exploit it.

To be sure, children of those directly affected by collective trauma inherit a horrific, unknown, and unknowable past that their parents were not meant to survive. Second-generation fiction, art, memoir, and testimony are shaped by the attempt to represent the long-term effects of living in close proximity to the pain, depression, and dissociation of persons who have witnessed and survived massive historical trauma. They are shaped by the child's confusion and responsibility, by a desire to repair, and by the consciousness that her own existence may well be a form of compensation for unspeakable loss. Loss of family, home, of a sense of belonging and safety in the world "bleed" from one generation to the next.

For those of us in the *literal* second generation, as Eva Hoffman writes, "our own internal imagery is powerful" and linked both to the particular experiences communicated by our parents, and to the way these experiences come down to us as "emanations" in a "chaos of emotions." Even so, other images and stories, especially those public images related to the concentration and extermination camps, also "become part of [our] inner storehouse" (193). I would argue that, as public and private images and stories blend, distinctions and specificities between them are more difficult to maintain, and the more difficult they are to maintain, the more some of us might wish to reassert them so as to insist on the distinctiveness of a specifically *familial* generational identity.[35]

The photo corners at the edges of Art Spiegelman's early drawing, and the arrow pointing at "Poppa," show how the *language* of family can literally reactivate and reembody an archival image whose subjects are, to most viewers, anonymous. This "adoption" of public, anonymous images into the family photo album finds its counterpart in the pervasive use of private, familial images and objects in institutions of public display—museums and memorials like the Tower of Faces in the United States Holocaust Memorial Museum or certain exhibits in the

Museum of Jewish Heritage in New York—which thus construct every visitor as a familial subject. This fluidity (some might call it obfuscation) is made possible by power of the *idea* of family, by the pervasiveness of the familial gaze, and by the forms of mutual *recognition* that define family images and narratives.

Postmemory is *not* an *identity* position but a *generational* structure of transmission embedded in multiple forms of mediation. Family life, even in its most intimate moments, is entrenched in a collective imaginary shaped by public, generational structures of fantasy and projection and by a shared archive of stories and images that inflect the broader transfer and availability of individual and familial remembrance. Geoffrey Hartman's notion of "witnesses by adoption" and Ross Chambers's term "foster writing" acknowledge breaks and fractures in biological transmission even as they preserve a familial frame.[36] If, however, we thus *adopt* the traumatic experiences of others as experiences we *might ourselves have lived through*, if we inscribe them into our own life story, can we do so without imitating or unduly appropriating them?

This question applies equally to the process of identification, imagination, and projection of those who grew up in survivor families, and of those less proximate members of their generation or relational network who share a legacy of trauma and thus the curiosity, the urgency, the frustrated *need* to know about a traumatic past. Still, their relationship to the past is certainly not the same. Eva Hoffman draws a line, however tenuous and permeable, between "the postgeneration as a whole and the *literal* second generation in particular."[37] To delineate the border between these respective structures of transmission—between what I would like to refer to as *familial* and "*affiliative*" postmemory—we would have to account for the difference between an inter-generational vertical identification of child and parent occurring within the family, and the intra-generational horizontal identification that makes that child's position more broadly available to other contemporaries.[38] But survivor families are often already fractured and disrupted: traumatized parents return from the camps to be taken care of, or to be rejected, by children who survived in hiding; families flee or emigrate to distant lands, and languages in host countries are more easily navigated by children than by parents. Affiliative postmemory

is thus no more than an extension of the loosened familial structures occasioned by war and persecution. It is the result of contemporaneity and generational connection with the literal second generation, combined with a set of structures of mediation that would be broadly available, appropriable, and, indeed, compelling enough to encompass a larger collective in an organic web of transmission.

Coda: A Work in Progress[39]

My travels with *Maus* span over three decades. My first attempt, the 1992 essay on mourning and postmemory, was no more than an introductory sketch, followed by refinements, renegotiations, and elaborations over nearly three decades. If it was, and still is, a work in progress, however, it is due not so much to my rush to publish an unfinished argument, but to the ways in which memory and the past are, in Sonali Thakkar's terms, "transformed by the present and future as they come into being."[40] The provisional quality of this early essay is no doubt also a response to the inspiring work on the memory of painful pasts done by scholars, artists, and activists across the globe and the many conversations in this burgeoning field that I've been fortunate to join.

"What comes after postmemory?" Tahneer Oksman provocatively asks, citing Toni Morrison's reflections on moving from "history" to "culture."[41] For Oksman, this means moving from a preoccupation with the past, such as we see in *Maus* and in my work, to a way of "more fully inhabit[ing] the present, with all its 'real possibilities.'" As scholars, artists, and activists presently working on memory are urging, the task of postmemory is precisely to locate us in the present and, in whatever ways possible, to point us to a more hopeful progressive future. And that, surely, continues to be work in progress.

(1992, 1997, 2012, and 2020)

Cartoons of the Self

Portrait of the Artist as a Young Murderer—
Art Spiegelman's *Maus*

NANCY K. MILLER

A writer is someone who plays with his mother's body.
—ROLAND BARTHES, *The Pleasure of the Text*

Autobiography by women is said to differ from autobiography by men because of a recurrent structural feature. Historically, according to academic critics, the self of women's autobiography has required the presence of another in order to represent itself on paper: for women identity is constructed "by way of alterity." From the Duchess of Newcastle to Gertrude Stein the acknowledgment and "recognition of another consciousness" seem to have been the necessary and enabling condition of women's self-narrative.[1] Unlike, say, Augustine or Rousseau, the female autobiographer rarely stages herself as a unique one-woman show; as a result her performances don't quite fit the models of individual exemplarity sought to be a defining criterion of autobiographical practice.

The number of women's autobiographies that display this construction of identity through alterity is quite remarkable. Yet several recent autobiography performances by male authors—Art Spiegelman's *Maus*, Philip Roth's *Patrimony*, Jacques Derrida's "Circonfession," Herb Gardner's *Conversations with My Father*—have made me

wonder whether we might not more usefully extend Mary Mason's insight that "the disclosure of the female self is linked to the identification of some 'other'" rather than restrict it to a by now predictably bi-polar account of gendered self-representation (22). What these male-authored works have in common is precisely the structure of self-portrayal through the relation to a privileged other that characterizes most female-authored autobiography.[2]

Self-representation in these memoirs *of the other* is not thematically the designated subject of disclosure. In *Maus* Spiegelman sets out to tell his father's story; his own is necessarily subordinated to that purpose. But the son's struggle with his father proves to be as much the subject of *Maus* as the father's suffering in Auschwitz. In what follows I show some of the ways in which this double paradigm operates at the heart of the *Maus* books as a form of self-narrative. I argue further that the father/son material is intertwined with, even inseparable from two equally powerful autobiographical strands: the son's self-portrayal as an artist and his relation—both as an artist and as a son—to his (dead) mother.[3] (It may also be that along with the entanglements of gender, the project of making autobiography is always tied to this intergenerational matrix of identity.)

From the first pages of *Maus* to the last of *Maus II* the figuration of the father/son relation constructs the frame through which we read (and hear) the father's story. We can think of this frame as *generative*, in the sense that it literally—and visually—produces the material of the "survivor's tale." This frame has a powerful double effect on the reader because it mimes the production of testimony and naturalizes the experience of listening to it. In the frame of narrative time, which is the present of Rego Park, we are lured into the account of a Holocaust past through the banality of American domestic life. The father pedals on an exercise bike in his son's former room and asks him about the "comics business." Art answers by reminding him of his old project of drawing a book about him. His father Vladek protests: "It would take *many* books, my life, and no one wants anyway to hear such stories." But Art has already incorporated his resistance into his book. "*I* want to hear it. Start with Mom . . . Tell me how you met." "Better you should spend your time to make drawings," Vladek protests, "what will bring you some money" (*Maus I*, 12).

These opening panels announce several of the book's themes: the transformation of oral testimony into (visual) narrative, the role of the listener (and then the reader) in that production, the place of his mother, Anja, in the family imaginary (Art holds her photograph as he speaks to his father), and the failure or success of Art's work as a cartoonist. The generative frame in which these problems about art and life, life and death, death and success, are sketched out also works at allaying the anxiety of the readers and critics who may enter the *space* of the *Maus* project with misgivings about its premises: Who wants to hear such stories, and as comics, no less? How could a reader fail to be captivated by such self-deprecation?

The first page of "Time Flies," the second chapter of *Maus II*, lays out the terms of Art's self-portrait as an artist. The top half of the page is divided into four symmetrical panels. On the left, Art, wearing a mouse mask, gazes at his drawing board and thinks: "Vladek died of congestive heart failure on August 18, 1982 . . . Françoise and I stayed with him in the Catskills in August 1979." On the right, the time flies buzzing around his head, Art comments on his sketch: "Vladek started working as a tinman in Auschwitz in the spring of 1944 . . . I started working on this page at the very end of February 1987." Again, on the left, Art says: "In May 1987 Françoise and I are expecting a baby . . . Between May 16, 1944, and May 24, 1944 over 100,000 Hungarian Jews were gassed in Auschwitz . . ."; and on the right, Art looks out at the reader: "In September 1986, after 8 years of work, the first part of MAUS was published. It was a critical and commercial success." Below the matching panels is a single frame. Art, in despair, leans on his arms at his drawing board, which is now at the height of a podium. The bottom half of the panel is occupied by a flattened pyramid of mouse corpses, above which the flies continue to buzz. Art complains: "At least fifteen foreign editions are coming out. I've gotten 4 serious offers to turn my book into a T.V. special or movie. (I don't wanna.) In May 1968 my mother killed herself. (She left no note.) Lately I've been feeling depressed." And an agentless bubble of words tries to get his attention: "Alright Mr. Spiegelman . . . We're ready to shoot! . . ." (*Maus II*, 41).

What does it mean to make (cartoon) art out of Auschwitz, money from the Holocaust? Is it possible to visualize and then represent a

world designed to confound and destroy the human imagination? These are the questions that *Maus* rehearses, wrestles with, and displaces through a set of concrete choices. Spiegelman's strategy for crafting his piece of this challenge to the ethics and materials of popular culture is first to personalize the enormity without reducing it. This is done in two simultaneous gestures whose interconnectedness is essential to the aesthetic project: Spiegelman narrativizes the experience of Auschwitz as an individual's trajectory and a family's saga, but the collective horror never ceases to haunt the horizon of a singular history. In re-telling that tale as a comic book, Spiegelman binds its meaning to the process itself of rendering that material. This process literally and metaphorically is thus tied to the father/son relation.

The deliberateness of the binding is shown on the back cover of the volumes. In *Maus I* a map of Poland at the time of World War II features an insert of a map of Rego Park and a drawing of the father/son story grid: the father in his armchair explaining to an attentive son stretched out at his feet. On the back cover of *Maus II* an insert of a New York/New Jersey map showing a detail of the Catskills is laid down on the plan of Auschwitz II (Birkenau, where Anja was imprisoned); Vladek in his striped prisoner's garb connects the two territories; his head is in New York, his body in Poland.

As Art heads for his therapy session, he dwells painfully on the effects of these simultaneous geographies and temporalities on him as a son and an artist. (If his father, as Art puts it, "bleeds history," the son draws blood.) Climbing onto the chair in the body of the child the interview session seems to have reduced him to in his own eyes, Art complains about his creative block. (In the show about *Maus* held at the Museum of Modern Art is a drawing placed in counterpoint to the "Time Flies" panels that literalizes that metaphoric state: a self-portrait of the artist as a slightly warped child's playing block, under which Spiegelman has written: "My projections of what others now expect of me from *Maus* have bent me out of shape . . . They're not meetable." The block looks a little the worse for wear.) This crisis has to do in part with the effects of commercial success, in part with the nature of the project itself: "Somehow," he explains, "my arguments with my father have lost a little of their urgency . . . and Auschwitz just seems too scary to think about . . . so I just lie there . . ." Pavel, the

"A remarkable work, awesome in its conception and
execution...at one and the same time a novel, a documentary, a memoir, and a comic book.
Brilliant, just brilliant."
— Jules Feiffer

"All too infrequently, a book comes along that's as daring as it is acclaimed. [This] is such a book."
— Esquire

"A quiet triumph, moving and simple — impossible to describe accurately, and impossible to achieve
in any medium but comics." — Washington Post

"Maus compels us to bear witness in a different way: the very artificiality of its surface makes it
possible to imagine the reality beneath." — Newsweek

Back cover of *Maus I*

therapist, who is also a survivor of the camps, zeroes in on the father material: "It sounds like you're feeling remorse—maybe you believe you exposed your father to ridicule." "Maybe," Art replies, "but I tried to be fair and still show how angry I felt" (*Maus II*, 44).

In the therapy session Art rehearses the ambivalence inherent in his project: being fair and staying angry. In the therapy panels the son gets to justify his anger: "Mainly I remember arguing with him . . . and being told that I couldn't do anything as well as he could." "And now that you're becoming successful, you feel bad about proving your father wrong." "No matter what I accomplish, it doesn't seem like much compared to surviving Auschwitz." As a good therapist, Pavel works to undo that bind: "But you weren't in Auschwitz . . . you were in Rego Park. Maybe your father needed to show that he was always right—that he could always SURVIVE—because he felt GUILTY about surviving. And he took his guilt out on YOU, where it was safe . . . on the REAL survivor" (*Maus II*, 44). Art leaves the session cheered up, ready to work on the next panels—his father's stint as a tinman at Auschwitz—but his "maybe" lingers unresolved.

The anger Vladek inspires in his son is palpable in the narrative frames in which Vladek's post-Holocaust manias are thoroughly detailed but it also shapes Art's representation of the Holocaust testimony itself. In "Of Mice and Menschen: Jewish Comics Come of Age," Paul Buhle makes the important point that one of the "less discussed, but more vital" reasons for the extraordinary success of *Maus* (beyond the brilliant decision to render the insanity of the Holocaust as a cartoon) "is the often unflattering portrait of the victim-survivor Vladek." The father, Buhle goes on to argue, "was not a nice guy, ever"; and (as he observes that Spiegelman commented to him) "the mainstream critics seem to have missed this point entirely, quite an important one to the artist. Perhaps they can't accept the implications."[4] *The Nation*'s reviewer, Elizabeth Pochoda, flagging Buhle's review, emphasizes his "political point . . . that more sentimental critics have missed: Vladek began as a typical selfish bourgeois with no politics and no ideals."[5] In *The New Yorker*, Ethan Mordden offers one case of this mainstream "sentimental" reading: "Through his increasingly astonishing composure in retelling these adventures, Vladek becomes oddly heroic. . . . Perhaps this is the reason Art is so forgiving of a father who was over-

critical when Art was growing up and is now, not to put too fine a point on it, a real pest."[6]

Despite these differences of interpretation, both Buhle and Mordden identify the panels I've described above as emblematic of the *Maus* project. Buhle chooses them to illustrate his remarks ("The reflexive work of Art Spiegelman probes the perils of success and the burden of survival" [9]); Mordden to make his point about the father/son relation and its classical pedagogies: "the son trying to learn from the father" (96). Mordden, I think wrongly, separates "Art . . . a man wearing a mouse mask" from "Art, son of Vladek." He distinguishes between the son and "Art Spiegelman, artist, passing himself off as some kind of Jew—huddled over his drawing board on top of a heap of mouse corpses" (96). The work of a son, or the work of an artist? This question of genre played itself out in the best-seller lists of *The New York Times* when Spiegelman himself challenged their categories and had *Maus* moved from fiction to nonfiction. The man in the mouse mask is precisely the figure of the *son as the artist* and nothing makes the difficulty of that dual identity more visible than his representation of Vladek as Art's father.

The success of *Maus* is due to a double audacity. The first is the choice to represent the Holocaust as a cartoon; the second to cast its star witness as a victimizer in his own world, a petty tyrant at home. In *Maus II* Spiegelman, who is an acutely self-conscious artist, agonizes over this problem of representation in a conversation with Mala, his father's second wife. Mala and Art discuss Vladek's stinginess. Art tries to exonerate his father: "I used to think the *war* made him that way . . ." "Fah!" Mala succinctly replies, "*I* went through the camps . . . *All* our friends went through the camps. Nobody is like him!" If Vladek's cheapness is unique to him and not due to the war experience, then what is its justification? Art comments: "It's something that worries me about the book I'm doing about him . . . In some ways he's just like the racist caricature of the miserly old Jew." Art adds, "I mean, I'm just trying to portray my father *accurately*! . . ." (*Maus I*, 131–132). But the relationship between accuracy and caricature for a cartoonist who works in a medium in which accuracy is *an effect of exaggeration* is a vexed one, especially if the son is still angry at his father: not a nice guy, ever.

He then stubbornly invokes his mother: "I wish I got *Mom's* story while she was alive. She was more sensitive . . . It would give the book some balance" (*Maus I*, 132). But the mother's story is doubly missing here. Although Vladek tells the parts of Anja's wartime experience which overlaps with his, what's missing is her own self-narrative, her chance to refigure herself. Anja, we learn earlier, killed herself in Queens in 1968. Art has already published his cartoon version of her suicide as "Prisoner on the Hell Planet: A Case History" (1973) in, as Art puts it, "an obscure comic book." He reprints it thirteen years later *en abyme* in *Maus*. Why?

In the course of the frame narrative Art discovers that his father (who, Art complains, "doesn't even look at my work when I stick it under his nose") has just read "Prisoner" (*Maus I*, 104). Drawn in a neo-expressionist style resembling a primitive woodcut, the cartoon depicts in four stark black pages the aftermath of his mother's suicide.[7] When we as readers of "Prisoner" return to the world of *Maus*, Mala, who says she found the "personal" material of "Prisoner" shocking when it first came out, now grants approval: "It was . . . very accurate . . . objective" (*Maus I*, 104). Vladek says he read it and cried because of the memories it brought him of Anja. The invocation of Anja in turn leads Art to inquire about her diaries. This exchange tells us something about why Spiegelman might have decided to reproduce the early work and what his relation to his mother and *her* story has to do with the emotional effectiveness of the full-scale memoir.

The father's narrative in the first volume of *Maus* ends with Anja's and Vladek's arrival at Auschwitz, but the framing text—the conversation between Art and Vladek—concludes the volume itself. The discussion of the couple's separation at the camp leads Art to ask again for his mother's diaries so that he could discover "what she went through while you were apart." At this point he finally learns that in a second holocaust his father has burned Anja's notebooks: "these papers had too many memories" (*Maus I*, 159). Acknowledging that Anja had expressed the hope that her son would be interested in her recorded thoughts, the father blames the depression that followed Anja's suicide for his actions.[8] To his son's enraged questions he has no real answers. In the last panel of *Maus*, Art walks off, smoking his eternal cigarette, and thinking a single word: "Murderer" (*Maus I*, 159).

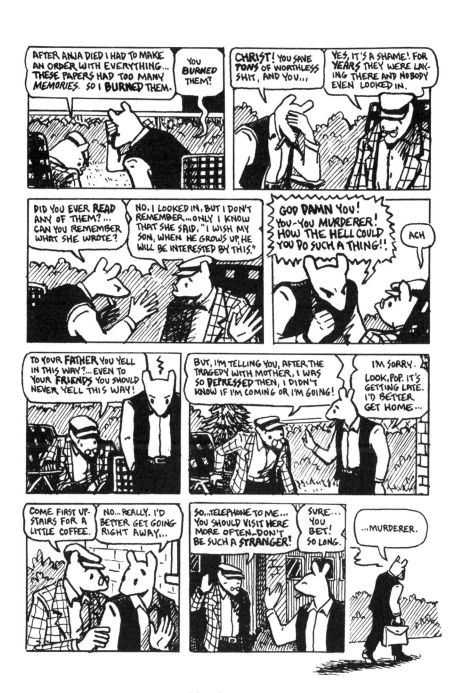

Maus I, page 159

"Murderer" is the epithet Art assigns to the man who has destroyed his mother's memoirs without reading them (he only, as he puts it, "looked in"). But we have seen this interpellation before. At the end of "Prisoner on the Hell Planet" Art draws himself in jail, calling out to his mother: "Congratulations! . . . You've committed the perfect crime. . . . You *murdered* me, Mommy, and you left me here to take the rap!!!" Now, immediately after the scene in which Art and Vladek discuss the early comic strip, Vladek lies when asked about the diaries, claiming he couldn't find them. When Art learns the truth, he can't believe that his father, who saves everything (string, nails, matches, "tons of worthless shit"), would throw these notebooks away (in *Maus II,* Françoise, Art's wife, acidly remarks that Anja must have written on both sides of the pages, otherwise Vladek would never have burned the blank ones).[9] The importance of Vladek's "murder" is underlined again in the credits page of *Maus II* where Spiegelman notes: "Art becomes furious when he learns that his father, VLADEK, has burned Anja's wartime memoirs." The highlighting of that act not only points to the ways in which the question of Anja's story has haunted the *Maus* project from the start but also serves to guide the reading of its second installment.

Art's quest for his mother's diaries punctuates the dialogue with the father out of which Vladek's testimony is produced. The inclusion of "Prisoner on the Hell Planet" connects the enigma of the suicide—

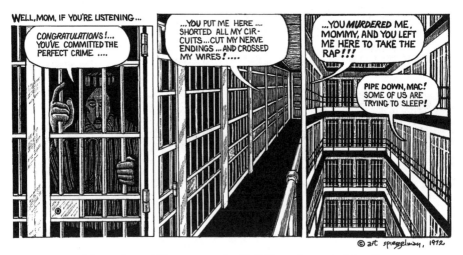

The ending of "Prisoner on the Hell Planet," 1972, in *Maus I*

the mother left no note—to the violence of destroying the diaries. Both gestures entail the suppression of a maternal "text." As a son and an artist Art's response to his erasure is complexly layered: in "Prisoner on the Hell Planet" he blames himself and his mother for her death; in *Maus* he attempts to provide a measure of reparation for "murdering" his mother by putting into images what he could know from Vladek of life during the war; throughout the volumes he indirectly links his task as an artist to her body by representing a crucial piece of the *Maus* project his own doomed and belated attempt to figure out her reality.

In the penultimate episode of "Prisoner" "Artie" turns away from his mother's plea. "Artie . . . you . . . still . . . love . . . me . . . Don't you?" and fantasizes that this rejection makes him responsible for her suicide. The image of his mother in pained retreat locks him literally into the jail of his guilt, fed by the imagined "hostility mixed in with [the] condolences" of his father's friends. "Arthur . . . we're so sorry." "It's his fault—the punk!" But in a single panel Spiegelman also renders the impossibility of ever knowing the answer to "why." At the top of the panel Anja lies naked in a tub, under which thick capital letters spell out "MENOPAUSAL DEPRESSION." A triangle of concentration camp iconography—barbed wire, piled-up human corpses, a swastika—under which HITLER DID IT! is scrawled—separates the body in the tub from the jarring scene below in which three images are juxtaposed: a mother reads in bed with a little boy dressed in min-

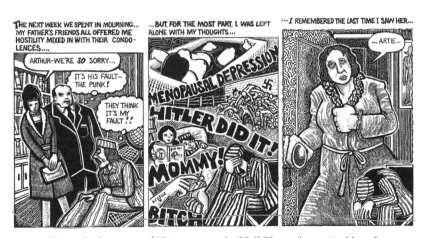

From the last page of "Prisoner on the Hell Planet," 1972, in *Maus I*

iature prison garb by her side, MOMMY!; a forearm with concentration camp numbers on it slits a wrist with a razor blade, BITCH; and, finally, diagonally across the body in the tub, the prisoner sits on his bunk and holds his head. The mosaic of images proposes the pieces of the truth to which no single answer is available.

Replaced in the *Maus* books, the mother's suicide is given not an answer but other images through which to locate it. What more would the son have learned about his mother from her memoirs? After Vladek has told the story of the hanging in Sosnowiec of four Jews for dealing in goods without authorization, Art asks what his mother was doing in those days: "Houseworks . . . and knitting . . . reading . . . and she was writing always her diary." "I used to see Polish notebooks around the house as a kid. Were those her diaries?" "Her diaries didn't survive from the war. What you saw she wrote after: Her whole story from the start." "Ohmigod! Where are they? I *need* those for this book!" (*Maus I*, 84). But the book will get made without them. In the absence of his mother's autobiography, Art writes his father's. He also writes his own; or rather, through the father's murder of the mother's texts, the son seeks to repair his own monstrosity: the fatal unseemliness of surviving the victims, but not without violence of his own.

As *Maus II* opens Art and Françoise drive from Vermont to the Catskills where Vladek has summoned the couple to his aid. In the car Art agonizes over the presumption of doing his book: "I mean, I can't even make any sense out of my relationship with my father . . . How am I supposed to make any sense out of Auschwitz? . . . of the Holocaust?" He then asks: "When I was a kid I used to think about which of my parents I'd let the Nazis take to the ovens if I could only save one of them . . . Usually I saved my mother. Do you think that's normal?" Although Françoise replies reassuringly that "*nobody's* normal," the question hangs fire (*Maus II*, 14).

In the panels about the incredible success of *Maus* which appear in the next chapter, Art, the man behind the mask, puts his head down and remembers: "In May 1968 my mother killed herself. (She left no note.) Lately I've been feeling depressed" (*Maus II*, 41). In the Vermont frame narrative it is Françoise's question "Depressed again?" (*Maus II*, 14) that leads to Art's reflection about the enormity of his book venture. Toward the end of the therapy session about survivors'

guilt, Pavel, the shrink, says: "Anyway, the victims who died can never tell *their* side of the story, so maybe it's better not to have any more stories." Art (reminding himself of Beckett's comment that "Every word is like an unnecessary stain on silence and nothingness" and the fact, as he puts it to himself, that nonetheless Beckett *said* it!) seems to feel compelled as an artist to try to represent the words otherwise condemned to silence (*Maus II,* 45). It's as if at the heart of *Maus*'s dare is the wish to save the mother by retrieving her narrative; as if the comic book version of Auschwitz were the son's normalization of another impossible reality: restoring the missing words, the Polish notebooks. Though Vladek tries to shrug off the specificity of Anja's experiences: "I can tell you," he gestures disparagingly, "I can tell you . . . She went through the same what me: terrible!"—that isn't good enough for Art, who keeps the question of Anja alive from the beginning to the end of the memoir (*Maus I,* 158).[10]

What is the relation between creating *Maus* out of his father's words and restoring the maternal body? For the reader of the autobiographical collaboration at the heart of *Maus,* who wants to find the place that might exceed the artist's recorded self-knowledge, there's not much to do beyond playing secondhand shrink (and he's already got a great therapist!). But if the outrageousness of comic book truth is any guide, and what you see is what you get, then we should I think understand the question of Anja as that which will forever escape representation and at the same time requires it: the silence of the victims. Perhaps that impossibility is what keeps Art forcing his father back into the memoirs he has tried to destroy. In one of the framing sections of *Maus II* chapter 3 (which bears the heading that is the subtitle to the volume: "And Here My Troubles Began"—and which narrates the final scenes at Auschwitz), Art asks Vladek about a Frenchman who helped him at the camps, whether he saved any of his letters.[11] "Of *course* I saved. But all this I threw away together with Anja's notebooks. All such things of the war, I tried to put out from my mind once for all . . . until you *rebuild* me all this from your questions" (*Maus II,* 98).[12]

For Vladek "rebuilding" memory means reviving the link to Anja; Anja cannot be separated from the war: "Anja? What to tell? Everywhere I look I'm seeing Anja . . . From my good eye, from my glass

eye, if they're open or they're closed, always I'm thinking of Anja" (*Maus II*, 103). But this memory is by now the artist's material as well and despite Vladek's protest, Art finally extracts the images he needs from his father's repertoire in order to close his narrative, including Anja's last days in Sosnowiec and their reunion: "More I don't need to tell you. We were both very happy, and lived happy, happy ever after" (*Maus II*, unpaginated [136]). The tape recorder stops. Vladek begs for an end to stories and in his exhaustion from the past brought to the present, calls Art by his dead brother's name, Richieu. The last drawing in *Maus II* is of the tombstone bearing the names of Art's parents as well as their birth and death dates; beneath the monument the artist signs the dates that mark the production of his book: 1978–1991. The dates on the tombstone give the lie to Vladek's "happy ever after" since Anja killed herself some twenty years after the war. Did she live happy ever after? Mala, Vladek's second wife, doesn't mince words: "Anja must have been a *saint!* No wonder she killed herself" (*Maus II*, 122). The dates also point indirectly to the fact that Art's text keeps his father as well as his mother alive: Vladek died in 1982. Both volumes of *Maus* were published—and critically acclaimed—after the death of the man who thought, after looking at some of his son's early sketches of the Jews hanged in Sosnowiec, that he might someday "be *famous*, like . . . what's-his-name? . . . You know . . . the big-shot cartoonist . . ." "What cartoonist could *you* know . . . Walt Disney??" "YAH! Walt Disney!" (*Maus I*, 133).[13]

Throughout the frame narrative to the survivor's tale Art forces Vladek back into the past of suffering and the double loss of Anja. In the corners of the pages Art presses Vladek to continue with his narrative, and Vladek pleads: enough. Vladek dies before *seeing* himself "comically" reunited with his beloved Anja, and before seeing his words and deeds in some ways turned against himself (though given his incapacity for self-criticism and his talent for self-justification, he would probably have missed the bitter ironies of his portrait). And before seeing his son become the Walt Disney of the Holocaust.

The frame narrative displays an acute self-consciousness about what's at stake psychologically for the son in telling his father's story. The Museum of Modern Art show in turn emphasized the *work*

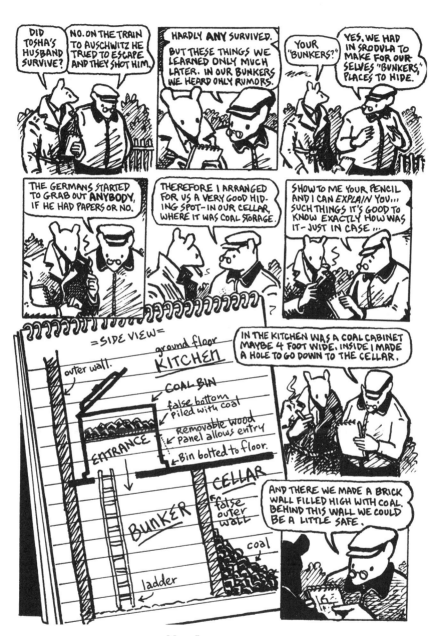

Maus I, page 110

involved in the process. Located in the "Projects" room, the exhibition illustrated the detail of the Spiegelman method. In one display case the process by which Life becomes Art is broken down and narrated. "An incident from V. Spiegelman's transcripted memories becomes a page of *Maus*." A typed page of the transcript describing the long march out of Auschwitz is displayed and marked. The episode involves the shooting of a prisoner, which Vladek likens to a childhood memory of a mad dog being shot by its owner: "And now I thought: 'How amazing it is that a human being reacts the same like this neighbor's dog.'" The commentary in the display case deals with Spiegelman's technical process: "The incident is broken down into key moments, first into phrases, then into visual notations and thumbnail sketches of possible page layouts." "Phrases are rewritten, condensed and distilled to fit into the panels."

The exposition of the myriad details involved in the transformation of the father's narrative of lived atrocity into the son's comic book underscores the degree of re-presentation involved in the *Maus* project and the skills required for its realization. Although the son claims that he became an artist in part to define his identity *against* his father's—"One reason I became an artist was that he thought it was impractical—just a waste of time . . . It was an area where I wouldn't have to compete with him"—the boundaries between them turn out to be more permeable than distinct. Vladek, for instance, also draws: early in *Maus* Art reproduces Vladek's detailed sketch of the bunker he designed for hiding in Sosnowiec: "Show to me your pencil and I can explain you . . . such things it's good to know exactly how was it— just in case" (*Maus I*, 110). The exhibit lays bare the literal dexterity entailed in the "comics business." It materializes the challenges posed to an artist committed to rendering what was never meant to be seen again. Art had to learn to *draw* what his father had faked in the camps: how, for instance, to be a shoemaker when you're a (fake) tinman.[14]

This is part of what Art's self-portrait in the mouse mask preparing to render Vladek's stint as a tinman also points to: the work of "rebuilding" Holocaust memories. There's also a specific issue here about the ethics involved in converting oral testimony—"the ruins of memory" to borrow Lawrence Langer's phrase—into a written and visual document (let alone a comic strip!).[15] This leads us to a final question about

the making of *Maus*: what happens *between* the father's voice and the son's rendering of it as text?

In the exhibition, a tape of the father's voice was made available to the listener curious to know what Vladek sounded like. The desire to hear his voice is intensified by the inscription throughout the frame narrative of the tape recorder—both as the mark of their collaboration (even after Vladek's death)—"Please, Pop, the tape's on. Let's continue . . . Let's get back to Auschwitz"—and of the testimony's authenticity (*Maus II*, 47). The reader of *Maus*—especially one with immigrant parents or grandparents (me)—is also made (uncomfortably) aware of the foreign turn of Vladek's English; the tape offers the possibility of hearing what she has been reading.

What surprised me when I listened to the tape was an odd disjunction between the quality of the voice and the inflections rendered in the panels. For while Vladek *on tape* regularly misuses prepositions—"I have seen on my own eyes," "they were shooting to prisoners," mangles idioms—"and stood myself on the feet," pronounced "made" as "med," "kid" as "ket"—the total *aural* effect, unlike the typically tortured *visualized* prose of the dialogue in the comic balloons, is one of extraordinary fluency.[16] It's almost as though in "distilling" his father's language to fit the comic strip the son fractured the father's tongue. By contrast, the voice on the tape has the cadences of a storyteller: it is smooth, eloquent, seductive. Is breaking the rhythms of that voice an act of violence or restoration, or both at once?

What the show allows to happen which the text as *representation* necessarily forecloses is that the reader of *Maus* gains momentary access to the voice that survived the event, freed from the printed voice of the frame. In that moment (and listeners greedily listened to every word of the tape, unwilling to relinquish the headphones), one is tempted to say, the father performs unmediated—to the world.[17] But this would also be to miss the crucial function of the listener in the production of testimony. As Dori Laub writes in *Testimony: Crises of Witnessing in Literature, Psychoanalysis, and History*:

> The listener . . . is party to the creation of knowledge. . . . The testimony to the trauma thus includes its hearer. . . . The listener to trauma comes to be a participant and co-owner of the traumatic

event. . . . The listener, however, is also a separate human being . . . he preserves his own separate place, position, and perspective; a battleground for forces raging in himself, to which he has to pay attention and respect if he is to properly carry out his task.[18]

Paradoxically, then, the reader's experience of the father's voice returns her to the son's task and its realization. As "co-owner" of his father's trauma the son cannot fail to map out those places and those wars.

By forcing Vladek to "rebuild" his memory, Art becomes both the *"addressable other"* necessary to the production of testimony and the subject of his own story (Felman and Laub, 68). In the end the man in the mouse mask moves beyond his task by fulfilling it, by turning it into art, and replacing it in history. This is not to say that his losses, any more than those which define the survivor's life during and after Auschwitz, are erased by that gesture—Anja will not return to explain herself—but rather than by joining the murderers he also rejoins himself. If after the Holocaust violence and reparation can no longer be separated, perhaps this is also the form postmodern forgiveness takes.

(1992)

"We Were Talking Jewish"

Art Spiegelman's *Maus* as "Holocaust" Production

MICHAEL ROTHBERG

Prologue

He's dying, he's dying. *Look at him.* Tell them over there. *You saw it.*
Don't forget . . . Remember this, remember this.
　　　—JAN KARSKI, speaking in Claude Lanzmann's *Shoah*

In the final comic set piece of Philip Roth's novelistic memoir about
his relationship to his father, *Patrimony: A True Story,* Herman Roth
attempts to cajole his author-son into helping one of his card-playing
buddies from the Y get his memoirs of World War II published. Philip
is understandably resistant—especially as his father has regularly asked
him over the years to aid other aspiring authors of books about home
mortgages or annuity funds. Of course, a book about the Holocaust is
different, and Philip even admits that he has taught Holocaust mem-
oirs and briefly knew Primo Levi.

The invocation of Levi and the ensuing description of his suicide
hardly foreshadow a comic scene. Indeed, Philip wonders

if Primo Levi and Walter Herrmann [his father's friend] could pos-
sibly have met at Auschwitz. They would have been about the same
age and able to understand each other in German—thinking that it
might improve his chances of surviving, Primo had worked hard at

Auschwitz to learn the language of the Master Race. In what way
did Walter account for *his* survival? What had *he* learned? However
amateurish or simply written the book, I expected something like
that to be its subject (212).

But Walter's subject and the lesson he learned in Nazi Germany
turn out to be quite different. In fact, they turn out to be comic and
even obscene. According to Walter, he was "the only man left in Ber-
lin," and his memoirs are the graphic depictions of his sexual exploits
with the women who hid him, quite a twist on the usual tales of hero-
ism and betrayal (212). "My book is not a book like Elie Wiesel writes,"
Walter honestly remarks. "I couldn't write such a tragic book. Until
the camps, I had a very happy war" (213). What with Katrina and
Helen and Barbara, Walter's war was more a multiple orgasm than the
greatest tragedy of human history.

This odd episode at the end of *Patrimony* suggests that there
might be something pornographic about making images and ulti-
mately commodities out of the Holocaust. It is as if the fundamental
obscenity of the events themselves cannot be represented without a
pornographic contamination of the person doing the representing.
Walter seems to grasp this truth unconsciously and displaces it into
farce; this is perhaps the flip side of Levi's, and many other survivors',
ultimately tragic and desperate inability to redeem their experience by
working through, and representing to themselves, the meaning of the
camps. I think we might gain insight into this irony and angst about
the decorum of representing destruction by considering it as a partic-
ularly (although not uniquely) Jewish question. Well before what has
come to be known as "the Holocaust," certain aspects of the debate
surrounding the Nazi genocide and the question of representation
were foregrounded in Jewish discourse.[1] The examples of Roth and
Art Spiegelman demonstrate how a biblically mandated suspicion of
idolatry and image making, as well as a cultural claim to "a kind of
privileged relation to the very idea of textuality" (Shohat, 9), come to
constitute specifically Jewish parameters, or at least "themes," of even
secular Jewish writing.[2]

Roth's self-consciousness about representation in general and
his tragicomic recognition of the ungraspable contamination of rep-

resenting the Holocaust form the background of *Patrimony* against which Roth frames the story of his father's losing battle with cancer. Roth uses metaphors which call upon both timeless Jewish themes of memory and survivorship and historically specific evocations of the Nazis. Despite the father's obstinate "survivor" mentality, Herman's tumor, Roth writes, "would in the end be as merciless as a blind mass of anything on the march" (136). This Nazi-like image resonates uncannily with a passage from Roth's novel *The Anatomy Lesson*. There Roth describes not his father's actual death but an imagined version of his mother's death (a death which in reality, we know from the chronology of *Patrimony,* must have prompted *The Anatomy Lesson*). But the categories of reality and imagination become here—as everywhere in Roth's writing—hopelessly confused, since the fictional version *anticipates* the memoir. Nathan Zuckerman's mother develops a brain tumor in this 1983 novel, as Herman Roth will a few years later. Admitted into the hospital for the second time, Zuckerman's mother was able to recognize her neurologist when he came by the room, but when he asked if she would write her name for him on a piece of paper, she took the pen from his hand and instead of "Selma" wrote the word "Holocaust," perfectly spelled. This was in Miami Beach in 1970, inscribed by a woman whose writings otherwise consisted of recipes on index cards, several thousand thank-you notes, and a voluminous file of knitting instructions. Zuckerman was pretty sure that before that morning she'd never even spoken the word aloud (269).

The carefully situated Jewish mother's death serves here as a metaphor for the emergence in the Jewish community of a new understanding of "the Holocaust" in the late 1960s, an understanding which testified to the spatially and temporally displaced effect on Jewish-American identity of the extermination of European Jewry (even, or especially, for Jews comfortably situated "in Miami Beach in 1970"). The association of Holocaust and tumor forged by Roth in *The Anatomy Lesson* reappears in *Patrimony,* a memoir which further measures the health of the collective and individual Jewish body.

Patrimony's last line, and most frequently repeated motif, is a slogan often applied to the Nazi genocide: "You must not forget anything" (238). This line, which so closely echoes my epigraph from *Shoah* (cited in Felman and Laub), also occurs in the passage where Philip gives

his father a bath and pays special attention to the signifier of Jewish manhood:

> I looked at his penis. I don't believe I'd seen it since I was a small boy, and back then I used to think it was quite big. It turned out that I had been right. It was thick and substantial and the one bodily part that didn't look at all old. I looked at it intently, as though for the very first time, and waited on the thoughts. But there weren't any more, except my reminding myself to fix it in my memory for when he was dead. . . . *You must not forget anything.*

Here, the phallic law of the father takes on the particularly Jewish imperative to "remember everything accurately," a commandment metonymically linked to the contemplation of the one "substantial" organ of his father's body which resists the deterioration of time (177). In *The Anatomy Lesson* Roth had already connected the deterioration caused by cancer with a maternal evisceration (of body and language). In *Patrimony*—despite the holocaust of cancer and the cancer of the Holocaust—the Jewish communal body survives in and through the memory of the solidity of the father: his "substantial" penis and his "vernacular" speech, with "all its durable force" (181).

The power and ultimately the sentimentality of Roth's portrait arise from his manner of combining traditional Jewish motifs of survival, memory, and the law with a subtle evocation of the Holocaust in order to depict a particular Jewish life in the diaspora. Roth's text simultaneously exposes the potential for pornographic kitsch in his account of Walter Herrmann and draws upon a kind of emotional kitsch in the depiction of his father. Such a paradoxical stance constitutes a particular, and in this case gendered, configuration of contemporary Jewish-American identity—one in which the abuses of the Holocaust have been made manifest by years of facile mechanical reproduction, but in which the Holocaust still serves as the dominant metaphor for collective and individual Jewish survival.

1.

Sometimes it almost seems that "the Holocaust" is a corporation headed by Elie Wiesel, who defends his patents with articles in the Arts and Leisure section of the Sunday *Times*.
—PHILLIP LOPATE, "Resistance to the Holocaust"

I resist becoming the Elie Wiesel of the comic book.
—ART SPIEGELMAN, "A Conversation with Art Spiegelman"

In moving from Philip Roth to Art Spiegelman—that is, from the comic to the comic book—the motifs of survival and suffering become radically reconfigured even as the subjects of that survival and suffering (the authors' fathers) seem so similar. Within the context of the ban on graven images and the "mystique" of the text—from which Roth derives both his pornographic ironization and his narrative sentimentalization—the two volumes of Art Spiegelman's "survivor's tale," *Maus*, come as a particular shock. *Maus* represents a new strand of Jewish-American self-construction related to but significantly divergent from Roth's writings. Spiegelman transgresses the sacredness of Auschwitz by depicting in comic strip images his survivor father's suffering and by refusing to sentimentalize the survivor. A phrase from Roth's memoir actually suits Spiegelman's depiction of his father, Vladek, better than it does that of Herman: "what goes into survival isn't always pretty" (*Patrimony*, 126). While Spiegelman is no Walter Herrmannesque comic pornographer of the Holocaust, his use of coded animal identities for the ethnic and national groups he depicts certainly strikes readers at first as somewhat "obscene." Spiegelman even admits that going into a comic book store is "a little like going into a porno store" ("Conversation"). But the power and originality of Spiegelman's effort derive quite specifically from this shock of obscenity which demands that we confront "the Holocaust" *as* visual representation, as one more commodity in the American culture industry.

For Jewish readers, the challenge of *Maus* will likely be even harder to assimilate since the experience (and the memory) of the Holocaust, even for those of us who know it only at a distance, remains,

"The most affecting and successful narrative ever done about the Holocaust." —*Wall Street Journal*

CAMP EX-TENSION

WORK-SHOPS

AUSCH-WITZ

S.S. HEAD-QUARTERS

POLAND 1944

AUSCHWITZ II (BIRKENAU)

600-1000 prisoners per barrack

WOMEN'S BARRACKS

GAS CHAMBER AND CREMATORIUM II

NEW YORK

28

To ALBANY

CATSKILL MOUNTAINS

Woodstock

9

Liberty

209

Hyde Park

Pines Hotel

Ellenville

Monticello

17

52

42

84

23

87

Hudson River

Bear Park

N.Y.C.

"AN EPIC STORY TOLD IN TINY PICTURES." —*NEW YORK TIMES*

US $16.95 / $22.95 CAN
ISBN 978-0-679-72977-8

51695

9 780679 729778

Back cover of *Maus II*

fifty years later, one of the defining moments of American Jewish identity. Although the situation is beginning to change, Jewish identity remains relatively undertheorized, if overrepresented, in contemporary culture and criticism. Those of us who occupy Jewish subject positions thus come to the task of what that most talmudic of anti-Semites, Céline, has called "reading Jewish" with an impoverished set of tools to help us to examine our being-in-America.[3] In this essay I will pursue a double-edged strategy, demystifying Céline's assumption of an essential Jewishness while at the same time demonstrating how Spiegelman brings a secular Jewish interpretive specificity to his rendering of the Holocaust.[4]

The need for an adequate discourse of Jewish identity strikes me as politically critical because of two phenomena which require, among other things, a specifically Jewish response: the worldwide reassertion of anti-Semitism and the relatively free rein American Jews have given to the often oppressive policies of the state of Israel. *Maus* assists us in this intellectual and political task because, even if it rarely addresses these issues directly, it does tell us at least as much about the contemporary situation of Jews in the North American diaspora as about "the Holocaust." Or rather, it meditates as much on the production of the concept of "the Holocaust" and of the concept of Jewishness as it does on Nazi inhumanity.

Maus critiques popular productions of Jewishness and the Holocaust not from a safe distance but from within, in an accessible vernacular form. In his recent "goodbye to *Maus*" comments, Spiegelman worries that his books "may also have given people an easy way to deal with the Holocaust, to feel that they've 'wrapped it up'" ("Saying Goodbye to *Maus*," 45). While the texts' very commodity form participates in the marketing of the Holocaust—*Maus I* and *Maus II* were first "wrapped up" together in boxed sets in the 1991 pre-Hanukkah/Christmas season—they also simultaneously resist this "wrapping up." As Robert Storr notes, Spiegelman creates a visual pun on the back cover of *Maus II* which connects the stripes of his father's prison uniform with the stripes of the jacket's bar code. The text's very "wrapping" asks the reader to consider its implication in a system of economic entrapment. The self-conscious irony of this parallel between imprisonment and commodity production marks one

From lithograph series "Four Mice," 1991, previously published in *Tikkun*, 1992

of the many places where Spiegelman rebels against the terms of his success; such cleverness, however, reminds us that this very rebellion constitutes a large part of the artist's appeal. This paradox, which is foregrounded everywhere in *Maus,* can be read as a comment not only on the status of memory and history in capitalist culture, but also on recent debates about the possibility and desirability of representing the Nazi genocide.

Among the last *Maus* images, which Spiegelman contributed to *Tikkun* ("Saying Goodbye"), two in particular stand out as emblematic of the dangers that the artist recognizes in mass-marketing death. In the first, Spiegelman draws his characteristic "Maus" self-portrait standing in front of a smiling Mickey Mouse background and gazing mournfully at a "real" mouse which he cups in his hands. The uneasy coexistence of three levels of representation in the same pictorial space literalizes the artist's position—backed by the industry, but everywhere confronted with the detritus of the real. In the second drawing, the artist sits in front of a static-filled TV screen and plays with his baby daughter, who is holding a Mickey Mouse doll; silhouetted in the background, mouse corpses hang from nooses. This

drawing transposes a frame from *Maus I* in which Spiegelman depicts his family (Vladek, Anja, and the soon-to-be-dead Richieu) before a backdrop of Jews hung by the Germans in a Polish ghetto (84). This transposition, along with the drawing of the three mice, illustrates an aspect of repetition compulsion which the work as a whole enacts. The Nazi violence lives on, with the survivor son just as much the subject and object of the terror as his father.

Spiegelman's self-portrait on the jacket flap of *Maus II* also delineates this tension inherent in the relationships between the artist, his historical sources, his representational universe, and his public artworks.[5] Wearing a mouse mask, Spiegelman sits at his desk with *RAW* and *Maus* posters behind him and a Nazi prison guard outside the window. One morbid detail stands out: the picture reveals Art's ubiquitous cigarettes as "Cremo" brand. On page 70 of the second volume we find the key to this deadly pun when Vladek refers to the crematorium as a "cremo building." Such black humor implies that with every cigarette, with every image—and Spiegelman seems both to smoke and to draw relentlessly—he does not just represent the Holocaust, he literally brings it back to life (which is to say, death). Taken together, these disturbing portraits figure forth *Maus*'s strange relationship to the ashes of the real—simultaneously haunted by the inadequacy of representation in the fate of the catastrophe of history and overconscious of the all-too-real materiality that representations take on through the intervention of the culture industry.

The impossibility of satisfactorily specifying the genre of *Maus* expresses this representational paradox. After *Maus II* came out, Spiegelman requested that his book be moved from the fiction to the nonfiction best-sellers' list; but a few years earlier, in an introduction to a collection of "comix" from *RAW,* the magazine he edits with his wife, Françoise Mouly, Spiegelman remarked that he had been at work on his "comic-book novel, *Maus*" (Spiegelman and Mouly, 7). While perhaps merely an artist's whim, I read this seeming contradiction as grounded in the specificity of the problem of representing the Holocaust, an event taken at once as *paradigmatic* of the human potential for evil and as a truly *singular* expression of that potential which frustrates and ought to forbid all comparison with other events.

On the one hand, critics such as Theodor Adorno, Maurice Blan-

chot, and Berel Lang have suggested that "after Auschwitz," poetry and fiction are impossible.[6] This proscription I understand as moral rather than technical—it would be unseemly, these writers imply, to fabricate in the face of the need for testimonial and witnessing. These critics have also tended to assert that the Nazi genocide constituted a radical and unprecedented break within Western culture, an absolutist position which tends to totalize and prescribe the practices of representation in the wake of the Event. The impossibility of fiction is also true in another sense. After the Nazis' rationalized irrationality, no horror remains unthinkable; neither the "journey to the end of night" of a Céline nor a "theater of cruelty" à la Artaud seems fantastic or unreal any longer. On the other hand, such a historical trauma also de-realizes human experience. Accounts of the death camps in memoirs never fail to document the fictional, oneiric aura that confronted the newly arrived prisoner.[7] By situating a nonfictional story in a highly mediated, unreal, "comic" space, Spiegelman captures the hyperintensity of Auschwitz—at once more real than real and more impossible than impossible.

Yet *Maus* also replies to the debates about representation in ways which go beyond formalist subversion of generic categories and which indeed shift the terrain of the debate onto the cultural conditions, possibilities, and constraints of Holocaust representation (thus displacing the frequently prescriptive epistemologies and ontologies of the debate set by Adorno, Blanchot, and Lang). Spiegelman frankly recognizes the inevitable commodification of culture, even Holocaust culture. In *Maus*'s multimedia marketing (through magazines, exhibitions, the broadcast media, and now CD-ROM), as well as through its generic identity as a (non)fiction comic strip, Spiegelman's project refuses (and indeed exposes) the sentimentality of the elite notions of culture which ground the Adornean position. Spiegelman's handling of the Holocaust denies the existence of an autonomous realm in which theoretical issues can be debated without reference to the material bases of their production. He heretically reinserts the Holocaust into the political realm by highlighting its necessary imbrication in the public sphere and in commodity production.

2.

My parents survived hell and moved to the suburbs.
—ART SPIEGELMAN (sketch for *Maus*)

As a primarily visual artist, Spiegelman challenges dominant representations of the Holocaust by *drawing* attention to the pornographic effect of graven images within a Mickey Mouse industry dedicated to mechanical reproduction in the name of profit. But *Maus* also operates significantly on the level of text and, in doing so, takes part in the discursive production of contemporary Jewish identity. Spiegelman makes analogies between image and text "grammar" and claims that, unlike most of his projects, *Maus* is "a comic book driven by the word" ("Conversation"). This "word" can only refer to the words of the father which Spiegelman renders not as mystical text but as fractured speech—what Roth calls, in the case of his father, "the vernacular" (*Patrimony,* 181). As he makes clear in both volumes, Spiegelman created this comic book by taping Vladek's voice as he recounted his life and then transcribing the events with accompanying pictures into *Maus.* He makes a particular point of describing the pains he went to in order to ensure the "authenticity" of Vladek's transcribed voice. Many readers have testified that much of the power of *Maus* comes from the heavily accented cadences—the shtetl effect—of Vladek's narrative.[8] Spiegelman's staging of an exhibit on the making of *Maus* at the Museum of Modern Art, complete with the actual tapes of Vladek from which he worked, has, for most people, tended to reinforce this aura of documentary realism.

However, in a perceptive discussion of *Maus* and the MoMA exhibit, Nancy K. Miller has pointed to the illusion which grounds this version of realism:

> What surprised me when I listened to the tape was an odd disjunction between the quality of the voice and the inflections rendered in the panels. For while Vladek *on tape* regularly misuses prepositions—"I have seen on my own eyes," "they were shooting to prisoners," [and] mangles idioms . . . the total *aural* effect, unlike

the typically tortured *visualized* prose of the dialogue in the comic
balloons, is one of extraordinary fluency. (51)

A particularly good example of Spiegelman's (unconscious) ten-
dency to overdo his father's accent comes in a passage, featured in the
exhibit and broadcast on *Talk of the Nation,* in which Vladek recounts
the shooting of a prisoner, a shooting which reminds him of having
seen a neighbor shoot a rabid dog. In the book, Art has Vladek say,
"How amazing it is that a human being reacts the same like this neigh-
bor's dog" (*Maus II,* 82). But on tape, Vladek says simply and gram-
matically, "How amazing it is that a human being is like a dog." This
passage also contradicts Spiegelman's assertion that the changes he
made were dictated by the necessity of condensing Vladek's speech,
since in this case he adds words. For related reasons of affect, Spiegel-
man occasionally alters Vladek's words to keep up with the changing
language habits of contemporary English-speaking Jews, as when he
renders his father's phrase "We were talking Jewish" as "We spoke
Yiddish" (*Maus I,* 150); this subtle semantic gentrification registers the
uneasiness at the heart of Jewish identities, as well as their susceptibil-
ity to change over time.[9]

Spiegelman is right: the power of *Maus* does derive from his father's
words and evocative accent. But a close analysis of these words demon-
strates the artist's reconstruction of a marked dialect. In *Jewish Self-
Hatred,* Sander Gilman discusses the perception of Jews as possessing
a "hidden" and devalued language of ethnic difference called, appro-
priately enough for Spiegelman's work, "mauscheln." Gilman quotes
"Hitler's racial mentor, Julius Streicher," for his description of this
perceived "hidden language of the Jews": "'Speech takes place with a
racially determined intonation: *Mauscheln.* The Hebrews speak Ger-
man in a unique, singing manner. One can recognize Jews and Jewesses
immediately by their language, without having seen them'" (312). Argu-
ably, an element of self-hatred exists in Spiegelman's careful "maus-
chelnizing" of *Maus,* displaced into aggression against the vernacular
of the father. But another reading of the linguistic manipulations of
the book, analogous to my reading of the images and the animal motif,
would emphasize the irony, conscious or not, which uses caricature to
unsettle assumptions about the "naturalness" of identities. Self-hatred

and (more obviously) aggression against the father would then become not so much qualities of the work as two of its significant themes. The source tape of the passage from *Maus II* about the shooting of the prisoner/neighbor's dog carries another level of significance for an understanding of the verbal narration of the story. As John Hockenberry remarked to Spiegelman after playing the segment of tape on NPR, during Vladek's telling of the story the barking of dogs can be heard in the background ("Conversation"). Nobody, including Vladek, I would guess, could definitively say whether the dogs simply triggered the memory of the association between the prisoner and the dog in Vladek's mind, or, more radically, whether the association derived from the present circumstances of the narration. But, in either case, this example points to the importance of the moment of enunciation in the construction of a narrative.[10] This narratological insight is not simply a truism of literary analysis; *Maus* everywhere thematizes the constitutive relationship between the present and different moments of the past. The importance of this temporal structure emerges in various facets of the work: in the constant movement between the tense interviews between father and son and the unrolling of the Holocaust story; in the second volume's insistent self-reflexivity and thematization of writer's block; and in Spiegelman's practice—in exhibit and interview—of revealing the process of "making *Maus*."[11] Not simply a work of memory or a testimony bound for some archive of Holocaust documentation, *Maus* actively intervenes in the present, questioning the status of "memory," "testimony," and "Holocaust" even as it makes use of them.

3.

Pain is the most powerful aid to mnemonics.
—FRIEDRICH NIETZSCHE, *On the Genealogy of Morals*

Thus far I have not differentiated between the two volumes of *Maus*, but Spiegelman's style clearly changes during the course of the thirteen years of his work on this project. While both volumes focus on the interplay of the past in the present and the present in the past, as Spiegelman has remarked, *Maus: A Survivor's Tale: My Father Bleeds*

History concentrates more on the woundedness and wounding of the familial body, as its title suggests ("Conversation"). Because Spiegelman wrote much of *Maus II: And Here My Troubles Began* in the wake of widespread popular acclaim, the second volume explicitly interrogates its own status in the public sphere, reflexively commenting on its production and interrogating the staging of "the Holocaust." But given the serial nature of their publication in *RAW* over the course of many years, both volumes of *Maus* resist such easy binaries: the form and content of the comic strip's unfolding put into question the propriety of present/past and private/public distinctions.

Maus I, among its many functions, serves to catalogue "the Jew's body," an important concept in emergent Jewish theorizing which has been elaborated most fully by Sander Gilman in his book of that name.[12] In focusing on multifarious "representations and the reflection of these representations in the world of those who stereotype as well as those who are stereotyped," Gilman draws attention to the constitutive character of "difference," a category which need not succumb to the kind of binary ossification *Maus* resists (*Jew's Body,* 1). Spiegelman, like Gilman, anatomizes various Jewish bodies, including his parents' bodies and his own; he draws attention to feet (20, 83), eyes (40), hands (51), the beard (65), and the voice (throughout). Subtly but perhaps decisively different are the Jewish/mouse noses, understood in contrast to the upturned snouts of the Polish pigs. When Vladek and Anja walk as fugitives through Sosnowiec, Spiegelman shows them hiding their noses by wearing pig masks (as he himself will later don a mouse mask). But while Vladek is able confidently to feign Polishness, Anja's body leaks Jewishness, and her mouse tail drags behind her: "Anja—her appearance—you could see more easy she was Jewish" (136).

The emphasis on the body and its difference, as all commentators have noted, reinscribes the same essential ethnic differences that drove the Nazi war machine. But this discourse on the body is fundamentally destabilized by the more pressing truth about the Jewish body under Nazism which haunts Spiegelman's story: its disappearance. Richieu's and Anja's absence, and, by analogy, the absence of the millions of (Jewish and gay and Roma) victims, underlies Spiegelman's aesthetic choice of grappling with the Holocaust as an impossible visual text. Spiegelman's story does not seek, however, to flatten

out analogous differences into a morality tale of universalist pluralism, but draws its power from negativity: an intimacy with death, pain, and loss motivates *Maus*'s memory work. In the first volume, the multiply disappeared story of Art's mother, Anja, constitutes the primary wound around which the story turns and points to an almost erased narrative of Jewish gender relations.[13] Anja's story is absent for three reasons, all significant: her original diaries from Poland were lost in the war (indicating the immediate destruction at the hands of the Nazis); Anja cannot tell her own story because she committed suicide twenty-three years after the war (indicating the unassimilable damage to the "survivors"); and Vladek later threw out her notebooks, in which she probably reconstructed her diaries (indicating the legacy of violence reproduced in some "survivors") (*Maus I, 84*). *Maus I* builds toward the revelation of Vladek's crime against Anja and memory, which Art names "murder" (159). Anja's suicide and Vladek's inability to mourn her death radically upset the notion of "survival" which ordinarily legitimates the Holocaust memoir; as Art puts it, "in some ways [Vladek] *didn't* survive" (*Maus II,* 90). I do not think it would be an exaggeration to read this first volume as an attempt to occupy, or speak from, the impossible position of the mother's suicide; in this, Spiegelman's project resembles Claude Lanzmann's *Shoah,* which attempts "less to narrate history than to *reverse the suicide*" of many of its potential sources (Felman and Laub, 216).

Spiegelman cannot literally reverse his mother's suicide, but he does question representations of Jewish women in his careful tracing of Anja's absent place of enunciation. Such a strategy takes on further significance given the relative lack of attention paid in dominant culture to the specific bodies and lives of Jewish women, a fact which emerges in the contrast between *Maus* and the respective academic and literary discourses of Sander Gilman and Philip Roth. In *The Jew's Body,* Gilman writes that "full-length studies of the actual roles of Jewish women in this world of representations [of the body] and their own complex responses are certainly needed and in fact such studies at present are in the planning or writing stages by a number of feminist critics." Gilman goes on to assert, however, that his own work "has generally focused on the nature of the male Jew and his representation in the culture of the West; it is *this* representation which I believe

lies at the very heart of Western Jew-hatred" (5). Gilman points to the importance of the circumcised penis as an index of Jewishness, but, given the tendency of the last couple of generations of North Americans of all religions to circumcise their male children, perhaps this particular symbolic structure is waning. I don't find it unreasonable to assume, for example, that in a book dedicated to "the Jew's body," Orthodox women's shaved heads or the ubiquitous Jewish mother's body would merit chapters.[14]

Spiegelman, like Gilman, implicitly acknowledges the "need" for inquiry into the Jewish woman's body. But Spiegelman goes further in structuring his story around just such a lack, and in repeatedly drawing attention to the gendered violence that has produced this empty space in his family history: Art's mother has had her voice forceably removed by Vladek's stubborn annihilation of her diaries. The fictional and nonfictional writings of Philip Roth, which (I have already argued) also mobilize family stories and historical motifs to reconfigure Jewish-American identity, similarly foreground the gender asymmetry of those very stories. But—in contrast to Spiegelman's portrait of Anja—Roth renders his fictional mother, Selma Zuckerman, as essentially and eternally without language: her writing, for example, is belittled as consisting only of recipes, thank-you notes, and knitting instructions. In *Patrimony*, he depicts his real mother not as a producer of language but as an archive; this "quietly efficient" woman was "the repository of our family past, the historian of our childhood and growing up" (36). There are, in the memoir, suggestions of a kind of patriarchal violence analogous to that enacted by Vladek—Bessie Roth's "once spirited, housewifely independence had been all but extinguished by [Herman's] anxious, overbearing bossiness"—but, unlike Anja, Bessie is never granted an autonomous voice which transcends the domestic sphere (36). Although she presided within what Roth calls "her single-handed establishment of a first-class domestic-management and mothering company," the mother's restriction to this limited space by a patriarchal Jewish culture never becomes thematized since *Patrimony*, as its title suggests, is first and foremost the story of "the male line, unimpaired and happy, ascending from nascency to maturity" (37, 230). The mother is notably absent from (although one wonders if

she has taken) the family photograph which inspires this last formulation and which adorns *Patrimony*'s cover.

Both Roth and Spiegelman present narratives in which a certain version of history, the family, and the Holocaust implicitly disappears with the mother in the late 1960s and early 1970s. Selma Zuckerman dies after substituting "Holocaust" for her own name; Bessie Roth, the family "repository" and "historian," is "extinguished" upon Herman's retirement in the mid-1960s; and Anja takes her Holocaust testimony to the grave in 1968. In their wake, the history of the family and the "race" devolves into the hands of what Paul Breines, in a recent attempt to characterize post-1960s Jewish maleness, has called a "tough Jew." These three "tough" figures—Nathan, Herman Roth, Vladek—are all equally well described by what Roth calls "obsessive stubbornness" (*Patrimony*, 36).

The quality is indeed ambiguous, seeming to provide at once the means for survival in difficult situations (whether historical or medical) and the resources for self- and other-directed violence in domestic and public spheres. While Roth's writing certainly produces ambivalent feelings about the "tough Jew," only Spiegelman foregrounds the ways in which this new Jewish subject has emerged through the repression (in two senses) of Jewish women's bodies and texts and the ways in which it can initiate new tales of violence. The insertion into *Maus I* of the previously published "Prisoner on the Hell Planet"—the story of Anja's death—not only presents an expressionist stylistic rupture with the rest of the work but reopens the wound of the mother's suicide by documenting the "raw" desperation of the twenty-year-old Art. We should not read "Prisoner," however, as a less mediated expression of angst, despite its "human" characters and the reality-effect of the inserted 1958 photograph of Anja and Art. Rather, the "presence" of the maternal body here vainly attempts to compensate for what, many years later, remain the unmournable losses of Anja's suicide and of the years of psychic and political suffering which her life represents for Art. "Prisoner" draws attention to itself as at once *in excess* of the rest of *Maus*—a "realistic" supplement framed in black—and *less than* the mother (and the history) it seeks to resuscitate. With artist's signature and date (1972) following the last frame, "Prisoner" also complicates

Maus's moment of enunciation—it simultaneously stands apart tempo-rally and spatially from the rest of the work and yet is integrated into it. Like Art in this segment and throughout *Maus,* "Prisoner" cannot hide its difference from the totality of the family romance, but nor can it fully separate from the mother's story.

4.

By highlighting, once again, the complexity of the time of enun-ciation in *Maus,* "Prisoner" points to the possibility of reading the work as part of a historical process which Spiegelman has focalized through the family, but which opens into questions of public culture and politics. The moment of Anja's suicide—May 1968—serves as a touchstone for the countercultural rebellion which obviously informs Spiegelman's work. In the same year that "Prisoner" appeared in an underground comics magazine, for example, Spiegelman edited an (explicitly) pornographic and psychedelic book of quotations, *Whole Grains.* This book, dedicated to his mother, foreshadows some of the irreverence, eclecticism, and black humor of *Maus* (and even contains the Samuel Beckett quotation that Art cites in *Maus II* [45]), but it serves more as a marker of the cultural material of Spiegelman's life/career than as a developmental stage on the road to his masterpiece. The 1960s cemented Spiegelman's identity as an artist, putting him in touch, through the underground comics scene, with other "damned intellectuals"; in *Maus* and in the pages of *RAW,* he continues this tra-dition of underground comics-with-a-message, even after "what had seemed like a revolution simply deflated into a lifestyle" (Spiegelman and Mouly, 6).[15] Besides constituting a moment of general cultural upheaval, the late 1960s inaugurated a new era for Jews in North America, one which would provide the sociological setting in which and against which Spiegelman would create *Maus.* Around this time "the Holocaust" took on its central articulated importance in Jewish life—and it did so in a particular context. As Jewish liberation theolo-gian Marc Ellis writes,

> It is in light of the 1967 war that Jews articulated for the first time both the extent of Jewish suffering during the Holocaust and the

significance of Jewish empowerment in Israel. Before 1967, neither was central to Jewish consciousness; the Jewish community carried on with a haunting memory of the European experience and a charitable attitude toward the fledgling state. After the war, both Holocaust and Israel are seen as central points around which the boundaries of Jewish commitment are defined. (3)

For Ellis, it is imperative that Jewish people of conscience pass beyond the now problematic dialectic of innocence and redemption which poses all Jews as innocent victims and sees the state of Israel as a messianic redemption. Theology—indeed all discourse—that partakes of the innocence/redemption dialectic ultimately serves as a legitimating apparatus for Jewish chauvinism and for the Jewish state, since, within its terms, we cannot acknowledge Jews as themselves victimizers, either as individuals or as a collective.

Spiegelman's *Maus* operates precisely in this troubled space "beyond innocence and redemption." The Jewish subjects he produces are certainly not innocent (they're barely likable), nor have they found redemption in Rego Park, the Catskills, SoHo, or indeed anywhere. The depiction of Vladek—a survivor—as a purveyor of violence in his own home, especially against his second wife, Mala, raises the crucial question of how a people with such a long history of suffering (one which continues to the present) can in turn become agents of violence and torture.[16] While neither volume of this comic strip addresses the question of Israel/Palestine (except for one ironic aside in *Maus II* [42]), in an interview Spiegelman makes a rather interesting comment which I believe invites this contextualization. During the discussion of *Maus* on NPR, Spiegelman alludes to the newscast which had opened the show. The top three stories, he notes, were on Pat Buchanan, South Africa, and an Israeli invasion of southern Lebanon in which Israeli tanks crushed U.N. peacekeeping vehicles. Spiegelman calls these three disturbing news stories evidence of the "constant reverb" of the past into the present which *Maus* seeks to illuminate, "if you dig my drift." The drift is that for post-1967 diasporic and Israeli Jewish communities, any text which explicitly challenges sentimental renderings of the Holocaust also implicitly challenges that tragedy's dialectical double—the legitimacy of Israeli incursions into Arab land.[17]

In the United States today, for Jews to speak out against the policies of the state of Israel, or to question the uses to which the Holocaust has been put, almost guarantees them unofficial excommunication from the Jewish community.[18] Although it carefully and provocatively explores the specificity of different generations of Jewish-American identity, *Maus* does not explicitly raise the question of American Jews' relation to the policies of Israel. To do so would have been (in my opinion) to lose the mass audience so important to the book's effect among Jews and non-Jews. Revealing Jewish racism against African-Americans, as Spiegelman does, falls within the mainstream realm of possibility and might be considered part of a coded effort to demystify Jewish-American complicity with the state-sponsored crimes of Israel (*Maus II*, 98–100).

In any case, the true strength of Spiegelman's critique comes from his presentation of a people situated "beyond innocence and redemption," in that implausible ethical space which Jews must occupy in relation to their troubled history. In this sense, I believe, Spiegelman avoids what Edward Said has justly called "a *trahison des clercs* of massive proportions," the "silence, indifference, or pleas of ignorance and non-involvement [on the part of Jewish intellectuals which] perpetuate the sufferings of [the Palestinian] people who have not deserved such a long agony" (xxi). To remember genocide without abusing its memory, to confront Jewish violence while acknowledging the ever-present filter of self-hatred—these are the difficult intellectual tasks which mark the minefield of identity explored in *Maus* through the "lowbrow" medium of comics.

Maus as a whole works through the desacralizing and secularization of Jewish experience, but the second volume, in particular, marks a further crisis in Jewish identity. Through a staging of his own anguish at the success of the first volume, Spiegelman interrogates the ambivalent concept of Jewish power, especially the cultural capital won through the re-presentation of the Holocaust. Spiegelman condenses in one frame (which has attracted the attention of nearly all commentators) the various forces which unsettlingly intersect in *Maus*. At the bottom of the first page of the chapter "Auschwitz (Time Flies)," Spiegelman draws Art seated at his drawing board on top of a pile of mouse corpses (*Maus II*, 41). Outside his window stands the concen-

tration camp guard tower which also figures in his "about the author" self-portrait; around the man in the mouse mask buzz the "time flies." Art's thought bubbles read, "at least fifteen foreign editions [of *Maus*] are coming out. I've gotten 4 serious offers to turn my book into a T.V. special or movie. (I don't wanna.) In May 1968 my mother killed herself. (She left no note.) Lately I've been feeling depressed." Meanwhile, a voiceover—revealed in the next frame as a camera crew—calls ambiguously, "Alright Mr. Spiegelman . . . We're ready to shoot!" Among other meanings hovering, like the flies, in this frame, the overlay of positions and temporalities communicates an important fact about anti-Semitism: its effects persist across time and situation; someone is always "ready to shoot," even when no Nazis are visible and the media is under your control.

But the successful, avant-gardist artist has another difficulty to confront: his own implication in the scene. Who, after all, is responsible for the corpses at Art's feet, this frame asks? How would Spiegelman draw a pile of Palestinian corpses, I wonder? Art lets us know that he started working on this drawing in 1987, the same year the *intifada* brought Israeli repression into renewed focus, thus ending the triumphalist era which ensued from the 1967 war and putting the Holocaust/Israel dialectic under increasing pressure in mainstream American politics.

Art's guilt and depression, as thematized here, arise from his inability to make his mother reappear or the corpses (past and present) disappear. Instead, he finds himself unwillingly positioned as a willing victim of the culture industry. This industry—against which Spiegelman constantly defines himself—underwent its own crisis in the years between the publication of the two volumes of *Maus*. Articles proliferated on the deterioration of American publishing, and Spiegelman's own publisher, Pantheon, underwent a change in direction which caused an uproar among intellectuals concerned about the disappearance of nonmainstream work. In *Maus II,* Art finds that he can actively resist such commodification only through the contradictory gesture of directly addressing his audience and thus assuring that his success—based in the first place on such self-consciousness—will continue. Art's subsequent conversation with his shrink, Paul Pavel (who died in 1992), carries this double bind to its logical (in)conclu-

sion. Pavel, a survivor, wonders whether, since "the victims who died can never tell THEIR side of the story, so maybe it's better not to have any more stories." Art agrees and cites the aforementioned Beckett quotation—"Uhhuh. Samuel Beckett once said: 'Every word is like an unnecessary stain on silence and nothingness'"—but then realizes the bind: "On the other hand, he SAID it" (*Maus II, 45*).

The impossibility of staying silent—which Spiegelman's ceaseless work on *Maus* embodies—entails what Marianne Hirsch, following psychiatrist Dori Laub, has called "the aesthetic of the testimonial chain—an aesthetic that is indistinguishable from the documentary" (26), and that calls the reader into the story. The most striking example of this process, as Hirsch notes, comes at the end of the second volume when Spiegelman includes a photograph of his father taken just after his escape from the Nazis. This picture, sent to Anja as proof of his survival, was taken under strange circumstances: "I passed once a photo place what had a *camp* uniform—a new and clean one—to make *souvenir* photos" (*Maus II,* 134). This photo, which could have been taken of anyone, survivor or not, "dangerously relativizes the identity of the survivor" (Hirsch, 25). Taken out of the context of Vladek's message to Anja, it also marks the becoming-kitsch of the Holocaust. Thanks to the miracle of mechanical reproduction, anybody can be a survivor! Philip Roth draws on a similar iconography, but, at least in *Patrimony,* he leaves out Spiegelman's self-conscious ironization. Roth seeks to wrap his father simultaneously in the uniforms of sentimentality and "tough" Jewish survivorhood, a strategy which, we have seen, works through the abjection, or at least forgetting, of the mother's experience.

Spiegelman's relationship to the photograph is more complicated. He clearly recognizes the sentimental tradition it inaugurates, *but he also has to use it:* "I need that photo in my book!" he exclaims (134). In a gesture worthy of Beckett, *Maus* "stains" the "clean" uniform of Jewish suffering in the Holocaust; it reveals the impure basis of all Auschwitz *souvenirs.* Spiegelman "needs" to offer us this uniform because it figures the act of reading: for those living "after Auschwitz" (even those who, like Vladek and Anja, lived through Auschwitz), the uniform provides a kind of access, albeit highly mediated, to the events

themselves. As a "site of memory" (see Nora) the photograph—and by extension the book which contains it—creates the space of identification which Spiegelman relies on for affective and artistic success.

But identifications are always multiple, unforeseeable, and tinged with repudiation; readers are at least as likely to refuse to empathize with Vladek and instead to occupy Art's trademark vest—offered as a souvenir by an entrepreneurial "dog" (*Maus II*, 42). The vest, as opposed to the uniform, represents the power and risk of writing (and drawing): the ability and the need of those raised in what Hirsch calls "postmemory" to reconfigure their parents' stories without escaping either their failure to revive the dead or their recuperation by a dominant non-Jewish culture (8). Between the vest and the uniform, *Maus* unravels as "a survivor's tale" of "crystalline ambiguity."[19] Spiegelman demonstrates how "the Holocaust" ultimately resists representation, but he uses this knowledge as authorization for *multiplying* the forms of portraiture. In this mongrelized, highbrow/lowbrow animal tale, ethnic and familial identities hover between a painful present and an even more painful past, between futile documentary and effective fiction. Simultaneously reproducing and recasting Holocaust history, *Maus* partakes of the melancholy pleasures of reading, writing, and talking "Jewish."

This essay is dedicated to the memory of three Jewish-Americans: Nina Chasen, Benjamin Chasen, and Helene Rosenzweig. I am very grateful to Nancy K. Miller and Lucia Russett for insightful readings of earlier drafts. Thanks also to Karen Winkler for providing me with the NPR interview.

(1994)

The Language of Survival

English as Metaphor in Spiegelman's *Maus*

ALAN ROSEN

Writing on the Holocaust regularly reflects on the languages spoken by victims and perpetrators. However, English, as a primary language of neither, rarely and only marginally receives attention. Yet in *Maus*, Art Spiegelman emphasizes the extraordinary role English plays in aiding the survival of his father, Vladek. The prominence of English in the chronicle of events implicitly directs attention to the fractured English in which the survivor's story is told and, more generally, to the complex significance of language and languages in representing the Holocaust. *Maus*'s exceptional concern with English operates on at least three levels. First, in Vladek's biography, his knowledge of and competence in English is important both for initiating his relationship with his future wife, Anja, and for aiding or determining his survival while in concentration camps. Second, Spiegelman presents Vladek's narrative of survival in immigrant English, rife with errors and neologisms. In contrast to the biographical events recounted, Vladek's English here is noteworthy not because of competence but rather because of incompetence. Third, the fluent English of virtually all other characters (even those who, like the psychotherapist, Pavel, are also immigrants) frames and envelops both Vladek's biography and his Holocaust narrative, establishing English as the dominant language. These three levels interrogate the status

of English as a language of the Holocaust and, consequently, as a language (un)fit to recount the Holocaust.

Maus's interrogation of English can be situated in the context of previous efforts to assess the significance of specific languages in relation to the Holocaust. While these attempts have focused primarily on Yiddish, Hebrew, and German, they have also considered other European tongues, including English. Sidra Ezrahi, for example, positions English in opposition to Yiddish and German, the major languages, respectively, of the victim and persecutor.[1] In contrast, English, of little significance in the camps and ghettos, has a marginal standing, making it an "outsider," and marking it with "autonomy" and "purity." Moreover, Ezrahi places English in opposition in another way: as the chief language of the allies, English came to stand for "defiance," for "a different hierarchy of values," values presumably informed by the democratic ideals associated with English-speaking countries.

Yet if this ascription of purity and legacy of defiance implies for English a certain heroic stature, Ezrahi's schema also suggests its vulnerability: because it was not vitally implicated in the events of the Holocaust, English is less qualified to represent them. This reservation has informed writing and testimony in, and commentary on, English. One of the most important English anthologies of Holocaust writing, for instance, registers the degree that English stands, as it were, in the shadow of the primary languages. "The Book of Books, out of the depths of the Sacred Martyrdom," writes Israel Knox, the editor of that volume, "will not find its first and original home in English or French or Russian, but in Hebrew and Yiddish."[2] Even though some languages can serve testimony better than others, he continues, "no item was included or excluded [from the anthology] solely because of language." Yet when out of a wish to be "comprehensive and representative," Knox cites languages other than the primary ones, he does not refer to English: "There are items here from Yiddish and Hebrew but also from the French and German and Russian and Polish" (xv). To be sure, he goes on to note that the "sensitive and perceptive" reader will be able to distill the essence from an English translation. But at best, English plays only a tertiary role.

Intervening in this complex, even antithetical, legacy of English as a language of the Holocaust, Spiegelman's *Maus* makes the position

of English itself a theme. Indeed, this self-reflexive investigation of English begins with the title. On first hearing, the title would seem to be in English, the word "maus/mouse" paralleling the audacious animal imagery Spiegelman uses to represent the Jews. But while the title is phonetically English, Spiegelman actually writes (draws?) it in German, a gesture that not so much eliminates the English as, I would suggest, contaminates it, associating it with, rather than opposing it to, the essential languages of the Holocaust.

This strategy would seem to endow English with an authority that it previously lacked. There are, however, several ways that the association not only confers authority but provokes suspicion. First, the title links English with German, the language of the persecutors, a linkage that implicitly associates English with the debate regarding the fitness of German as a language of representing the Holocaust. And second, the devious German of the visualized title estranges the English, making it, for the American reader, not only curious but foreign, rendering the once familiar and comfortable into something strange and disconcerting.[3]

Spiegelman's choice of title suggests the complex ways he reformulates the issue of representing the Holocaust in English. On the one hand, he challenges its legacy of purity, moving English from outside to inside the Holocaust. On the other hand, by positing English as foreign, Spiegelman frustrates the American audience's sense of familiarity, moving the reader, in a sense, from inside to outside the Holocaust.

This essay will elaborate the strategies that Spiegelman employs throughout *Maus* to effect this reformulation and revaluation of English. Admittedly, to foreground the verbal dimension of *Maus* perhaps seems to miss what is most singular about its approach to the Holocaust: the cartoons. But as these preliminary comments suggest, this graphic novel compels attention to its words.

1.

English becomes a subject in the first represented conversation between Vladek and Anja. Vladek reveals to Anja that he has deciphered the private conversation in which Anja and her cousin praise Vladek (*Maus I*, 16). Anja and her cousin spoke in English to protect

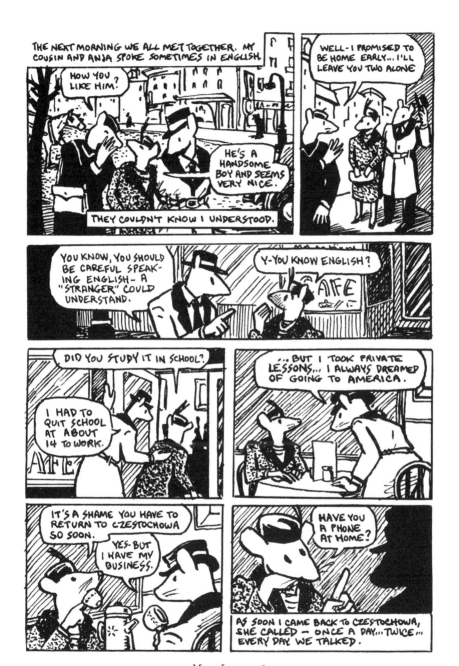

Maus I, page 16

their secret; Vladek's capacity to "know" English comes as a surprise, displaying not only his hitherto hidden capacity to negotiate English but also his access to the secrets that, in this case, were conveyed within, and by means of, English. English thus initially takes on a number of striking associations. As a language of secrets, English signifies a language spoken to prohibit understanding, specifically the understanding of the one who is being spoken about.

The associations around secrecy, resistance, and access also address the complex relation of Vladek and Anja as presented in *Maus*. For in this initial encounter, Vladek understands (or at least in his recounting suggests an understanding of) certain information that Anja would prefer he did not know. Whereas Anja resorts to English to deflect his understanding, Vladek employs it to appropriate a sensitive cluster of thought and feeling not his own. This dynamic parallels the ongoing issue of Vladek's belief that he has full access to Anja's story, a belief put in doubt repeatedly by Art's counterbelief that Anja's memoirs would give another, alternative version to the events his parents lived through.[4]

In his recounting of this episode, then, Vladek has command of even what seems most secret, most unpenetrable. In essence, English on this level suggests a fantasy of complete mastery. Indeed, it is a fantasy that accumulates economic, political, and psychological associations as the story unfolds.

Tellingly, the discovery that Vladek understands English (and hence understands the appreciation that Anja feels for him) steers their initial conversation to further consideration of the role of English in their lives, considerations this time dominated by economic and class issues. To Anja's question, "Did you study it [English] in school?" Vladek responds, "I had to quit school at about 14 to work," a reply that sets out sharply contrasting class assumptions and realities (*Maus I*, 16). In presuming that English is learned "in school," Anja is seemingly guided and constricted by her upper-class sensibility, a sensibility that takes for granted the leisure and resources for children to attend school. Vladek's motivation for learning English—"I always dreamed of going to America" (16)—continues to suggest contrasting class orientations. Whereas Anja acquires her English as part of a secure life lived in a land of plenty, Vladek acquires his based on a

"dream," a fantasy of secure life in a different land of plenty, America. The dream of America, while never spelled out, implies a society redeemed by an alternative social vision—a vision of radical social mobility and opportunity, in other words, where a child would not have to quit school in order to support a family. Such a dream also, of course, offers an alternative to the social stratification that so powerfully governs the contrasting methods by which Anja and Vladek have acquired English.

What America (and the English associated with it) stands for in *Maus* is ambiguous and complex, partaking of the associations of Vladek's dream but going beyond it as well. At this stage of *Maus,* English is not yet a language of survival.[5] Rather, this first meeting represents English as a romantic language of secrets and deciphering, as well as a property that is acquired through various kinds of labor. Indeed, it is through the speaking of, and the speaking about, English that one sees class as a key factor in accounting for experience and perception in *Maus.* Moreover, English also becomes the site in which fantasies of mastery, on the one hand, and transformation, on the other, are entertained and played out. These fantasies will continue to operate when, in three remarkable episodes in *Maus II,* English becomes the language of survival and the language of the survivor.

Early in *Maus II,* English returns to the foreground, serving as a form of knowledge that can generate extraordinary transformations. And in the context of the concentration camp, this power to transform can determine survival. After deportation to Auschwitz and separation from Anja upon arrival, Vladek tries simply to remain alive. Faced with little food, insufficient clothing, and a constant threat of brutal death, relief comes in an unexpected manner. The *kapo* of Vladek's barracks decides to find a tutor in English, and, after examining the proficiency of the candidates, the *kapo* deems Vladek the best qualified.[6] During his three-month tenure as the *kapo*'s tutor, Vladek is able to eat and dress well and to obtain the *kapo*'s protection. Under the eye of a Polish *kapo* interested in bettering his own circumstances, English becomes the key to survival.

English has such leverage because of, in the *kapo*'s words, its

"worth." The *kapo* wants to learn English because it will stand him in good stead with the allies when the war is over. In the *kapo*'s view, language is generally a means to improve social status, and English is the specific instrument to achieve that end in the future. The *kapo*'s reference to the worth of English indicates that English has the capacity not only to aid survival but also to secure privileged status in the society one inhabits. This view of the worth of English suggests that English is not pure, that it does not inhabit a place outside of camp society, but rather, like other commodities, it is subject to the particular logic and laws of camp life. And like other simple commodities in Auschwitz for which there is great demand and little supply, its value rises astronomically.

Vladek's competence in English, as well as the association with the *kapo* that it garners, enables him to achieve a meteoric rise in status. By means of this facility, he obtains not only food but also preferential clothing—"With everything fitted," says Vladek, "I looked like a million!" (*Maus II*, 33)—and secures privileges with which he can help friends. That Vladek's rise in status is so closely associated with his competence in English is powerfully suggestive. For paradoxically, in the midst of the deprivation of Auschwitz, Vladek's success fulfills his "dream of America"—a dream of transformation that presumably centered on the acquisition of material abundance and that, we recall, originally motivated his own study of English.

The power of English to transform circumstances continues even as conditions worsen. The next instance in which English figures centrally occurs in the last stages of the war, after Vladek tells of the death march that he and the other prisoners in Auschwitz were compelled to endure. Ending up in Germany, in the concentration camp Dachau, Vladek registers the new degree of torment that he underwent: "Here, in Dachau, my troubles began" (*Maus II*, 91). It is this phrase, of course, that Spiegelman uses for the subtitle of *Maus II*. On one level, the phrase is clearly ironic because it is absurd: Vladek's troubles began significantly before this. The clumsiness of Vladek's formulation is also emblematic of the problems involved in telling a story of this kind. By emphasizing through the subtitle an idiom that seems inappropriate for the circumstances to which it refers, Art calls attention both to Vladek's foreignness—his difficulty with mastering

English idiom—and to the foreignness of the experience—a degree of suffering that resists idiomatic formulation.

On another level, however, it is clear that Vladek (or Art) wishes to suggest with this phrase that a new dimension of anguish here enters the story, anguish generated by conditions in Dachau at the end of the war that bring Vladek closer to death than ever before—"we were," he says, "waiting only to die" (*Maus II,* 91). Here then, when conditions have become most acute, English once again determines survival. On the verge of starvation, Vladek meets a Frenchman who, in a camp filled only with Eastern Europeans, is desperate to find someone to speak to. Vladek and the Frenchman discover they have a common language, English, and daily conversation relieves the Frenchman's isolation. Grateful to Vladek, the Frenchman, a non-Jew who benefits from extra rations mailed to him via the Red Cross, "insisted," says Vladek, "to share with me, and it saved me my life" (*Maus II,* 93).

Several aspects of this episode recall the earlier situation in Auschwitz: Vladek's interlocutor is a non-Jew, a fellow prisoner, and English is a language foreign to both speakers. Again, Vladek's ability to speak English results in his receiving abundant food in a situation where others are starving to death. The worth of English, however, is at least tacitly redefined. English here is not valued primarily as a commodity but rather as a therapy, as a means of countering the madness of isolation that the Frenchman suffers.

The salvific encounter with the Frenchman in Dachau also recalls, in part, the original English episode with Anja. Here, too, Vladek's ability to speak English provokes in the Frenchman the question: "How you know English?" Vladek's response, moreover, is virtually the same as the one he gives to Anja, foregrounding the "dream of America" as the motivating force for learning English.

Once in America, however, Vladek's dream of the future becomes transformed into a nightmare about the past, and this transformation is most glaringly felt when Spiegelman refers again to the French benefactor, and to the English that linked him and his father. The two corresponded after the war, writing in English, an English that Vladek "taught to him." But Vladek destroyed the letters at the same time as Anja's memoirs.

Up to the end of the war, the English that plays such a vital role in

Vladek's story is spoken only by nonnative speakers, by those for whom English is the "other tongue."[7] Though thus far in *Maus II,* knowledge of English has meant the power to determine survival, "knowledge" refers only to a relative mastery, a timely, if partial, competence among those who have little or none. But when the American army arrives, the real masters of the language set the standard for competence. Thereafter, Vladek's knowledge of English no longer needs to be the key to survival that it was in the previous episodes. Nevertheless, English continues to play a vital, if altered, role in Vladek's story. Although no longer the language of survival per se, English becomes the language of the survivor. For in response to the army's command, "Identify yourselves!" (*Maus II,* 111), Vladek responds not by giving his name but by telling for the first time his story of "how we survived to here" (*Maus II,* 112). While still in Europe, then, Vladek first tells the story of the Holocaust in English, to an American audience, a telling, moreover, that is linked to identity.

Even while English is playing a key role in negotiating the change from survival to survivor and in constructing Vladek's postwar identity as a witness, the encounter with the native speakers of English ushers in another, more problematic, dimension. As the liberated Vladek settles in with the Americans, and English becomes the language of daily discourse, there is something unsettling about the relations that are mediated by the English that they speak. For, as it turns out, this

From *Maus II,* page 112

English is spoken as much by colonizers as by liberators. Initially, Vladek and his friend are permitted to stay with the Americans only on the condition that they "keep the joint clean and make our beds" (*Maus II,* 112). The condition, in other words, is that Vladek and his friend serve as domestic servants for the soldiers. Spiegelman accentuates the imposition of servant status in exchange for protection by drawing Vladek receiving gifts for shining shoes and being called "Willie"; the stereotyping task and nomenclature recall the stigmatized position imposed by white Americans on African-Americans of this era (*Maus II,* 112).[8] Although the American soldiers conquer the Nazis and set free their victims, the liberators are nevertheless primed, through gesture and language, to enact the role of colonizer, even subjugating (while liberating) those for whom, presumably, they have gone to war in the first place.[9] In this climactic episode, then, when English as other tongue encounters English as mother tongue, English becomes even more deeply associated with mastery and domination.

2.

How does this account of English as the language of survival inform the story Vladek tells in English, the story told by the survivor? How are we to understand the association of English with knowledge, with power, with transformation, and eventually, with the capacity to attest to one's identity, on the one hand, and the fractured English with which Vladek testifies, on the other hand? And how does the tension between English as the competent language of survival and English as the incompetent language of the survivor address the issue of representing the Holocaust in English and the issue, more generally, of representing the Holocaust? In one respect, the function of this "incompetence" is clear and forceful. Vladek's accented English is mimetically appropriate for a Polish-Jewish immigrant to America, and critics have noted in this light that Art has a "good ear."[10] But I want to suggest that Vladek's "tortured visualized prose" (the phrase is Nancy Miller's) is not only meant to represent an English-speaking "foreigner" but is also meant to torture English into being a foreign language.[11] Indeed, this quality of "foreignness" is the means by which

English can become a language of testimony. By fracturing Vladek's English, and by making it the most foreign language in *Maus* (a point to which I will return), Spiegelman uses it to convey the foreignness of the Holocaust itself.[12]

That Vladek's tortured English does more than reveal Spiegelman's ear for language can be appreciated by contrasting it with the way he represents the language of the other survivors in *Maus*. These other émigrés—Mala, Pavel, and Anja—also European-born and arriving in the United States no earlier than the end of the war, are candidates for an accent like Vladek's. But Spiegelman presents them as fluent in English, speaking like natives, virtually without accent. We know that these survivors are foreigners only by *what* they say and *what* is said about them, not by *how* they say it. It is for Vladek alone that Spiegelman reserves the distortions of syntax, the malapropisms, the quirky idiom—the stylistic correlates, as it were, of an accent.[13]

Although it is but the inflection of an individual voice, Vladek's accent also shapes the aesthetic structure of *Maus*, providing Spiegelman with the means to represent, and distinguish, present and past. For a time, says Spiegelman, he entertained the possibility of drawing the past episodes in black and white, the present episodes in color, but rejected such a blunt visual dichotomy as too simplistic.[14] Yet what resisted visual coding yielded to an aural one: for episodes in the past, Spiegelman uses fluent, colloquial English to represent the languages of Europe as spoken by their native speakers; for episodes in the present, Vladek's broken, accented English serves as a constant marker. On the surface, this strategy seems misguided; continental languages do not deserve an English better than English itself. But within the terms *Maus* establishes, Vladek's broken English becomes the means by which Spiegelman articulates the incommensurability between present and past.

Spiegelman's decision to place a distinctive burden on Vladek's English as a vehicle to represent the Holocaust came only after experimentation with other options. The earliest publication of the *Maus* project, a three-page vignette appearing in 1972, already draws Vladek recounting his ordeal by means of a tortured prose.[15] But for at least two reasons, Vladek's accented narration in this earlier installment is less well defined and exceptional than it becomes in the later full-

length treatment. First, Vladek speaks with an accent when he is recounting his story and also when he is shown in his European past; the distinction that informs both *Maus I* and *Maus II* between Vladek in America and Vladek in Europe, between Vladek in the present and Vladek in the past, does not obtain. And second, and perhaps even more fundamental, is that *all* European Jews "speak" with an accent. "The safest thing it would be that we kill him," says one of the Jews hiding in a bunker with Vladek ("Maus," 2). A decade or so later, in a revised version of this scene in *Maus I,* Spiegelman eliminates the accent, and now the Polish Jew says simply: "The safest thing would be to kill him!" (*Maus I,* 113).

The contrast between the vignette and the books shows an evolution in Spiegelman's representational vision of English. In the earlier version, every victim speaks with an accent, a strategy that divides the linguistic world of "Maus" between native speaker and foreigner, between American and European. In the books, however, the erasure of group accent and exaggeration of Vladek's individual one make Vladek's American English singular. Paradoxically, it is not the representation of the events of the Holocaust itself that is most foreign to the American readers of *Maus;* it is rather the *telling about* the Holocaust—the testimony—that carries the burden of everything foreign.

That Vladek's broken English testimony is meant to carry immense authority is attested by the single instance in which Vladek speaks from a different vantage point. On the way home with Vladek from the supermarket, Art's wife, Françoise, stops to pick up a Black hitchhiker, whom Spiegelman represents as speaking a highly inflected (and also "visually tortured") form of Black English. Vladek condemns Françoise's seemingly charitable gesture, using degrading racial stereotypes to justify his own admonitions (*Maus II,* 98–99). Inclusion of this unflattering view of his father's bigotry—Vladek himself, according to Art, seems not to have learned the lesson of the Holocaust—is clearly meant to complicate the reader's reaction to Vladek.

But the episode is made more remarkable by Spiegelman's deployment of Vladek's language. For at the moment when the hitchhiker speaks broken English, Vladek relinquishes his own. Instead, he expresses his bigoted regrets in his native Polish (the only example of Vladek speaking Polish in either *Maus I* or *II*), represented here first

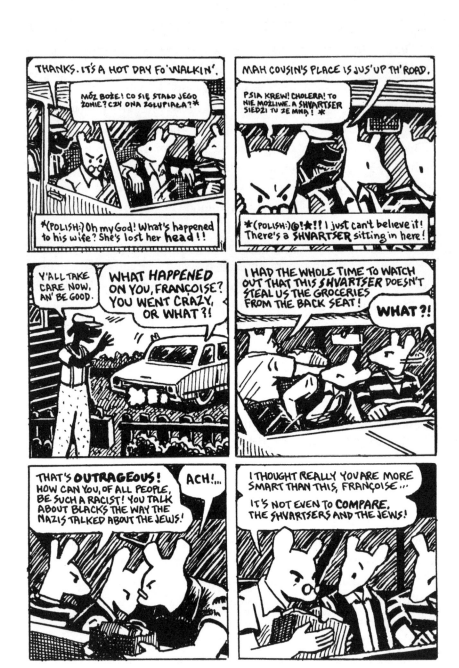

Maus II, page 99

in the original, then underscored with a fluent English translation. To be sure, Vladek's recourse to Polish allows him to vent his chauvinism without infuriating the other passengers in the car. But the movement from English to Polish also mobilizes a set of representational values. No longer telling the story of the Holocaust, but rather uttering racial slurs, it is as if Vladek has forgone the right to the tortured English that is the vehicle for his testimony. In reverting to his native Polish, he finally regains a fluency—even the English translation has overcome the foreignness that defines his usual American voice—but that fluency comes at the expense of, and suspends, the authority evinced by his tortured English. Moreover, the episode witnesses a shift of roles and voices. For the Black hitchhiker himself, the victim of Vladek's bigotry, speaks an English that, in its idiosyncrasy and visual effect, approximates the foreign English that defines Vladek's authoritative voice as a survivor.

On one level, then, *Maus* celebrates English. By displaying its heroic capacity to transform and pacify the most adverse conditions, *Maus* conveys a sense of the unlimited power of English, of its almost magical potency, even of its harboring the secret of life and death. Seemingly, English can master anything it confronts, can dominate whatever demands subjection. This celebration would seem to authorize English as a language of testimony, investing it with the knowledge and power to chronicle the events of the Holocaust with unparalleled eloquence. This glorification of English would likely confirm what American readers of the late twentieth century believe about the language they—or their neighbors—speak.

On another level, however, Spiegelman's graphic novel tells a story about limitations, and particularly about the limitations of English as language of the Holocaust. *Maus* inscribes these limits ironically, designating fluency, competence, and mastery as relative and questionable accomplishments. The very capacity to use words well often becomes the ironic sign of blindness and coercion. Significantly, *Maus* enforces the limitations of English by representing as authoritative an English that is uniquely broken, incompetent, unmastered. Indeed, the only English by which to tell "a survivor's tale" is one that is singularly foreign. Such a repositioning of English would seem to go against expectations of an American audience, asking them, asking us, to

question the fantasy—one that *Maus* itself rehearses—that English can know and master everything, even the Holocaust.

I am grateful to Alan Berger, Ruth Clements, Jorg Drewitz, Nancy Harrowitz, Lindsay Kaplan, and Herbert Levine for their reading of and comments on various stages of this manuscript.

(1995)

Holocaust *Laughter?*

TERRENCE DES PRES

Writing about the Holocaust is like any other writing insofar as the field of Holocaust study requires unproved, and usually undeclared, principles to generate order and authorize perspective. At one time, the critical term for a writer's unverified assumptions was *myth*. More recently, the notion of informing *fictions* has come to the fore, although the term *ideology* is also used, as when in their study of Bakhtin, Clark and Holquist write: "Ideology in this sense is locatable in all that texts take for granted, the preconditions held to be so certain by their authors that they need not be stated."[1] In every case, we recognize that texts and fields cannot go forward without grounding in attitudes that are themselves groundless. And it is not only ideas that function in this way; as Foucault has pointed out, any body of knowledge depends on methods that are officially prescribed, in particular "the techniques and procedures accorded value in the acquisition of truth [and] the status of those who are charged with saying what counts as truth."[2] Some system of practice and belief, some format of permission and taboo, must be accepted before knowledge becomes possible—a "regime of truth" from which discourse takes its bearing and legitimacy.

That writing depends on fictions, on principles of organization that cannot be proved or even accounted for, is perhaps apparent; it is also, with the agony of Auschwitz in mind, a little shocking. For as soon as we ask if the field of Holocaust studies is, like other fields, ordered by

an uncertified set of assumptions and procedures, we have to concede that it is. The artists among us go forward in any way obsession compels or invention points. But those of us who interpret these things, if we want our ideas accepted by a community of peers, conform to the fictions that underwrite our enterprise. It is true, of course, that fields reconstitute themselves. Newer fictions supplant others no longer helpful or exciting. It seems possible that the field of Holocaust studies might modify itself in this way—or even, at this distance from the event, that a change is under way. My concern, however, is less to chart new directions than to establish the fact that fictions shape discourse generally; and that, in writing about the Holocaust, we are at every moment governed by rulings of this fictional kind. At present, the following prescriptions set limits to respectable study.

1. The Holocaust shall be represented, in its totality, as a unique event, as a special case and kingdom of its own, above or below or apart from history.
2. Representations of the Holocaust shall be as accurate and faithful as possible to the facts and conditions of the event, without change or manipulation for any reason—artistic reasons included.
3. The Holocaust shall be approached as a solemn or even a sacred event, with a seriousness admitting no response that might obscure its enormity or dishonor its dead.

These fictions are not tyrannical; but, even so, they foster strong restrictions. They function as regulatory agencies to influence how we conceive of, and write about, matters of the Holocaust. Because they are fundamental and widely shared, we are convinced of their authority and accept them without question. The third of these is my concern—the attitude of solemnity, as we might call it—but I have cited three to establish the notion of a class. We might see, moreover, that any of these is enforced by the others: the Holocaust is unique, its data cannot be trifled with, and we respect these conditions by staying within the bounds of high seriousness.

In the opening essay in *Writing and the Holocaust,* Raul Hilberg says that the Holocaust remains "a novel event" and "a new marker in history," something "new in the history of the world, something

almost out of this world." Professor Hilberg goes on to point out that our deepest responsibility is to bear witness by rigorous attention to what happened, as if, perhaps, the integrity of the facts was absolute. So fierce an obligation, in any case, rules out imagination and looks upon the artist's creative response with distrust. There is, however, a problem. If the event cannot be seen within the long continuum of human experience, while at the same time the facts are self-sufficient, how shall the Holocaust be written about at all—assuming that representations of the world are necessarily different from the world in itself? In terms of literary response, moreover, are some genres useful while others are not? Tragedy, perhaps, but not comedy? When Elie Wiesel says that a novel about Auschwitz is either not a novel or not about Auschwitz, does he mean that, in this special case, fiction cannot cope? Or does he mean—as Hilberg implies—that in the presence of this awful godlike thing, no graven image is permitted?

A set of fictions controls the field of Holocaust studies and requires of us a definite decorum, a sort of Holocaust etiquette that encourages some, rather than other, kinds of response. One of these fictions dictates that anything pertaining to the Holocaust must be serious, must be reverential in a manner that acknowledges the sacredness of its occasion. This imperative is natural, or so at first we feel. But when we come to questions of literary treatment, especially to the disposition of literary modes, difficulties arise. In particular, the *problem of response* is surrounded by questions. To begin with, is laughter possible in literary treatment of the Holocaust? If possible, is it permitted? Is the general absence of humor a function of the event in itself, or the result of Holocaust etiquette—or both? Laughter may or may not be possible; but it is not too much to say that most of us take a dim view of jokes or playfulness in matters so painful.

Since the time of Hippocrates, on the other hand, laughter's medicinal power has been recognized, and most of us would agree that humor heals. Even so, can laughter be restorative in a case as extreme as the Holocaust? That something so slight should alleviate the burden of something so gigantic might, on the face of it, be a joke in itself. But then, humor counts most in precisely those situations where more decisive remedies fail. The situation, in this case, is our helplessness facing our knowledge of the Holocaust. The question is whether or

not, on occasion, laughter can be helpful. We know the ready answer because we know what has been said, namely, that toward matters of the Holocaust the comic attitude is irreverent, a mode that belittles or cheapens the moral severity of its subject. At the same time, no one disputes its survival value. In dark times, laughter lightens the burden. Possibly this accounts for the fact—to which I will return—that in his *Notes from the Warsaw Ghetto* Emanuel Ringelblum included the many jokes that kept people going in the ghetto.

I would like, at this point, to cite three works of fiction that span the duration of literary reaction to the Holocaust, all of which are comic in degree, though by no means alike or even similar. The books I have in mind are Tadeusz Borowski's *This Way for the Gas, Ladies and Gentlemen,* first published in story format in 1948; then Leslie Epstein's *King of the Jews,* which appeared in 1979; and, most recently, published in book form in 1986, Art Spiegelman's *Maus.*[3]

Whereas *King of the Jews* is comic in a multitude of ways, including play of language as well as management of plot, the other works are comic mainly in conception. The literary conceit at the heart of *This Way for the Gas* is the narrator's pretense of normality. In *Maus* the governing conceit is the cartoon itself, the comic book pretense that Jews are mice and Nazis cats. In all three cases, however, the world depicted is grotesque and exaggerated by virtue of its comic perspective. Of course, the actuality of the Holocaust is already exaggerated and grotesque. Here, however, actuality is displaced by a fiction—by a *what if*—that is durable enough, and skillfully enough imposed, to inform the narrative with its own invented principle.

Displacement is the goal of any story, in degree; all fiction aims to usurp the real world with a world that is imagined. In comedy, however, the revolt is more pronounced, and we might suppose that without Borowski's pretense of normality, or Epstein's larger-than-life figure of the trickster, or Spiegelman's game of cat-and-mouse, the books I have cited would be as grim as the world they refer to. It is largely for this reason, moreover, that realistic fiction so often fails. In its homage to fact, high seriousness is governed by a compulsion to reproduce, by the need to create a convincing likeness that never quite succeeds, never feels complete, just as earnestness feels inadequate to best intentions. Comic works, on the contrary, escape such liabilities;

laughter is hostile to the world it depicts and subverts the respect on which representation depends.

The crucial distinction, in this case, has much to do with the different ways the world of actuality is accepted (and blessed) or rejected (and cursed) by different literary modes. Whereas tragedy and lamentation affirm the authority of existence, and proceed in a mimetic mode that elevates *what is*, the comic spirit proceeds in an antimimetic mode that mocks *what is*, that deflates or even cancels the authority of its object. Tragic seriousness, with its endorsement of terror and pity, accepts the terrible weight of what happens. There is thus a connection between solemnity and reverent regard for the burden of the past, a sense of responsibility, perhaps also of guilt, that unites us with the scene of suffering and quiets us with awe.

Of the many imperatives informing Holocaust studies, none is so potent as the need to affirm historical authority—in this case, a strict fidelity to the memory of the camps and the ghettos. Our way of saying Never Again is to insist that the Holocaust took place, and then to ensure—through the act of bearing witness—that this unique evil and pain are wholly with us even now. We preserve the truth of the event by saying yes to the authority of the Holocaust over our spiritual lives, allowing its shadow to darken our judgment generally. We guard the future by bondage to the past. This seems a noble posture, reassuring, but perhaps also debilitating.

The tradition of high seriousness will not be abandoned, but at this point in time—a certain weariness having settled upon us—I want to consider the energies of laughter as a further resource. We know, to begin with, that a comic response to calamity is often more resilient, more effectively equal to terror and the sources of terror than a response that is solemn or tragic. Why this should be so takes us again to the difference in genres (genres considered as frames of reception in terms of which we settle our relation to the world). The mimetic mode is proper to high seriousness because tragedy celebrates the mystery of what comes to pass. The antimimetic mode is proper to comedy because the comic spirit ridicules what comes to pass. Laughter revolts (and from the perspective of lament appears revolting). The works I have cited enact this resistance; they refuse to take the Holocaust on its own crushing terms, even though all three depend for their foun-

dation upon sharp memory of actual events. In each case, however, what survives is the integrity of an imagined world that is similar to, but deliberately different from, the actual world of the Holocaust. Our knowledge of history is not denied but displaced, and we discover the capacity to go forward with, so to speak, a foot in both worlds. A margin of self-possession is thereby gained, a small priceless liberty, urging us to take heart.

Of the books cited, *This Way for the Gas* affords the least amount of breathing space, the least distance between actuality and comic displacement. Tadek, the principal character, tells us that "having, so to say, broken bread with the beast," he has become one with the world of Auschwitz (111–112). The horror of the camp, for such as himself, becomes normal. He and his fellows speak with easy familiarity about "the ramp," "the Cremo," and "the puff." When things are going well they say, "Keine Angst" ("No problem"). The perversity of the German phrase resides in the comic incongruity of superficial meaning (as in "No problem") with meaning truly horrible (as in *Todesangst*, a term for "mortal fear"). In *This Way for the Gas*, ordinary behavior mocks and is mocked by simultaneous behavior entirely inhuman, as when, on the ramp, Tadek and his comrades take pleasure in eating while they shove children and whole families to their deaths.

In Borowski's narrative, horror and banality join, and a central ludicrous moment emerges to repeat itself each time the main character slips, each time he loses his ironic grip and falls back into his humanity. In one instance, a prisoner in the women's barracks, Mirka, has hidden a baby she is trying to save. Of course, the child will not be saved and, seeing the stupidity of the attempt, Tadek is suddenly possessed by "a wild thought" and says to himself: "I too would like to have a child with rose-colored cheeks and light blond hair. I laugh aloud at such a ridiculous notion" (89–90). It is not that his laughter is comic, but that an elementary human response is out of place, has become ridiculous and wild. Possibly only those *too* familiar with the camps will appreciate Borowski's point—as if laughter were, in this case, a curse upon us all.

This Way for the Gas is a ferociously ironic book, and nothing so genteel as humor can be said to exist within its pages. The kind of laughter that confers charity and saving grace is altogether absent.

Not distance but violent proximity is its aim. Borowski sets his comic energies against the world of Auschwitz, but also against the world that allowed Auschwitz to happen, and then against the self's helpless decency as well; thus, in the end, his laughter is set against life altogether. Back home, having survived the camp and the war, Tadek feels "full of irreverence bordering almost on contempt" (179). That is *one* kind of Holocaust laughter. Almost wholly negative, it can be called demonic, a kind of self-conscious ridicule devoid of redemptive power except for the vigor of mockery itself. The comic spirit is often ambivalent, cursing and blessing at once, but in *This Way for the Gas* the curse is nearly total. Reviling that which overwhelms him, Borowski is in hopeless revolt; hence his inflexible stance and grim disregard for the reader.

By contrast, in Leslie Epstein's *King of the Jews* the narrator's voice promotes a wonderful civility, a sweet insistence on decorum in a world where decorum sounds out of place and quaint. The narrator addresses us as "ladies and gentlemen," and assumes that those to whom he speaks (the readers) are an extension of the community he speaks about (the imaginary ghetto). This emphasis on community is part of the fiction and a cardinal point to keep in mind. Even in its zany naming, the novel assigns a communal as well as a private identity to its characters—for example, Phelia Lubliver, the Ghetto Queen, or Urinstein, Minister of Vital Statistics, and of course Chaim, who is the ghetto's Elder. For the most part, behavior among the Ghettoites of Suburb Balut is bizarre, frenetic, but almost always shared. In this way, Epstein's novel presents a comic spectacle that is larger than life (which seems, on reflection, to be a paradox of the Holocaust itself, at once much larger—yet greatly lesser—than life). But the goings-on in Epstein's novel are large in a more comprehensive way, as well, and take their gross size and shape from a kind of folk or communal laughter that Mikhail Bakhtin, in his book on Rabelais, calls "carnivalesque."[4]

I do not mean to say that the Holocaust becomes a carnival, but rather that in a world of death the spectacle of life defending itself is open to unusual perspectives. In Bakhtin's view, carnival laughter draws its authority from utopian hunger in general. It attacks all rules, regulations, and hierarchies, and revolts against any order that

claims to be preeminent or fixed. Things lofty, grand, and solemn are degraded, pulled down to earth, officialdom and worldly power first of all. At the same time, carnival laughter celebrates the regenerative powers of human community as such, life and the plenitude of life, and proceeds by way of vulgarity and excess. Food and sex take on exaggerated value as the functions of the belly and genitals are magnified. Lower forms of humor—jokes, puns, slapstick, and clowning—prevail in an endless spectacle of humble becoming. Here, then, is an appalling feast of fools. Here is neither terror nor pity but, rather, a fearless affirmation of life against death.

Such is the sense of carnival laughter in Bakhtin's definition. To connect it with the Holocaust, let us go back for a moment to Ringelblum's *Notes*, in particular to the jokes he recorded as he observed them circulating in the Warsaw ghetto. Here are three:

A Jew alternately laughs and yells in his sleep. His wife wakes him up. He is mad at her. "I was dreaming someone had scribbled on the wall: 'Beat the Jews! Down with ritual slaughter!'" "So what were you so happy about!" "Don't you understand? That means the good old days have come back! The Poles are running things again!"

Horowitz [Hitler] asked the local Governor General [Hans Frank] what he has been doing to the Jews. The Governor mentioned a number of calamities, but none of them sufficed for Horowitz. Finally, the Governor mentioned ten points. He began: "I have set up a Jewish Self-Aid Organization." "That's enough; you need go no further!"

H[itler] is trying to imitate Napoleon. He began the war with Russia on the 22d of July [*sic*], the same day Napoleon invaded Russia. But H. is already late. . . . They say that at the beginning of his Russian campaign Napoleon put on a red shirt, to hide the blood if he should be wounded. H. put on a pair of brown drawers.[5]

In examples one and two, the community laughs at itself. In the third case, the community laughs at its enemy, exploding its fear with a punch line. These jokes are part of the historical record and are sig-

nificant in the following ways: (1) they are the property of the ghetto community; (2) they are examples of carnival humor, in which bodily existence is emphasized and disaster is absorbed by the community at large; and (3) these jokes reappear, along with others from Ringelblum, in *King of the Jews*, in which Hitler is called the Big Man and is often referred to as Horowitz. I take it that Epstein sees what Ringelblum sees, an entrance to the hidden spirit of the ghetto through its jokes, a view of communal underlife that opens the possibility for a comic enactment of life against death, and thus for a representation of the Holocaust that includes laughter.

As I suggested earlier, the major scenes and episodes in the novel are communal, often with the entire ghetto population involved. There is, however, one exception. In the part of the novel entitled "The Yellow Bus," a single citizen of the ghetto—the boy Lipiczany— follows the route of the resettlement trains to see where the deportees are being transported. They are sent to their death, of course: first to be gassed in a bus, then disposed of in a nearby ravine. Here the community is absent, and so is the lively spirit of carnival laughter. Insofar as comedy survives, it is the muted laughter of last blessing. In a situation where the victims are often condemned for going to their deaths "like sheep," Epstein's humor commiserates with the frail humanity of those who perish.

The rest of the narrative takes place in Suburb Balut, in an embattled situation where the social order of the ghetto, organized in fluid ways to promote life, is set upon by the inflexible order of Hitler's "death's-head" regiment, organized to maximize destruction. All survivors of the camps remember the intense necessity referred to by the term "to organize," the need to steal and improvise and trade in order to support collective life, a kind of fluid organization distinct from the infamous "organization" of Hitler's killing-machine. In the world of the Holocaust, moreover, the organization of death is the official order; the organization of life is unofficial, against the law, and exists as an undersurge of renegade energies supporting the community in a multitude of spontaneous ways. Between these contrary orders is a no-man's-land occupied by the *Judenrat* and even more, of course, by the Elder himself. The ambiguity of these border positions is extreme, undecidable. Ghetto leaders are forced to preserve a hidden order of

life by accommodating the official order of death; and, inevitably, the realms of life and of death begin to be fused.

Epstein's characterization of the ghetto's leadership thrives on the inherent ambiguity of power's position. Twice the goings-on of the *Judenrat* are presented, each time as dramatic, highly comic dilemmas. The first of these episodes enacts the formation of the Council's initial membership. Notables gather at the ghetto's grand café, the Astoria, to appoint a Council of Elders. The sixteen slots are grabbed by the ghetto's rich and influential citizens, who expect their official position to save them. But in fact they were tricked, and in the street they find themselves trapped: "There, between the gutters, in their underclothes, or wearing no clothes at all, were the Council of Elders, hopping like frogs over each other's backs. On either side, holding a pistol, stood a Totenkopfer. Laughing. Joking. Puffing a cigarette" (*King of the Jews*, 70).

One of the novel's grander debacles, the demise of the first *Judenrat,* is horrific and ludicrous alike—a scene outrageous to readers unused to comic mediation in literature of the Holocaust. That the SS did sometimes force captive Jews into the "game" of leapfrog would seem to rule out any response except the sternest lament. Yet what can lament, or any mode of high seriousness, do with behavior so bizarre? Vigorous ambivalence is perhaps a better, more capable response in cases so appalling and funny at once, a kind of ambivalence that is the especial domain of carnival laughter.

In the later *Judenrat* episode, the members must produce the first list of victims for deportation, a list that the decency of the Ghettoites forbids them to draw up. In despair, they collectively decide to commit suicide, and everyone on the Council takes poison. They appear to be dead, but then Trumpelman arrives to resurrect them, and in gratitude for a second life they compose, pell-mell and in a frenzy, the list required of them. Their death was a hoax brought on by poison that was "just sleeping pills." The scene is certainly funny, perhaps also outrageous, but in it we see the activity of actual ghetto councils in all their ambiguity, the sort of sad, insufficient endeavor that makes action in extremity difficult to judge—and not so easily dismissed by the kind of condemnation in hindsight that surrounds the historical record of *Judenrat* behavior.

The great point—without which there could be no comedy—is that in *King of the Jews* the characters assert themselves as members of a community. In one of the novel's central episodes, the communal character of events takes political form and results in an energetic, if short-lived, surge of festival triumph during the period of the General Strike, led by the "fecalists"—those whose humble job is the removal of the ghetto's waste. The artist Klapholtz has been shot for painting the Jacobin tricolor on the ceiling of the Church of the Virgin Mary for the Elder's Jewish wedding. The martyrdom of Klapholtz provokes an uprising among the Citizens of the Balut, and thus they proceed:

> Hundreds of workers broke ranks and raced across the street. Even the shirtwaist girls were coming. They surrounded the excrement wagons and turned them around. Then they began to march behind them out of Jakuba Street. Their voices rang out: "Food! Fuel? A better life!" Their fists were in the air. . . .
>
> What a spectacle it was. A procession of resolute Jews! They seemed to themselves to consist of an irresistible force. The world, which had been snatched from them, would be seized once again. . . .
>
> The broken body of Klapholtz draped over the wooden staves of the leading wagon, rocked back and forth. His arms and legs and the head on his neck seemed full of energy. Someone ran up and attached a flower to his trousers. He was their martyr, their hero. Ladies and gentlemen, what other artist—not even Victor Hugo, not Michelangelo—has moved men so greatly, or filled them with the conviction that they could change the course of their lives?
>
> So began the first day of the Five Day General Strike. (148–149)

The foregoing passage stands as an illustration for the carnival form of Epstein's novel overall. Pouring into the street, the citizens of the ghetto join forces behind the "excrement wagon" on which their hero—"full of energy"—flops along at their head. In these lowly circumstances they feel possessed by "an irresistible force," which is the power of imagination summoning the power of life in its collective thrust, a force magnified by the community acting as a whole. This is the same power that they, the Ghettoites, invest in I. C. Trumpelman, in the ghetto's view a figure messianic and immortal. In fact, Trum-

pelman is a monstrous benefactor; he is a medicine man and a quack, a savior and a betrayer who destroys the ghetto in order to save it. His behavior, like that of the *Judenrat*, is radically ambivalent, a blessing and a curse together. Precisely this ambivalence, pointing to life and death at once, is the carnivalesque element and the sign of laughter in *King of the Jews*.

That the General Strike is festive as well as grotesque is plain enough. But, in their lesser way, so are the episodes depicting the *Judenrat*, and so, finally, is every communal scene in the novel. We cannot convincingly imagine such goings-on in a realistic mode, even though events similar to these did actually occur. Nothing that takes place in the novel is impossible, but only exaggerated and exploited for its life/death ambiguity. In its historical enactments, carnival is a actual event made possible by art—by the deliberate suspension of actual order in favor of an imagined order faithfully mimicked. Festival is the dramatic representation of a utopian order that exists nowhere but that follows from the logic of community and finds embodiment through artifice. For a specific allotment of time, carnival reigns and the "real" world is turned upside down; the antimimetic order cancels, for a time, official reality. Bakhtin would say that realism and respect for the status quo go hand in hand with oppression; whereas the antiworld of carnival, with its gross rejection of *what is*, is integral to freedom.

In Epstein's novel, carnival excess frees the citizens of Suburb Balut from bondage to an order of death. At another level, the highly artificial style of the novel—its play with polite formalities, its mockery of programs, its patent delight in distortion—frees us from the hegemony of terror in the spectacle we behold. We are facing the Holocaust, but at a liberating distance, a point Epstein makes over and over by deriving the novel's central episodes from actual records of the Holocaust. Real events are recalled, reminding us that all of this happened. Examples include the rule of M. C. Rumkowski, head of the *Judenrat* at Lodz (mimicked in the novel by Trumpelman's career); the betrayal and failed escape in disguise of Itzak Wittenberg, leader of the resistance at Vilna (mimicked by the fate of Lipsky, the leader of the Edmund Trilling Brigade); and, at the end, the Soviet army's refusal, on the far bank of the Vistula, to come to the aid of the Polish uprising in Warsaw (mimicked by the fate of the ghetto fighters

at the King Ladislaus Bridge). Like the other books, *King of the Jews* derives its urgency from faithful attention to actual experience—but then goes on to displace it in grotesque and exaggerated ways.

Ringed round by its destroyers, caught up in a perfect net of death, the community of Epstein's novel conducts itself with frantic energy, the better to resist the darkness closing in. They know what is in store for them, and so do we. But carnival laughter admits no fear, and against their fate the Ghettoites embrace an antimimetic counterworld that shuts out terror and pity together. During the European Middle Ages, this kind of festive revolt was permitted only on feast days and other occasions—births, marriages, funerals—separating carnival time from the structures of daily life. If it occurred at all during the Holocaust, it could only take rise in the ghettos, where a degree of community was still intact. Ringelblum's collection of jokes suggests that the spirit of carnival laughter was fitful and appeared in small ways only. From this modicum of evidence, Epstein has taken his cue and gone on to create, inside the historical world alluded to, an antiworld, the communal space of Baluty Suburb. This secondary world resists the reality principle. Actuality is recognized, but not accepted as final—even when, of course, its finality is obvious. But human beings do not live by reality alone, or even chiefly. And it is this willful displacement, this shrewd mockery of the real in serious works of art, that we might call "Holocaust laughter."

The idea of a cartoon about the Holocaust is more or less upsetting. At least I thought so when I first encountered *Maus*. But, in fact, the notion of victims as mice and assailants as cats opens a wholly unexpected perspective that feels—this is what upsets—remarkably apt. Art Spiegelman portrays two stories side by side—his own with his father in Queens, then his father's in Poland through the war—and both are faithful to actual circumstance. It appears, moreover, that Spiegelman manages this double story only so long as the fairy-tale element intervenes; he requires a comic shield against knowledge too starkly hideous and weighted with guilt to face apart from laughter's mitigation.

At the request of his son, Vladek recalls his story of flight and final capture as he, his wife, and their family scramble to survive in Poland under the Nazi occupation. This part of *Maus* is too grim, perhaps, to

From *Maus I*, page 68

be credited in normal human imagery; but it is also accurate, indeed obsessively attentive to the ordeal in Poland at that time. There is nothing funny about Vladek's story as a whole, although details and moments of the narrative are comic for the fantastic slapstick horror, the incongruities and sharp reversals, that he and his wife undergo day by day, sometimes hour by hour, as they struggle to survive. In Artie's story, on the other hand, there is a good deal of humor. His father, for example, has picked up the survivor's scavenger habits and saves useless items (a piece of phone wire found in the street) to no purpose beyond the son's exasperation. Vladek and his second wife, Mala, bicker endlessly, he has a tricky heart condition, and at one point he sneaks Artie's favorite coat into the trash the better to force a new one—a cheap, vinyl ski jacket—upon his son. This is almost situation comedy, the sort of thing that, apart from its terrible background, we expect on television. The two stories are linked by a network of historical and psychological connections, and then by a pathos too deep, perhaps, for words—but not for Spiegelman's mouse-and-cat iconography. In one example, helplessness is palpable as the family in Poland struggles to save its small son, Richieu (*Maus I*, 81).

The moment of tension in the top frames replays itself as, in the lower frame, the outcome is known and defeat is acknowledged.

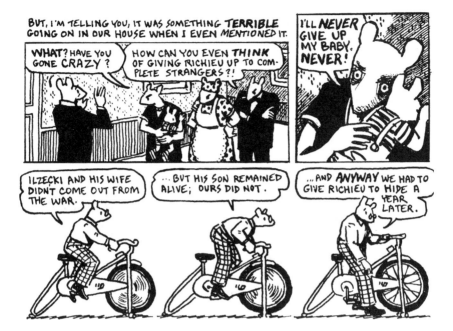

From *Maus I*, page 81

Vladek pedals his exercise bike at a furious pace, all the while getting nowhere. The speed of his pedaling corresponds to the effort to save Richieu, the brother Artie never saw; and with the confession—the renewed recognition?—of failure, the pedaling stops. The agony of the earlier predicament and Vladek's pain as he remembers yield a pathos that would be excessive except for the iconography through which suffering is displaced. By portraying the victims as mice, we see them at a distance, and they, in turn, are able to say things that were long-ago clichés in Holocaust writing of the standard sort—for example, "synagogues burned, Jews beaten with no reason, whole towns pushing out all Jews" (*Maus I*, 33). It seems clear that the cat-and-mouse fable, together with its comic book format, work in a Brechtian manner to alienate, provoke, and compel new attention to an old story.

The testimony of survivors often requires a detachment that keeps them at a distance from self-pity, whereas for us the pathos of their stories, and sometimes the mere telling of such stories, is nearly overwhelming. In flight from the Nazis, Vladek and Anja strain themselves to the utmost; they manage to escape a dozen deaths, but in the end comes arrest and transport to Auschwitz. Their life, their entire

being, is part of a vast inescapable agony that must simply be endured. Much the same, in its lesser way, is true for the attempt Artie and Vladek make to improve father-son relations between them; there is a great deal of maneuvering that comes, pretty much, to nothing. Both stories are steeped in futility. The path of destiny is governed by the swastika, while the priority of loss makes belated measures—the safety box—quixotic and sadly humorous (*Maus I*, 125).

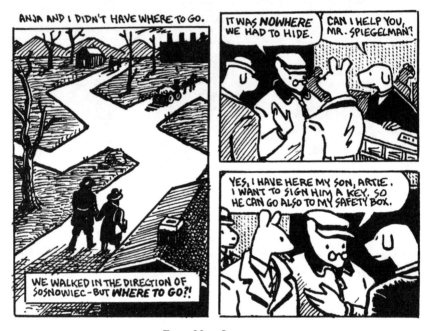

From *Maus I*, page 125

In *Maus* the spectacle of pathos is complete, a seamless world of pain except for the comic energies at work. What is needed is a representation that will not swamp us and the story together, and this Spiegelman provides by conceiving of Jews as mice, Germans as cats, Poles as pigs, and all others as dogs. This single displacement allows us to reimagine the terror of events in images that are often horrible but usually humorous, as well. The iconography of the mouse is perhaps the perfect sign for this amalgam of lightness and weight. And at every moment, finally, the separate stories of Vladek and Artie turn out to be inseparable—a point confirmed by the comic book format, by the way the two worlds interlock on the page. In yet another example, the

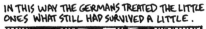

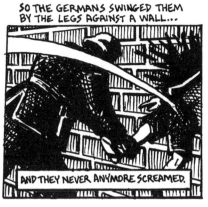

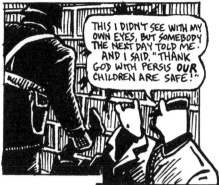

From *Maus I*, page 108

children were thought to be safe, and Artie, too, as a son of survivors, is one of "our" children (*Maus I*, 108).

At the heart of *Maus* is the family romance, replete with guilt and unresolved complexities caused by the hold of the past upon the present, a kind of knowledge-as-suffering that cannot be dismissed, but only shared in the "survivor's tale" before us. The best-laid plans of mice and men come to nothing—except, in this case, a remarkable work of art. In Spiegelman's book, laughter is used to dispel and to embrace, a kind of comic ambiguity that diffuses hostility, on the one hand, and on the other prompts charity toward those who suffered, those who remember, and also those who might simply wish to know. Humanity at large is at fault in a world where no one is a hero, and therefore a world in which to laugh is as good as, and possibly wiser than to weep.

In *Maus*, as in the other books I have cited, pity and terror are held at a distance, and this is not, finally, a bad thing. To be mired still deeper in angst and lament is hardly what is needed. The value of the comic approach is that by setting things at a distance it permits us a tougher, more active response. We are not wholly, as in tragedy's serious style, compelled to a standstill by the matter we behold. At the same time, however, the books I have cited manage to respect the "fictions" with which I began. They take the Holocaust seriously. They allow for its particularity and even for the historical record. All this

they assume and point to. But they would not, as I said, lie down in darkness. As comic works of art, or works of art including a comic element, they afford us laughter's benefit without betraying convictions. In these ways they foster resilience and are life-reclaiming.

The Albany conference, "Writing and the Holocaust," ended with a sense that our struggle to derive value from the Holocaust has exhausted itself. If so, the most powerful sign of our time is without, at the moment, shared significance or common ground for understanding. Some of our best commentators—Raul Hilberg, Cynthia Ozick, and Saul Friedländer among them—have declared outright that the Holocaust is without meaning, that it allows for no redeeming grace, that the years of Hitler's death-sweep remain a time unique to history and with no hope of mediation apart from the heroism of sheer remembrance.

Possibly they are right. But is writing about the Holocaust at an impasse by necessity? The works I have cited suggest that it is not. Then again, Borowski, Epstein, and Spiegelman have taken peculiar directions, difficult to judge, still more difficult to follow. Creative artists, moreover, are quicker to break taboos than critics like ourselves who must, to perpetuate discourse, accept some degree of protocol. How to come to terms with the Holocaust is still our foremost problem. Meanwhile, the prevailing etiquette has limits, or so it would seem from laughter's prospect.

(1988)

Of Mice and Mimesis

Reading Spiegelman with Adorno[1]

ANDREAS HUYSSEN

I resist becoming the Elie Wiesel of the comic book.
—ART SPIEGELMAN

Since the 1980s, the question is no longer *whether*, but rather *how* to represent the Holocaust in literature, film, and the visual arts. The earlier conviction about the essential unrepresentability of the Holocaust, typically grounded in Adorno's famous statement about the barbarism of poetry after Auschwitz and still powerful in some circles today, has lost much of its persuasiveness for later generations who only know of the Holocaust through representations: photographs and films, documentaries, testimonies, historiography, and fiction. Given the flood of Holocaust representations in all manner of media today, it would indeed be sheer voluntarism to stick with Adorno's notion of a ban on images which translates a theological concept into a very specific kind of modernist aesthetic. It seems much more promising to approach the issue of Holocaust representations through another concept that holds a key place in Adorno's thought, that of mimesis.

In his recently published book, *In the Shadow of Catastrophe: German Intellectuals Between Apocalypse and Enlightenment*, Anson Rabinbach persuasively shows how Adorno's understanding of Nazi anti-Semitism is energized by his theory of mimesis.[2] More impor-

tantly, however, he links Adorno's discussion of the role of mimesis in anti-Semitism to Horkheimer's and Adorno's historical and philosophical reflections on mimesis as part of the evolution of signifying systems, as they are elaborated in the first chapter of the *Dialectic of Enlightenment*.[3] Here Horkheimer and Adorno discuss mimesis in its true and repressed forms, its role in the process of civilization, and its paradoxical relationship to the *Bilderverbot*, the prohibition of graven images.[4] At the same time, the concept of mimesis in Adorno (and I take it that Adorno rather than Horkheimer is the driving force in articulating this concept in the coauthored work) is not easily defined, as several recent studies have shown.[5] Rather it functions more like a palimpsest, in that it partakes in at least five different yet overlapping discursive registers in the text: first in relation to the critique of the commodity form and its powers of reification and deception, a thoroughly negative form of mimesis [*Mimesis ans Verhartete*]; secondly in relation to the anthropological grounding of human nature which, as Adorno insists in *Minima Moralia*, is "indissolubly linked to imitation";[6] third in a biological somatic sense geared toward survival as Adorno had encountered it in Roger Caillois's work, some of which he reviewed for the *Zeitschrift fur Sozialfoschung*;[7] fourth in the Freudian sense of identification and projection indebted to *Totem and Taboo*; and, lastly, in an aesthetic sense that resonates strongly with Walter Benjamin's language theory, as it relates to the role of word and image in the evolution of signifying systems. It is precisely this multivalence of mimesis, I would argue, that makes the concept productive for contemporary debates about memory, trauma, and representation in the public realm. Thus it is more than a mere paradox that mimesis serves Adorno to explain Nazi anti-Semitism, whereas it serves me to understand the ethics and aesthetics of approaching Holocaust memory in our time.

In this essay, then, I will focus on one specific aspect of memory discourse, namely the vexing issue of (in Timothy Garton Ash's succinct words) if, how, and when to represent historical trauma.[8] The historical trauma to be represented is the Holocaust, a topic on which, as already indicated, Adorno had provocative things to say, although he never said quite enough about it. But I do think that the issues raised in this essay pertain as much to other instances of historical

trauma and their representation: whether we think of the *desaparecidos* in Argentina, Guatemala, or Chile, the stolen generation in Australia, or the post-apartheid debates in South Africa—in all these cases issues of how to document, how to represent, and how to view and listen to testimony about a traumatic past have powerfully emerged in the public domain.

I hope to show that a reading through mimesis of one specific Holocaust image-text may allow us to go beyond arguments focusing primarily on the rather confining issue of how to represent the Holocaust "properly" or how to avoid aestheticizing it. My argument will be based on the reading of a work that has shocked many precisely because it seems to violate the *Bilderverbot* in the most egregious ways, but that has also been celebrated, at least by some, as one of the most challenging in an ever-widening body of recent works concerned with the Holocaust and its remembrance. But more is at stake here than just the reading of one work through the conceptual screen of another. A discussion of Art Spiegelman's *Maus* in terms of the mimetic dimension may get us beyond a certain kind of stalemate in debates about representations of the Holocaust, a stalemate which, ironically, rests on presuppositions that were first and powerfully articulated by Adorno himself in a different context and at a different time.[9] Reading *Maus* through the conceptual screen of mimesis will permit us to read Adorno against one of the most lingering effects of his work on contemporary culture, the thesis about the culture industry and its irredeemable link to deception, manipulation, domination, and the destruction of subjectivity. While this kind of uncompromising critique of consumer culture, linked as it is to a certain, now historical type of modernist aesthetic practice, resonates strongly with a whole set of situationist and poststructuralist positions developed in France in the 1960s (Barthes, Debord, Baudrillard, Lyotard, *Tel Quel*), it has generally been on the wane in contemporary aesthetic practices. For obvious reasons, however, it has proven to have significant staying power in one particular area: that of Holocaust representations where Adorno's statements about poetry after Auschwitz (often misquoted, unanalyzed, and ripped out of their historical context)[10] have become a standard reference point and have fed into the recent revival of notions of an aesthetic sublime and its dogmatic antirepresentational stance.[11]

But this is where the issue of public memory emerges. Although there is widespread agreement that, politically, the genocide of the Jews is to be remembered (with allegedly salutary effects on the present and the future) by as large a public as possible, mass cultural representations are not considered proper or correct. The paradigmatic case exemplifying this broad, though now perhaps fraying, consensus is the debate over Spielberg's *Schindler's List* and Claude Lanzmann's *Shoah*. Spielberg's film, playing to mass audiences, fails to remember properly because it represents, thus fostering forgetting: Hollywood as fictional substitute for "real history." Lanzmann's refusal to represent, on the other hand, is said to embody memory in the proper way precisely because it avoids the delusions of a presence of that which is to be remembered. Lanzmann's film is praised as a heroic effort in the *Kulturkampf* against the memory industry, and its refusal to re-present, its adherence to the *Bilderverbot* becomes the ground for its authenticity.[12] Aesthetically speaking, these opposing validations of Spielberg and Lanzmann still rest on the unquestioned modernist dichotomy that pits Hollywood and mass culture against forms of high art.[13] Looking at Spiegelman's *Maus* through the various discursive screens of mimesis, I want to argue, may allow us to approach Holocaust memory and its representations today in a way different from this earlier dominant paradigm.

Maus undercuts this dichotomy in the first rather obvious sense that Spiegelman draws on the comic as a mass cultural genre, but transforms it in a narrative saturated with modernist techniques of self-reflexivity, self-irony, ruptures in narrative time, and highly complex image sequencing and montaging. As a comic, *Maus* resonates less with Disney productions than with a whole tradition of popular animal fables from Aesop to La Fontaine and even Kafka. At the same time, it evolved of course from an American comic book countertradition born in the 1960s that took inspiration from *Krazy Kat*, *Fritz the Cat*, and others. At the same time, *Maus* remains different from the older tradition of the enlightening animal fable. If the animal fable (taking George Orwell's *Animal Farm* as a twentieth-century example) had enlightenment as its purpose either through satire or moral instruction, *Maus* remains thoroughly ambiguous, if not opaque, as to the possible success of such enlightenment. Rather than providing us with an enlightened moral or with a happy reconciliation between high

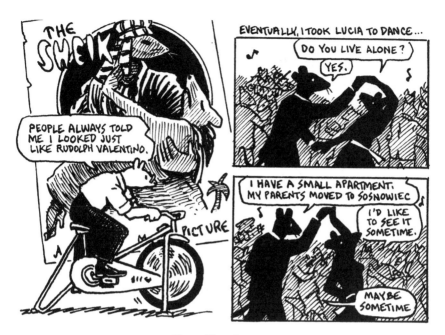

From *Maus I*, page 13

and low, human and animal, trauma and memory, the aesthetic and emotional effect of *Maus* remains jarring throughout. This jarring, irritating effect on the reader results from a variety of pictorial and verbal strategies that have their common vanishing point in mimesis, both in its insidious and in its salutary aspects which, as Adorno would have it, can never be entirely separated from each other.

Let me turn now to some of the dimensions of mimesis in this image-text. As is well known, *Maus* as narrative is based on interviews Art Spiegelman conducted with his father, Vladek, an Auschwitz survivor, in the 1970s. Spiegelman taped these interviews in Rego Park, Queens, in his childhood home, and during a summer vacation in the Catskills. The subject of these interviews is the story of Spiegelman's parents' life in Poland in the years 1933 to 1945, but the telling of this traumatic past, as retold in the comic, is interrupted time and again by banal everyday events in the New York present. This cross-cutting of past and present, by which the frame keeps intruding into the narrative, allows Spiegelman, as it were, to have it both ways. For Vladek, it seems to establish a safe distance between the two temporal levels; the tale of his past is visually framed by Spiegelman as if it

were a movie projected by Vladek himself. As Vladek begins to tell his story, pedaling on his exercise bicycle, he says proudly: "People always told me I looked just like Rudolph Valentino" (*Maus I*, 13). Behind him in the frame is a large poster of Valentino's 1921 film *The Sheik*, with the main actor as a mouse holding a swooning lady in his arms. The exercise bicycle mechanism looks remotely like a movie projector, with the spinning wheel resembling a film reel and Vladek as narrator using it to project his story. But this crosscutting of past and present points in a variety of ways to how this past holds the present captive, independently of whether this knotting of past into present is being talked about or repressed. Thus one page earlier Art, who is sitting in the background and has just asked Vladek to tell him the story of his life in Poland before and during the war, is darkly framed within the frame by the actor's arms and the bicycle's handlebars in the foreground. Vladek's arms, head, and shirt with rolled-up sleeves are all striped, and the Auschwitz number tattooed onto his left arm hovers ominously just above Art's head in the frame (*Maus I*, 12). Both the narrator (Art Spiegelman) and the reader see Vladek's everyday behavior permeated by his past experiences of persecution during the Nazi period. This first narrative framing is then itself split in two. In addition to the narrative frame the interviews provide, there is yet another level of narrative time that shows the author Art Spiegelman, or rather the *Kunstfigur* Artie, during his work on the book in the years 1978 to 1991, years during which Vladek Spiegelman died and the first part of *Maus* became a great success—all of which is in turn incorporated into the narrative of the second volume. But the complexity of the narration is not just an aesthetic device employed for its own sake. It rather results from the desire of members of the second generation to learn about their parents' past of which they are always, willingly or not, already a part: it is a project of mimetically approximating historical and personal trauma in which the various temporal levels are knotted together in such a way that any talk about a past that refuses to pass away or that should not be permitted to pass, as discussed in the German *Historikerstreit* of the mid-1980s, seems beside the point.[14] The survivors' son's life stands in a mimetic affinity to his parents' trauma long before he ever embarks on his interviews with his father.[15] Therefore this mimetic relationship can not be thought of simply as a ratio-

nal and fully articulated working through.[16] There are dimensions to mimesis that lie outside linguistic communication and that are locked in silences, repressions, gestures, and habits—all produced by a past that weighs all the more heavily as it is not (yet) articulated. Mimesis in its physiological, somatic dimension is *Angleichung*, a becoming or making similar, a movement toward, never a reaching of a goal. It is not identity, nor can it be reduced to compassion or empathy. It rather requires of us to think of identity and non-identity together as non-identical similitude and in unresolvable tension with each other.

Maus performs precisely such a mimetic approximation. Spiegelman's initial impetus for conducting these interviews with his father came itself out of a traumatic experience: the suicide of his mother, Anja, in 1968, an event Spiegelman made into a four-page image-text originally published in 1973 in an obscure underground comic under the title "Prisoner on the Hell Planet." It is only in the latter half of the first part of *Maus* that Artie suddenly and unexpectedly comes across a copy of this earlier, now almost forgotten attempt to put part of his own life's story into the comics. *Maus* then reproduces the "Prisoner on the Hell Planet" in toto (*Maus I*, 100–103). These four pages, all framed in black like an obituary in German newspapers, intrude violently into the mouse narrative, breaking the frame in three significant ways. First, in this earlier work, the figures of Vladek and Artie mourning the death of Anja are drawn as humans, a fact that goes surprisingly unremarked by the mice Artie and Vladek as they are looking at these pages in the narrative of the later work. The identity of the non-identical seems to be taken for granted in this porousness between human and animal realm. Secondly, the comic "Prisoner on the Hell Planet" opens with a family photo that shows a ten-year-old Art in 1958 with his mother during a summer vacation in the Catskills.[17] It is the first of three family photos montaged into the comic, all of which function not in order to document, but in order to stress the unassimilability of traumatic memory.[18] Thirdly, "Prisoner" articulates an extreme moment of unadulterated despair that disrupts the "normal" frame of the interviewing process, the questioning and answering, bickering and fighting between father and son. These pages give testimony of the emotional breakdown of both father and son at Anja's burial: in Art's case, it is overlaid by a kind of survivor guilt of the

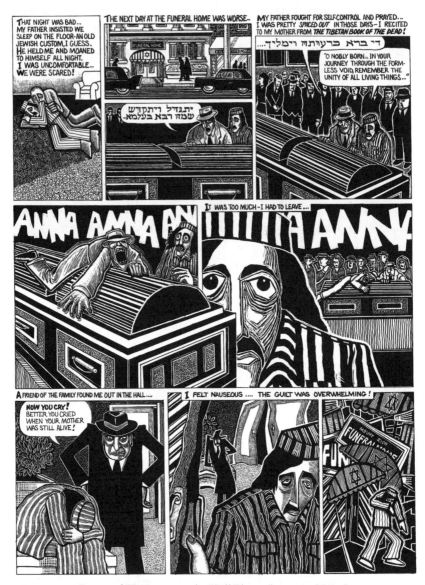

Page 3 of "Prisoner on the Hell Planet," 1972, in *Maus I*

second degree, once removed from the original trauma of his parents. The memories of Auschwitz do not only claim Anja; they also envelop the son born years after the war. Thus Art draws himself throughout this episode in striped Auschwitz prisoner garb which gives a surreal quality to these starkly executed, woodcut-like, grotesque images. In this moment of secondary Holocaust trauma Spiegelman performs a kind of spatial mimesis of death in the sense of Roger Caillois's work of the 1930s which Adorno read and commented on critically in his correspondence with Benjamin.[19] Spiegelman performs a compulsive imaginary mimesis of Auschwitz as a space of imprisonment and murder, a mimesis, however, in which the victim, the mother, becomes perpetrator while the real perpetrators have vanished. Thus at the end of this raw and paralyzing passage, Art, incarcerated behind imaginary bars, reproaches his mother for having committed the perfect crime: "You put me here . . . shorted all my circuits . . . cut my nerve endings . . . and crossed my wires! . . . You *murdered* me, Mommy, and you left me here to take the rap!!!" (*Maus I,* unpaginated [103]). The drawings are expressionist, the text crude though in a certain sense "authentic," but it is easy to see that Spiegelman's comic would have turned into disaster had he chosen the image and language mode of "Prisoner" for the later work. It could only have turned into psycho-comikitsch. Spiegelman did need a different, more estranging mode of narrative and figurative representation in order to overcome the paralyzing effects of a mimesis of memory-terror. He needed a pictorial strategy that would maintain the tension between the overwhelming reality of the remembered events and the tenuous, always elusive status of memory itself. As an insert in *Maus,* however, these pages function as a reminder of the representational difficulties of telling a Holocaust or post-Holocaust story in the form of the comic. But they also powerfully support Spiegelman's strategy of using animal imagery in the later, longer work. The choice of medium, the animal comic, is thus self-consciously enacted and justified in the narrative itself. Drawing the story of his parents and the Holocaust as an animal comic is the Odyssean cunning that allows Spiegelman to escape from the terror of memory—even "postmemory" in Marianne Hirsch's term—while mimetically reenacting it.

But the question lingers: what do we make of the linguistic and pic-

torial punning of *Maus*, Mauschwitz and the Catskills in relation to mimesis? The decision to tell the story of Germans and Jews as a story of cats and mice as predators and prey should not be misread as a naturalization of history, as some have done. Spiegelman is not the Goldhagen of the comic book. After all, the comic does not pretend to be history. Another objection might be more serious: Spiegelman's image strategies problematically reproduce the Nazi image of the Jew as vermin, as rodent, as mouse. But is it simply a mimicry of racist imagery? And even if it is mimicry, does mimicry of racism invariably imply its reproduction or can such mimicry itself open up a gap, a difference that depends on who performs the miming and how? Mimesis, after all, is based on similitude as making similar (*Angleichung* in Adorno's terminology), the production of "the same but not quite," as Homi Bhabha describes it in another context.[20] And *Angleichung* implies difference. Thus Spiegelman himself draws the reader's attention to his conscious mimetic adoption of this imagery. The very top of the copyright page of *Maus I* features a quote from Hitler: "The Jews are undoubtedly a race, but they are not human." And in *Maus II*, the page following the copyright page begins with a motto taken from a Pomeranian newspaper article from the mid-1930s:

> Mickey Mouse is the most miserable ideal ever revealed. . . . Healthy emotions tell every independent young man and every honorable youth that the dirty and filth-covered vermin, the greatest bacteria carrier in the animal kingdom, cannot be the ideal type of animal. . . . Away with Jewish brutalization of the people! Down with Mickey Mouse! Wear the Swastika Cross!

Maus thus gives copyright where it is due: Adolf Hitler and the Nazis.

But that may still not be enough of an answer to the objection. More crucial is the way in which the mimesis of anti-Semitic imagery is handled. Here it would be enough to compare Spiegelman's work with the 1940 Nazi propaganda movie *The Eternal Jew*, which portrayed the Jewish world conspiracy as the invasive migration of plague-carrying herds of rodents who destroy everything in their path. Such a comparison makes it clear how Spiegelman's mimetic

adoption of Nazi imagery actually succeeds in reversing its implications while simultaneously keeping us aware of the humiliation and degradation of that imagery's original intention. Instead of the literal representation of destructive vermin we see persecuted little animals drawn with a human body and wearing human clothes and with a highly abstracted, non-expressive mouse physiognomy. "Maus" here means vulnerability, unalloyed suffering, victimization. As in the case of the "Prisoner on the Hell Planet," here, too, an earlier much more naturalistic version of the mouse drawings shows how far Spiegelman has come in his attempt to transform the anti-Semitic stereotype for his purposes by eliminating any all-too-naturalistic elements from his drawings.

Defenders of *Maus* have often justified the use of animal imagery as a necessary distancing device, a kind of Brechtian estrangement effect. Spiegelman's own justification is more complex:

First of all, I've never been through anything like that—knock on whatever is around to knock on—and it would be a counterfeit to try to pretend that the drawings are representations of something that's actually happening. I don't know what a German looked like who was in a specific small town doing a specific thing. My notions are born of a few score of photographs and a couple of movies. I'm bound to do something inauthentic. Also, I'm afraid that if I did it with people, it would be very corny. It would come out as some kind of odd plea for sympathy or "Remember the Six Million," and that wasn't my point exactly, either. To use these ciphers, the cats and mice, is actually a way to allow you past the cipher at the people who are experiencing it. So it's really a much more direct way of dealing with the material.[21]

This is, in my terms, an estrangement effect in the service of mimetic approximation, and thus rather un-Brechtian, for at least in his theoretical reflections, Brecht would not allow for any mimetic impulse in reception. Spiegelman accepts that the past is visually inaccessible through realistic representation: whatever strategy he might choose, it is bound to be "inauthentic." He also is aware of his generational positioning as someone who knows of this past mainly

through media representations. Documentary *authenticity* of representation can therefore not be his goal, but *authentication* through the interviews with his father is. The use of mice and cats is thus not simply an avant-gardist distancing device in order to give the reader a fresh, critical, perhaps even "transgressive" view of the Holocaust intended to attack the various pieties and official memorializations that have covered it discursively. Of course, Spiegelman is very aware of the dangers of using Holocaust memory as screen memory for various political purposes in the present. His narrative and pictorial strategy is precisely devised to avoid that danger. It is actually a strategy of another kind of mimetic approximation: getting past the cipher to the people and their experience. But before getting past the cipher, Spiegelman has to put himself into that very system of ciphering: as Artie in the comic, he himself becomes a mouse, imitates the physiognomic reduction of his parents by racist stereotype—the post-Auschwitz Jew still as mouse—even though he is now in the country of the dogs (America) rather than the cats. Paradoxically, we have here a mimetic approximation of the past that respects the *Bilderverbot* not despite, but rather because of its use of animal imagery, which tellingly avoids the representation of the human face. *Bilderverbot* and mimesis are no longer irreconcilable opposites, but enter into a complex relationship in which the image is precisely not mere mirroring, ideological duplication, or partisan reproduction, but where it approaches writing.[22] This Adornean notion of image becoming script was first elaborated by Miriam Hansen and Gertrud Koch in their attempts to make Adorno pertinent for film theory.[23] But it works for Spiegelman's *Maus* as well. As its image track indeed becomes script, *Maus* acknowledges the inescapable inauthenticity of Holocaust representations in the "realistic" mode, but it achieves a new and unique form of authentication and effect on the reader precisely by way of its complex layering of historical facts, their oral retelling, and their transformation into image-text. Indeed, it is as animal comic that *Maus*, to quote a typically Adornean turn of phrase from the first chapter of *Dialectic of Enlightenment*, "preserves the legitimacy of the image [. . .] in the faithful pursuit of its prohibition."[24]

If this seems too strong a claim, consider the notion of image

becoming script in *Maus* from another angle. Again, Spiegelman himself is a good witness for what is at stake:

> I didn't want people to get too interested in the drawings. I wanted them to be there, but the story operates somewhere else. It operates somewhere between the words and the idea that's in the pictures and in the movement between the pictures, which is the essence of what happens in a comic. So by not focusing you too hard on these people you're forced back into your role as reader rather than looker."[25]

And in a radio interview of 1992, he put it even more succinctly by saying that *Maus* is "a comic book driven by the word."[26]

I cannot hope to give a full sense of how the linguistic dimension of *Maus* drives the image sequences. A few comments will have to suffice. Central here is the rendering of Vladek's language taken from the taped interviews. The estranging visualization of the animal comic is counterpointed by documentary accuracy in the use of Vladek's language. The gestus of Vladek's speech, not easily forgotten by any reader with an open ear, is shaped by cadences, syntax, and intonations of his East European background. His English is suffused by the structures of Yiddish. Residues of a lost world are inscribed into the language of the survivor immigrant. It is this literally—rather than poetically or mystically—broken speech that carries the burden of authenticating that which is being remembered or narrated. On the other hand, Vladek himself is aware of the problematic nature of any Holocaust remembrance even in language when he says: "It's no more to speak" (*Maus II,* 113). Spiegelman's complex arrangement of temporal levels finds its parallel in an equally complex differentiation of linguistic registers. Thus the inside narration about the years in Poland as told by Vladek are rendered in fluent English. A natural language gestus is required here because at that time Vladek would have spoken his national language, Polish. It is only logical that Vladek's broken speech only appears on the level of the frame story, the narrative time of the present. Past and present, clearly distinguished by the language track, are thus nevertheless suffused in the present itself in Vladek's broken English, which provides the linguistic marker of the insuper-

able distance that still separates Artie from Vladek's experiences and from his memories. Artie, after all, always speaks fluent English as his native language.

If Spiegelman's project is mimetic approximation not of the events themselves, but of the memories of his parents, and thus a construction of his own "postmemory" (Marianne Hirsch), then this mimesis is one that must remain fractured, frustrated, inhibited, incomplete. The pain of past trauma is repeated through narration in the present and attaches itself to the listener, to Artie as listener inside the text as well as to the reader who approaches the contents of Vladek's autobiographic tale through its effects on Artie. Artie as a *Kunstfigur*—the same but not quite the same as the author Art Spiegelman—thus becomes the medium in the text through which we ourselves become witnesses to his father's autobiographic narration. While this narration, gently and sometimes not so gently extracted from the survivor, aims at a kind of working through in language, it is a mimetic process that will never reach an end or come to completion, even if and when Vladek's tale catches up to the postwar period. And then there is always that other most painful obstacle to a full mimetic knowledge of the past. For the process of an *Angleichung ans Vergangene*, an assimilation to the past, is not only interrupted by the inevitable intrusion of everyday events during the time of the interviews; another even more significant gap opens up in the sense that only Vladek's memories are accessible to Artie. The memories of Artie's mother, whose suicide triggered Art Spiegelman's project in the first place, remain inaccessible not only because of her death, but because Vladek, in a fit of despair after her death, destroyed her diaries in which she had laid down her own memories of the years in Poland and in Auschwitz. And just as Artie had accused his mother for murdering him, he now accuses his father for destroying the diaries: "God *damn* you! You—you murderer!" (*Maus I*, 159). Anja's silence thus is total. If it was Anja's suicide that generated Art Spiegelman's desire to gain self-understanding through mimetic approximation of his parents' story and of survivor guilt, then the discovery that the diaries have been burned points to the ultimate elusiveness of the whole enterprise. Artie's frustration about the destruction of the diaries only makes explicit that ultimate unbridgeable gap between Artie's cognitive desires and the memories

of his parents. Indeed it marks the limits of mimetic approximation, but it marks them in a quite pragmatic way and without resorting to sublime new definitions of the sublime as the unpresentable within representation.

All of Spiegelman's strategies of narration thus maintain the insuperable tension within mimetic approximation between closeness and distance, affinity and difference. *Angleichung* is precisely not identification or simple compassion. By listening to his father's story Artie understands how Vladek's whole habitus has been shaped by Auschwitz and the struggle for survival, while Vladek, caught in traumatic reenactments, remains oblivious to that fact: rather than assuming continuity, Vladek's storytelling seems to assume a safe and neutralizing distance between the events of the past and his New York present. But his concrete behavior constantly proves the opposite. Artie, on the other hand, is always conscious of the fact that the borders between past and present are fluid, not only in his observation of his father, but in his self-observation as well. Mimetic approximation as a self-conscious project thus always couples closeness and distance, similitude and difference.

This dimension becomes most obvious in those passages in *Maus II* where Spiegelman draws himself drawing *Maus* (*Maus II*, 41). The year is 1987; Vladek has been dead for five years; Art works on *Maus II* from the tapes which have now become archive, and *Maus I* has become a great commercial success. This chapter, entitled "Auschwitz (Time Flies)," demonstrates how beyond the multiply fractured layering of language and narrative time, the very pictoriality of the animal comic is significantly disrupted as well. We see Art in profile, sitting at his drawing table, but now drawn as a human figure wearing a mouse mask. It is as if the image track could no longer sustain itself, as if it collapsed under its own weight. Artie's mimicry reveals itself to be a sham. The mask reveals the limits of his project. The ruse doesn't work any longer. The task of representing time in Auschwitz itself, just begun in the preceding chapter, has reached a crisis point. This crisis in the creative process is tellingly connected with the commercial success of *Maus I*: the Holocaust as part of the culture industry. The crisis of representation and the crisis of success throw the author into a depressive melancholy state in which he resists the

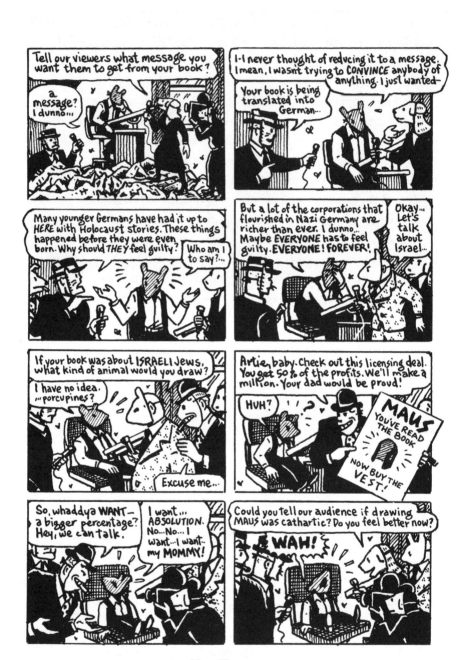

Maus II, page 42

marketing of his work (translations, a film version, television) through a fit of total regression. He avoids the annoying questions of the media sharks ("What is the message of your book?" "Why should younger Germans today feel guilty?" "How would you draw the Israelis?") by literally shrinking in his chair from frame to frame until we see a small child screaming: "I want . . . I want . . . my *Mommy!*" (*Maus II, 42*). The pressures of historical memory are only intensified by Holocaust marketing, to the point where the artist refuses any further communication. The culture industry's obsession with the Holocaust almost succeeds in shutting down Spiegelman's quest. The desire for a regression to childhood, as represented in this sequence, however, is not only an attempt to cope with the consequences of commercial success and to avoid the media. This moment of extreme crisis, as close as any in the work to traumatic silence and refusal to speak, also anticipates something of the very ending of *Maus II*.

On the very last page of *Maus II*, as Vladek's story has caught up with his postwar reunification with Anja, ironically described by Vladek in Hollywood terms as a happy ending and visually rendered as the iris-like fade-out at the end of silent films, Artie is again put in the position of a child.[27] In a case of mistaken identity resulting from a merging of past and present in his father's mind, Vladek addresses Artie as Richieu, Artie's own older little brother who did not survive the war, whose only remaining photo had always stared at him reproachfully during his childhood from the parents' bedroom wall, and to whom *Maus II* is dedicated. As Vladek asks Artie to turn off his tape recorder and turns over in his bed to go to sleep, he says to Artie: "I'm tired from talking, Richieu, and it's enough stories for now . . ." (*Maus II*, unpaginated [136]). This misrecognition of Artie as Richieu is highly ambiguous: it is as if the dead child had come alive again, but the traumatic past simultaneously asserts its deadly grip over the present one last time. For these are a dying Vladek's last words to Artie. This final frame of the comic is followed only by an image of a gravestone with Vladek's and Anja's names and dates inscribed and, at the very bottom of the page and below the gravestone, the signature and date "art spiegelman 1978–1991," years that mark the long trajectory of Spiegelman's project of approaching an experience which ultimately remains beyond reach.

Much more could be said about Spiegelman's mimetic memory project, but I hope to have made the case that the Adornean category of mimesis can be made productive in a reading of Holocaust remembrance in such a way that the debate about the proper or correct Holocaust representation, while perhaps never irrelevant, can be bracketed and the criteria of judgment shifted. If mimetic approximation, drawing on a variety of knowledges (historical, autobiographic, testimonial, literary, museal), were to emerge as a key concern, then one could look at other Holocaust representations through this prism rather than trying to construct a Holocaust canon based on narrow aesthetic categories pitting the unrepresentable against aestheticization, or modernism against mass culture, memory against forgetting. This might open up a field of discussion more productive than the ritualistic incantations of Adorno regarding the culture industry or the barbarity of poetry after Auschwitz.

As a work by a member of the "second generation," *Maus* may indeed mark a shift in the ways in which the Holocaust and its remembrance are now represented. It is part of a body of newer, "secondary" attempts to commemorate the Holocaust while simultaneously incorporating the critique of representation and staying clear of official Holocaust memory and its rituals. I have tried to show how Spiegelman confronts the inauthenticity of representation within a mass cultural genre while at the same time telling an autobiographic story and achieving a powerful effect of authentication. Like many other monuments, works of film, sculpture, literature, theater, even architecture, Spiegelman rejects any metalanguage of symbolization and meaning, whether it be the official language of Holocaust memorials or the discourse that insists on thinking of Auschwitz as the telos of modernity. This approach to Holocaust history takes place in an intensely personal, experiential dimension that finds expression in a whole variety of different media and genres. Prerequisite for any mimetic approximation (of the artist/reader/viewer) is the liberation from the rituals of mourning and of guilt. Thus it is not so much the threat of forgetting as the surfeit of memory that is the problem addressed by such newer works. How does one get past the official memorial culture? How does one avoid the trappings of the culture industry while operating within it? How does one represent that which one knows only through rep-

resentations and from an ever-growing historical distance? All this requires new narrative and figurative strategies including irony, shock, black humor, even cynicism, much of it present in Spiegelman's work and constitutive of what I have called mimetic approximation. The *Bilderverbot* is simply no longer an issue since it has itself become part of official strategies of symbolic memorializing. This very fact may mark the historical distance between Adorno—whose "after Auschwitz" chronotope, with its insistence on the prohibition of images and the barbarism of culture, has a definite apocalyptic ring to it—and these younger postmodernist writers and artists to whom the prohibition of images must appear like Holocaust theology. But if, on the other hand, Adorno's notion of mimesis can help us understand such newer artistic practices and their effects in a broader frame, then there may be reasons to suspect that Adorno's rigorously modernist reflection itself blocked out representational possibilities inherent in that mimetic dimension. In its hybrid folding of a complex and multilayered narration into the mass cultural genre, Spiegelman's image-text makes a good case against a dogmatic privileging of modernist techniques of estrangement and negation, for it demonstrates how estrangement and affective mimesis are not mutually exclusive, but can actually reinforce each other.

Finally, there is a weaker, less apocalyptic reading of Adorno's "after Auschwitz" statements. Such a reading would emphasize Adorno's historical critique of that attempt to resurrect German culture after the catastrophe, that attempt to find redemption and consolation through classical cultural tradition—Lessing's *Nathan der Weise* as proof of German "tolerance" of the Jews, Goethe's *Iphigenie* as proof of German classical humanism, German poetry, music, and so forth: "Healing through quotation"—as Klaus Scherpe has called it.[28] The spirit of such a critique of an official German post-Auschwitz culture is one that Adorno shares with the newer generation of artists in many countries today all of whom try to work against contemporary versions of official Holocaust culture the dimensions of which Adorno could not even have imagined yet during his lifetime. There is another sentence, less frequently quoted, but perhaps more pertinent today than the famous statement: "To write poetry after Auschwitz is barbaric." A sentence that continues to haunt all contemporary attempts to write

the Holocaust: "Even the most extreme consciousness of doom threatens to degenerate into idle chatter" (Adorno, *Prisms*, 34). Only works that avoid that danger will stand. But the strategies of how to avoid such degeneration into idle chatter in artistic representations cannot be written in stone.

(2003)

LEGACY

Making Maus

ROBERT STORR

"After Auschwitz, to write a poem is barbaric." Although later recanted by its author, Theodor Adorno, this much quoted dictum of 1955 has deep roots in public sentiment. How can a work of art compare to, much less prevail against, such monstrosities? And how can a single lyric voice presume to bespeak such massive suffering? Furthermore, how can art about genocide avoid the insult to the dead implicit in aestheticizing their slaughter? Judged by this standard, the idea of making a comic book about the Holocaust must be an infinitely worse offense. It sounds like a sick joke. That, however, is what Art Spiegelman has been doing for the past thirteen years, and more.

In its entirety a 269-page chronicle, *Maus* is composed of well over 1,500 interlocking drawings. The initial five chapters were published serially between 1980 and 1985 in *RAW,* the experimental "comix" magazine that Spiegelman cofounded and coedits with Françoise Mouly. With a sixth chapter added to those original installments, the first half of *Maus* was published in book form by Pantheon, New York, in 1986; it was followed five years later by the second and concluding volume, which was issued by Pantheon in November of 1991. The completion of *Maus* is the occasion for this exhibition, which consists of all the original pages of the book, plus an extensive display of cover art, preparatory drawings, process-related and research materials, as well as graphic digressions from the central theme. The purpose is to illu-

minate the final entity—a mass-produced work—by showing its complex genesis in the artist's mind and on the draftsman's page.

Maus centers on the Spiegelman family's fate at the hand of the Nazis, as told by the artist's father, Vladek. The story line shifts ground back and forth between the recent past, in which the formerly estranged son interviews his father about the persecution of the Jews in Europe before and during the Second World War, and the distant past of Vladek's vivid memories of courtship, marriage, military service, pogroms, life in hiding, forced marches, and the nightmare of the extermination camps. The book's subtitle, *A Survivor's Tale,* refers first and most obviously to the father, but the appellation applies equally to the son, who has inherited a dark historical burden and hopes to free himself by opening it up and examining its every detail. Fundamental to the latter's struggle is coming to terms with the reality that suffering does not necessarily ennoble the victim. The Vladek who responds to the cartoonist's persistent queries is often petty and manipulative. Worse, it is revealed, he burned the wartime diaries of his first wife, Anja, forever cutting their son off from his most direct access to that shattered and shattering period and to her (she is the mother mourned in the parenthetical chapter "Prisoner on the Hell Planet"—a much earlier, four-page comic inserted into the narrative—which describes her suicide and the artist's consequent nervous breakdown).

Book I, *My Father Bleeds History*, which recounts the onset of Nazi terror, closes with an image of Spiegelman cursing his father as a "murderer" for this act of destruction. Book II, *And Here My Troubles Began,* describes Vladek and Anja's internment, separation, and liberation, and ends with an image of the grave in which they are ultimately reunited. Under it appears the signature of the artist, who has survived the traumatic legacy they left him by dedicating himself to an unsparing but eventually forgiving record of their collective experience.

Other war-haunted stories of Spiegelman's age have responded to a similar compulsion to examine the fascist era through imaginative reconstruction and so lay personal if still only partial claim to its moral dilemmas. Disconcerting and ironic play with the object of their horrid fascination is the common denominator of much of this work. David Levinthal has photographed blurry scenes of the Blitzkrieg staged with plastic soldiers and tanks, thus eliding boyish bellicosity

with a gritty Robert Capa–like realism. Anselm Kiefer has reenacted sea battles in his bathtub and Panzer-division maneuvers on empty studio floors as well as having himself photographed raising his arm in the Nazi salute in places Hitler's troops once occupied. Sigmar Polke has likewise been photographed goose-stepping with manic elan, and often incorporates symbols of the fascist past into his pictures, as has the cartoon-inspired artist Jörg Immendorff. The Russian team of Vitaly Komar and Alexander Melamid also belongs on this list for its pastiches of Socialist Realist history painting.

All of these artists have in one way or another appropriated "debased" artistic forms for use in fine art formats. Spiegelman is

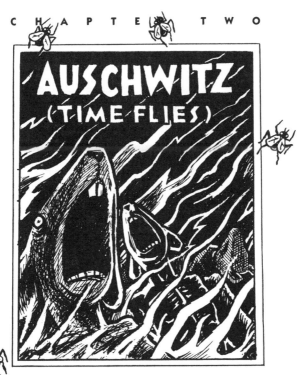

Title page for chapter two,
Maus II, page 39

unique in having realized his project not only within the conventions but within the aesthetic and social context of his chosen models. A veteran of San Francisco's underground comix scene and of New York's cartoon industry—he was creator of the Garbage Pail Kids, Topps Gum Inc.'s gleefully impudent bubble gum card rejoinder to the market onslaught of the cloying Cabbage Patch Kid dolls—Spiegelman is thoroughly at home with the "trashiness" that supposedly rots immature minds but definitely causes conservative brains to short-circuit when thinking about his craft. Moreover, he plays with fire even more aggressively than his previously mentioned contemporaries, aligning the stripes of a concentration camp prisoner's uniform, for example, with computer bar codes on the back of the boxed set of *Maus* or titling one of its sections "Auschwitz (Time Flies)." Spiegelman's mixed feelings about the harsh ironies of his endeavor are summed up in a self-portrait that nonetheless insists on his satiric prerogatives. In it he slouches mouse-masked over his drafting table, at the foot of which bodies are piled as they were in the camps but also like crumpled waste paper. This is not a sick joke but evidence of the heartsickness that motivates and pervades the book; it is the gallows humor of a generation that has not faced annihilation but believes utterly in its past reality and future possibility.

Spiegelman's conformance to comic strip structure is not just a matter of loyalty to his much condemned metier. The simple but readily reconfigured grid of the standard comic book page permits a more orderly story progression and a higher density of visual information than any single surface tableau or montage could possibly accommodate. A collector of graphic serials of all types, from Sunday funny pages to pulpy Little Big Books to the wordless picture novellas of Milt Gross, Lynd Ward, and Frans Masereel, Spiegelman has cultivated an appreciation of how much any one frame or image can convey, and how little each within a sequence should at times vary for maximum narrative emphasis. Accordingly, when the plot of *Maus* unfolds in the situations where the artist plays a part, the pictures generally succeed one another at the ordinarily even pace of the present tense. However, when Vladek's memories take over, the intervals are generally more disjunctive, with oversized dramatic views, explanatory notes, diagrams, and tipped or otherwise irregular boxes frequently interrupt-

Time flies...

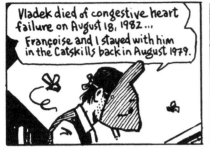

Vladek died of congestive heart failure on August 18, 1982...

Françoise and I stayed with him in the Catskills back in August 1979.

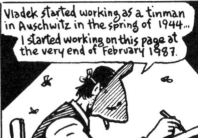

Vladek started working as a tinman in Auschwitz in the spring of 1944...

I started working on this page at the very end of February 1987.

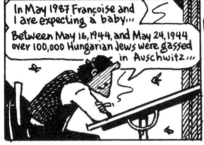

In May 1987 Françoise and I are expecting a baby...

Between May 16, 1944, and May 24, 1944, over 100,000 Hungarian Jews were gassed in Auschwitz...

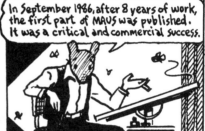

In September 1986, after 8 years of work, the first part of MAUS was published. It was a critical and commercial success.

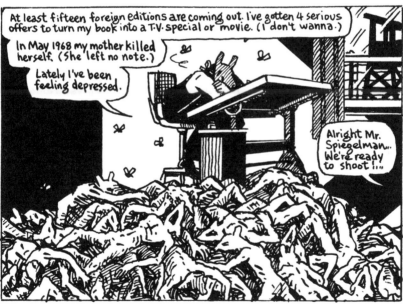

At least fifteen foreign editions are coming out. I've gotten 4 serious offers to turn my book into a T.V. special or movie. (I don't wanna.)

In May 1968 my mother killed herself. (She left no note.)

Lately I've been feeling depressed.

Alright Mr. Spiegelman... We're ready to shoot!...

Maus II, page 41

ing his discursive account of events and breaking this episode's usual eight-frame grid.

On occasion Spiegelman runs images of Vladek telling the story parallel to images of the story he tells, in which case the larger drawings of remembered events operate almost like thought balloons next to the smaller drawings of the conversation between father and son. An especially effective spread in *Maus II* shows a scene of Spiegelman and his father sorting through old family photographs, overlaid with drawn facsimiles of those pictures which accumulate at odd angles until their profusion fractures the vertical and horizontal template of the story frames and brings the confusion of past and present cascading to the bottom margin and into the reader's lap. In some instances Spiegelman unifies a page or part of a page by allowing a pictorial element from one frame to continue into an adjacent frame, effecting a kind of visual enjambment or run-on. For example, in the page following the one just described the image of Vladek slumped over the couch with photos scattered at his feet is pieced together in four abutted close-ups covering five eighths of the whole. In other cases Spiegelman uses a dominant motif such as bunk beds or uniforms, or a consistent direction or density of hatching, to coalesce the separate sections of a given sheet.

Such overall conceptualization and varied phrasing are the essence of comic book art. For *Maus*, it is especially crucial given the extent of research Spiegelman quotes. In his determination to "get it right" the artist became a practical scholar of his medium while pursuing every conceivable avenue leading to or from his focal point in Vladek's recollections. In addition to the graphic precedents already cited, the artist's referents encompass cartoons and gag photos gleaned from old magazines; that industry staple, war comics (including Nazi examples); snapshots taken by the artist when he visited his parents' native Poland; archival materials covering everything from how shoes were sewn to the look of buildings and cars during the war; and postcard portfolios and booklets of art made by the Nazis' captives.

Seen in related clusters, the enormous quantity and variety of drawings Spiegelman has made and preserved document the distillation of *Maus*'s diverse but interconnected components. Spontaneous warm-ups, meticulous revisions, overlays, and outtakes—a great many

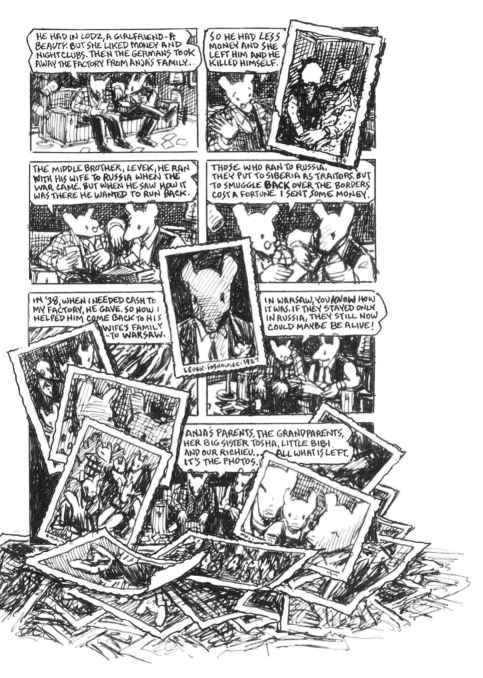

Study for page 115 of *Maus II*. See final version of this page on page 122.

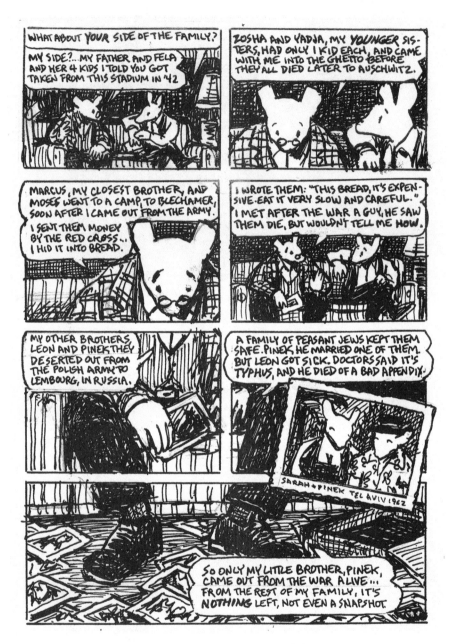

Study for page 116 of *Maus II*. See final version of this page on page 123.

of them remarkable as individual works—testify to the painstaking work required to pack the book as full of information and insight as possible while retaining its overall coherence. Here novel adaptations of signature trade devices were indispensable to Spiegelman's visual syntax. The Dick Tracy "Crime Stopper" inserts, for example, are the acknowledged precursors of the boxes and medallions he uses to explain the Auschwitz exchange rate of cigarettes for bread, and to chart the floor plans of secret hiding places in the ghetto as well as plans of the crematoria, or to map the grounds of the camps or the rail lines between them. Intersplicing macrocosmic views and microcosmic details, firsthand description and library finds, Spiegelman shows how a cataclysm befell the stable provincial society into which his parents were born and how a huge and hellish system was organized to consume their "small" lives. The agonizing incremental choices between escape into the memory or hope of normalcy and the conscious reckoning with the Final Solution's planned indignities and chance cruelties, heretofore best described in Bruno Bettelheim's analytic memoir *The Informed Heart,* have now been depicted by Spiegelman with unmatched completeness and concision.

Maus is presently on two best-seller lists—first as fiction and second as nonfiction. That dual status says something about its importance but also about its misunderstood nature. Although a Mickey Mouse muse no doubt looked over the artist's shoulder while he wrote and drew this book—a recent lithograph by Spiegelman shows Disney's character behind a mouse-cartoonist pondering his rodent model—*Maus* is not an entertainment, nor is it a modern Aesop's fable or an *Animal Farm* allegory of totalitarianism. It is a work of history and of autobiography undertaken in a revisionist period when the very idea that any history, much less a narrative one, has broad public value or a legitimate claim to the truth is under constant assault on several fronts.

Despite its seemingly eccentric, if not aberrant, match of form and content, *Maus* is a radically traditional work of art—traditional in its comprehensive understanding and innovative treatment of the medium's conventions, and traditional in its faith in art's capacity to accurately describe physical and psychological realities over time. Spiegelman's sober graphic manner—criticized by some as insuffi-

ciently developed or stylish and overlooked by others who "read" his pictures as if they were merely settings for the text—is a result of trial and error followed by a firm aesthetic decision. His other options are evident in his previous as well as contemporaneous work, and in the outside sources he called upon. Eschewing the psychedelic scratch-board buzz of "Prisoner on the Hell Planet," the problematic cuteness of his earliest versions of *Maus,* and the Fritz Eichenberg–inspired chiaroscuro Mannerism of other proto-*Maus* experiments, Spiegel-man also forswore the expressionism found in the most sophisticated of the concentration camp drawings, like those of Fritz Taussig (pen name, Fritta), who ran the inmate studios at the "model" village of Terezín and left behind fantastic and frightful representations of that fake utopia's brief existence. If any one example most guided Spiegel-man it would seem to have been that of the modest and unskilled sketch artist Alfred Kantor, whose post-liberation journal is an appall-ingly explicit composite of collaged "souvenirs," maps, and captioned vignettes of daily life and death in Auschwitz. The lesson Kantor teaches and Spiegelman confirms with greater scope—and in the face of much wider choices—is that one does *not* stylize horror. Not so much out of respect for the dead, but to communicate to the fullest possible extent the unrelieved actuality of the crimes committed. A signal achievement of the documentary genre and a prototype of what one might call "comix-vérité" in honor of its equally prosaic cinematic equivalents, *Maus* underscores the easily forgotten aesthetic axiom that nothing is as difficult nor as artful as discretion nor as hard to imagine as the facts.

(1991)

"The Shadow of a Past Time"

History and Graphic Representation in *Maus*

HILLARY CHUTE

Because I grew up with parents who were always ready to see the world grid crumble, and when it started feeling that that was happening here and now, it wasn't a total surprise. I think the one thing I really learned from my father was how to pack a suitcase. You know? It was the one thing he wanted to make sure I understood, like how to use every available centimeter to get as much stuff packed into a small space as possible. The ice might be thinner than one would like to think.

—ART SPIEGELMAN (D'Arcy, 3)

I n *In the Shadow of No Towers,* his most recent book of comic strips, Art Spiegelman draws connections between his experience of 9/11 and his survivor parents' experience of World War II, suggesting that the horrors of the Holocaust do not feel far removed from his present-day experience in the twenty-first century.[1] "The killer apes learned nothing from the twin towers of Auschwitz and Hiroshima," Spiegelman writes; 9/11 is the "same old deadly business as usual" (np). Produced serially, Spiegelman's *No Towers* comic strips were too politically incendiary to find wide release in the United States; they were largely published abroad and in New York's weekly Jewish newspaper, the *Forward. In the Shadow of No Towers* powerfully asserts that

"the shadow of a past time [interweaves] with a present time"; to use Spiegelman's own description of his Pulitzer Prize–winning two-volume work *Maus: A Survivor's Tale* (Silverblatt, 35). In one telling panel there the bodies of four Jewish girls hanged in World War II dangle from trees in the Catskills as the Spiegelmans drive to the supermarket in 1979.[2]

The persistence of the past in *Maus*, of course, does figure prominently in analyses of the text's overall representational strategies. We see this, for instance, in Dominick LaCapra's reading of the book's "thematic mode of carnivalization" (175), Andreas Huyssen's theorizing of Adornean mimesis in *Maus*, and Alan Rosen's study of Vladek Spiegelman's broken English.[3] Most readings of how *Maus* represents history approach the issue in terms of ongoing debates about Holocaust representation, in the context of postmodernism, or in relation to theories of traumatic memory. But such readings do not pay much attention to *Maus*'s narrative form: the specificities of reading graphically, of taking individual pages as crucial units of comics grammar.[4] The form of *Maus*, however, is essential to how it represents history. Indeed, *Maus*'s contribution to thinking about the "crisis in representation," I will argue, is precisely in how it proposes that the medium of comics can approach and express serious, even devastating, histories.[5]

"I'm *literally* giving a form to my father's words and narrative," Spiegelman observes about *Maus*, "and that form for me has to do with panel size, panel rhythms, and visual structures of the page" (Interview with Gary Groth, 105, emphasis in original). As I hope to show, to claim that comics makes language, ideas, and concepts "literal" is to call attention to how the medium can make the twisting lines of history readable through form.

When critics of *Maus* do examine questions of form, they often focus on the cultural connotations of comics rather than on the form's aesthetic capabilities—its innovations with space and temporality.[6] Paul Buhle, for instance, claims, "More than a few readers have described [*Maus*] as the most compelling of any [Holocaust] depiction, perhaps because only the caricatured quality of comic art is equal to the seeming unreality of an experience beyond all reason" (16). Where Michael Rothberg contends, "By situating a nonfictional story in a highly mediated, unreal, 'comic' space, Spiegelman captures

the hyperintensity of Auschwitz" (*Traumatic Realism,* 206), Stephen Tabachnick suggests that *Maus* may work "because it depicts what was all too real, however unbelievable, in a tightly controlled and brutally stark manner. The black and white quality of *Maus*'s graphics reminds one of newsprint" (155). But all such analyses posit too direct a relationship between form and content (unreal form, unreal content; all too real form, all too real content), a directness that Spiegelman explicitly rejects.[7]

As with all cultural production that faces the issue of genocide, Spiegelman's text turns us to fundamental questions about the function of art and aesthetics (as well as to related questions about the knowability and the transmission of history: as Hayden White asserts, "*Maus* manages to raise all of the crucial issues regarding the 'limits of representation' in general" [42]). Adorno famously interrogated the fraught relation of aesthetics and Holocaust representation in two essays from 1949, "Cultural Criticism and Society" and "After Auschwitz"—and later in the enormously valuable "Commitment" (1962), which has been the basis of some recent important meditations on form.[8] In "Cultural Criticism" Adorno charges, "To write poetry after Auschwitz is barbaric" (34).[9] We may understand what is at stake as a question of betrayal: Adorno worries about how suffering can be given a voice in art "without immediately being betrayed by it" ("Commitment," 312); we must recognize "the possibility of knowing history," Cathy Caruth writes, "as a deeply ethical dilemma: the unremitting problem of *how not to betray the past*" (27, Caruth's italics). I argue that *Maus,* far from betraying the past, engages this ethical dilemma through its form. Elaborating tropes like "the presence of the past" through the formal complexities of what Spiegelman calls the "stylistic surface" of a page (*Complete Maus*), I will consider how *Maus* represents history through the time and space of the comics page.[10]

In the hybrid form of comics, two narrative tracks never exactly synthesize or fully explain each other.[11] In "their essence," Spiegelman says, comics

are about time being made manifest spatially, in that you've got all these different chunks of time—each box being a different moment of time—and you see them all at once. As a result you're always, in

comics, being made aware of different times inhabiting the same space. (Silverblatt, 35)

Comics are composed in panels—also called frames—and in gutters, the rich empty spaces between the selected moments that direct our interpretation. The effect of the gutter lends to comics its "annotation" of time as space.[12] "Time as space" is a description we hear again and again from theorists of comics. However, it is only when one recognizes how *Maus* is able to effectively approach history through its spatiality that one appreciates the form's grasp on nuanced political expression. Emphasizing how comics deals in space, as I do here, highlights how this contemporary, dynamic medium both informs and is informed by postmodern politics in a productive, dialogical process. Space, Fredric Jameson contends, is the perceptual modality of postmodernity (*Postmodernism*, 154–180); and where the dominant rhetoric of modernism is temporal, Susan Stanford Friedman argues, postmodernism adopts a rhetoric of space—of location, multiplicity, borderlands, and, I would add, boundary crossings.[13]

In the epigraph to this essay, describing how his father taught him to pack a suitcase to "use every available centimeter to get as much stuff packed into a small space as possible," Spiegelman alludes to his father's experiences in wartime Poland. Yet the historical lesson also shapes Spiegelman's formal preoccupations. Throughout *Maus* he represents the complicated entwining of the past and the present by "packing" the tight spaces of panels. He found an "architectonic rigor . . . necessary to understand to compose the pages of *Maus*," he explains (Silverblatt, 33), and has commented: "Five or six comics on one piece of paper . . . [I am] my father's son" (Spiegelman, Address).[14] It is to this effect that *Maus* exploits the spatial form of graphic narrative, with its double-encodings and visual installment of paradoxes, so compellingly, refusing telos and closure even as it narrativizes history. In this light, I will analyze a range of sections of the book: some that have been treated comparatively little in *Maus* criticism, such as the multitemporal panel in the embedded comic strip "Prisoner on the Hell Planet" and the double epitaph of the book's last page, and some that have not been treated at all, such as the scene that centers on a timeline of Auschwitz.

Bleeding and Rebuilding History

The first volume of *Maus* is subtitled, significantly, *My Father Bleeds History*. The slow, painful effusion of history in this "tale," the title suggests, is a bloodletting: its enunciation and dissemination are not without cost to Vladek Spiegelman (indeed, it is his headstone that marks, however unstably, the ending of *Maus*). In suggesting that the concept of "history" has become and is excruciating for Vladek, the title also implies an aspect of the testimonial situation we observe over the course of *Maus*'s pages: the fact that, as Spiegelman reports, his father had "no desire to bear witness" (Interview with Cavalieri et al., 192). Indeed, throughout much of the book, Vladek would clearly prefer, we see, to complain about his rocky second marriage. Toward the end of the second volume of *Maus,* Vladek protests to Artie, "All such things of the war, I tried to put out from my mind once for all . . . Until you *rebuild* me all this from your questions" (98).[15] Vladek's bleeding is his son Artie's textual, visual (as well as emotional) rebuilding. Spiegelman as author is distinctly aware of Artie the character's shades of vampirism, however well intentioned. And the idea of "bleeding" history (at the demand of a son) acquires further poignancy when one realizes—as transcripts of the taped interviews between Vladek and Art Spiegelman on the CD-ROM *The Complete Maus* reveal—that Vladek and his wife, Anja Spiegelman, never spoke to each other in detail about their (literally unspeakable) experiences in the camps.[16] This "bleeding" of history is not an easy process; Anja's diaries, for instance, as Vladek explained, were too full of history to remain extant after her death: "I had to make an order with everything . . . These papers had too many *memories*. So I *burned* them" (*Maus I*, 159). Art Spiegelman's narrativization of his parents' history, then, as many critics have pointed out, is also his *own* making "an order with everything." He reconstructs history in his own language—comics—in frames and gutters, interpreting and interrupting as he rebuilds.[17] Comics frames provide psychic order; as Spiegelman recently remarked about 9/11: "If I thought in page units, I might live long enough to do another page" (Gussow).

Maus's chapter 1, "The Sheik," zooms into history. In the middle of its second page is a panel packed with signifiers of the past and present, jammed together in a long rectangular frame, only an inch

high, that spans the width of the page. In a space that was once Art-ie's bedroom (a pennant proclaiming "Harpur," Spiegelman's college, is still pinned to the wall), Vladek, his camp tattoo visible for the first time, pumps on an Exercycle. Not moving forward, he is literally spin-ning his wheels. This suspension is also indicated by the fact that a full view of his body, locked into position, appears across frames on the page: his head in panel four, his torso in panel five, his foot in panel seven. The wide berth of his arms frames Artie, who sits and smokes, looking small. A framed photo—of the dead Anja Spiegelman, we will later find out—is propped on a desk to the right of both men, representing both an object of desire and a rebuke. In a speech bal-loon on the left that echoes the photograph and tattoo on the right, as if the past—articulated (spoken), inscribed (tattooed), documented (photographed)—were flanking both men, closing in on them, Vladek proclaims: "It would take *many* books, my life, and no one wants any-way to hear such stories" (12).

From the start, Spiegelman crams his panels with markers of the past (the camp tattoo, prewar photographs) and the ultimate marker of the present: Artie Spiegelman himself, framed by his father's body, his parents' postwar child, born in Sweden after the couple lost their first son to the Nazis. And while the horizontally elongated panel implies a stillness—its page-spanning width eliminates any gutter, where the movement of time in comics happens—it yet registers Vladek's first moments of dipping into the past. While Vladek verbally refuses to offer "such stories," the panel below, an iris diaphragm depicting his dapper young self ("really a nice, handsome boy" [13]) in the early 1930s, pushes up into the rectangular panel of the present, its curve hitting the handlebars of Vladek's Exercycle between his grasping hands.[18] This protruding circular frame can be figured as the wheel to Vladek's Exercycle. Spiegelman points out, "You enter into the past for the first time through that wheel" (*Complete Maus*).

The visual intersection of past and present appears throughout in the architecture of panels. In chapter 3 of *Maus I*, "Prisoner of War," Artie sprawls across the floor of his father's Rego Park, Queens, home, pencil in hand, notebook open, soliciting stories (45). Artie's legs span decades. Looking up at his sitting father, facing forward toward the direction of the unfolding narrative, Artie's legs are yet mired in the

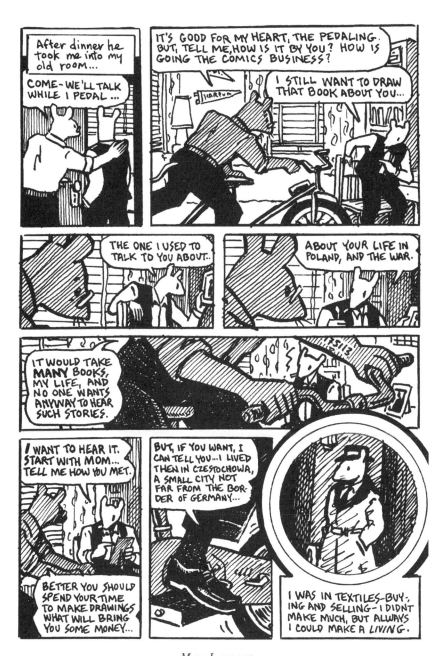

Maus I, page 12

past: they conspicuously overlap—indeed, unify—the panel depicting 1939 and the one depicting the conversation in 1978. Artie's body, then—in the act of writing, of recording—is visually figured as the link between past and present, disrupting any attempt to set apart Vladek's history from the discursive situation of the present.

The connection between past and present in this chapter is also emphasized by verbal parallels. Vladek, for instance, describes a grueling POW work detail, in which a German soldier demands that a filthy stable be spotless in an hour. Interrupting his own recollection, Vladek suddenly bursts out, *"But look what you do, Artie!* You're dropping on the carpet *cigarette* ashes. You want it should be like a stable *here?"* (52). Joshua Brown (in his essay reprinted in this volume) points out that this incident—which he identifies as one of many "interstices of the testimony"—suggests that "Vladek's account is not a chronicle of undefiled fact but a constitutive process, that remembering is a construction of the past" (see page 13). And the ways in which the past invades the present recollection, or vice versa, gradually grow more ominous: in the beginning of *Maus,* comparisons may involve issues like cleanliness, but by the second volume, Spiegelman will draw Artie's cigarette smoke as the smoke of human flesh drifting upward from the crematoria of Auschwitz (*Maus II,* 69).[19]

Inheriting the Past, Packing a Panel

The most striking instance of representing past and present together in *Maus I* is the inclusion of the autobiographical comic strip "Prisoner on the Hell Planet: A Case History" (1972) in the text of *Maus.* Breaking the narrative flow of *Maus,* interrupting its pagination, style, and tone, "Prisoner on the Hell Planet" enters into the story, it would seem, from outside, registering confrontationally—and materially—the presence of the past. First published in an underground comic book, *Short Order Comix* 1, it narrates the immediate aftermath of the 1968 suicide of Spiegelman's mother, Auschwitz survivor Anja Spiegelman, at his family's home in Queens.

Readers are introduced to the existence of "Prisoner on the Hell Planet" at the same time that a calendar is first made conspicuous in *Maus,* in the panel in which his stepmother, Mala, startles Artie by

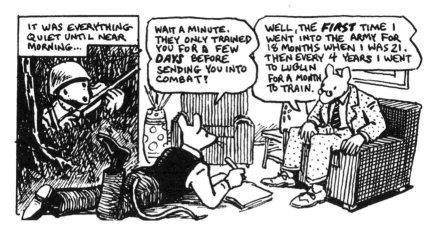

From *Maus I*, page 45

mentioning "that comic strip you once made—the one about your mother" (99). This calendar appears in five of eight panels preceding "Prisoner" and in eight out of the nine panels on the page directly following it, but this representation of the linear movement of time is disrupted by the intrusion of "Prisoner," which does not seamlessly become part of the fabric of the larger narrative but rather maintains its alterity. Featuring human characters, it is clearly distinct from the rest of *Maus* in its basic representational methodology; its heavy German expressionist style is an unsubtle analog to the angry emotional content of the strip. *Maus*'s page numbers stop while "Prisoner" unfolds; and the older strip's pages are set against a black, unmarked background, forming what Spiegelman calls a "funereal border" that stands out as a thick black line when the book is closed (*Complete Maus*).

"Prisoner" is Artie's earliest testament to what Marianne Hirsch persuasively describes as "postmemory" ("Projected Memory," 8), a now oft-cited term that she first conceived of in relation to *Maus*.[20] And while this visual and narrative rupture of the text suggests what and how the past continually means in the present, I want to focus in particular on one packed panel on "Prisoner"'s last page. Like the volume in which it is embedded, "Prisoner" spatially depicts multiple temporalities in single visual-verbal frames. If Spiegelman claims that he feels very much like his "father's son" when he draws five comics on one page, here we see five different moments in one panel, crisscrossed by text that alternates sentiments corresponding with the frame's

accreted temporalities: We get "Mommy!" (the past) but we also get "Bitch" (the present); we get "Hitler Did It!" (the past) but we also get "Menopausal Depression" (the present) (103). Approaching the past and the present together is typical for someone considering narratives of causality, but here Spiegelman obsessively layers several temporalities in one tiny frame, understood by the conventions of the comics medium to represent one moment in time. Artie's childhood bedroom is contiguous with a concentration camp; Anja's disembodied arm, readying for her suicide, floats out from the body of the youngster Artie, her thumb just about touching the leg of the adult Artie, who sits in despair on what looks like her casket.

This frame, smaller than two inches by two inches, depicts several images from different time periods: Anja's dead body in the bathtub; a heap of anonymous dead bodies piled high underneath a brick wall painted with a swastika; Anja reading to the child Artie; Anja cutting her wrist, her tattooed number fully visible on her forearm; the young man Artie in mourning, wearing the same Auschwitz uniform he wears even as a child, happily listening to his mother read. "Prisoner," then, posits that Artie inherited the burden that the uniform represents, in a natural transfer of pain that wasn't consciously accepted or rejected but seamlessly assumed.[21] He earned his stripes at birth.

Panel from "Prisoner on
the Hell Planet," 1972,
in *Maus I*

Maus II: Making an Order

In *Maus II: And Here My Troubles Began* Spiegelman's self-reflexivity is a strategy specific to representing the Holocaust. By explicitly centering portions of the text on its own enunciative context, he offers his doubts as to his adequacy to represent the Holocaust, as a secondary witness and as a cartoonist. He assiduously explores his feelings about *Maus I* in *Maus II,* whose subtitle, after all, refers not only to Vladek's statement made after he left Auschwitz ("Here, in Dachau, my troubles began" [91]), but also to Spiegelman's own success with *Maus I* ("things couldn't be going better with my 'career,' or at home, but mostly I feel like crying" [43]). The most metafictional section in the volume is the "Time Flies" episode (41–46). While "Prisoner" represents a retextualization and resignification of a past narrative into a newer, yet still provisional one, "Time Flies" works as a projection forward, a meditation on the viability of the present project.[22]

The double voicing of *Maus*—Artie's voice and his father's—presents a view of narrative generally and testimony specifically as a polyvalent weave.[23] Testimony and memory here are collaborative procedures generated by both speaker and listener. Further, the play of voices in *Maus* is complicated in light of Spiegelman's position that comics provides a "visual voice in the artist's hand" (D'Arcy, 2). In this Holocaust representation, the artist's hand is the visibilized link between the personal voice of the primary witness and its translation, the voice of the secondary witness: as such, Spiegelman's hands are frequently pictured in *Maus,* and his "artistic hands" are the subject of conspicuous conversation between him and his father. The comics medium, as Spiegelman makes us aware, is not only *dialogic*—able to represent the competing voices of autobiography and biography in one layered text—but cross-discursive, as when Spiegelman draws against his father's verbal narration, turning what he calls the "cognitive dissonance" between the two of them into representational collision (Silverblatt, 32). (One prominent example of the son battling his father's verbal testimony with his own visual medium is Spiegelman's drawing of an only just visible orchestra playing as prisoners march out

of the gates of Auschwitz, contradicting Vladek's firm vocal insistence that no orchestra was present.)[24]

Both Artie and Vladek want to order historical narrative. But Vladek's order—poignantly, understandably—involves a degridding. He wants to dismantle, to destroy in order to forget ("I had to make an order with everything . . . These papers had too many *memories*. So I *burned* them" [*Maus I*, 159]), even as his account is teased out by his son over a period of years. While Vladek's order is a defenestration, Artie wants to build windows, to resurrect; Spiegelman's language is that he "materializes" Vladek's words and descriptions in *Maus* (quoted in Brown, 98). In the introduction to his 1977 collection, *Breakdowns*, which contains the three-page prototype for *Maus*, Spiegelman attaches the concept of narrative to the spatial, "materializing" work of comics:

> My dictionary defines COMIC STRIP as "a narrative series of cartoons . . ." A NARRATIVE is defined as "a story." Most definitions of STORY leave me cold . . . Except for the one that says "A complete horizontal division of a building . . . [From Medieval Latin HISTORIA . . . a row of windows with pictures on them]." (np; Spiegelman's brackets)

And Spiegelman speaks of the act of ordering a comics narrative in frames as a kind of necessary reckoning: "The parts that are in the book are now in neat little boxes. I know what happened by having assimilated it that fully. And that's part of my reason for this project, in fact" (Witek, 101). Working with his father's slippery, strange, nonlinear, incomplete testimony, Spiegelman is drawn to the concept of imposing formal order.[25] It comes as no surprise, then, that at one point he was drawn to a high modernist ethic of representation for *Maus;* he thought he should compose the book "in a more Joycean way" (Brown, 94). Yet finally, Spiegelman ceded the structure of a *Ulysses* for the mere structural containment of "neat little boxes," a description that evokes both a hopeful (if impossible) burial of the past in coffin-panels, and the full, packed suitcases that are his father's history lesson for the present.

The difference in the way Vladek and Artie each "order" history registers clearly in a crucial scene in which Artie's attempt to chronologically account for Vladek's time in Auschwitz provides the basis for disagreement. While Artie emphasizes Vladek's *time* there, Vladek insists on the *space* of his Auschwitz experience. Appropriately, then, in the chapter "Auschwitz (Time Flies)," *Maus* presents a timeline of 1944 which is the only explanatory diagram not part of the authorial purview of Vladek. (Diagrams are a recurring subject, a mode of representation, and a collaborative textual practice in *Maus,* where, with this exception, they are organic to Vladek's narrative thread.) This diagram represents a disagreement; the son is "imposing order" while the survivor, caught up in his testimony, resists that historiographic impulse.

Artie wants to present a lucid and chronological narrative of his father's months in 1944, but Vladek resists Artie's accounting: "In Auschwitz we didn't wear watches" (68). When Artie draws a diagram for *Maus,* then, he draws it as the site of a father-son battle. Spiegelman presents his own desire for linear order and Vladek's resistance to that kind of order in an especially complex fashion. The diagram pierces three rows of frames. It begins at the end of the page's first tier, where it blocks a corner of Vladek's speech balloon, interrupting a first-person sentence. "I—" Vladek starts, before our eyes run up against a black-rimmed timeline, its corners sharp (68).

The timeline begins in March 1944 and continues down vertically, representing Vladek's Auschwitz activity: quarantine, tinshop, shoe shop, black work. It does not occupy the furthermost space of the page, however, but is recontextualized, if only teasingly, by the shrubs poking messily out from its right margin. Moreover, while the diagram cuts off Vladek's speech in the first tier and his shoulder in the second tier, in the third tier it is itself interrupted by Artie's wife, Françoise's, speech balloon—"*YOOHOO!* I was *looking* for you." We have, then, the present layered thickly by the past, framed tentatively by the present, layered again by the past, and interrupted by a present-day exclamation, a burst of the banal: lunch time. Directly under the timeline, Françoise calls attention to the tangle of temporalities in a comment as applicable, in the haunting abstract, to Vladek's months

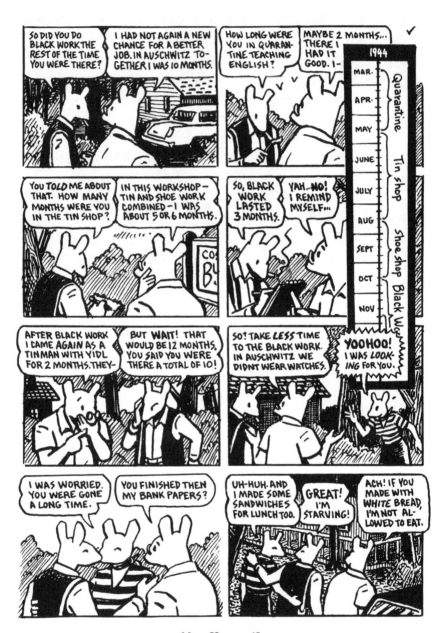

Maus II, page 68

in Auschwitz as it is to the length of Artie's stroll around the bunga-
lows: "I was worried. You were gone a long time" (68).

Superimposed over the frames, the timeline makes the sort of his-
toriographic gesture that the overall narrative, shuttling rapidly back
and forth from past to present, does not attempt, and that Vladek can-
not offer. As Spiegelman puts it: "The number of layers between an
event and somebody trying to apprehend that event through time and
intermediaries is like working with flickering shadows" (Brown, 98).
He thus represents the accreted, shifting "layers" of historical appre-
hension not only through language but also through the literal, spatial
layering of comics, enabling the presence of the past to become radi-
cally legible on the page.

The Question of Closure

Pointing to *Maus*'s specific argument about temporality and the rep-
resentation of history, one anecdote is particularly telling about the
political work *Maus* accomplishes. Spiegelman acted as a catalyst to
get a show about Bosnia at the Holocaust Museum in Washington,
D.C.—"a show which, to me, was a justification of that museum's exis-
tence," he says. (Spiegelman had rejected the idea of having a show
about *Maus* there: "The Holocaust Museum didn't need *Maus,* and
Maus didn't need the authority of the Holocaust Museum to make
itself understood") (Interview with Andrea Juno, 16).[26] Spiegelman
wanted to call the Bosnia show "Genocide Now." The museum drew
back. As Spiegelman narrates the museum's objection:

> "Does it have to be called Genocide Now? Got a better one? Can't
> we just talk about the atrocities in former Yugoslavia?" Well, if the
> situation looks and smells like genocide, it probably is. They were
> still against the title, and the best alternative I could come up with
> was: "Never Again and Again and Again." They didn't like that title,
> either, and that was about the time I checked out. (Interview with
> Andrea Juno, 16)

This insistence, "Genocide *Now,*" is a refusal to see "the past" as
past—which is an adamant, ethical argument that *Maus* undertakes

through the temporal and spatial experimentation that the narrative movement of comics offers. "Genocide Now" is blunt, grim, unflinching. But even its lesser incarnation, "Never Again and Again and Again," expresses the continuousness of history as "what hurts" (as Jameson puts it), as our nondivorce from the traumatic events of the past, the impossibility of rejecting horror as ever completely "behind us" (*Political Unconscious,* 102). This title strongly recalls Spiegelman's own choice of an internally repetitive title for his recent collection of work, *From "Maus" to Now to* Maus *to Now,* which itself posits the historical trauma represented in *Maus* as unending. Spiegelman insists on the persistence of trauma—in his choices of titles, in his textual practice of spatial intrusion, overlaying, and overlapping—in order to show how memory can be treated as an ongoing creative learning process, rather than something anchored in insuperable trauma. On the pages of *Maus,* Spiegelman shows us the violation and breaking of the "world grid" in both senses of the term—phenomenologically and literally on the page. Spiegelman's overtly political suggestion—which he registers in literal, graphic frame-breaking—is that the past is present, again and again and again: *Maus* questions the framework of everyday life that is taken for granted. As Robert Storr (in his essay reprinted in this volume) asserts of the obscene mouse-head corpses "piled . . . like crumpled wastepaper" under Artie's feet in the section "Time Flies" while he sits at his drawing board, contemplating his project: "this is not a sick joke but evidence of the heartsickness that motivates and pervades the book: it is the gallows humor of a generation that has not faced annihilation but believes utterly in its past reality and future possibility" (28). *Maus'*s enmeshed temporalities suggest a line of thinking that indeed stems from such a worldview. In his latest work, Spiegelman admits to having an "existential conviction that I might not live long enough to see [*In the Shadow of No Towers*] published" (np).

The effect of visually, spatially linking the past and the present as *Maus* does is to urgently insist on history as an "untranscendable horizon" (Jameson, *Political Unconscious,* 102). "Instead of making comics into a narcotic, I'm trying to make comics that can wake you up, like caffeine comics that get you back in touch with things that are hap-

pening around you," says Spiegelman (Silverblatt, 31). Indeed, *Maus*'s challenging multivocality, crossdiscursivity, and the thick surface texture of its pages demand a reading process that engages the reader in an act of consumption that is explicitly anti-diversionary.

In "Collateral Damage," a *PMLA* editor's column introducing an issue that explores visuality and literary studies, Marianne Hirsch focuses crucial attention on *In the Shadow of No Towers* and on the form of comics generally.[27] She asks: "What kind of visual-verbal literacy can respond to the needs of the present moment?" (1212). As Hirsch shows in her analysis of *No Towers,* certainly Spiegelman's work is one important place to go. Spiegelman himself expresses strong views about the literacy that comics require and hone: "It seems to me that comics have already shifted from being an icon of illiteracy to becoming one of the last bastions of literacy," he has said (Interview with Gary Groth, 61). "If comics have any problem now, it's that people don't even have the patience to decode comics at this point. I don't know if we're the vanguard of another culture or if we're the last blacksmiths."

Historical graphic narratives today draw on a popular form once considered solely distracting in order to engage serious political questions. We see in *Maus* faith in "making hopeful use of popular forms," to use a phrase of Neil Nehring's (36)—the (post)utopian impulse evident in Spiegelman's earlier work such as *RAW,* the magazine that declared it had "lost its faith in nihilism" (*RAW* 3, July 1981). Charles Bukowski wrote Spiegelman in the late 1970s, "Ah, you guys are all ministers in Popeye suits" (Silverblatt, 36). To the allegation of masking high moral seriousness with "the popular," Spiegelman responded, "Most of the artists in *RAW*—I won't say every single one of them—are moving forward from a moral center. As a result, it seemed to me to be interesting to be able to make ethics hip."

Indeed, the graphic narrative is a contemporary form that is helping to expand the cultural map of historical representation. Its expansive visual-verbal grammar can offer a space for ethical representation without problematic closure. *Maus* is a text inspirited with an intense desire to represent politically and ethically. But it is not a didactic text pushing moral interpretations or solutions.[28] An author "moving

forward from a moral center" is not the same as an author presenting an authoritative morality tale of history—a concept that Spiegelman's text vehemently rejects.[29] *Maus* defines itself against morality tales as Gertrud Koch describes them: narratives that "endeavor to convince us of their own moral qualifications and blur the dark and destructive future the past often presents to its victims" (406). As its stunning last page makes apparent, *Maus* eschews the closure implied by the concept of a moral text, offering instead multiple layers representing time as space; an unstable interplay of presence and absence; and productive, cross-discursive collisions.[30]

As Spiegelman notes, *Maus*'s last page "just keeps ending" (*Complete Maus*). It both suggests the ethical value of narrative and insists that no voice could or should have the last word, thus suggesting the work of memory as a public process.[31] Through a form that "folds in on itself in order to get out," the ending of *Maus* moves beyond the particularity of its "tale," inviting the reader to join in a collective project of meaning-making (*Complete Maus*).

As its grim ending so clearly reveals, *Maus* does not offer—with sincerity—the narrative closure that would seal a traditionally moral story. *Maus*'s last page breaks the frame because it is innovative in its *spacing*, ontologically suggesting that there is no closure, no "ending," no telos.[32] Unsurprisingly, the last page of *Maus* does not have a page number; it is not stamped with a linear logic of progression. In a way, *Maus* does end the most traditional way a narrative can: with a literal claim of "happy ever after." And it ends the most literal way a biography can: with the death of its subject. But like so much postmodern fiction, *Maus* offers, exploits, and undercuts the most traditional of happy endings (romantic reunion; family romance). And, like so much biography, it offers and undercuts that most traditional of structural principles: life dates.

The last page of *Maus* is charged with movement: the narrative accelerates and *decelerates*—if one can call it that—rapidly. The page offers six panels, two on each row, and each pair of frames works off of an opposition. The first tier moves from outside to inside, from the open Sosnowiec street to a close view of the Jewish Organization building (a speech balloon juts out from its closed window). The

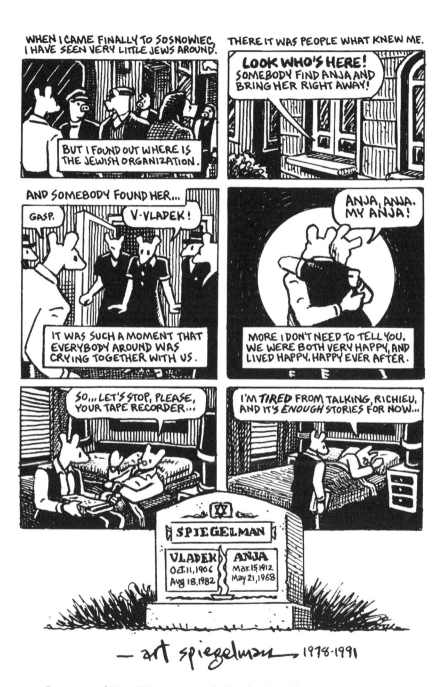

Last page of *Maus II* (unpaginated). See sketch of this page on page 289.

second tier moves from a position of graphically stark apartness (Vladek, dressed in white, and Anja, dressed in black, face each other disbelievingly across a room) to a position of dramatic togetherness (Vladek and Anja embrace in front of an iris diaphragm). In the third tier's first panel, Artie sits as if anchored to his father's bed, and in the second panel, Artie stands, leaving; in the first panel Artie is Art, and in the second, his father names him Richieu (the name of his long dead brother, who did not survive the war); in the first panel Vladek faces Artie—and the reader—and in the second he rolls over and turns away, bending his arm over his face. Essentially, for the readers of *Maus*, in that last moment he dies, for the next image Spiegelman presents is his tombstone, balanced exactly in the middle of the two last frames, its Star of David shooting up the gutter. The Spiegelman tombstone rises up into this bottommost tier of frames, splitting the two panels symmetrically. The literally central presence of the tombstone's Star of David on the last page of *Maus*, then, is a key affirmation of Judaism, for this prominently placed symbol resignifies: Spiegelman recalls the Star as a mark of hatred and oppression on the Nazi-enforced badges that are so prevalent in the first volume of *Maus*, reversing the "mark" to attest to the enduring survival of Judaism and Jews.[33]

Immediately, we notice that balanced below the headstone, marked with the uppercase "SPIEGELMAN," is a lowercase echo, a reply to this death—Art Spiegelman's signature, and the dates he worked on *Maus:* "art spiegelman 1978–1991." The narrative argument of this page is in its spacing, its echoes and replies, its gulfs and repetitions, what it buries and what it at once engenders. Narrative closure (death, marriage) is often, especially in postmodern fiction, questioned by epilogues.[34] Spiegelman's signature—shaggy, stylized, undercase—and the tombstone that he places exactly in the center of a symmetrical page, is that very questioning "epilogue." As ever, Spiegelman competes with his father's narrative while at the same time faithfully representing it. Spiegelman's signature—not an extra-narrative detail or flourish but part of the (post-plot) narrative itself, does not represent closure or finality. The Spiegelman signature, echoing the engraving on the Spiegelman parental tombstone, marks the narrative's awareness of the falsity of *Maus*'s patently unhappy "happy ending." Vladek and Anja did not live "happy, happy ever after," as Vladek claims in

the narrative voiceover that accompanies their reunion embrace. The doubled inscriptions, epitaphic and autographic, *show* us that Spiegelman does not intend to let his father have the "last word" (even as he might desire the incredible delusion behind the inaccurate "happy ever after"). The last *spoken* words in *Maus* are Vladek's: "It's *enough* stories for now . . ." (emphasis and ellipses in original). The "story" suggested by the tombstone, though, is one that Vladek does not himself narrate (Anja's suicide), but of which readers of *Maus* are aware. The traumatic stories, *Maus* implies, go on after its last image and will continue to come in the future; in this way, *Maus,* while a "survivor's tale," is not a morality tale. *Maus* rather exploits and resists the happy ending that punctuates a morality tale.

In *Maus's* last page, Vladek and Anja reunite after Auschwitz, and *Maus* completes its family romance. "V-Vladek!" cries Anja. "Gasp," manages Vladek. In his narrative voiceover to Artie, Vladek describes that "It was such a moment that everybody around us was crying together with us." In the next panel the couple embrace as in an old Hollywood movie, in the center of a dramatic iris diaphragm, their faces buried in each other's shoulders. Vladek narrates: "More, I don't need to tell you. We were both very happy, and lived happy, happy ever after." The intra-textual reference for *Maus's* last page is a page in *Maus I's* chapter 2, "The Honeymoon." In this scene, which takes place before the war breaks out definitively, the dressed-up Spiegelmans dance closely with each other (at Anja's sanitarium) in front of an iris diaphragm, in six separate frames (35). Vladek tells Anja, as the two dance, an amusing story about his father's pillow, which the elder Spiegelman had retrieved at great peril when the family fled the 1914 war (in *Maus's* last page, Vladek Spiegelman will place his arm, in a gesture of exhausted finality, across his pillow, almost like a child settling down to sleep). In this page's final panel, when Vladek completes the punch line, about his father's safe return but horse-sore behind, Anja—in the same posture as in *Maus's* dramatic final page—embraces Vladek, her arms around his neck. "I love you, Vladek," she says. Vladek's voiceover narration, in a box below the image—as in *Maus's* ending—is as follows: "And she was so laughing and so happy, so happy, that she approached each time and kissed me, so happy she was" (35).

This repetition of "happy" three times is echoed in *Maus's* con-

clusion, which correspondingly, unbelievably repeats "happy" three times: "We were both very happy, and lived happy, happy ever after." Of course, however, although they embrace as if in a melodramatic film still at the end of Vladek's testimony, readers of *Maus* know that the Spiegelmans' narratives do not end happily. Instead, *Maus*'s last sequence shows, as Gertrud Koch puts it, the "endlessness of sadness" (403). Anja did not live "happy ever after": even if the text had not earlier referenced her suicide, the tombstone punctuating the page clearly shows she died fourteen years before Vladek, at age fifty-six. And Vladek, as we well know, devastated by Anja's death, in ill health, was often estranged from his only son and unhappy in his second marriage.

On one hand, the doubling of nomenclature (a representation of engraving, the "SPIEGELMAN" inscribed in stone—and its mimicry, the representation of authorial "voice" and performance, the "art spiegelman" inscribed in ink below the drawn grave) indicates Spiegelman's attention to the idea of text as a social space, here particularly as a collaborative fabric created by father and son (and absent mother) that produces no single master of enunciation, but several interacting enunciators. It is clear that *Maus* subverts, even as it installs, the singularity and originality implied in signature (Hutcheon, 81). But here Spiegelman's narrative (implied in the open-endedness that his signature unexpectedly delivers) also competes with his father's narrative of closure. Terms like "polyphonic" or "dialogic" come to mind, but the page, intermixed in its "conversation" with different media, is more complicated than a rubric-like dialogism indicates, since Spiegelman responds to his father's verbal narrative *visually,* by drawing his gravesite and drawing his own signature. Reading this page, one is reminded, as Felman points out, that testimony often functions as signature. Here Spiegelman's literal signature competes with the signature of Vladek's testimony. Spiegelman is here, as ever, doing (more than) two things at once, contradictorily preserving and questioning his father's narrative. Spiegelman's visual post-dialogue epilogue is at once oppositional (calling our attention to the stories told on the tombstone as a rejoinder to his father's "ever after" conclusion), *and* commemorative, a tribute to his parents, a supplement to Vladek's testimonial signature that he marks with his own literal signature: a deferring, lowercase inscription.

If life dates are the most traditional way to narrate a biography, Spiegelman offers us his parents' life dates in *Maus*'s final page, gesturing toward the most basic, simplistic form of life narrative. Drawing their shared headstone as the penultimate punctuation of *Maus,* he officially immortalizes his parents in text (of course, their names are already preserved elsewhere, engraved in stone): "VLADEK Oct. 11, 1906–Aug. 18, 1982" and "ANJA Mar. 15, 1912–May 21, 1968." Directly below, his signature, followed by the dates he worked on *Maus*—"art spiegelman 1978–1991"—suggests several different meanings. We assume that the dates clearly indicate the "life" of *Maus*'s enunciation, the process of researching, drawing, and composing this work. Echoing the inscription of nomenclature on his parents' gravesite, then, his signature implies his desire to put *Maus* to rest; or rather, it defines the life of the project as its procedure. Another way to read this line—if one were keyed to the power of visualizing the literal, as Spiegelman prompts us to do throughout the text—is as Spiegelman's *own* life dates: indeed, this option makes the most *graphic* sense, even as we know these dates to be false as those marking his biological lifespan.

By placing his signature directly below his parents' grave—indeed, in the space of the ground below—Spiegelman figures himself as *buried* by his parents' history. (Indeed, we can recall his strongest response to his status as a member of the "postmemory" generation: his accusations of murder to both parents.) But Spiegelman's signature is also a way to read the book backward: his signature may be figured as *generative,* growing the text upward from the space of the buried, repressed, and "entombed"—where it appears to end. *Maus*'s ending, then, *spatially* marks itself as a "working through" (the spaces and enclosures of panels and gravesites and ground), which is that documentary/testimonial imperative that does not give in to closure.[35] From a graphic perspective, the movement of the page strikingly travels *upward* (and backward, then), suggesting the engendering of the narrative we have just read. Grass grows, somewhat wildly, up from the Spiegelman gravesite; the headstone is positioned as an arrow shooting up through the gutter into the grid of the page—and, it is implied, back through the narrative we have just completed. The Eternal Flame that is engraved on the stone, which represents Jewish persistence and permanence in the face of oppression and

death, points up through the dead center of the page, aligned with the straight white line of the gutter. Thus positioned, the Eternal Flame—spiritually and graphically—signals the unending of life and narrative. This marks a continuousness rather than a closure, as with *Maus*'s double epitaph, which resists the teleological and the epitaphic. Because of the complexity of *Maus*, the defining example of this politically invested aesthetic form, graphic narratives are now part of a postmodern cartography, with new work such as Marjane Satrapi's *Persepolis* charting childhood in revolutionary Iran, and Joe Sacco's *Palestine* and *Safe Area Gorazde* mapping the front lines of Palestine and Bosnia. Epitomizing the possibilities of the new comics form, *Maus,* interlaced with different temporalities whose ontological weave it frames and questions through spatial aesthetics, rebuilds history through a potent combination of words and images that draws attention to the tenuous and fragile footing of the present.

I would like to thank Marianne DeKoven, Richard Dienst, and James Mulholland for commenting on earlier versions of this essay.

(2006)

Art Spiegelman's Genre-Defying Holocaust Work, Revisited

RUTH FRANKLIN

A quest for ersatz verisimilitude might have pulled me further away from essential actuality as I tried to reconstruct it," muses the author of a seminal work of literature about the Holocaust. In a lengthy interview that has just been published, he reveals that his source material included thousands of hours of interviews; a shelf of books in Polish, Yiddish, and Ukrainian; detailed maps of the death camps; and even manuals of shoe repair. No element of the concentration camp universe has escaped his attention: confronted by a historian who disputes his depiction of the toilets at Auschwitz, he gleefully points out that he is referring to the lesser-known Auschwitz I, which had actual plumbing, rather than the more notorious Auschwitz II (Birkenau), with only rows of planks over open pits. "Maybe as a way of getting past my own aversion I tried to see Auschwitz as clearly as I could," he says. "It was a way of forcing myself and others to look at it."

This writer is not Elie Wiesel or Primo Levi, though his work, like theirs, is based in testimony. He is not Piotr Rawicz or H. G. Adler, though he shares their interest in viewing real events through a filter of surrealism. He is not Thomas Keneally, though his work has a quality of the "nonfiction novel" about it; nor is he W. G. Sebald, though his books, like Sebald's, have been described as a mix of fiction, documentary, and memoir. He is Art Spiegelman, and he has done more

than any other writer of the last few decades to change our under-standing of the way stories about the Holocaust can be written. *Maus*, Spiegelman's "epic story told in tiny pictures" (in the words of Ken Tucker, one of its first reviewers), is now twenty-five years old, and it is testimony to the book's wide reach that its premise hardly needs to be restated. The idea of a graphic novel about the Holocaust in which the Jews are drawn as mice and the Nazis as cats is as familiar to us now as it was unheard-of to its first readers.

But what is less well known about *Maus* is the way the book was put together—in a drawn-out process lasting thirteen years and incorpo-rating a vast amount of research. In *MetaMaus*, a combination book and DVD just published by Pantheon, the artist investigates his own creative process with a comprehensiveness that may well be unprec-edented. The book transcribes a long interview with Spiegelman by the literary scholar Hillary Chute, as well as interviews with the art-ist's family members and people who knew his parents during the war, reproductions of documents, and a transcript of the original interviews with Spiegelman's father, Vladek, on which *Maus* was based. In addi-tion to the full text of *Maus* itself, with nearly every frame hyperlinked and annotated, the DVD presents thousands of supporting docu-ments interspersed with sketches and studies, accompanied by critical essays on the book and even a home movie taken by Spiegelman and his wife on their second visit to Auschwitz. "Perhaps the only honest way to present such material is to say: 'Here are all the documents I used, you go through them,'" Spiegelman tells Chute. "'And here's a twelve-foot shelf of works to give these documents context, and here's like thousands of hours of tape recordings, and here's a bunch of pho-tographs to look at. Now, go make yourself a *Maus*!'"

Of course, no one else could make a *Maus*. One of the book's most striking qualities is how relentlessly personal it is: the story of Vladek's persecution and survival is inseparable from the story of his son's efforts to portray it on the page. "The subject of *Maus* is the retrieval of memory and ultimately, the creation of memory," Spiegelman says. "It's about choices being made, of finding what one can tell, and what one can reveal, and what one can reveal beyond what one knows one is revealing." The panels of *Maus* are so straightforward that it's easy to overlook the wrenching act of imagination required to fit so much

material into such a compact space. Spiegelman's painstaking working process required eight steps to compress the interviews with his father from transcript to finished page. The DVD version brings things full circle by embedding clips of these interviews on some of the relevant pages. Readers can now hear exactly what got left out and try to discern the ways Spiegelman supplemented the missing words in his drawings. At the very least, this is an impressive pedagogical tool, even if all but the most dedicated scholars will ultimately weaken under the flood of documentation. (*MetaMaus* will no doubt birth thousands of undergraduate term papers.)

In addition to rendering Vladek's story both as accurately and as concisely as possible, Spiegelman was obsessively focused on getting the visual details right, consulting drawings by survivors and contemporaneous photographs and maps to ensure that nothing was misrepresented. "In a way, it's a lot more challenging than trying to simply tell a story," he says of his chosen medium. "In a prose story, I could just write, 'Then they dragged my father through the gate and into the camp.' But here I have to live those words, to assimilate them, to turn them into finished business—so that I end up *seeing* them and am then able to convey that vision. Were there tufts of grass, ruts in the path, puddles in the ruts? How tall were the buildings, how many windows, any bars, any lights in the windows, any people? What time of day was it? What was the horizon like? Every panel requires that I interrogate my material like that over and over again."

The medium of the graphic novel, with its almost cinematic combination of word and image, is ideal for conveying both memory and its elisions. (Lawrence Weschler, in a magazine profile of Spiegelman included in *MetaMaus*, notes that in *Maus* "the ambiguity is of an almost crystalline precision.") In one sequence, Spiegelman mentions to his father the well-known fact that an orchestra played for the inmates as they marched through the Auschwitz gate every morning on their way to labor. "An orchestra?" Vladek asks in amazement. "No. I remember only marching, not any orchestras." In the first panel of this page, we see a group of inmates marching with an orchestra in the background. Below, after Vladek has contradicted the account of the orchestra, the inmates are depicted marching past it so that they cover up the musicians—only the tops of their instruments are now

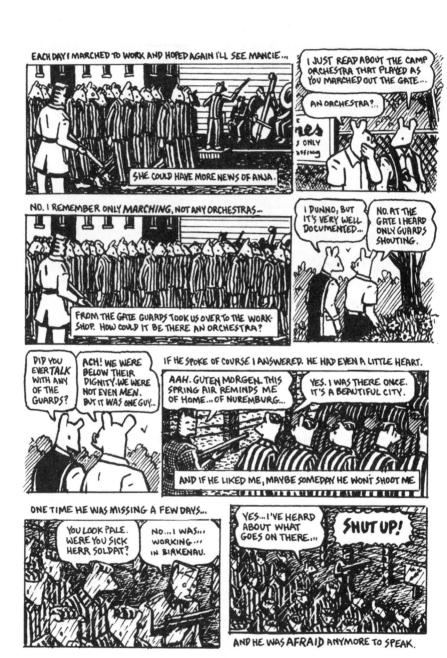

Maus II, page 54

visible. "I have the orchestra being blotted out by the people marching because that's all he remembers," Spiegelman explains. In the last panel of the sequence, Vladek and Art are in the present, debating the orchestra, and Vladek gets the last word. Was the orchestra there or wasn't it? Spiegelman knows, from all his documents, that it must have been, but Vladek is equally sure that it wasn't, and the images give them each their due.

There's something mildly lunatic about insisting on this sort of "verisimilitude" in a story in which all the people appear as cartoon animals. Or is there? The question of how truthful *Maus* can be is perfectly illustrated by the minor kerfuffle that broke out when the second section of the book was published in hardcover and promptly made its way to the *New York Times* best-seller list—in the fiction column. In a letter to *The New York Times Book Review* (reproduced, naturally, in *MetaMaus*), Spiegelman protested: "I shudder to think how David Duke . . . would respond to seeing a carefully researched work based closely on my father's memories of life in Hitler's Europe and in the death camps classified as fiction." One editor reportedly responded, "Let's go out to Spiegelman's house and if a giant mouse answers the door, we'll move it to the nonfiction side of the list!" But the *Times*, following Pantheon (which had listed it as both history and memoir), ruled with Spiegelman.

Though Spiegelman never fully explains why historical accuracy was so crucial to his project, I suspect his concern is less about Holocaust denial than about more fundamental questions of artistic and historical veracity. "I felt we need both artists and historians," Spiegelman says in *MetaMaus*. "I tried to explain that one has to use the information and give shape to it in order to help people understand what happened—that historians, in fact, do that as much as any artist—but that history was far too important to leave to historians." Even if there were no Holocaust deniers, the documentary novel would most likely be the dominant form of Holocaust fiction, for the simple reason that "getting it right" is crucial to the illusion of every historical novel. To give but one example, Jonathan Littell's *The Kindly Ones*, though it is the opposite of testimonial, rests nearly as heavily on historical resources. For a period as excruciatingly well documented as the Holocaust, any misplaced detail could be fatal to a work of literature.

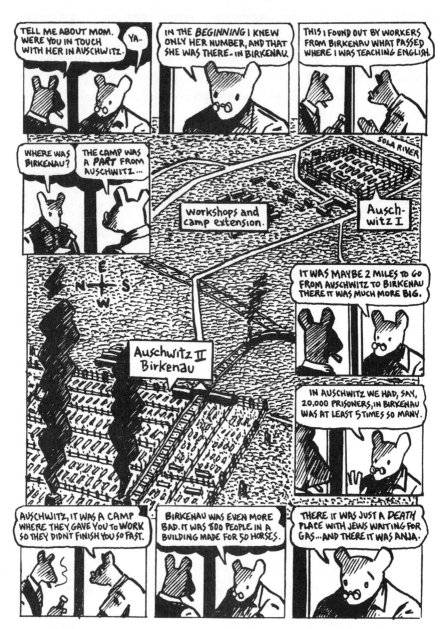

Maus II, page 51

I admit that I have always thought of *Maus* as a kind of novel; but I may use that term more broadly than Spiegelman does. What *MetaMaus* makes clear is that *Maus*, like the works of W. G. Sebald, exists somewhere outside of the genres as they are normally defined: we might call it "testimonially based Holocaust representation." But no matter what it is called, it gives the lie to the critics of Holocaust literature (as well as certain writers of it) who have insisted that either everything must be true or nothing is true. By finding a new medium for an old story, *Maus* became also a story about its medium. Similarly, in its quest to document its own documentation, *MetaMaus* is a profound meditation on the meaning of sources and the uses we make of them.

(2011)

Spiegelman, in Nobody's Land

PIERRE-ALBAN DELANNOY

Translated from the French by Marie Prunières

Introduction

In his latest comic strip, *In the Shadow of No Towers*, about the September 11th attacks, Art Spiegelman stages himself in front of his drawing board, showing the reader the routine conditions in which his work as a cartoonist is carried out.[1] But it is to say that he cannot create. The events of September 11, he explains, traumatized him to the point that he can no longer draw, and he has taken refuge, he says, in reading and dreaming. We see him asleep at his table, holding a page of comics in his hand, on which little paper characters appear waving in front of him.

This vignette reminds us of an earlier one in *Maus,* in which we see the author in front of his drawing board overrun by corpses, in a decor that evokes the camps.[2] The cartoonist speaks directly to the reader; he expresses his doubts, his anxieties, the difficulty he has in writing and drawing, echoing what he expressed a few pages earlier: "Just thinking about my book . . . It's so *presumptuous* of me" (*Maus II*, 14). "And trying to do it as a comic strip! I guess I bit off more than I can chew. Maybe I ought to forget the whole thing" (*Maus II*, 16).

This sense of *impuissance* is a recurring theme in Spiegelman's work, both in his youth and in his mature works. It is, of course, linked to the

subjects he tackles, which are particularly painful, emotionally charged, and difficult to treat graphically. But it is not limited to technical difficulties or mood swings. It is a deeper and more persistent discomfort, the effects of which cannot fail to be clear when reading. This manifests in two ways. First, Spiegelman's output is limited to a relatively small group of comic strips, along with *Maus*. Second, one could venture to say that this work is not a work of art, if one agrees that "works of art" are identifiable by the artist's signature style.[3] Indeed, it would be hard to define Spiegelman's graphic style, as it differs so much from one comic book to another. Not only is each comic book drawn in a different graphic style, but the author constantly appropriates and endorses the style of other artists, as in the case of "Nervous Rex"[4] or *In the Shadow of No Towers*. An author's style is his personal mark, his literary or artistic identity. The paradox here is that this work is essentially autobiographical, almost exclusively centered on the person of the author himself, in a sometimes overbearing and narcissistic way (this is particularly true in *In the Shadow of No Towers*). Thus, we are in the presence of a work whose main themes, treated in a constant if not obsessive manner, concern the history and existence of its author, while the graphic writing is always changing, unstable, heterogeneous, prolific.

To explain this paradox, I would argue that Spiegelman's autobiographical approach, his inability to write, and his stylistic instability have the same origin, a similar cause, an identity crisis that we can think of as not foreign to the Shoah.

Nobody's Land

To take the full measure of Art Spiegelman's work, one should remember that he belongs to that generation of children of Holocaust survivors who, in the words of Anny Dayan-Rosenman, "remained trapped in the rubble [of the war], fascinated by a time that preceded their birth and in which a fateful destiny was played out in their place and now constitutes their legacy."[5] Spiegelman finds in comics a means of expression that allows him to talk about himself, his obsessions, his discomfiture.

Edward Bond calls this discomfort on which Anny Dayan-

Rosenman expands "nobody's land."[6*] In his play *At the Inland Sea*,[†] he explains that during the crisis of adolescence, "imagination and reality collide" (62).[‡] If reality destroys the imagination, adolescents' lives will always remain empty, but "if imagination and reality are joined, they will live creatively." This crisis is resolved when imagination draws "a threefold map of past, present, and future. We live on this map. Without it, we pass our life lost in an unmapped 'nobody's' land" (63).[§] The expression "nobody's land" should be taken seriously. It is the land from which the name is absent, the proper name, and any other form of a personal mark of identity.

In Spiegelman's work, there are multiple encounters with "nobody's land"—or no man's land, nobody's country. Still, as one might suppose, these encounters can only be brief, furtive, lacunar, ellipsoid, because "nobody's country" escapes cartography, disappears with it, and when it appears in writing, it is to endanger it, dissolve it, and thus make its expression invisible. It is in the subversion of the narrative, the incoherence of the composition, the exhaustion of the writing that we are likely to glimpse it.

* *Ed. note:* Bond's phrase, "nobody's land," carries layered overtones. One might think of the legal concept of *terra nullius*, literally "nobody's land" or "land that belongs to no one," which was used to justify the eighteenth-century British invasion of Australia and the genocide of the Aboriginal people. One might also think of the "no man's land" between two enemy trench systems in warfare. Delannoy takes the phrase literally, as a space that belongs to "nobody," someone without or divested of a proper name.

† *Ed. note:* In Bond's play, an adolescent boy—simply named "Boy"—studies in his room for his exams, while his Mother bustles in and out. A Woman from the past suddenly appears in the Boy's bedroom: she wears rags and clutches her swaddled baby. Over the course of the play, it becomes clear that the Woman and her baby are prisoners at Auschwitz, soon to be herded into the gas chambers. With increasing desperation, the Woman pleads with the Boy to tell her a story, which she insists is the only way to save her child. To the Mother's consternation, confusion, and worry, the Boy falls into a dreamlike reverie, during which he imaginatively enters the Woman's unimaginable world. Several features of *At the Inland Sea* resonate strongly with *Maus*, buttressing Delannoy's adoption of Bond's "nobody's land." The Boy is called away from the trials of the everyday to tell a story that will save the Woman's baby from the gas chambers. Spiegelman in *Maus*, as Delannoy argues, attempts to tell a story—the "survivor's tale"—that will "restore" Richieu from his death. Further, the identities of the Woman's baby and the Boy are bound together under the imperative of the story she requests be told. This story begins as the soothing one the Woman tells her baby, becomes the story she wishes to tell to distract the soldiers, and concludes as, perhaps, the play "for young people" that Bond has written.

‡ *Ed. note:* The phrase "imagination and reality collide" is Bond's, quoted by Tony Coult in his "Notes and Commentary" following the playscript in the English edition (38).

§ *Ed. note:* For the first production of *At the Inland Sea* in 1995, Bond made extensive notes, some of which Delannoy quotes above. Bond explains that as young people grow, they enter a crisis of the imagination linked to the passage from childhood to adulthood, when the order of the imagination gives way to the order of the social.

Here I will examine the most blatant eruption of nobody's country in *Maus*. It seems to me that it shows well how the writing and composition of the work are altered and endangered, how the author's proper name and function are undermined.

Richieu's Complex[7]

Across Spiegelman's oeuvre, *Maus* is the most directly related to the Shoah, since it is largely devoted to the testimony of Vladek, the author's father and an Auschwitz survivor. It is also an autobiography,[8] even if, for the author, it is less about recounting his life than presenting the interview he conducted with Vladek to gather his testimony. Hidden at the junction of these two narratives, almost invisible, is a third, which could be described as an initiatory one: it runs under the other two from one end of the work to the other, from the first to the last page, very exactly, it supports them, it holds them, in the sense that it stitches them together. But, at the same time, it threatens them with destruction. It is in it that "nobody's country" emerges. It is an elliptical, irruptive narrative that emerges in the middle of the other two, then disappears and reappears further on.

Spiegelman's initiation into an ongoing identity marked by history begins with the prologue of *Maus* (*Maus I*, 5–6). The prologue relates an apparently insignificant anecdote, which one would be tempted to overlook, but which, if one thinks about it carefully, tells of a first painful experience in which several losses are superimposed. It all starts with a roller-skating race between the children of the neighborhood. The young Spiegelman is ten years old. The last one to arrive deserves the nickname of a "rotten egg."[9] The strap on one of Artie's skates breaks; he falls off, loses the race, and at the same time finds himself dispossessed of his proper name. The others make fun of him and call him rotten egg. It would not be serious or worth reporting if the loss of his name was not also the loss of the meaning of his existence, as shown in the rest of the prologue. The child complains about his misadventure to his father, hoping to find help and comfort from him. The opposite happens. Not only does his father not console him, but he also opposes his own flawed experience of friendship, inherited from the camps: "If you lock them together in a room with no food

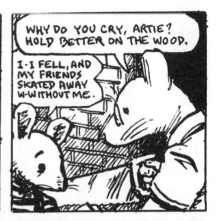

Maus I, page 6

for a week ... *Then* you could see what it is, friends!" (6). This is a disproportionate response, which not only reduces the importance of his misfortune as a child, but above all, gauges it by the concentration camp experience. From now on, for Spiegelman, he can do nothing "compared to surviving Auschwitz," as he puts it to Pavel, his psychoanalyst, explaining that he never loved his father but always admired him for surviving the genocide (*Maus II*, 44).

Like other books published by children of survivors, *Maus* is a cathartic enterprise. For its author, it is about purging the suffering inherited from a past he did not know, but which he experienced as a yardstick to measure meaning. Only the places and the time when the terrible events took place have disappeared; they are now accessible through the imagination and through the words of his father. This is why *Maus* is first and foremost the story of the investigation of a son who collects the testimony of his father. This is why the testimony is also integrated into the autobiographical narrative. For Spiegelman, it is a question of "drawing the map": linking the past, present, and future in order to confront together the terrible events of the Shoah and the trauma they caused in him. And it is in this that *Maus* is an initiatory work, a quest for meaning.

At the beginning of the second volume, the author reveals to the reader the exact nature of his undertaking: "I know this is insane," he says, "but I somehow wish I had been in Auschwitz *with* my parents" (*Maus II*, 16). The expression of this desire founds the whole work and gives it its initiatory dimension. What Spiegelman undertakes is nothing more and nothing less than a descent into hell, toward the horror of a terrible past, where the roots of his misfortune lie. Precisely, he tries to appropriate, as much as possible, a place, his own, within his symbolically reconstituted family. By family, one must certainly understand the restricted family nucleus constituted by his parents, his brother and himself, but more broadly the lineage, the genealogy, the name.

The central figure in this initiatory narrative is the author's brother, Richieu. The latter, who was born before the war and died during the genocide: it is he whom Spiegelman seeks at the bottom of the abyss and brings back to the surface of his own existence. Why him? One would be tempted to answer that he is the closest to Spiegel-

man, even though he never knew him. He is his alter ego, his brother, son of the same parents, occupying a similar position in the family tree. But Richieu is also the only one of the restricted family to have disappeared in the Shoah.

How is the story staged? It is based on two *coups de théâtre*, two appearances here by Richieu, irruptive and disturbing, which shake the work and put it in danger, as we will see later. These are at the same time the two milestones that mark the beginning and the end of the initiatory journey.

Richieu's first appearance as such is visual. It opens the second book even before the drawn narrative begins: it is the portrait of Richieu as a child. He appears alone on the white page, small and yet gigantic, accompanied only by the names of the dedicatees, Richieu and Nadja, the author's daughter.* It is not only distinguished by its location, but it also stands in contrast to the other images in the album, which are drawings. As a photograph, this portrait constitutes a first degree of dispossession: *Spiegelman,* the draftsman, *is not the author*, he merely had an image reproduced. In a way, this photo imposes itself on him, precedes him. This is all the more so since it has a history and status in the family and in Spiegelman's life. The author recounts that this portrait was enthroned in his parents' bedroom. This elder brother, whom he never knew, was however omnipresent in the form of this portrait, a real ghost that never ceases to question Artie's own identity: "That photo," he explains in *Maus*, "was a kind of reproach [. . .]. It's *spooky*, having sibling rivalry with a snapshot!" If Spiegelman perceives Richieu as a rival, it is because his father constantly presents him as a model whom he presents with model qualities and to whom he assigns a destiny, virtual of course, and extremely brilliant: "[He] was an ideal kid, and *I* was a pain in the ass" ("pain in the ass"—the equivalent of the rotten egg in the prologue), writes Spiegelman. "He'd have become a *doctor*, and married a wealthy Jewish girl" (*Maus II*, 15).

The appearance of this photo at the beginning of the second book has something traumatic about it; it appears as a kind of negation of the comic strip. The photograph has the peculiarity of being an indexical

* *Ed. note:* In later editions, Spiegelman added the name of his son, Dashiell.

FOR RICHIEU

AND FOR NADJA
AND DASHIELL

Dedication page of *Maus II*

trace of what it shows. This image proves that this child really existed. The photograph refers to the singularity of a person, in a space-time that is itself singular, unique. And yet, the photo has the specificity of eternalizing what it shows: Richieu's portrait does not only refer to an existence whose imprint it would be, it freezes him forever, eternally similar, in a time that has become inaccessible, an immobility that Philippe Dubois calls "the achronic and immutable afterlife" which simply looks like death.[10]

Here, then, is Richieu's photo, placed at the head of the book as a challenge: the marker that marks the bottom of the abyss, the anchor hanging in the underworld: in the historical time of the Shoah and in death.

The other spectacular appearance of Richieu occurs at the other end of the book, at the very last line of the last panel on the last page. It is verbal and just as much about identity as the photograph above. Vladek is sick, exhausted. He announces to his son that he is putting an end to his account of testimony: "I'm *tired* from talking, Richieu,

and it's enough stories for now . . ." (*Maus II*, unpaginated [136]). This last sentence of Vladek's has an extremely strong performative force. Not only does he end his narrative by effectively keeping silent, but at the end of the road, he *de-baptizes* Artie and calls him Richieu.

This could be seen as a simple slip of the tongue from the father, except that the name Richieu occupies an ultimate and singular place in the work, which gives it a necessarily important, if not definitive, meaning. But more than that, Artie's renaming ruins the autobiographical pact on which *Maus* is based. The author who signs the work and whose name appears on the cover of the book, the narrator and the main character, are, in the autobiography, three instances that designate one and the same person. This is how we read *Maus* before arriving at the last panel on the last page: the character Artie, the narrator who tells the story and the author who signs the work are Spiegelman. The author's proper name is the guarantor of the truth of the story. However, what seemed to work throughout the book suddenly unravels: Spiegelman receives from his father a new identity that explodes the principle of uniqueness of the three protagonists. A disjunction emerges that calls into question the coherence of the entire work—and this at the precise moment when the reader leaves it. The map that the book constituted becomes blurred: "nobody's land" has interfered in the code and subverts it. The renaming is also a sign that something has happened in the initiatory narrative.

These two disturbing appearances of Richieu mark the two terms of the path. Between the photo that keeps Richieu in an impassable past and the new name that Artie receives for the future, between the photo that "freezes" Richieu in death and the living word that renames Artie, what has happened? The descent into hell took place, the outward and return journey. Between these two terms, the bottom of the abyss and the surface, the past and the present promised for the future, there is another place in the book, another episode in the initiatory narrative, which informs the reader about the progress of the journey. These are pages 114, 115, and 116 of volume II of *Maus*. Here, too, photographs are mentioned. Vladek has found old photos of his wife, Anja's, family; he shows them to his son with this comment: *"All what is left, it's the photos"* (115). "From the rest of my family, it's *nothing* left, not even a snapshot" (116). But here, the photos we see are not

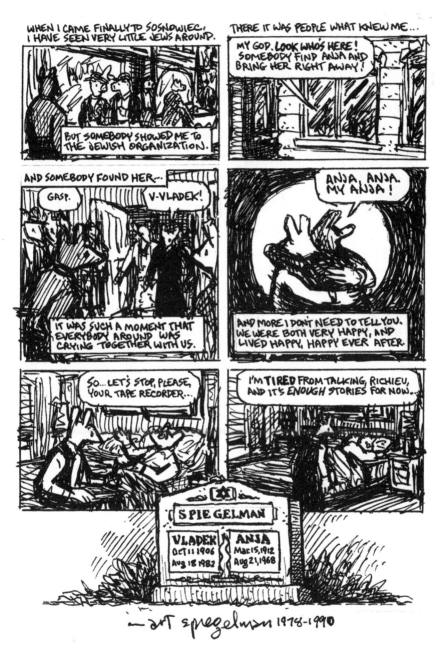

Study for last page of *Maus II* (unpaginated).
See final version of this page on page 267.

real photographs that would have been reproduced as is—they are por-
traits redrawn by Spiegelman, then incorporated into the comic strip.
Among the faces you see in these images, Richieu does not appear, but
his name is mentioned in Vladek's commentary, and he is associated
with other children, Lolek and Lonia. "The little girl. She finished
with Richieu in the ghetto" (114). The existence of Richieu is here
integrated into the procession of family members, among others in the
enumeration of victims and in the genealogical census.

Here again, the narrative is irruptive and threatens the book. The
portraits, by accumulating on the page, mask the narrative network
of the comic strip's boxes and interrupt the main narrative. "Their
profusion," notes Robert Storr, "fractures the vertical and horizontal
template of the story frames and brings the confusion of past and pres-
ent cascading to the bottom margin and into the reader's lap."[11] Here
again, the reader is confronted with a disruption of the book, an intru-
sion of another subject that we can see is disruptive.

The portraits of Spiegelman's ancestors invade the page, covering
the main story in the manner of the stones deposited on Jewish graves
as an act of mourning. More than that, they poignantly show Spiegel-
man's immense loneliness: he is the only survivor of this lineage, the
only continuator. Now the re-nomination of Artie as Richieu, which
occurs a few pages later, is nothing more than Spiegelman's inscription
in this lineage, as a survivor. By calling him by the name of his dead
brother, Vladek makes him reborn as a posthumous being. When Jew-
ish tradition has a newborn baby named after a disappeared person,
explains Alexis Nouss, "more than the mere pious or superstitious
perpetuation of his memory, it reveals the posthumous nature of the
proper name: it is not so much what designates life as survival."[12] This
is to say that through the narrative of "nobody's land," Spiegelman
establishes himself as a survivor. The new name he receives is that of
a survivor. In other words, not only does Spiegelman find at the end
of *Maus* a proper name that he had lost during the episode of the pro-
logue, but it is the missing meaning that is found: the fact of having
survived the Shoah, which counted so much in the eyes of father and
son unanimously, here it is given to him by the one who had denied it,
Vladek, the capital survivor. Spiegelman, renamed Richieu, is insti-

tuted as a survivor; he finds a place not only in the restricted family, but more widely in the lineage and in history.

The initiatory narrative has been brought to its conclusion, since it makes the author find his place in this "strange, intimate and foreign land" of which Anny Dayan-Rosenman speaks, and since it allowed him to "remember what he never knew," to use Ellen S. Fine's beautiful expression.[13] But the crossing "nobody's land" did not leave the author unharmed; it is a black hole that absorbs light and energy, its crossing left traces in the work, it pierced it here and there, it has cut into its coherence, blurred its meaning, and probably definitively exhausted the writing that Spiegelman had developed for *Maus*. After that, he will not take up this aesthetic style again for the rest of his career.

(2009)

Q&A with Art Spiegelman, Creator of *Maus*

DAVID SAMUELS

T he Holocaust trumps art every time," Art Spiegelman repeated more than once at the press opening for his traveling mid-career retrospective, which originated in Paris and finally landed at Manhattan's Jewish Museum this month. Spiegelman, whose name can be translated as "art mirrors man," is the owner of a stunningly fertile graphic imagination that over the past forty years has produced dozens of formally innovative and often searingly self-reflective strips in various magazines, including *Arcade* and *RAW*, which he cofounded and edited with his wife, French artist and editor Françoise Mouly. In his day job at the Topps trading card company, he created and edited the Garbage Pail Kids series before moving on to a more upscale day job at *The New Yorker*, where he tweaked that magazine's DNA with iconic cover images, including a Hasid and a Black woman kissing on Valentine's Day in Crown Heights and the famous post–September 11 "black cover," which, when you held it at an angle to the light, showed the outlines of the vanished Twin Towers.

Spiegelman credits *Mad* magazine and the sensibility of its founder Harvey Kurtzman for shaping his childhood in Rego Park, Queens, and his early desire to use cartoons to express his sense that something was not entirely right with the world. His first *Mad* anthology, which he studied with the intensity that some of his peers brought to pages of the Talmud, was a gift from his mother, who survived Auschwitz, and

he was kept on a tight budget by his father, who also survived Auschwitz. (Spiegelman was born in Stockholm, Sweden, after the war; his brother Rysio* died in Poland before he was born after being poisoned in a bunker along with two other small children by his aunt, so that they wouldn't be taken to an extermination camp.) When Spiegelman was twenty, and shortly after he was released from a one-month stay at a state mental hospital in Binghamton, New York, his mother killed herself—an event that would become the basis of one of his early, devastatingly personal cartoons. Spiegelman's father then burned his mother's diaries about her experiences during the war and in the camps, which she had intended for her son to read after her death.

In 1978, Spiegelman, then a well-known underground cartoonist, began interviewing his father about his wartime experiences for a long comics project. In the early 1980s, he began creating strips that narrated his father's stories and were gently framed by his own relationship with his father, a miserly and compulsive character; the strips were published in *RAW* under the title *Maus*. Both the title and the device of portraying Jews as mice and Germans as cats had been used by Spiegelman before, in a three-page strip he had published in 1972 and that was later published in his collection *Breakdowns: Portrait of the Artist as a Young %@&*!*, which attracted the deep admiration of hundreds of alternative comics fans but few buyers.

Today it seems clear that *Maus* and *Maus II* are the most powerful and significant works of art produced by any American Jewish writer or artist about the Holocaust. While their enduring popularity is a tribute to Spiegelman's incredible honesty and his graphic and narrative talent, it is also a reflection of the way in which the Holocaust has morphed from a threatening and largely repressed communal trauma to the glue that binds the American Jewish community together. If Art Spiegelman is a genius who created a work of searing originality and insight out of his familial and personal suffering, it is also hard not to worry about the anti-aesthetic consequences of his achievement. If he is right to complain that the Holocaust trumps art, it was *Maus* that opened the floodgates.

* "Rysio" is the correct spelling of Spiegelman's brother's name although the spelling "Richieu" is used in *Maus*; see *MetaMaus* for further discussion.

———

David Samuels: I was sitting downstairs waiting to talk to you this morning, and I was watching all the people passing by the hand-inked panels from *Maus II*, which are preserved safely behind glass in the gallery. And I suddenly had this vision of *Maus* being preserved for posterity like the Dead Sea Scrolls in some big weird-shaped climate-controlled building on the Mall in Washington, so that future generations of American Jews can remember the Holocaust, which is what we were apparently put here on earth to do.

Art Spiegelman: Okay, thanks for bumming me out. Let's move on.

DS: Does that bum you out? Why?

AS: I mean, I've now drawn it fifteen different ways—the giant five-hundred-pound mouse chasing me through a cave, the monument to my father that casts a shadow over my life right now. I've made something that clearly became a touchstone for people. And the Holocaust trumps art every time.

DS: Well, there's that, sure.

AS: I'm proud that I did *Maus*; I'm glad that I did it. I don't really regret it. But the aftershock is that no matter what else I do or even most other cartoonists might do, it's like, well, there's this other thing that stands in a separate category and it has some kind of canonical status. It's what you're describing with your Dead Sea Scrolls analogy. It's been translated into God knows how many languages, it stays in print, it's a reference point. So, when I'm reading some movie review in the *Times* about *12 Years a Slave*, all of the sudden I'm seeing a reference to *Maus*, even though the subject matter is quite different. It's studied in schools from the time they're like in middle school to the time they're doing postgraduate work.

DS: There was that great strip that you did for the *VQR* [*Virginia Quarterly Review*], where you were handing a little treasure chest to your son, Dash, "Hey, here's this wonderful magical present"—the gift being historical memory—and he opens the box and this horrible fire-breathing dragon comes out in an Auschwitz striped prisoner's

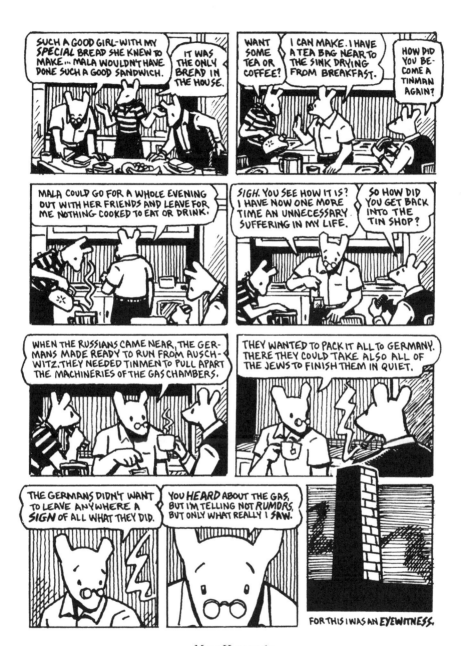

Maus II, page 69

cap with a little extra Hitler head and breathes fire on him and burns him. And he's like, "Gee, thanks, Dad."

AS: It's one that you can't deal with and then move on easily. I remember Claude Lanzmann at some point saying *Shoah* ruined his life.

DS: Except he wanted his life to be ruined in that way.

AS: Yeah, but I don't know if I wanted it or didn't want it. It wasn't part of my operating system. I wasn't thinking about it.

DS: Right, and that's what made *Maus* so different and effective as art, that feeling of absolute sincerity in an unexpected form. But if I wanted to really bum you out I'd say that some huge part of the genius of postwar American Jewish art took some energy from the repression of that monster that you let out of the box. You can read all of Philip Roth for a long time until you get to *The Ghost Writer,* you can read Bellow, you can read Joseph Heller, and look in vain for any mention of the Holocaust.

AS: I just watched on Netflix the Salinger film a few days ago, and all of the sudden, Dachau is the codex for *Catcher in the Rye.*

DS: Right. Except, he never wrote a book about being a young American soldier in Dachau. He wrote a book about a preppy kid riding the carousel in Central Park.

AS: Evidently he married a Nazi, and it's the subject of one of his unpublished manuscripts that's going to come out in the next five years or something.

DS: So, it turns out that J. D. Salinger was writing his own Glass family version of *Maus* up in Cornish, New Hampshire, in addition to eating sunflower seeds, or whatever else he was doing up there.

AS: I don't think his drawing is good enough to do it as *Maus.* What am I going to do? Say I wish I didn't make *Maus?* That's just not true. And on the other hand, do I want to have it dogging my steps everywhere? I'm going to say I'm lucky that it does, because it allows me to enter one folly after another and still make royalties from something else.

But what does it mean for me now at this point? Look, my cells have replenished themselves several times over, and it is what it is, and I did everything I could to tithe to it, to give service to it, by making *MetaMaus*, which is more easily accessible for most people than having to come to a room in the Jewish Museum. I guess it all reminds me of Joseph Heller's response to being told no matter what he did afterward, "Well, it's good but it's no *Catch-22*," to which he said, "Yes, but what is?"

But it's an issue because I'm not dead yet. So, I have to keep moving as best I can through the shadow of something that I'm glad I had pass through me.

DS: That's a very graceful, healthy, well-processed answer. And there are two directions that I want to take that. The Pew Foundation just did a big study on American Jewish life, and who American Jews are, and what they think makes them Jewish. And the No. 1 answer that the respondents gave about what being Jewish means was "remembering the Holocaust."

Now, I loved my grandfather, he was the person I felt closest to when I was a child, and he was the only member of his family to survive the war, and I grew up in a community with lots of survivors. So, the aftershock of those terrible experiences was definitely passed on to me and kids in my generation, even if it was outside our full awareness. And I wouldn't wish those effects on anybody, you know? So, it's interesting to see the American Jewish community choose "remembering the Holocaust" as the touchstone for its sense of communal purpose. American Jews are people who remember the gas chambers in Auschwitz.

AS: We are here to carry on the traditions of the Marx Brothers and Harvey Kurtzman, as far as I'm concerned.

Inevitably, this specific odd and intense cultural burden of carrying forth the near extinction is also something that Jews have a responsibility to do. And the problem for me, its most thorny place, is when we start thinking about the existence of Israel. If you wanna, since it's *Tablet*, we can go there.

DS: Go ahead.

AS: For me, it's sort of like, "Okay, Zionism existed before the Holocaust—but the Holocaust is the broken condom that allowed Israel to get born."

So, at that point, what are we remembering when we remember the Holocaust? Are we remembering that Jews specifically have to do whatever is necessary to ensure their own survival at the expense of others, who share a large part of our common DNA?

DS: That seems like a very pleasant humanistic lesson to pass on to one's progeny, no?

AS: The thing you can remember is "Nobody ever liked you, they're not going to like you, so fuck 'em. And therefore Israel is going to do whatever it has to do to survive, by God." Or the other lesson could be, "We got shafted because we were a landless people without a power base and therefore, what? We create another landless people without a power base?"

Fuck. I mean that doesn't seem like the best lesson to learn from the larger cosmos of what *Maus* grew out of. In the first three-page "Maus," if you look at it downstairs, there are no references to Jews, and no references to Nazis per se, although clearly it underlay the entire project.

At that point, very specifically, I was dealing with this from a very secularized notion of what it was to be oppressed in a political system. That's what it meant to not talk about Jews and Nazis. It grew out of thinking about the Black situation in America, which is why it's not totally divorced from *12 Years a Slave*. I didn't see that one coming, but I get it. It depends which lessons you choose to extract and move forward with. One is potentially useful because it increases one's empathy factor, and one is dangerous because it increases the ways in which you defend your little corner of the DNA empire from all others.

DS: I think the narrative that "Oh, Israel was born out of the Holocaust and never forget and whatever" was very popular in the U.S. at a certain point, particularly in Queens, where you grew up, and in Brooklyn, where I grew up. I get the sense from my family and friends

in Israel, though, that they were completely uninterested in the Holocaust when the state was created, and for a long time after that. I remember having lunch with the Israeli novelist Aharon Appelfeld, who in my opinion is perhaps the greatest living Jewish writer anywhere, who survived the Holocaust and emigrated to Israel. He told me that when he came to Israel they called the refugees "savonim"— soap people. The ones who were going to be made into soap by the Nazis. The Holocaust didn't really fit with the proto-Soviet realist aesthetic of sturdy pioneers with muscular asses working the fields, and all that.

AS: Yad Vashem wanted to show *Maus*. And I was going like, "Oh God; do I have to do this, I don't want to do this." Talking about your Dead Sea Scroll vision, you know.

DS: I imagine it in the Holocaust Museum in D.C., in its own special wing, you know?

AS: There was a point when we were talking about having *Maus* in the Holocaust Museum, and I was much more interested in seeing something about the former Yugoslavia and genocide now. So, that's the tug-of-war that I'm talking about.

I don't know how to respond to the prewar sabras and their vision of Zionism. I just don't think that Israel would have come into existence without the Holocaust happening in the world, because I don't think that the Balfour Declaration of 1917 or whatever would have held up that well without it. The world wouldn't have cared.

DS: I think those guys were tough and ideologically driven, and they were set on their goal of establishing a Jewish state. This summer, I interviewed Shimon Peres, the current president of Israel, and I asked him, when did you find out about the Holocaust? And he said, "Well, after the war, you know, when those people came."

AS: At least he didn't wait to read *Maus*.

DS: I was like, "What was your response?" And he told me, "Well, you know, we went to Poland in 1945," and then he started going into a long discourse about how Golda Meir was trying to undermine him at

the time with David Ben-Gurion, or whatever—my emotional trans-
lation of that story being that he actually didn't care about the Holo-
caust, because he was so wrapped up in the political infighting among
this hothouse group of people who came to Palestine when they were
fifteen and were building a Jewish socialist-collectivist mecca in their
own imaginary version of the Middle East.

AS: I understand all that but, you know, it used to be when I was first out
and talking about stuff, I would actually have horrible arguments when
people were talking about *Maus*, even when it was still not published
as a book yet and when it was first published as a book in which some-
how anything that had to do with Israel had to be supported absolutely.
That's changed since 1983–4–5, and now radically. So, now it's impos-
sible to think of these things as disconnected. Whether they want to
talk about it or not, something happened. And what happened was the
world's agreeing that, "All right, so you didn't have any place, and we
saw how well nationalism worked on the planet, so rather than trying
to like move beyond it, let's give you a nation! Let it be." And from that
moment on, certain things started happening. Parenthetically, I'm
amused by Chabon's really great *Yiddish Policemen's Union* book.

DS: The frozen chosen.

AS: There were a lot of alternate universes in which people are trying
to figure out what the hell to do with the Jews. We'll send them to the
tundra, we'll send them to Madagascar, depending on who was decid-
ing on the real estate for us. And one of the possible places was Pales-
tine, which in a way is an absurd place for it all to exist.

What little I found out about the secret origins of the superheroes of
the Jewish nation is that it was itinerant salesmen back in the Babylo-
nian days who planted their seed and said, "You're in charge of giving
these kids religion, and it's Jewish. Okay? Gotcha, I gotta go some-
where else now, I'm an itinerant." And this gives you a lease? Probably,
I don't know, but that seems pretty sketchy to me.

So, what there is now is there's this inevitable thing that came with the
trauma of World War II for the world's Jews, clearly. That led to some-
thing kind of interesting, which is—I can't quite say it. I tried to say

it when Tony Kushner was putting together a book about American liberal responses to the Jews. He asked if I would do the cover because I was doing a lot of these *New Yorker* controversial covers, helping that become part of the DNA of what *The New Yorker* now is. But at that time I said, "Look, I don't want to do a picture inside the book, man." It's great, but I'm so tired of having to submit work and see if it would pass for people and then having to submit work and see if it will pass, and then having to defend the work. So I said, "I can only take this on if you'll give me a blank check. I'll do it, you'll run it. But you have to know that up front."

And he said, "Uh, I'll have to check with"—I don't remember who the publisher was—"and see if that's okay." I said, "Fine." Then he said yes, and then I came up with an idea I really liked and then I thought, "He's a really fine fellow, that Tony. I really admire him. I like him. I don't want to give him any grief." I got only as far as getting the idea and making the very first sketch that had some photo-collage elements and whatever. I said, "Tony, I know we've got a deal, but I've decided I'm not going to hold you to it. So, here's the sketch, tell me if you want it. It's going to be a pain in the ass to paint, it'll take me a couple of weeks, if you want it it's yours."

It was a close-up based on the same famous *Life* magazine photo that was at the start of the three-page *Maus*: Palestinians behind barbed wire wearing Jewish stars. In front of the barbed wire was an Israeli soldier with his gun and also with a Jewish star, and he's also behind the barbed wire and looking mournful as well. And the implications of it are unbearable for a lot of people, it makes their heads explode. Still.

That image was all I could say. Because it was fortunate enough for my parents they went to the right rather than to the left in that line, and they ended up here, and so I don't have to bear the burdens directly of Israel's culture. So, that image just has to do with the fact that it's victims victimizing each other, damn it. Here we go again. And there's a responsibility that Israel doesn't live up to, and it drives me crazy.

DS: I hear you. But I'm a first-generation American who was born in Brooklyn. So, while there's something interesting about these American Jewish narratives about Israel being all good, or else bear-

ing some special moral responsibility for extra-good conduct that it spectacularly fails to meet, both those narratives seem a bit weird to me. There's one group of people who have a cartoonish vision of Israel as some beleaguered innocent state. And then there's another group of people who seem to say, "Well, of course, if it's going to be a Jewish state, my demand is that it should always be perfect, or otherwise it shouldn't exist at all." My personal feeling is that Jews, in some deep way, aren't inherently any different than Armenians or Serbs or any other of these tribes with long histories, all of which interest me aesthetically and historically. But I personally don't see Israel as any more intrinsically good or bad than France.

AS: Or America. But Israel's history went on for a very short time, which is the flip side of the same answer. It was born when I was, and it thereby is more directly discomfiting than when I drive around Monument Valley and see what's left of the Indians, even though that's pretty horrible. I somehow go, "Me, I'm a stranger here myself. I didn't do this, it's terrible, I agree it's terrible."

But that's slightly viscerally different to me than when somebody snarls at me because I'm Jewish, even though I haven't a religious bone in my body. And yeah, at that point the cultural heritage of what brought me here comes into play. And that makes me more able to tap my own guilt than even when I get to see *12 Years a Slave* and get to feel guilty about what I did in the slave trade.

DS: The historical "I" that is a white male Southerner, circa 1850.

AS: Right, but here I am as a white male in 2013 living with the fruits of that exploitation, as well as the guilt and horrors that come with that nineteenth-century slave trade. And I don't know what to do about any of it. I was born a Jew in Sweden.

All I can say is I'm really glad I'm a diaspora Jew. I don't identify with Israel. I've almost gone several times as an adult—never, always bailed at the last minute. If I go I'm going to mouth off, and then I'll get myself involved in some project I don't want.

DS: There's a thriving Israeli left, they spend their time mouthing off, and they get a lot of money from foundations for doing it. I guess

my personal posture on these big issues is "Hey, I grew up in a housing project in Brooklyn, I didn't oppress Black people in the South, I didn't kill any Palestinians in Israel, so I'm happy to talk to anybody, as long as they are being cool with me." And if they're not, my interest wanes.

AS: Yeah, it's just it's inevitably part of anything that comes out of that *Maus* book that I end up having to at least think it through, because of what you were saying to start this particular gambit. And that has to do with the fact that the primary thing that defines one's Jewishness unfortunately is not Groucho Marx. It's the Holocaust.

DS: I remember when *RAW* first appeared, I was in high school in New York. And it was just one of those touchstones of cool if you had a new copy. That's like the way high school kids used to read that stuff, it's just like it's sacred. And it was great. I remember the fact that someone had turned the Holocaust into a cartoon strip, and that the Jews were mice and the Germans were cats, I remember thinking, how did he even get on top of all that shit, which none of us could begin to imagine except in the ways that it was given to us, as something that was too big to imagine in anything but the accepted ways. It was just like, "Was the person who did this evil thing, is he a genius?" It was the total coherence of that gesture, like Cubism—

AS: That's interesting, ha.

DS: And the emotion in it, and the drawing, and all of it. Growing up in a Jewish community here, it felt like the ultimate Samizdat. We didn't even know, like do we bring this to our teachers and ask them if it's good or bad, because what if they punished us, or, even worse, what if they liked it?

AS: Now we find out, they seem to like it. I know we're talking about only the middle part of the exhibit that I'm grateful to have it, because it has the two other parts. But we're talking about the middle part.

DS: And this is your life now that you created *Maus,* and you have to sit in well-appointed conference rooms with people like me and go over and over that.

Maus inset in *RAW*, 1983

AS: But you know you're the first interview where this was true. Because you're Jewish. They might be Jewish too, but they at least came from a different set of perspectives where I am not trapped again in this same conversation.

DS: So, maybe it is me. But I was going in a completely different direction now, which is depressing in a different way. I think that part of the power of your original gesture was that there was still this feeling of resistance in the culture. There was something that you could push against. The thing that I feel now is that spirit has been diced and tamed and put through some kind of food processor. I don't find the places where the culture blob doesn't engulf whatever it is in three minutes flat.

AS: This can actually bring me back to my Groucho Marx moment here, or pivot, which has to do with the Groucho Marx and Milt Gross and Harvey Kurtzman legacy, which was an incredibly important one. Now, if you're talking about nationalism, then you have to get to *Duck Soup* within a couple of seconds. And that impulse predates World War II, and it's an outsider's perspective on a culture, and there are still plenty of outsiders to this culture, and things will come from that still, I believe. That's one point.

The other point, which is more to the point perhaps, is the impulse—I see it through *Mad*, because it's the one that's imprinted on me. *Mad* made the resistance to the Vietnam War even possible. And that seems really, deeply true, not just some kind of wisecrack true. Because the '50s felt incredibly monolithic. The early '50s was an incredibly oppressive place in America, very iconically represented by a decent-enough liberal chap named Norman Rockwell. It's when we got this "In God We Trust" on our money, it's when we had our crazy McCarthy moments, we had all of these things happening, and yet there was room for a very effective antibody, which was this kind of self-reflexive, self-deprecating, angry response to the homogeneity from people who weren't thoroughly homogenized in our culture, i.e., Jews. It led to something very fruitful, and we still have the aftermath of it, both positively and negatively.

Positively for me, I would say, *The Simpsons, The Daily Show, Colbert* are among the healthiest aspects of American culture right now. And they have to do with carrying the genuine legacies of the earliest *Mad*s forward.

There's another thing that happened as a result of any antibody becoming weaker after a period of time like now that all our cows have antibiotics in them we're not as good at fending off all of the diseases. Similarly, the *Mad* impulse of irony has been reduced to the air quote, and the self-reflexivity is everywhere in the culture. It starts in the spin room, and spins on out. And the spin room is about spinning us as viewers of news, it's not about deconstructing news, it's about enforcing the takeaway messages, right?

So, I felt that like, now we needed something else, and for a while I was just calling and now I've dropped it, it was a particular thing I think about a lot. But I was thinking, we needed this thing that I was calling "neo-sincerity," which was involved with specifically using the tools that *Mad* offered but only in the pursuit of absolute conviction. And that that was the only way to get back to a place where you could tell where people were coming from and figure out what actually has value and is important and can't be reduced to the ironic Letterman shrug.

DS: Yeah, a lot of writers my age came to that conclusion too. Dave Eggers was certainly one. And lots of smart people tried it, but it was like, you know in a way, all those nice liberal people from the '60s have become the Eisenhower Americans of today, except they vote for Democrats. They're the baby-boomer grown-ups of your generation, and in some ways they are more dangerous. Because they always have just enough sympathy with whatever the gesture is, and they smoked pot too, and they dropped acid back in the day, and they go, "Yeah, yeah, yeah, we like that and we'll appropriate some of it, but then please don't do this other thing that you just did, because it's just too transgressive and messy and gross." And it's like, they've already let you in the door and are paying your rent, so please don't do that yucky cover you wanted to do.

AS: There's that. But there's also the fact that even if you get to do the yucky cover, it's like what was the really great metaphor from a

Kafka story about leopards? The priests have a ritual, then one day the leopards show up and eat all the priests, and then they resume the ritual the year after, including all the leopards. It's an amazingly resilient and resistant culture, capitalism. And we're the beneficiaries of it, so we're not about to go to the barricades and set fire to our own houses. But then what?

DS: If Jews carried that oppositional torch for a while for particular historical reasons in twentieth-century America, the truth is that Jews are just another group of rich white people now. They're not outsiders, but they go on believing that they are still outsiders, raging against the machine as part of their secular religion of being good empathetic liberals. And at a certain point, it becomes silly.

AS: It's a condition of outsiderness that we can build on. That's all we've got. Because the alternative is to become a Madoff or something, I don't know.

DS: I think the alternative is to own up to being WASPs.

AS: Oh, WASPs don't get to complain, so I don't think I want to go there.

DS: Maybe Jews can be the new complain-y kind of WASPs.

AS: Maybe the new complain-y WASPs.

I think that there's something that gets eroded, which is, you know, that outsider thing obviously doesn't happen as easily once you're inside. It gives me reason to pause and worry about what it is that keeps driving me. And because I don't see where anyone can actually find a place to pry at, that pries it all open.

I could say that, there was a minute there where Occupy Wall Street was the only positive thing I saw in the culture. And it was amazing how easy it was to watch it evaporate and get pushed to the sidelines with the first rainstorm. We have it in the corner of our ears because of one slogan that survived, that moment which has to do with the 1 percent, but it was a useful moment to enter in, despite everything that didn't happen. And as little as that is, it's still a step in the right direction, to notice who has got the cards.

DS: On the subject of cards, maybe the moment is right for you to go back to the Garbage Pail Kids.

AS: They're still being done.

DS: I feel there's a reimagining of that imagery for the era of Facebook and Twitter, which are the new untouchable toxic brands.

AS: I'm sure that will be done, and it sort of exists without it being homogenized. There are artists who are working off of that energy because they were at the right age when that thing happened. Were you? You were a Garbage Pail Kid fan?

DS: I used to buy them sometimes for my younger brother. He really loved them.

AS: A lot of people are imprinted with them, and it made a difference. I thought of it very consciously as taking my *Mad* lessons and passing them along dutifully to the next generation. And there I must say, I made sure that the title cards at least in this show were clear about what parts I had to do with and what parts I didn't have to do with it. I didn't paint those things, I planned them.

DS: It was an intervention, as the French people say. Yeah.

AS: Now it would unfortunately just be more leopards coming into the ritual. Because that existed, now what's next; I'm sure we'll find out, you know?

DS: Is that a problem for culture? If you look back at the stuff that I was raised on, whether it was little 'zines or it was *RAW* or whatever, that stuff was actually hard to get. You had to go to a specific store somewhere weird to find it. And people had to stew in their festering little pool for a while, until you got desperate enough to visit someone else's pool and risk them making fun of you and the clothes you wore.

AS: I think that that's an issue at this point. Everybody can sit in their own stew, they never visit the other stews. And the fact is that nothing is hard enough to get so you concentrate. The main thing that the Internet seems to have given is Attention Deficit Disorder to an entire culture, and I include myself. I don't stand aside and say "*Tsk,*

tsk, these young people with their computers." But I don't see exactly where things move, which is why I'm still thinking about Occupy Wall Street because their resistance to being co-opted allowed them to be wiped out as a force. And it's such an estimable gesture, while it's also so pathetic.

[*The gallery assistant comes in to signal that the interview is over and asks Spiegelman how it went.*]

Wow, okay. We didn't talk about anything but *Maus*.

Gallery Assistant: Well, I only hear the very ends of interviews, but you end with a bang every time.

(2013)

Everything Depends on Images

Reflections on Language and Image in Spiegelman's *Maus*

HANS KRUSCHWITZ

Translated from the German by Elizabeth Bredeck

S ince 1992 at the latest, the year Art Spiegelman received a Pulitzer Prize, *Maus* has been viewed as a milestone of Holocaust literature and a pioneering work in helping comics gain recognition as a serious art form. Ever since, they have often been referred to as graphic novels.[1] The cover of the current Penguin edition of *Maus* therefore includes high praise for the book as an example of the genre, including this quote from *The Washington Post*: "A quiet triumph, moving and simple—impossible to describe accurately, and impossible to achieve in any medium but comics."[2] I'd like to use this sentence as the starting point for a consideration of two questions. First, in the case of *Maus*, what expressive possibilities does the comic book have that may enable it to possibly surpass nongraphic literature in telling the tale of a Holocaust survivor? And second, to what extent are the two impressions in the *Washington Post* sentence—that *Maus* is "moving and simple," yet "impossible to describe"—effects of these very same superior expressive possibilities? What makes the particular story of Vladek Spiegelman better suited to storytelling based on images rather than words, and to what extent does its comic form provoke an emotional response and at the same time produce epistemological uncertainty? Several things suggest that this question is of more than just narra-

tological interest, and that answering it will also help settle the issue underlying Spiegelman's intense "investigation of his father's story," namely, his questions about "his mother's suicide in 1968, the trauma in his own life. [. . .] Almost all of the interview sequences start with requests [. . .] like 'Start with mom . . . tell me how you met'" (238).[3] The first indication that in *Maus*, reflections on language and image are intimately connected in the effort to better understand both his father and his mother, can be found already in the opening pages of the comic, which capture what appears to be an important moment of initiation: the moment when Art Spiegelman becomes aware of the fundamental inadequacies of language and the power of images.

1. "Rotten Eggs"

Part I of *Maus* begins with a childhood memory. Young Art enters a race to the school on roller skates against his friends Howie and Steve. "Last one to the schoolyard is a rotten egg!" they shout (*Maus I*, 5). Naturally, things don't go well for Art. He almost immediately loses one of his skates and takes a fall; when he does, his friends merely laugh and leave him behind lying on the ground. Returning home alone, he tells his father what happened: "I-I fell and my friends skated away w-without me" (*Maus I*, 6). His father replies: "Friends? Your friends? . . . If you lock them together in a room with no food for a week then you could see what it is, friends!" (*Maus I*, 6). Instead of consoling his son, he teaches him a thing or two about language and human behavior, thereby setting the basic tone of the comic.

This scene merits careful examination from a language-critical perspective. The first part of the short episode, the actual race, revolves around the expression "a rotten egg," which makes no real sense when applied to a person. Referring to a food that is spoiled and certainly inedible, its figurative meaning is simply "loser," with no special significance attached to the egg itself. The second part of the episode centers on the word "friend," a seemingly clear word in need of no explanation. The crux of the episode is that very quickly, the metaphor of the "rotten egg" and Art's notion of "friend" converge. His father's response, which brings back memories from the time of his persecution, marks the moment when the space between Art's notion

Rego Park, N.Y. c.1958

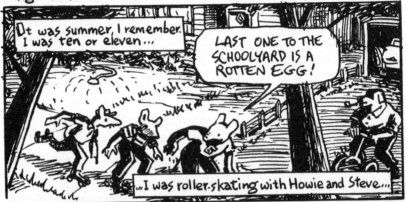

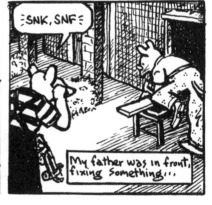

Maus I, page 5

of "friendship" and the expression "rotten egg" disappears. It is clear that Art's "friends" are most likely not friends at all, but "rotten eggs."

This is of crucial importance for Vladek's own story. It means that a language without stable images that are what they seem, and that attach value and meaning to the spoken word, is in Vladek's opinion a dubious language. In his view, it's possible to speak in earnest only when language and sustainable images coincide. Whoever speaks without such stable images runs the risk of operating on false premises or missing what is essential. This does not mean that Vladek thinks appearances can't also be deceptive, which of course they can. Rather, it means that language is tied to images, is dependent on them, and that the durability of everything figurative needs to be tested. In the very first chapter of *Maus*, where Vladek describes how he met Spiegelman's mother, Anja, we see how he adheres to this motto. The title of the chapter, "The Sheik," itself evokes a particular image: that of Rudolph Valentino, one of the earliest male sex symbols in film. Vladek uses Valentino's picture to describe his own handsome appearance as a young man (*Maus I*, 13). This image is authenticated and stabilized in the story he then tells about the years-long love story involving the attractive Lucia Greenberg, whom he later leaves for Anja. Though Anja is not as attractive as Lucia Greenberg, she is wealthier and more clever. The cousin who introduces him to Anja does so with the words: "There's a girl in my class . . . She's incredibly clever, from a rich family . . . A very good girl" (*Maus I*, 15).

Vladek can confirm the accuracy of his cousin's description at his first meeting with Anja. "Looks aren't everything," he concedes, and he quickly sends Lucia packing (*Maus I*, 17). Which is not to say that the bond with Anja is now firmly secured. For that to happen, the material image he has of Anja—a picture he has obtained and framed—must first be stabilized metaphorically. This process is aided by a former teacher they meet while taking a walk, who effusively praises Anja. But there are also setbacks. Vladek uses his first invitation to her family's home to secretly look through her closet, where he discovers some suspicious pills. His less than enamored commentary on finding them: "If she was sick, then what did I need it for?" (*Maus I*, 19). Only when a pharmacist friend tells him the pills are not to treat a specific illness but to improve Anja's overall health does his trust of

her increase enough to become engaged to her. Notably, Spiegelman devotes only a single frame to the results of Vladek's search and his decision to marry Anja (*Maus I*, 19).

The counterpart to Vladek's image-centered thinking can be found in Anja's word-focused thinking. Shortly after Vladek's cousin introduces them, the two women discuss Anja's impression of him, and speaking in English they assume Vladek cannot understand. It turns out they are mistaken. Vladek corrects this image that Anja has formed about his education over coffee when he says to her in English: "You know, you should be careful speaking English—a 'stranger' could understand" (*Maus I*, 16). Anja's misplaced trust in language becomes even clearer when she believes what she reads in a letter from the recently jilted Lucia Greenberg, which is intended to cast doubt on Vladek's character. In contrast to Vladek's actions after discovering the pills, Anja does nothing after receiving the letter to defend the image she has formed of her beloved. Instead, she trusts the written word, and breaks off contact with Vladek. It is Vladek who has to seek her out and explain things in order to win her back.

2. Vladek's Masks

As the story continues, Vladek's ability to differentiate between stable and unstable images, and to produce such durable—or at least seemingly durable—images himself, becomes invaluable. There are at least two categories of such images. The first involves Vladek's habitus.[4]

Vladek is a master of performance. As we learn in the third chapter of *Maus I*, this ability is something he has learned at least in part against his will. When he receives his first military summons at the age of twenty-one, his father does everything he can to see that he is rejected as unfit. In the months leading up to the medical exam, Vladek is allowed only three hours of sleep a night and given little to eat. In the final days before the appointment his father denies him any sleep whatsoever, and replaces his food with coffee. Vladek subsequently presents the military doctor with the image one would expect, and receives his deferral. His father's plan succeeds—but only in part, since Vladek is not permanently dismissed. The following year he

must report once more. Unable to face the ordeal again, he appears without resisting, and performs his military service every four years thereafter.

When called up in 1939, however, Vladek realizes how useful it might have been to make the "right" impression on a military doctor a second time. At least, the tale of his involvement in the war and subsequent imprisonment consists of little more than a string of episodes in which his (mis)fortune is tied to external appearances. In the only battle of World War II where he sees action, a Polish officer accuses him of not firing his weapon in the expectation of better treatment in German captivity, which is imminent. The muzzle of his weapon is indeed cold, but the real reason is probably not cowardice, but the fact that in the surrounding darkness he can see nothing. To satisfy the Polish officer he begins to shoot, which earns him a beating when he is taken prisoner by the Germans. Hearing their accusation: "It's hot! You were shooting at us!" his "chastened" response is one that his father probably would have given—he replies in German: "My commander made me shoot. I only fired in the air!" (*Maus I*, 49). In short, he tries to give the impression that he is a German-born or Germanophile Polish soldier, and his bet pays off. The beating stops.

In the POW camp near Nuremberg, however, where Jewish and non-Jewish Polish prisoners are separated, he cannot keep using this strategy. Appearances work against him. When a German officer orders the Jews to surrender their valuables, he is forced to reveal 300 zlotys, significantly more than his fellow prisoners, which is precisely in keeping with the anti-Semitic caricature held by the Germans. The German officer instantly sees him as a "rich Jew" who has "never worked a day in his life," and threatens: "Well, Jew, don't worry. We'll find work for you!" (*Maus I*, 51). This is the passage that, based on Vladek's experience, justifies Spiegelman's decision to represent the Germans as cats in the comic and Jews as mice, for it is here that we clearly see how Nazi anti-Semitism is fundamentally driven by metaphors. The image says nothing fundamental about Germans and Jews, but a great deal about the fantasies that turn people into hunters and the hunted. This point is forcefully underscored in a later episode when Vladek tells of an Auschwitz prisoner who insists he is actually

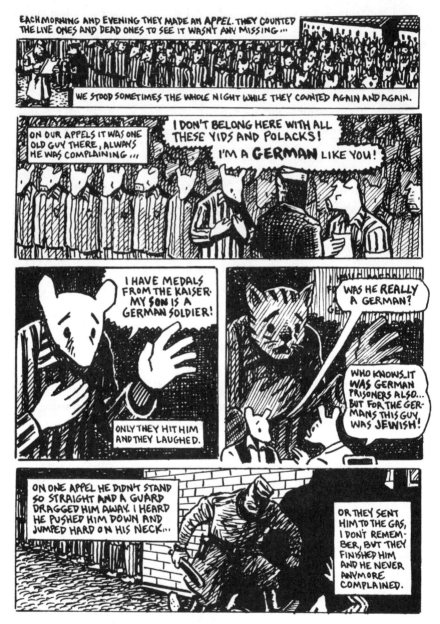

Maus II, page 50

a German and has been misidentified as a Jew. It does nothing to help him, since in making this claim he may be creating precisely the wrong impression (*Maus II*, 50).

From then on, Vladek tries to present himself as a "simple Pole" whenever possible. Granted, this only works in situations where he is almost unknown and no one can expose him as a Jew. The first but certainly not the last time that Spiegelman draws his father as a Pole, that is, with a pig mask over his face, is on his return home from the POW camp. When Vladek boards the train to return from Lublin to his family in Sosnowiec, he consciously does so wearing a Polish uniform, correctly assuming that if he appears to be an "ordinary" Polish soldier, the Polish conductor will patriotically allow him to board even without identification papers. And when he actually says: "You're a Pole like me, so I can trust you . . . The stinking Nazis had me in a war prison . . . I just escaped" and asks the conductor to hide him during the trip, the conductor quickly agrees to do so (*Maus I*, 64). From this scene until Vladek and Anja's deportation to Auschwitz, the motif of the mask becomes increasingly important; by the final chapter of *Maus I*, which shows Vladek and Anja's life after the "evacuation" of the Środula ghetto, a life underground, it is the single dominant motif. The chapter movingly shows what freedom wearing a mask can bring and what its limits are. On the one hand, Vladek can now publicly board the streetcar, even the car reserved for Germans and functionaries. On the other, already on his first walk through the city he is recognized as a fellow sufferer by another Jew living underground, who immediately addresses him in Hebrew: "In Hebrew he said to me, 'Our nation?'" (*Maus I*, 138).

During this period, Vladek is involved with multiple publics. First there are the Germans, for whom he poses as a Pole with astonishing confidence, since to them it is unthinkable that a Jew might dare to appear among them. Then there are the other Jews, who immediately— inexplicably—recognize him as one of their own, despite all his masquerading. And third there are the Poles, who do not immediately recognize him as a Jew but still suspect that he is one, which is also the reason he uses the tram car reserved for Germans: "In the *Polish* car they could *smell* if a Polish Jew came in" (*Maus I*, 140). His statement is confirmed in a remarkable way when Vladek passes a group of

Polish children and one begins to shout: "*A Jew! A Jew!*," bringing the mothers scurrying. Vladek now has to decide if it would be smarter to flee, and decides against it. Instead, he approaches the group, greets the mothers with "Heil Hitler," and assures the children that he is no Jew. He thus saves himself with a behavior, a habitus, that makes it sufficiently believable that he is no "mouse" who has unexpectedly met a "cat." The mothers then take their leave with the words: "Sorry Mister. You know how kids are . . . Heil Hitler" (*Maus I*, 149).

Vladek's relationship to non-Jewish Poles is complicated, not only because of their ability to somehow "smell" Jews, but also because of his dependence on them as soon as he tries to live among them. While his playacting helps him on the street, at home he relies on their benevolence, or at least the illusion of benevolence. In reality, Vladek's relationship to the people he lives with is shaped by economic factors. He must pay to be hidden. This is not to say that economic concerns now take the place of the mask. Instead, the payments he makes guarantee that the mask of goodwill worn by both sides remains intact. Spiegelman's interjection in this chapter, the question that interrupts his father's story about life in the underground, "You had to *pay* Mrs. Motonowa to keep you, right?" clearly recalls the beginning of the comic with its issue of the "friend," and is answered brusquely by Vladek: "Of course I paid . . . and *well* I paid. What you think? Someone will risk their life for nothing?" Furthermore, Vladek describes how the relationship to Mrs. Motonowa deteriorates when at one point he falls behind on his payments. After telling her that he won't be able to pay her for his bread until the next day, she returns that evening from the black market and claims: "Sorry . . . I wasn't able to *find* any bread today" (*Maus I*, 142). The image of friendly goodwill maintained by both sides immediately begins to crumble.

In addition to images relating to Vladek's habitus we find others involving objects he has worked on and produced. Vladek is also a master of manual improvisation and manual deceit. Tests of these abilities are found primarily in chapters 4 and 5 of *Maus I*, where Vladek describes the "bunker" he uses to conceal first Anja's grandparents and later the rest of the family. Even the first mention of a bunker, the grandparents' hiding place, is noteworthy, since it could hardly be a clearer reflection of the importance of images. Here, Vladek is shown

together with his father-in-law during his earlier stay in Sosnowiec, bent over a recent German proclamation that all Jews over the age of seventy must go to Theresienstadt. The announcement looks like a macabre sort of advertisement: in Spiegelman's drawing, Vladek's comment on the picture from Theresienstadt is that "It doesn't *look* too bad!," prompting his father-in-law to reply, "Like a convalescent home" (86). But as the next panel makes clear, no one in the family trusts the picture of Theresienstadt, so they decide to hide the grandparents. Two panels later we find out where, aided by the first of many cutaway drawings. The grandparents are housed behind a false wall of the storage shed in the courtyard of the house where the rest of the family lives (86). The next bunker Vladek builds is in the Środula ghetto. This one is in the basement of the house the family must move into, once again behind a false wall; coal piled high in front of it makes it difficult to recognize as a false wall, and also makes the bunker inaccessible from the basement. Anyone wishing to enter it must do so through the coal bin with a false bottom in the kitchen (110).

On the page where Vladek explains this design to Art, the usual page layout of the comic is disrupted, since Vladek wants to not only describe how the bunker was constructed, but also show it. He therefore takes his son's notebook out of his hand and makes a cutaway drawing, which Spiegelman shows as a separate, greatly enlarged panel with no linear border. On the facing page we can also see how the bunker worked during house searches. Vladek cowers in the bunker with Anja's family as German soldiers with dogs search the kitchen and basement, and although they know that Jews are in the house, they find no one: "Even when they came with dogs to smell us out—and they *knew* that Jews are laying here—[. . .] they couldn't find" (111).

The depictions of both the first and second bunker clearly show that their value lies in their ability to convey a convincing image. The best bunker is one that a person standing right in front of fails to recognize since everything looks normal, and perhaps the very best bunker is one that makes it look like everything is normal even though you know that it is not. Measured against this standard, Vladek's bunkers achieve a high degree of perfection. Even so, they fail to save him from deportation, since they do not protect him from betrayal. In the third bunker Vladek builds, he and Anja's family are discovered by another

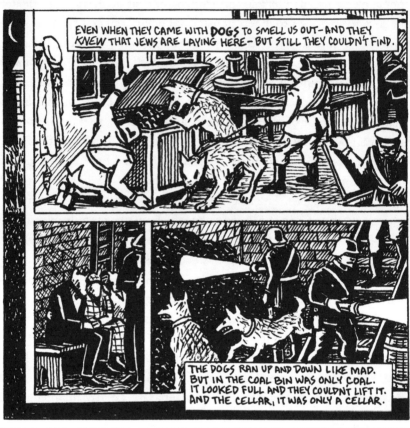

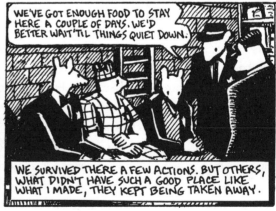

Maus I, page 111

Jew in the ghetto, who appears outside the entrance of their hiding place one night as they are leaving in search of food. He is either standing there by chance, in the ostensibly abandoned house looking for anything of value, or he is not, having been tasked with finding hidden Jews (113). It is hard to say which, so Vladek and Anja's family drag him into the bunker and discuss what they should do. Opinion is divided: Anja's cousin suggests killing the stranger, but the others hesitate. In the end, they keep him overnight and send him home the next day with something to eat. A fateful error, it turns out, since in the afternoon he comes back to their hiding place, this time with the Gestapo. They are brought to a prison whose inmates are deported to Auschwitz on a weekly basis. Yet they manage to save themselves once more, using the same type of bribe that will spare their lives in the underground, one that allows everyone involved to preserve the mask of familial and/or friendly goodwill as best they can. It is Vladek's cousin Haskel Spiegelman who saves them, but only for a hefty payment in gold and jewels.

When from his prison window Vladek glimpses another cousin who works with Haskel and calls to him for help, the first response he gets is: "Vladek?! There's nothing I can do!" But once Vladek shows the cousin his valuables, the reply changes abruptly: "Okay. Don't worry! Haskel will come help you!," which then does actually happen. Here Spiegelman interrupts again, with a question that once more recalls the beginning of the comic and the notion of the "friend": "Wouldn't they have helped you even if you couldn't pay? I mean, you were from the same family . . ." Vladek again responds with irritation, this time saying: "*Hah!* You don't understand . . . At that time it wasn't anymore families. It was everybody to take care for himself!" (114). It almost sounds as if Vladek is completely destroying the notion of family and friendship with these words, but two subsequent scenes show that this is not the case. Now back in the "normal" Środula ghetto, Vladek is stopped in the street by a German soldier who threatens: "Halt, Jew! . . . Give me your I.D. papers—I'm going to blow your brains out," but when the soldier discovers he is a relative of Haskel's, he does not shoot Vladek as threatened. In contrast to many other times when he had to make good on such threats, the soldier now confidentially puts his arm around Vladek's shoulder and says: "Ah. I see you're a member of the illustrious Spiegelman family . . . Go on your

way then, and give Haskel my regards." Vladek comments to his son: "*Such* friends Haskel had." He thus uses the very term whose use he had warned about at the outset of the comic to now describe the suddenly all-too-chummy soldier who was almost his murderer. What's more, he tells his son that up until a few years ago, he had sent packages to his fellow survivor Haskel in Poland on a regular basis. Art is understandably perplexed, and asks: "Gifts? Why? He sounds like a rotten guy!" Vladek replies, "Yes. I don't know why. I know only that I sent" (118).

The direct clash of these two terms—"friend" for the German soldier, and "rotten guy" for Haskel—demonstrates not only that the opening pages of the comic represent the tonic in a melody with later variations, but also that the image of familial and friendly solidarity matters more to Vladek than his experience would seem to justify. His practice of sending packages to Haskel even long after the war is fairly easy to explain in psychological terms. Like a neurotic, who according to Freud revisits a traumatic experience in order to overcome it by re-experiencing it, Vladek repeats the act of bribing with his gesture of familial concern so that despite what he now knows, he can preserve a notion of family and friendship that has become untenable.[5] It is an attempt to put a mask on the earlier bribery, to protect an image that might be salvaged for Haskel and the German soldier, but not for himself. His grumpy answers to the repeated question about the need to pay helpers correspondingly reveal more about his own damaged state than they do about the presumed naïveté of the questioner.

3. Vladek's Prophecies

For the survival of Spiegelman's parents, the importance of Vladek's ability to assess, produce, and preserve images can hardly be overstated. This way of reading *Maus* helps explain even the event that ultimately leads to the parents' deportation, as well as Vladek's depiction of his existence in the Auschwitz extermination camp.

Their deportation is the result of an attempt on Vladek's part to have Anja and himself smuggled into Hungary, where Jews are ostensibly more welcome. He places his trust in two swindlers, even though they are strangers he knows nothing about, and even though

kindly Mrs. Motonowa, who has hidden them but may well have self-ish motives in keeping him there, urges him not to go: "Don't do it, Mr. Spiegelman—it's just not safe! You don't know anything about these smugglers. . . . I've had awful nightmares about your trip—please stay with me!" (*Maus I*, 151).

Vladek is in fact unable to gauge the trustworthiness of the smugglers. Everything he "knows" about them is based on hearsay. Understandably, the prospect of a more bearable life in Hungary is so appealing that in order to attain that life, he is prepared—for the first and last time—to put complete trust in language. After one conversation with the smugglers involving Vladek and a number of other Jews in hiding, they deliberate in Yiddish, believing that the smugglers will not understand. They decide to test the smugglers: instead of leaving as a group, one person will first make the trip alone, and send a letter to the others from Hungary upon his safe arrival. What happens of course is the same thing that had happened at the start of Vladek and Anja's relationship when Vladek's cousin and Anja were chatting in English. Like Anja at that time, Vladek is now mistaken, since the smugglers can of course understand Yiddish. They have no trouble betraying the first person they smuggle to the Germans, then forcing him to write the expected letter to the others.

During his subsequent time in Auschwitz, Vladek survives primarily because of his ability to make images relating to his habitus align for the most part with those involving objects he produces or works on. He has successive jobs as an English teacher for an overseer, a plumber, and a shoemaker in the workshops of the camp. Though he has not learned any of these trades, in each case his habits and clever workmanship manage to create a plausible impression that he has. In this way, he manages to significantly reduce the amount of time he has to spend doing particularly heavy construction, which quickly leads to death by exhaustion.

His captivity in Auschwitz is also marked by something of equal if not greater importance than his ability to produce sustainable images with his habitual and manual dexterity, namely, the prophecy of a Catholic priest. Upon seeing his peculiar prisoner's tattoo, the priest predicts that Vladek will survive the camp: "I can't know if I'll survive this hell, but I'm certain you'll come through all this alive" (*Maus II*,

28). With this prophecy he creates an image that belongs to a new, third category of images, since its durability cannot be tested through any comparison with an "original." While the authenticity of a habitus or a crafted product can always be measured against some object of comparison, the same is not true of prophecies. A false wall can be compared with an actual one, but prophecies can only be believed—and Vladek believes. At least, Spiegelman has him conclude his story about the priest with the words: "I started to believe. I tell you, he put another life in me" (*Maus II*, 28). Notably, this is not the first time Vladek tells of such an event. Back when he was a prisoner of war near Nuremberg, he had already dreamed that his grandfather, a devout Jew wearing tefillin, approached his bed and said: "You will come out of this place—free! . . . On the day of Parshas Truma" (*Maus I*, 57). When this actually occurs, a rabbi he has told of the dream calls him a *Roh-eh Hanoled*, "one who sees what the future will bring" (*Maus I*, 60). In Auschwitz something similar appears to happen. In both cases, though, what we see is not that Vladek really has been "chosen," as Stephen Tabachnick claims, but that he has a remarkable ability to find within himself both moral support and an emotional outlet.[6]

That the belief in chosenness can be a source of moral support is hardly a matter of dispute. Sigmund Freud's speculative answer to the cultural-philosophical question about the source of the Jews' "incomparable ability to resist," which even in the present day enables them to defy all "misfortunes and mistreatments," is his well-known reference to the Jews' belief that they are God's chosen people.[7] This is no secret to Vladek, since he acknowledges that the words of the priest always had a salutary effect on him: "[W]henever it was very bad I looked [at the tattoo] and said: Yes. The priest was *right!*" (*Maus II*, 28). The priest's words also provide Vladek some emotional relief; they keep him from developing guilt feelings about those who are less fortunate and die in the camp. The chapter following the one with the priest opens with Art's psychiatrist, Pavel, wondering if the reason Vladek had often treated his son as a loser was perhaps that he felt guilty over being a Holocaust survivor: "Maybe your father needed to show that he was always right—that he could always SURVIVE—because he felt GUILTY about surviving" (*Maus II*, 44). At the same time, he rejects the idea that there are compelling underlying reasons for such feel-

ings: "Life always takes the side of life, and somehow the victims are blamed. But it wasn't the BEST people who survived, nor did the best ones die. It was RANDOM!" (*Maus II*, 45). It is no contradiction of the psychiatrist's assessment to assume that the suggestion of chosenness could initially relieve Vladek as described above, yet later become a burden to him since an event occurred that destroyed that suggestion. Instead, we are merely emphasizing the key importance of the psychological aspect of the comic, a work that does after all recount the traumatic suicide of Art's mother and the author's therapy.

In the given context, it makes sense that Vladek could draw strength from the prophecy of the priest only so long as the image of chosenness, together with the images it entails, remains intact. Certainly among these images is the one Vladek preserves of his firstborn son, Richieu, Art's older brother, who in Środula is entrusted to the care of a presumably influential acquaintance, and family. After all, Vladek underscores twice how the belief that he and Anja had saved Richieu from the clutches of the Nazis had an uplifting effect on him afterward, whereby the kind of effect as well as the words used to describe it point toward his later description of the priest's powerful words in Auschwitz. There he says, "[W]henever it was very bad I looked [at the tattoo] and said: Yes. The priest was right!," and here he says, "When things came worse in *our* ghetto we said always: 'Thank God the kids are with Persis, safe'" (*Maus I*, 108). The importance Vladek attaches to the image of Richieu's safety is further reinforced by his refusal to believe the "Gypsy" who reveals Richieu's death to Anja at the end of *Maus II*. It is the first and only time he refuses to accept such a revelation. For if he did believe her, Art would be unable to later say, "I wonder if Richieu and I would get along if he was still alive. . . . After the war my parents traced down the vaguest rumors, and went to orphanages all over Europe. They couldn't believe he was dead." Richieu is of course never found. His photograph takes his place: mounted on the wall of his parents' bedroom, it to Art—even as an adult—serves as a rebuke: "The photo never threw tantrums or got in any kind of trouble . . . It was an ideal kid, and I was a pain in the ass. I couldn't compete. They didn't talk about Richieu, but that photo was a kind of reproach" (*Maus II*, 15).

The reader realizes just how deep-seated this feeling is on the last

page of the comic, when Vladek finishes his tale and takes leave of Art with the words: "I'm tired from talking, Richieu, and it's enough stories for now . . ." (*Maus II*, np). Why would Spiegelman put his father's slip of the tongue in such a prominent place, if not to provide some clear basis for his own inability to ever completely shake the feeling that his status is that of a replacement son? If this really is the reason, then we need to see this passage as proof that Vladek's ability to question, create, and also believe in images when it was necessary to build himself up, an ability at times essential to his very survival, is now transforming into a destructive obsession, as key elements of his image cosmos implode. He is unable to let go of his image of Richieu despite the certainty of his death, and instead has to continually compare him with his younger son. He cannot correct his image of the "family," despite what he experienced during the time of his persecution, and instead has to continue sending packages to Haskel even long after the war. Nor can he tarnish his image of Anja; instead, he must live "happy, happy ever after" with her, which means he has to destroy her diaries, since they are likely to contradict this image. As Keith Harrison correctly observes of Vladek, "His triumphant words remain true and uncontroverted only in their historical moment, since the reader knows of her [Anja's] later despair and suicide" (67).[8] As for Vladek himself, Spiegelman depicts him not only as a survivor, whose "whole habitus has been shaped by Auschwitz," but also as someone who progressively deteriorates into an image, or more precisely, a distorted image: a "racist caricature of the miserly old Jew" (*Maus I*, 131).[9]

4. A Comic Book Driven by the Word

Maus scholarship that explores its imagery almost always begins with Adorno's famous dictum that after Auschwitz it is barbaric to write a poem. A key insight in this body of work is that Spiegelman's decision to draw the Jews as mice and the Germans as cats offers its own solution to the dilemma raised by Adorno, namely, that false representation and aestheticization put the memory of the Holocaust in the hands of the very culture industry that helped make it possible. In *Maus*, Spiegelman's metaphorization results in images that are

obviously unsustainable. As Andreas Huyssen observes (in an essay reprinted in this volume):

Paradoxically, we have here a mimetic approximation of the past that respects the *Bilderverbot* not despite, but rather because of its use of animal imagery, which tellingly avoids the representation of the human face. *Bilderverbot* and mimesis are no longer irreconcilable opposites, but enter into a complex relationship in which the image is precisely not mere mirroring, ideological duplication, or partisan reproduction. (76)

A similar line of argument is taken by Keith Harrison and Anja Lemke, but their work also goes a step further, exploring the constructedness of identity that is revealed in the process.[10] Lemke holds that the animal masks do not symbolize race-based entities, but instead help to make visible the ambiguous construction of every identity. There is nothing "behind" the mask; the play of masks instead reveals the underlying ambivalence of identity itself (235). These observations are all correct. However, in answering the "big" question about the narratability of the Holocaust in images, they tend to obscure the somewhat smaller one as to why Vladek's tale in particular needs to be told in pictures. By focusing on how much Vladek's very survival depends on appearances, we can help to fill that gap.

To understand a Holocaust survivor who (for good reasons) relies more on images than words, and whose fixation on images leads him to destroy the diaries his wife had hoped their son would read one day ("when he grows up, he will be interested by this"), a comic that interrogates the reliability of its own images is quite possibly the best approach (*Maus I*, 159).[11] The comic's greatest achievement is perhaps not so much that it gives us an image of the Holocaust that would be impossible to convey any other way or that we did not already have, but in how it skillfully negotiates between Spiegelman's (emotional) investment in his father's images and the image of his mother. The son takes the father's images seriously and essentially does not question them. At the same time, he reflects on the near impossibility of closing the distance he feels from them himself, thereby creating both a proximity to his father and a separation from him. (Spiegelman empathizes

with Vladek, but does so without overstepping the bounds objectively set for him, and where his father's images set perhaps only subjective barriers, he robs them of their potency. For example, his inability to fully grasp and depict the complex reality of the Holocaust becomes less weighty through the figure of the psychiatrist, who is also a survivor. With him, it becomes clear that giving precise details when rendering its horror is likely impossible (*Maus II*, 46). Art should therefore not develop any exaggerated guilt feelings, even about the father he is trying to do justice.

After this conversation, Art returns home feeling somewhat relieved, but he can hardly be described as "liberated." The sense that he has fallen short in attempting to better understand his father and all that he experienced continues to haunt him. Still: not everything stays as it was. The "BOO!" of his psychiatrist echoes in his head and provides an overlay for his images, albeit less of one for those of the camps than those of the present. In other words, what is almost impossible to record about the extermination becomes increasingly captured in its oppressive long-range effects and interferences. Without judgment, but with a keen sense of his images' emotional quality, Spiegelman shows the reader that he "is always conscious of the fact that the borders between past and present are fluid," as Huyssen puts it (79). For example, at the beginning of chapter 2 in *Maus II*, "Auschwitz (Time Flies)," Spiegelman does not show how time flies in the sense of *tempus fugit*. Instead we see Art, constantly surrounded by insects called "time flies" or *Zeitfliegen* as he draws, until at the end of the chapter, which includes a conversation about imagining the Holocaust, he begins to gas the pesky insects (*Maus II*, 74). The scene would be unremarkable if it were not so obvious that here, an analogy (however robust) is being drawn.[12] BOO! The same applies *mutatis mutandis* to Spiegelman's depiction of Vladek returning already opened groceries to the supermarket, and to Vladek's racist reaction to the Black hitchhiker picked up by his daughter-in-law. Both episodes would be less unsettling if we did not expect Vladek to have developed a more confident attitude toward groceries and supposed "strangers" by now. BOO again!

It would certainly be wrong to see Spiegelman's depiction of his own alienation from his father as an abandonment of that father.

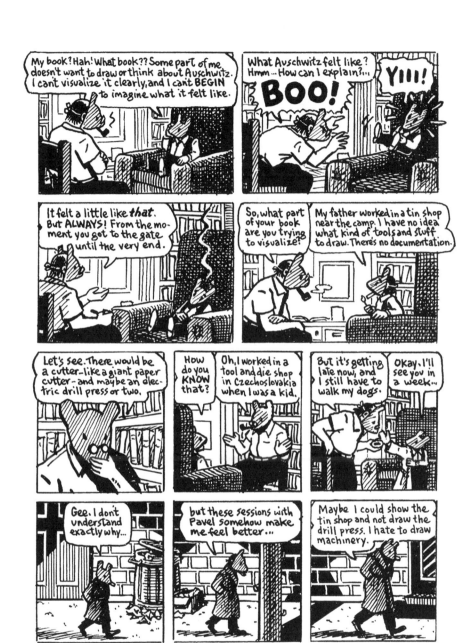

Maus II, page 46

Rather, the scenes described here, in which Spiegelman primarily depicts himself, serve as substitute depictions for the horror he is unable to adequately describe. What otherwise Vladek alone can say, Spiegelman could now say himself: "For this I was an *eyewitness*" (*Maus II*, 69). Yet his drawings, insofar as they show the consequences of an unyielding attachment to images, remain both: just as much a form of distancing as they are a rapprochement.

This clever duality allows Spiegelman, working through his father's story (not getting over it), to also come closer to his mother. For where images reveal their fragility, and no longer give the sense of corresponding to "reality," they signal that they are part of a system of differences—and become language. Completely in keeping with Spiegelman's intent, the viewer becomes a reader. As Michael Rothberg points out (in his essay reprinted in this volume), "Spiegelman makes analogies between image and text 'grammar' and claims that, unlike most of his projects, *Maus* is 'a comic book driven by the word'" (671).[13] The reader is thrown back to the medium of the mother's (destroyed) diaries, which might have shed light on certain issues, most importantly her suicide, but that now form the blank space at the center of the comic. We come no closer to her.

If we ask once more in closing what makes *Maus* "moving and simple" yet "impossible to describe," one possible answer might be: *Maus* is "moving" because Spiegelman's comic simultaneously depicts very different emotions: not just the love of Vladek and Anja, but also Spiegelman's despair over the unbridgeable distance from his father, and his shame when Vladek returns already opened groceries to the supermarket, all partially sublated in—or overlain with—the attempt to capture the horror of Auschwitz in images of the present. *Maus* is "impossible to describe" since even though the use of images is emphasized, their reliability is constantly called into question, especially in the second part, making it increasingly difficult to decide what is more important: Art's steps to move closer to his father or those that maintain his distance; and to say what is actually at the heart of the comic: the depiction of the Nazi persecution and the camps, or Art's attempt to come closer to his mother through the medium of his father's tale.

Without question, this complexity makes using *Maus* in schools decidedly more difficult. First, because the comic cannot be read as a

simple, straightforward depiction of the Holocaust, but instead must be understood as a text that problematizes every simple, straightforward depiction. This applies just as much to its cultural-critical insights as it does to the fact that *Maus* is not the story of a "representative" survivor, but something extraordinarily ambitious: the programmatically told tale of a loner. Only because Vladek insists on his uniqueness, refusing to accept the "simple" identity of a victim who is by nature inferior to the cat, does he survive. And finally, the psychological cases of the father and son in *Maus* constantly overlap, and in schools it is impossible to give the same attention to both. Should we therefore look for a different, more accessible comic to use in history and German classes? The decision would obviously depend on the didactic aims in the individual case. But if the goal is to study the actual history of the Holocaust together with questions about how it can be referenced and represented, its psychology, and its long-term psychological effects, the answer would be: certainly not.

(2018)

The Haus of Maus

Art Spiegelman's Twitchy Irreverence

ALISA SOLOMON

A faint murmur wafted toward the entrance of "Art Spiegelman's Co-Mix: A Retrospective" at the Jewish Museum in New York City. Barely audible and wholly indecipherable at first, it grew louder as one moved through the first few galleries and could begin to discern a human voice. Then, at the center of the show, amid scores of preliminary sketches, research materials, and finished panels from Spiegelman's masterpiece *Maus*, one discovered its source: excerpts of the interviews that the artist recorded with his father, Vladek, beginning in 1972, in which Vladek recounts his experience surviving in Nazi-occupied Poland and in Auschwitz—the basis of his son's celebrated two-volume graphic memoir, published in book form in 1986 and 1991.

Encountering Vladek's voice was shocking. In part that's because, as with any retrospective, "Co-Mix" is dominated by the artist's consciousness, and the intrusion of someone else's breaks the spell that is one of the pleasures of a large solo survey—submerging oneself entirely in a single imagination. First mounted in Angoulême, France, in 2012, then moving on to Paris, Cologne, and Vancouver before showing in New York (with some additions) for four months, and now headed to Toronto for a December opening at the Art Gallery of Ontario, the exhibit is the first to take stock of Spiegelman's sweeping fifty-year career. If his sensibility has remained constant, his drawing style has shifted constantly over the decades—from the inchoate, simple-line

caricatures in the hectographed satirical zine *Blasé* that he produced
at age fifteen, to the busy, bulbous, lurid scenes of his underground
comix years in the early 1970s; the visual homages to old masters like
Winsor McCay and Chester Gould as he staked out an avant-garde in
the 1980s; and the stark graphic forms in the painted-glass window
he recently designed for his alma mater, New York's High School of
Art and Design. Meanwhile, from the mid-1960s through the 1980s,
Spiegelman paid the rent by working in another, altogether different
vernacular, parodying consumer goods and popular dolls in the Topps
bubble-gum sticker series Wacky Packages ("Crust Toothpaste,"
"Botch Tape," etc.) and Garbage Pail Kids ("Bony Joanie," "Potty
Scotty," etc.). From early on, and to this day, Spiegelman's work betrays
a restless, cheeky intellect at play, filtered through a smarty-pants Jew-
ish anxiety; he tests the formal limits of his medium while champion-
ing its illustrious history, and refuses to give up the charge of *épater la
bourgeoisie* (despite knowing how long ago that battery drained).

Against the twitchy irreverence and boho self-consciousness of
Spiegelman's art, Vladek's voice sounds steady and calm, its soothing
tone all the more astonishing in contrast to the tale it tells. Spiegel-
man's first stab at *Maus*, a three-page strip that ran in a 1972 under-
ground comic (with a cover by R. Crumb) called *Funny Aminals*,
captures the disjunction brilliantly by figuring Vladek's narration as a
bedtime story. After an opening panel that mimics Margaret Bourke-
White's famous photograph of Buchenwald prisoners in striped uni-
forms lined up behind barbed wire—but with the inmates drawn as
mice and one, in the second row, labeled "Poppa"—the story begins.
Poppa sits on the edge of his son Mickey's bed, the boy snugly bundled
under the covers, head on his father's lap. Poppa describes life in the
ghetto, then its liquidation, the hiding place he and Momma shared
with several others in an attic, their betrayal to the Gestapo, and so
on, all in highly condensed language that incorporates the syntacti-
cal and prepositional glitches of a nonnative English speaker. ("One
night it was a stranger sitting in the downstairs of the house . . .") The
story is told via narrative captions, while the panels illustrate those
scenes—goateed and helmeted cats pursuing long-snouted mice, with
no trace of the word "Jew," "Nazi," or "Holocaust," the mice wear-
ing "M" badges rather than yellow stars—and the story occasionally

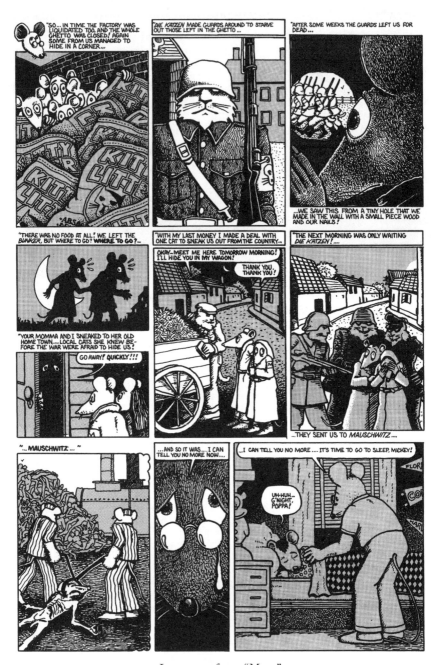

Last page of 1972 "Maus"

flashes forward to the cozy bedroom in Rego Park. By page 3, Poppa and Momma have been sent to "Mauschwitz." One panel shows a pair of mice in striped uniforms hauling a skeletal corpse to a heap adjacent to the smoke-spewing crematorium chimneys, and the next crosscuts back to Queens, where Poppa tucks Mickey in, telling him it's time to sleep. The sweet final image—it almost looks like it was culled from the Russell Hoban–Garth Williams children's classic *Bedtime for Frances*, which features a family of adorable badgers—belies the nightmares sure to trouble the child's slumber.

When he was first invited to contribute to *Funny Aminals*, Spiegelman imagined a 1950s-style horror comic about a mouse caught in a trap, as he relates in a series of autobiographical strips. The comic portrays him as stuck until he visits a film class where his friend Ken Jacobs lectures on the parallels between early animation and minstrelsy; Spiegelman envisages a piece about racism in America, with lynched mice and "Ku Klux Kats." But as he lumbers down a snowy road, mice scampering behind him, he quickly realizes, in a thought bubble: "Shit! I know bupkis about being Black in America. Bupkis." The caption adds: "Then Hitler's notion of Jews as vermin offered a metaphor closer to home." The next panel shows the sun shining over a row of homes in Rego Park, while a single gray cloud engulfs only the "Maus Haus" in rain.

Later, when Spiegelman decided to pursue a long-form comic based on his father's story, the animal motif made even more sense: Spiegelman knew he could never find out what the particular Germans and Jews his parents encountered looked like (as the canvas expanded, he added Poles as pigs and Americans as dogs), and he also realized that the accuracy he wanted to convey would be better served through abstraction. At the same time, the schema functioned as a distancing device, inoculating the work against sentimentality. The drawings became simpler than those in the 1972 strip—and as the visual variety in "Co-Mix" makes plain, this was a painstakingly deliberate choice—but the framing device became much more complex. And this is the third reason that hearing Vladek's voice is so startling: in the full *Maus,*

PRISONERS WHAT WORKED THERE POURED GASOLINE OVER THE LIVE ONES AND THE DEAD ONES.

AND THE FAT FROM THE BURNING BODIES THEY SCOOPED AND POURED AGAIN SO EVERYONE COULD BURN BETTER.

From *Maus II*, page 72

Vladek's story is always mediated. To happen upon it naked feels like a violation.

Here, Spiegelman portrays himself not as a little boy, but as the adult son drawing the story out of Vladek and then drawing it onto paper—both arduous processes of stops and starts, digressions and snags, erasures and harrowing details. Thus, the story of the story—set in the narrative present in Queens, SoHo, and the Catskills—focuses on the relationship between the Holocaust-survivor parent and the boomer-generation child, as well as the process of representing the putatively unrepresentable.

One effect of this structure—and a reason for *Maus*'s blockbuster success—is that it blasts away the mawkish and heroic tropes of familiar Holocaust narratives. I have always thought of *Maus* as the flip side of Anne Frank's diary, and not only because (as *Maus*'s subtitle puts it) it is "A Survivor's Tale." Both diaries—Spiegelman's framing story, after all, is the first-person account of Art's trials—are told in the youthful voice of an aspiring artist with a sharp eye for the irritating foibles of others, an ardor for popular culture, and a sense of belonging to a rich, if remote, wider world. But Anne's story, of course, is cut off abruptly, with the pathos of her life and talent left unfulfilled. Where she is all innocent promise, Art is a guilt-wracked success. A panel in *Maus II* shows him, bedecked in a mouse mask, hunched at his drawing table and describing *Maus I*'s triumph. Part of a Nazi guard tower can be glimpsed outside his window; there's a pile of emaciated corpses at his

feet. A speech bubble from an unseen figure—Hollywood tempter or Nazi executioner?—announces, "Alright Mr. Spiegelman . . . We're ready to shoot!"

Maus tells of an older brother, Richieu, whom Art never met: his parents left Richieu with friends in a vain attempt to save his life; he died in Poland somewhere around the age of six. A photograph of Richieu (one of three actual snapshots reproduced and collaged into *Maus*) hung in their parents' bedroom—a silent rebuke to the comfortable boy in Queens, alive and thus capable of becoming a disappointment. Anne Frank has occupied a similar place in the Jewish-American psyche: despite her moments of adolescent sarcasm and (at one time, expurgated) sexual curiosity, she came down to us as the irreproachable Jewish daughter, haunting the girlhoods of those growing up flawed and fortunate in postwar America, who were enjoined to remember that we, too (no matter if our own parents were born here in safety), could have been pursued and exterminated like vermin. Among his other achievements, Spiegelman intimately lays bare this dynamic, with all its rancor, yearning, and shame. Even in a bowdlerized Hollywood or Broadway adaptation, one could never imagine Art believing, in spite of everything, that people are really good at heart. Hasn't that always been part of *Maus*'s allure?

Spiegelman was rattled by *Maus*'s success (though he no doubt laughs now over the letters from many of the country's top editors who turned down the chance to publish the book). On top of the standard "How can I top this?" anxiety experienced by any mega-hit artist, he was distressed by the accusation—coming most insistently from his own tormented soul, though also from some drive-by detractors—that he was profiting from the Holocaust. *Maus* had taken him thirteen years to complete, and then his creativity stalled for a good decade as he found himself unable to sustain any significant new comics project.

But Spiegelman hardly stopped working. He made slinky and sinister illustrations for a new edition of Joseph Moncure March's 1928 poem *The Wild Party*. He designed covers for *The New Yorker*, where his collaborator and spouse, Françoise Mouly, became art director in 1993 (the pair edited the avant-garde comix journal *RAW* from 1980

Art Spiegelman, self-portrait
with *Maus* mask, 1989

to 1991, and *Maus* was first serialized there before being published
in its entirety by Pantheon). And, with Mouly, he launched a series
of enchanting children's picture books. Spiegelman's *Open Me . . . I'm
a Dog!*—in which a bright orange pup insists on its canine identity
despite having been turned into the very book in your hands—is, I
have it on good authority, irresistible to three-year-olds, who know a
thing or two about imbuing inanimate objects with life. All the while,
he was promoting his medium and building its archive. Working with
the designer Chip Kidd, he paid tribute to a Golden Age master by
writing the book *Jack Cole and Plastic Man* (extolling Cole's "cheerful
streak of perverse violence"), and he constantly spoke about comics at
colleges, bookstores, and anyplace else that gave him a platform. (You
can watch him hold forth in thousands of YouTube clips.)

It was the trauma of September 11, 2001, that reignited Spiegel-
man's pilot light for extended work: "disaster is my muse" he contends
in *In the Shadow of No Towers* (2004), an oversized book, printed on
heavy cardstock, that, in forty-two glossy color pages, follows sev-
eral simultaneous trajectories. The central narrative relates his and
Mouly's panicked sprint to pick up their daughter from a school near

the World Trade Center as the towers fell; in a loud obbligato, he rants against the Bush administration's jingoistic manipulations of the crime. Meanwhile, visually and thematically, Spiegelman calls upon early-twentieth-century newspaper comic strips—"the only cultural artifacts that could get past my defenses"—to help him contain his terror. He transports *Bringing Up Father* into the twenty-first century, where Jiggs grows ever more paranoid as TV and radio blare bad news; he has the Katzenjammer Kids running for their lives as the Twin Towers burn atop their very own heads. Jumpy and dense with activity, these strips break the comics grid more aggressively than he'd done before. The book's second section anthologizes seven strips from the early 1900s in which war breaks out, flags flap furiously, and buildings threaten to topple. The gesture behind this section resembles that of David Hockney assembling his "Great Wall" of artworks dating from 1350 to 1900 as he explored the manipulation of light in painting: both men demonstrate a specific historical continuity in their medium and place themselves within it.

In recognizing a sense of individual trauma within a collective historical one, Art can't help but recall his father in many of the scenes. I don't know of another work that so acutely captures the discombobulating sense of alarm and rage and love of the city that overtook so many of us in the months after the attacks. Still, no doubt because of its savaging of the Bush doctrine, you won't find it for sale in the gift shop of the new 9/11 Memorial & Museum; you can, however, buy postcards of Spiegelman and Mouly's iconic *New Yorker* cover of the towers silhouetted against a black background in the Jewish Museum's shop.

A surge of work followed, some of it completely new—a theatrical collaboration with the dance company Pilobolus; a lecture-demonstration slide show, with music by the jazz composer Phillip Johnston, on the history of wordless novels—and much of it retrospective. Indeed, even before the "Co-Mix" exhibit with its attractive, image-packed catalogue—bookended by essays by J. Hoberman (on Spiegelman's collapse of high and low art) and Robert Storr (making a case for comics departments in museums)—Spiegelman was documenting his *oeuvre*.

He first chronicled his early experiments in narrative strategies and drawing styles in 1977 in a large-format album called *Breakdowns*; having found his voice as a cartoonist, he explained later, he "needed to see my strips in a setting separate from the underground comix they had been born in, to understand what I had articulated." The pieces show his allusive, self-referential, often witty and sometimes bizarre explorations of plot-making in comics, appropriating insights and images from Dada, Cubism, TV soap operas, the comics canon, porn, his own dreams. The three-page proto-*Maus* from 1972 was here. So was a breakthrough strip, "Prisoner on the Hell Planet," a gut-wrenching four-page account of his response to his mother, Anja's, suicide in 1968, when Spiegelman was twenty.

Drawn in an Expressionistic scratchboard style that makes the panels resemble woodcuts, "Prisoner on the Hell Planet" portrays Art dressed in a striped concentration camp uniform, his stunned eyes large and drooping on a face made haggard with multiple hatch-marks. The lines become more jagged as the strip progresses: Anja's coffin juts out of the comics grid as Vladek drapes himself over it, howling; Art slumps in the corner of another panel, "alone with my thoughts," which he pictures in a stack of images (a heap of corpses in Auschwitz; his mother reading him a story in bed as a little boy; a close-up on her right hand, stamped with its Auschwitz number, slit-ting her left wrist with a razor). The closing frames show him locked up in prison, a speech bubble emerging from the bars: "You *murdered* me, Mommy, and you left me here to take the rap!!!"

Years later, Spiegelman inserted "Hell Planet" whole into *Maus*. With the jarring visual disruption, he provided important exposition and introduced both a powerful new plot point and a layer of fury and sorrow: Vladek finds the strip, which Art never intended him to see. Later, the father admits that in a fit of grief he had burned Anja's reconstructed wartime diaries, further silencing the mother Art still longs to know (and to be known by). Incensed, Art transfers a share of his guilt to his father: "You—you murderer!" Vladek thoroughly medi-ates Anja's story, dismissing Art's question of what happened to her while they were separated at Auschwitz, saying, "she went through the same what me: Terrible!" An agonizing sense of her absence pervades the father-son drama of *Maus*.

Nothing else in *Breakdowns* approaches the strong emotion of "Hell Planet." The overall tone is one of intellectual whimsy and delight in the tricks that comics can perform: one strip moves from frame to frame in any number of directions; another renders the pair of crooks in a hardboiled detective story as Mr. Potatohead and Picasso's split-faced Weeping Woman.

The book barely sold and was hardly noticed. But Spiegelman reissued it in 2008, this time introduced by the nineteen-page autobiographical comic essay "Portrait of the Artist as a Young %@&*!" In richly drawn color strips—into which he occasionally collages a page of an early work—he traces his development toward the *Breakdowns* pieces that follow. Eyeballs bulging and tongue lolling, Art pants after Harvey Kurtzman's *Mad* the moment he sees it in a store at age seven (and the small boy is drawn with the older artist's bearded chin, receding hairline, and perpetual cigarette hanging from his mouth). Another chapter shows him as an incompetent, bored, and amblyopic boy in the outfield, reading a comic book as a baseball comes his way and whomps him on the head; in the next frame, he is a decked Charlie Brown and, in the last one, he is shown hiding from sports in the library after school reading Kafka. So this *bildungs*-cartoon continues, not always chronologically, ending with a peroration on form, content, and the power of narrative that cites Susan Sontag and Viktor Shklovsky.

Looking at all these works, it's not surprising to learn that the impetus for *Maus* was formal: Spiegelman wanted to create a comic that "needed a bookmark" and would be worth rereading. (For the most part, poring over his *oeuvre* in book form is more rewarding than gazing at it on walls.) The process is recounted in minute detail in *MetaMaus* (2011), a three-hundred-page compendium of notes, sketches, resource materials, and all the rest that went into making *Maus*, with a lengthy interview conducted by the comics scholar Hillary Chute. The book comes with a DVD, *The Complete "Maus" Files*, that contains the words and images of both *Maus* volumes, with individual pages linked to relevant background materials and preparatory drawings; the 1946 booklets of renderings of concentration camps and other contemporary accounts that Spiegelman had found on his mother's bookshelf; home-movie footage from his second research trip to Auschwitz; and the full

audio of the interviews with Vladek. In all, the volume is like a cross between a variorum *King Lear* and the six-disc deluxe reissue of *The Velvet Underground and Nico*, designed for prospecting academics and zealous fans—who can't ever come close to Spiegelman's own obsessiveness. Not that they haven't tried. Dozens of doctoral dissertations have been written about *Maus*, and a scholarly-journal database shows thousands of references to it; in the comments notebook by the exit from "Co-Mix," one museumgoer wrote: "My future wife and I have matching Maus portrait tattoos taken from the endpages of *Maus*. Thank you." One can only wonder if they put them on their forearms.

In *Breakdowns/Portrait* and *MetaMaus*—and in the more overt teleology presented in the exhibit, where, in the most satisfying use of the museum format, all of *Maus II* is mounted in horizontal sequence, with variant pages running in vertical branches—one sees Spiegelman clambering up the mountain and applying the lessons of his earlier experiments, in which he mastered the use of the distancing devices that, as in theater, are built into the very form of the medium, available to those who want to make use of them: breaking the fourth wall, juxtaposing disparate realms of story and meaning, making metaphor material, monkeying with metonymy. Comics can captivate the reader with representational narrative even as they reveal and comment upon their own themes and strategies. They can simultaneously make and break illusion—while yakking about the process. Sometimes, this takes the simple form of making figures of speech visual. When a "Portrait" strip recalls how Art was "in the grip of my recovered memories" while working feverishly on "Hell Planet," a huge white hand squeezes around the artist at his drawing table; in *Maus II*, when Art visits his therapist, he is actually shrunk—tiny against his chair and barely a third of the other man's size.

Sometimes, the strategy involves giving graphic shape to the unspoken. In another "Portrait" strip, after Vladek unwittingly buys his son crime and horror comic books—once banned for allegedly causing juvenile delinquency—the boy tosses his "pops" a quarter for another batch, appearing in the frame transformed into a hoodlum replete with leather jacket, shades, and greaser pompadour. A strip called "A

Father's Guiding Hand" offers a powerful portrayal of trauma trans-
mission, as the middle-aged Art presents his own son with the family
heirloom: a chest from which a fire-breathing monster bursts forth
and keeps growing, a Hitler face protruding, *Alien*-like, from its belly.

Most important, as Spiegelman enthuses, comics turn time into
space. Panels can collapse or juxtapose different temporalities, pit
them against each other, dissolve them entirely. And all that can
happen in the visuals alone, in the accord or contradictions between
image and text or between speech bubble and caption. Early in *Maus I*,
Art asks Vladek to describe his life in Poland and the war as he pedals
on a stationary bike in Art's old bedroom. Vladek's arms dominate a
long, narrow panel as they grasp the handlebars, framing Art in the
background—just beneath his father's concentration camp tattoo.
In *Maus II*, when Art and Françoise visit Vladek in the Catskills, he
tells them about the cremation pits dug for the mass arrival of Hun-
garians at Auschwitz: as big as the swimming pool at the Pines Hotel.
While driving to the Shop-Rite, he answers Art's question about four
women who revolted and blew up a crematorium: as he explains that
these women—good friends of Anja's—were caught and hanged, the
car travels a wooded road, passing four bodies dangling from the trees.
The perpetual presence of the past in comics maps directly onto the
perpetual presence of past trauma.

Maus has long been credited with winning some highbrow legit-
imacy for comics, best exemplified by its special Pulitzer Prize in
1992 and an exhibit on the making of *Maus* (largely incorporated into
"Co-Mix") at the Museum of Modern Art in 1991 (there, one had to
don earphones to hear Vladek's testimony). It's hard to imagine that
the serious, long-form narratives by artists like Chris Ware, Marjane
Satrapi, and Alison Bechdel could have happened without it (nor, per-
haps, the spate of comics about the Holocaust like Bernice Eisenstein's
I Was a Child of Holocaust Survivors, Miriam Katin's *We Are on Our
Own*, Joe Kubert's *Yossel: April 19, 1943*, and even a manga version of
Anne Frank's diary). Spiegelman helped open the way, too, for works
in other media, like Ari Folman's animated film *Waltz with Bashir* and
Lisa Kron's solo performance *2.5 Minute Ride*.

Less widely noted—and tied to the ways comics allow the present
to be permeated by the past—is the fact that *Maus* became the proof

text for academic study of the transgenerational transmission of trauma and its representation. It was in her discussion of *Maus* that the scholar Marianne Hirsch coined the term "postmemory" to describe the experience of second-generation children being so intimately and powerfully shaped by the stories and images of events that preceded them that they take on the force of their own memories.

Spiegelman likely still wishes to get out from under the shadow of the giant mouse—"a monument I built to my father," though "I never dreamed [it] would get so big," as a strip in *Portrait* puts it. But *Maus* is one of the great artistic works of the twentieth century, so what can he do? It is also a monument to the medium he has championed, and expanded, for decades.

(2014)

Acknowledgments

Emmy Waldman was a wonderful research assistant on this book, and having her as an interlocutor about *Maus* and its critics was one of the great pleasures of working on Maus *Now*. I look forward to reading, in print, her own writing on Spiegelman (she defended a PhD dissertation on Spiegelman and Alison Bechdel during the time we completed this project). I'm grateful for her ideas, commitment, and energy.

I am profoundly appreciative of this volume's contributors. I have learned a lot from each of them, and am grateful for permission to include their work (original publication information appears starting on page 395). I'd also like to thank AP Watt at United Agents on behalf of Philip Pullman, as well as Dr. Elizabeth Gaufberg and Siegfried Kohlhammer for their permission to reprint essays by Terrence Des Pres and Kurt Scheel, respectively.

One of the many fun parts of this project was researching *Maus* essays published in languages other than English. For his help with Hebrew-language essays, I'd like to thank Ran Keren, who went above and beyond, as ever, and whose research and other efforts on my behalf were key. Johannes Schmid's early and consistent feedback, and scouting, were integral to learning about the German-language field of *Maus* criticism. I am hugely grateful to both Ran and Johannes, and lucky they were both so generous with their time in assisting me. Codruța Morari, too, generously lent her skills at an early (and a late!) stage, as did Benedikta Karaisl von Karais. Tamar Abramov also kindly aided with investigating Hebrew writing. For translation, I would like to thank both the fantastic group of translators who worked on the book,

and also the people who helped me find them: Odile Harter, Johannes Schmid, Elaine Chen, Marie Prunières (whose role in securing Pierre-Alban Delannoy's essay, as well as translating it, was crucial), Elizabeth Bredeck, Elizabeth Nijdam, and Yardenne Greenspan.

I want to thank Deborah Geis, editor of the 2003 book *Considering Maus: Approaches to Art Spiegelman's "Survivor's Tale" of the Holocaust*, published by the University of Alabama Press, for her support of this project; as she concludes in her introduction, in a statement with which I strongly agree: "the emotional, aesthetic, and intellectual power of *Maus* is of such resonance that there will always be more to say." Deborah, among others, also helped me track down people whose work appears in this volume; thanks on that front also goes to Thomas Landy, the director of Holy Cross's McFarland Center for Religion, Ethics, and Culture, and Ana Novak of Harvard's Society of Fellows. Thanks to André G. Wenzel at the University of Chicago Library for providing the image from *RAW*.

Eric Bulson invited to me think about "*Maus* now" in a fall 2020 talk to his class at Claremont Graduate University, which turned out to be very useful in sorting my ideas. Thanks also to Kenny Oravetz and Cailin Roles for working with me and Emmy during the final stages, and to Chris Spaide for last-minute advice. Gabe Fowler generously helped me with images.

I am indebted to Zoë Pagnamenta, as ever, for her instincts and invaluable guidance, as well as to Jess Hoare and Alison Lewis at the Zoë Pagnamenta Agency. I can't thank them enough.

It was a deep privilege and an honor to work with Dan Frank on Maus *Now*. His encouragement, ideas, good humor, and general tolerance of me provided an immeasurable benefit to this project. He is an inspiration. Vanessa Haughton, associate editor at Pantheon, is as supremely capable as she is good-natured, and I feel lucky for her shepherding of this book. I thank both Dan and Vanessa for their vision. Thanks too to Chip Kidd for the cover, and the many others at Pantheon who patiently helped guide the book through. Patrice Hoffmann's support, further, has been key to this project.

Thanks, Matthew.

Finally, an enormous thank-you to the ever-inspiring Art Spiegelman.

Notes

HILLARY CHUTE: *Introduction:* Maus *Now*

1. Perry Stein, "Students at Elite Sidwell Friends Projected Swastikas During Assembly," *Washington Post*, March 7, 2019; Katrin Bennhold, "Germany's Far-Right Reunified, Too, Making It Stronger," *New York Times*, October 3, 2020.
2. Caroline Jebens, "Art Spiegelmans 'Maus': Dieser Comic gehort auf den Lehrplan." *Frankfurter Allgemeine Sonntagzeitung*, January 10, 2021.

KURT SCHEEL: *Mauschwitz? Art Spiegelman's "A Survivor's Tale"*

1. Art Spiegelman, *Maus. Die Geschichte eines Überlebenden* (Reinbeck: Rohwolt, 1989).

DORIT ABUSCH: *"The Holocaust in Comics?"*

1. Page 73 of *Co-Mix* visually quotes *Where the Wild Things Are*, and page 79 portrays the conversation with Charles M. Schulz.
2. The encounter with Mama of *The Katzenjammer Kids* is on page 2 of *In the Shadow of No Towers*. The sequence about seeing the world in 2D is on page 9 of the introduction to *Breakdowns* (which is unpaginated).
3. The comic about the MS *St. Louis* is on page 89 of *Co-Mix*. Goya's print *The Sleep of Reason Produces Monsters* is visually quoted in "Real Dream," on page 21 of the body of *Breakdowns* (which is unpaginated).
4. "Ace Hole, Midget Detective" on pages 28–35 of *Breakdowns* visually quotes Picasso's *Guernica* and has a female cubist character. *The Birth of Venus* is visually quoted on page 24 of *Breakdowns*. Ingres's *The Source* is visually quoted in "Two-fisted Painters," which appeared as an insert in *RAW #1: The Graphix Magazine for Postponed Suicides*, and was republished in *Co-Mix*. The image of Dick Tracy as the Duke of Urbino is in Spiegelman's *Be a Nose!* sketchbook

compilation, in the 1983 sketchbook. A Guston cyclops is found on p. 121 of *Co-Mix*.

5. Harvey Kurtzman is referenced on pages 80–81 of *Co-Mix*. "Ace Hole, Midget Detective" on pages 28–35 of *Breakdowns* quotes Picasso. "Cracking Jokes" quotes Mark Twain on page 17 of *Breakdowns*. Page 19 of the introduction to *Breakdowns* references Shklovsky. Page 18 of the introduction to *Breakdowns* shows a fistfight between words and pictures. A strip on page 38 of *Co-Mix* compares the immediacy of bubbles and captions.

6. The scene at the drafting table is part of a sequence on pages 41–47 of *Maus II* where Spiegelman as author wears a mask.

7. The scene where Vladek and his second wife are shown sketches for the book is on pages 132–33 of *Maus I*. The sketchbook page with animal heads in seen on page 11 of *Maus II*.

8. The sequence with the clinging mouse mask is on pages 8–9 of *MetaMaus*.

9. Englishmen are depicted as fish on page 131 of *Maus II*, and a fortune teller is depicted on page 133 as a spongy moth (in the terminology of the time, a "gypsy moth").

10. The story of the metamorphosis of the dog is *Open Me . . . I'm a Dog!* "Prince Rooster" is the first comic in *Little Lit*. The Gregor Samsa image is on page 99 of *Co-Mix*. Jiggs and Maggie and Happy Hooligan appear on pages 8 and 10 respectively of *In the Shadow of No Towers*.

THOMAS DOHERTY: *Art Spiegelman's* Maus:
Graphic Art and the Holocaust

1. Art Spiegelman, "A Problem of Taxonomy," *New York Times Book Review*, December 29, 1991, 4. Spiegelman did suggest a possible compromise: that the *Times* add a special "nonfiction/mice" category.

2. Art Spiegelman, *Maus I: A Survivor's Tale: My Father Bleeds History* (New York: Pantheon, 1986) and *Maus II: A Survivor's Tale: And Here My Troubles Began* (New York: Pantheon, 1991). Subsequent references to *Maus* are cited parenthetically.

3. Calvin Reid, "A '*Maus*' That Roared," *Publishers Weekly*, January 31, 1994, 26–27. Spiegelman is quoted as saying, "I was not interested in animation or in licensing *Maus*. It would just be destroyed. But *The Complete Maus* will allow for a lot of extra information about the original that should be useful and interesting." Typical of the hypertext adaptations challenging the perceptual boundaries of both print and moving image media, *The Complete Maus* bills itself as a document that "grants the user unprecedented access to the historical and structural details behind the finished book. The pages of *Maus* are linked to preliminary sketches, alternate drafts, archival photographs, and drawings made by prisoners and audio from the interviews between Art Spiegelman and his father that were the basis for the narrative." For readers of the comic book version, the CD-ROM version is apt to be an expansive, if spooky, excursion into the Spiegelmans' backstory. The tape recordings of Vladek comprise its eeriest and most electrifying moments—a melodic, sparse voice from the past

summoning the vision again before the eyes. In truth, the CD-ROM seems more a supplement to the original than an autonomous text, an ancillary package that assumes the "user" has already experienced the narrative of *Maus* in the antediluvian role of "reader."

4. Saul Friedländer, *Reflections of Nazism: An Essay on Kitsch and Death* (New York: Harper & Row, 1984), 96; italics in original.

5. From Hitler's 1938 speech opening the second Great German Art Exhibition; quoted in Berthold Hinz, *Art in the Third Reich* (New York: Pantheon, 1979), 10.

6. From *The Guide to the Exhibition of Degenerate Art*; quoted in Hinz, 41.

7. Susan Sontag, "Fascinating Fascism," in *Movies and Methods: An Anthology,* ed. Bill Nichols (Berkeley: University of California Press, 1976), 40.

8. Laura Mulvey's "Visual Pleasure and Narrative Cinema," the touchstone essay on the scopophilic gaze, is reprinted in Mulvey, *Visual and Other Pleasures* (Bloomington: Indiana University Press, 1989), 14–26.

9. Although a good deal of written criticism has made this point, it is vividly explored in two documentary films on the aesthetics of Nazism, Peter Cohen's *The Architecture of Doom* (1986) and Roy Muller's *The Wonderful, Horrible Life of Leni Riefenstahl* (1994).

10. Sontag, "Fascinating Fascism," 41.

11. For a comprehensive discussion of film and the Holocaust, see Annette Insdorf, *Indelible Shadows: Film and the Holocaust* (New York: Random House, 1983).

12. Art Spiegelman, "Drawing Pens and Politics: Mightier Than the Sorehead," *The Nation,* January 17, 1994, 46. Hence, too, the epigraph to *Maus I:* "The Jews are undoubtedly a race, but they are not human."—Adolf Hitler.

13. Taken from a Nazi newspaper article in the mid-1930s, the epigraph to *Maus II* joins together a comic and not-so-comic constellation of aesthetics, history, and cartoons: "Mickey Mouse is the most miserable ideal ever revealed. . . . Healthy emotions tell every independent young man and every honorable youth that the dirty and filth-covered vermin, the greatest bacteria carrier in the animal kingdom, cannot be the ideal type of animal. . . . Away with Jewish brutalization of the people! Down with Mickey Mouse! Wear the Swastika Cross!"

14. Spiegelman, "Drawing Pens and Politics," 46.

15. The single best work on comic book aesthetics is Scott McCloud, *Understanding Comics: The Invisible Art* (Northampton, Mass.: Kitchen Sink Press, 1993). On *Maus* specifically, see Joseph Witek, *Comic Books as History: The Narrative Art of Jack Jackson, Art Spiegelman, and Harvey Pekar* (Jackson: University Press of Mississippi, 1989), 96–120.

16. Nechama Tec, *Dry Tears: The Story of a Lost Childhood* (New York: Oxford University Press, 1984).

17. In the wake of recent neo-Nazi efforts to deny the Holocaust, demands for scrupulousness in research and monitoring of careless scholarship have become particularly urgent. In this light, it is worth noting that Spiegelman's insistence on his own historical precision came after the publication of his second volume in 1991—not after the first volume in 1986. The guidelines for literary adap-

tions of the Holocaust, no less than historical works, are articulated by Pierre Vidal-Naquet: "It remains the case nonetheless that if historical discourse is not connected—by as many intermediate links as one likes—to what may be called, for lack of a better term, reality—we may still be immersed in discourse, but such discourse would no longer be historical" (*Assassins of Memory: Essays on the Denial of the Holocaust*, trans. Jeffrey Mehlman [New York: Columbia University Press, 1992], 110–11). See also Deborah Lipstadt, *Denying the Holocaust: The Growing Assault on Truth and Memory* (New York: Plume, 1994).

STEPHEN E. TABACHNICK: *Of* Maus *and Memory: The Structure of Art Spiegelman's Graphic Novel of the Holocaust*

1. As early as October 1941, the twenty-four-year-old creator of The Spirit, Will Eisner, told a reporter that "The comic strip is no longer a comic strip, but, in reality, an illustrated novel. It is new, and raw just now, but material for limitless intelligent development. And eventually and inevitably, it will be a legitimate medium for the best of writers and artists" (quoted in Alan Edelstein, "Will Eisner's Spirit," *Forward,* January 1, 1993, 1, 9). It is now commonly agreed that Eisner's 1978 *A Contract with God,* about the occupants of a New York tenement in the 1930s, is the first American graphic novel. One of the problems with the term "graphic novel" is that it is currently used to denote biographical, historical, and autobiographical as well as fictional works. But if we accept the dictum that all autobiographies are fictional and all fictions autobiographical to some degree, even this difficulty disappears, and the term proves very serviceable: I will employ it throughout this discussion, referring to Spiegelman's "autobiographical graphic novel" when that seems necessary.

2. The constraints on the commercial comic book occur primarily because of commercial considerations. But the question of how words and images work together to influence the reader's perceptions, whether in comic books or in graphic novels, is an interesting one. Eisner believes that the image dominates, since even the words in a panel are drawn by the artist and are seen as part of the picture. Abbott, on the other hand, privileges words over images when he writes that "The comic artist must be a story-teller in words and pictures, but a story-teller above all, because the medium is a narrative one, in which the pictorial is perhaps best thought of as the para-literary" (176). But in "Deconstructive Comics," *Journal of Popular Culture* 25, no. 40 (Spring 1992): 153–61, Ronald Schmitt points out that in absorbing sequential art, the eye jumps from text to picture and vice versa. According to him, in this new, more erratic version of the standard, linear reading experience, neither word nor image predominates. I agree with Schmitt that it is not possible to give precedence to either the verbal or the visual in the graphic novel or other sequential art media.

It is, of course, possible to have a brief comic or cartoon that is entirely visual, but I cannot think of a single graphic novel without words. Writing one might be an interesting experiment, like Georges Perec's writing of a novel without using the letter "e" (*La Disparition*), but it would be an exceptional formal exercise rather than a straightforward artistic attempt to represent some-

thing about the world. On the other hand, there is little point to a graphic novel without pictures; it would simply become a novel. Once again, both words and pictures are necessary to the form, and neither words nor pictures can be clearly shown to be predominant in affecting the reader.

3. Interestingly enough, as a *Forward* article of April 10, 1992, states, the Pulitzer Prize committee decided that the category of newspaper cartoon was not appropriate for *Maus* and that it needed a category of its own. While one can scarcely complain about their decision, it might be possible to argue that *Maus* is actually the most distinguished example ever of the political cartoon, although, as Joseph Witek points out, Spiegelman deliberately chose a vague style of drawing in order to avoid telling the reader what to think, as political cartoons do. Among purely literary fictions, Orwell's *Animal Farm* is a comparable masterpiece using the techniques of the political cartoon. Apropos of *Animal Farm*, Ethan Mordden notes that Spiegelman's inspiration for the use of animals was the barnyard, in which mice as vermin are always eliminated, pigs are used and then killed, and dogs are mongrels—thus making dogs particularly appropriate for the representation of Americans, who are a very heterogeneous people. But there is no sign that Spiegelman was influenced by Orwell. For Spiegelman's feelings about other media, see Richard Pachter's interview with him in *Comics* 108 (1992): 4–13.

4. Art Spiegelman was born in Stockholm in 1948 but came to the United States at an early age; in the opening section of *Maus I* we see him as a regular American kid.

5. *Maus* has sometimes been called a biography of Vladek, but I believe that this is a mistaken identification of genre since Vladek tells his story in his own words, making it an autobiographical narrative. Yet it is not only autobiography either because Vladek's words and related pictures are filtered and reported through Spiegelman's art. What we really have in Vladek's story in *Maus*, then, is Vladek's spoken autobiography transformed into an epic structure by Spiegelman. This story has the usual epic's structure of the unwilling separation of the hero from normal society, his confrontation with the great evil, and his reentry into society. Out of the Holocaust, Spiegelman has created a modern Jewish epic, whose primary theme is the family and its survival under impossible conditions.

6. One of the undergraduates in my fall 1992 course on the graphic novel, Trang Nguyen, noticed a further refinement—a verbal pun embedded in volume II's back cover: "*Catskill* [my italics] Mountains" conjures up cats killing mice. She went on to comment that the bungalows Spiegelman depicts in that resort area can also be seen as faintly reminiscent of the Auschwitz barracks—yet another chilling juxtaposition of past and present.

7. That might be very appropriate and might well reflect Israelis' own self-perceptions as well as Spiegelman's perceptions of them. "Kipi HaKipod" ("Porky the Porcupine") is the equivalent of "Big Bird" in the Israeli version of *Sesame Street*.

8. See also Ethan Mordden's comment about animals in note 3, above.

MARIANNE HIRSCH: *My Travels with* Maus, *1992–2020*

1. From Marianne Hirsch, *The Generation of Postmemory: Writing and Visual Culture After the Holocaust* (New York: Columbia University Press, 2012), 9–11.
2. From Marianne Hirsch, *Family Frames: Photography, Narrative and Postmemory* (Cambridge: Harvard University Press, 1997), 17–40. Revised version of "Family Pictures: *Maus*, Mourning and Postmemory," *Discourse* 15, no. 3 (1992–93), 3–29.
3. Susan Sontag, *On Photography* (New York: Anchor Doubleday, 1989), 70.
4. Roland Barthes, *Camera Lucida: Reflections on Photography*, trans. Richard Howard (New York: Hill & Wang, 1981), 80, 81.
5. Barthes, *Camera Lucida*, 82.
6. Marguerite Duras, *Practicalities: Marguerite Duras Speaks to Michel Beaujour*, trans. Barbara Bray (New York: Grove Weidenfeld, 1990), 89; Barthes, *Camera Lucida*, 91.
7. Sontag, *On Photography*, 70.
8. Helen Epstein, *Children of the Holocaust: Conversations with Sons and Daughters of Survivors* (New York: Penguin, 1979), 11.
9. Pierre Nora, "Between Memory and History: *Les Lieux de Mémoire*," *Representations* 26 (Spring 1989): 19.
10. W. J. T. Mitchell, *Picture Theory: Essays on Verbal and Visual Representation* (Chicago: University of Chicago Press, 1994), 192.
11. "Postmemory" is usefully connected to Kaja Silverman's notion of "heteropathic recollection"—her elaborate psychoanalytic theorization of the self's ability to take on the memory of others, even culturally devalued others, through a process of heteropathic identification. Silverman's argument also relies on the visual and considers the role of photography, though not the notion of family. See *The Threshold of the Visible World*, esp. chapter 5.
12. Nadine Fresco, "Remembering the Unknown," International Review of Psychoanalysis 11 (1984): 417–27.
13. Henri Raczymow, "Memory Shot Through with Holes," *Yale French Studies* 85 (1994): 98–106.
14. In conjunction with a 1996 photographic exhibit in Warsaw, "And I Still See Their Faces," one Zahava Bromberg writes: "I carried this photograph of my mama through two selections by Dr. Mengele at Auschwitz. Once I held it in my mouth, the second time I had it taped with a bandage to the bottom of my foot. I was 14 years old." *New York Times*, May 19, 1996, 1.
15. I have deliberately quoted only that part of Adorno's sentence which has become so determinative and familiar. The actual sentence reads: "Perennial suffering has as much right to expression as a tortured man has to scream; hence it may have been wrong to say that after Auschwitz you could no longer write poems." *Negative Dialectics*, trans. E. B. Ashton (New York: Continuum, 1973), 362. In his later essay "Commitment" (1962), Adorno further elaborates his thoughts: "I have no wish to soften the saying that to write lyric poetry after Auschwitz is barbaric; it expresses in negative form the impulse which inspires committed literature. . . . Yet this suffering . . . also demands the continued existence of art while it prohibits it; it is now virtually in art alone that

suffering can still find its own voice, consolation, without immediately being betrayed by it." Andrew Arato and Eike Gebhardt, eds., *The Essential Frankfurt School Reader* (New York: Urizen Books, 1978), 312. But this seeming reversal of his original injunction is subject to further rethinking in the essay: "The esthetic principle of stylization . . . make[s] an unthinkable fate appear to have some meaning; it is transfigured, something of its horror is removed. . . . Even the sound of despair pays its tribute to a hideous affirmation" (313).

16. Peter Haidu, "The Dialectics of Unspeakability: Language, Silence, and the Narratives of Desubjectification," in Saul Friedländer, ed., *Probing the Limits of Representation: Nazism and the "Final Solution"* (Cambridge: Harvard University Press, 1992), 294.

17. Julia Kristeva, "The Pain of Sorrow in the Modern World: The Works of Marguerite Duras," *PMLA* 102 (March 1987): 139. Clearly, this profusion of images must be seen in relation to their absence, as well. With their massive extermination program, Nazis systematically destroyed the very records of Jewish life, documents and photographs, that could attest to its history. Many survivor families, unlike the Spiegelmans and the Jakubowiczs, have no pictures of their prewar life. I am grateful to Lori Lefkowitz for pointing out this corrective to Kristeva's argument.

18. Cited in Andrea Liss, "Trespassing Through Shadows: History, Mourning, and Photography in Representations of Holocaust Memory," *Framework* 4, no. 1 (1991): 33.

19. Art Spiegelman, *"Maus* & Man," *Voice Literary Supplement,* June 6, 1989, 21. But the Pulitzer Prize committee invented a special category for *Maus*, suggesting the impossibility of categorizing it as either "fiction" or "nonfiction." As Lawrence Langer says in his review of *Maus II:* "It resists defining labels." "A Fable of the Holocaust," *New York Times Book Review* (November 3, 1991), 1.

20. Christina von Braun, *Die schamlose Schönheit des Vergangenen: Zum Verhältnis von Geschlecht und Geschichte* (Frankfurt: Neue Kritik, 1989), pages 116, 118, 119 (my translation).

21. W. J. T. Mitchell points out that *"Maus* attenuates visual access to its narrative by thickening its frame story . . . and by veiling the human body at all levels with the figures of animals" (*Picture Theory,* 93). We might add that the few photos that cut through that veil can thus acquire their particular force through contrast.

22. See Alice Kaplan's comparison of *Maus* as the text of the child of survivors to Klaus Theweleit's *Male Fantasies* as the text of the child of the perpetrators. See also Angelika Bammer: "The formal composition of *Maus* creates a structure that bridges, even though it cannot fill in, the spaces of silence created by the people whose stories remain untold" (*Displacements,* 93).

23. See Nancy K. Miller's account (reprinted in this volume) of the 1992 *Maus* exhibition at the Museum of Modern Art where some of Vladek's tapes could be heard. Miller analyzes the levels of mediation and transformation that separate the father's voice from the son's text. In the CD-ROM version of *Maus,* we can hear the oral testimony and can compare the aural and visual texts; we can assess the transformations and revisions that the son performs on his father's words.

24. Shoshana Felman and Dori Laub, *Testimony: Crises of Witnessing in Literature, Psychoanalysis and History* (New York: Routledge, 1992), 48.
25. Alvin K. Rosenfeld's book on the literature of the Holocaust is called *A Double Dying: Reflections on Holocaust Literature* (Bloomington: Indiana University Press, 1980).
26. See also Nancy K. Miller's incisive analysis (reprinted in this volume) of the missing mother's story as the basis for the father/son relationship in *Maus*, and more generally her discussion of the intergenerational and relational nature of the autobiographical project. In Miller's reading, Anja Spiegelman duplicates the generative power of St. Augustine's Monica.
27. Felman and Laub, *Testimony*, 71.
28. Klaus Theweleit, *Buch der Könige, 1: Orpheus und Euridike* (Frankfurt: Roter Stern, 1989).
29. Debórah Dwork, *Children with a Star: Jewish Youth in Nazi Europe* (New Haven: Yale University Press, 1991), xxxiii.
30. From Marianne Hirsch, *The Generation of Postmemory*, 29–36.
31. Art Spiegelman, "Maus" (1972), reprinted in *The Virginia Quarterly Review* 82, no. 4 (Fall 2006): 41.
32. Paul Connerton, *How Societies Remember*. Gary Weissman objects specifically to the "memory" in my formulation of postmemory, arguing that "no degree of power or monumentality can transform one person's lived memories into another's." (Gary Weissman, *Fantasies of Witnessing*, 17). Both Weissman and Ernst van Alphen refer back to Helen Epstein's 1979 *Children of the Holocaust* to locate the beginnings of the current use of the notion of "memory" in the late 1980s and 1990s: in contrast, they indicate, Epstein had described the "children of the Holocaust" as "possessed by a *history* they had never lived," and she did not use the term "second generation," which, van Alphen observes, implies too close a continuity between generations that are, precisely, *separated* by the trauma of the Holocaust. Epstein spoke of the "sons and daughters of survivors." Objecting to the term "memory" from a semiotic perspective, van Alphen firmly asserts that trauma cannot be transmitted between generations: "The normal trajectory of memory is fundamentally indexical," he argues. "There is continuity between the event and its memory. And this continuity has an unambiguous direction: the event is the beginning, the memory is the result. . . . In the case of the children of survivors, the indexical relationship that defines memory has never existed. Their relationship to the past events is based on fundamentally different semiotic principles" (Ernst van Alphen, *Art in Mind*, 485, 486).
33. Jan Assmann, *Das kulturelle Gedächtnis*. Assmann uses the term "kulturelles Gedächtnis" ("cultural memory") to refer to "Kultur"—an institutionalized hegemonic archival memory. In contrast, the Anglo-American meaning of "cultural memory" refers to the social memory of a specific group or subculture.
34. Aleida Assmann, "Re-framing Memory."
35. For a series of distinctions between familial and nonfamilial aspects of postmemory and for a strictly literal interpretation of the second generation, see Pascale Bos, "Positionality and Postmemory in Scholarship on the Holocaust." In *Haunting Legacies*, Gabriele Schwab relies on Nicolas Abraham and

Maria Torok's suggestive notion of the crypt to explain the intergenerational transmission of trauma from a psychoanalytic perspective. I have always seen the crypt as an inherently familial structure of transfer, but Schwab usefully defines "collective, communal and national crypts" that ensue from historical traumas (*Haunting Legacies*, esp. chapter 2).

36. Geoffrey H. Hartman, *The Longest Shadow*, 9; Ross Chambers, *Untimely Interventions*, 199ff.
37. Eva Hoffman, *After Such Knowledge*, 187 (emphasis added).
38. It is useful, in this regard, to recall Edward Said's distinction between vertical *filiation* and horizontal *affiliation*, a structure that acknowledges the breaks in authorial transmission that challenge authority and direct transfer. (Edward W. Said, *The World, the Text, and the Critic*.) While Said sees a linear progression from filiation to affiliation, however, Anne McClintock complicates what she calls this "linear thrust" to argue that "the anachronistic, filiative image of family was projected onto emerging affiliative institutions as their shadowy naturalized shape" (Anne McClintock, *Imperial Leather*, 45).
39. From Marianne Hirsch, "Works in Progress: Sketches, Prolegomena, Afterthoughts," *WSQ* 48, nos. 1 and 2 (Spring/Summer 2020): 141–42, 144.
40. Sonali Thakkar, "Reparative Remembering," *WSQ* 48, nos. 1 and 2 (Spring/Summer, 2020): 138.
41. Tahneer Oksman, "Postmemory and the 'Fragments of a History We Cannot Take In,'" *WSQ* 48, nos. 1 and 2 (Spring/Summer, 2020): 134.

NANCY K. MILLER: *Cartoons of the Self: Portrait of the Artist as a Young Murderer—Art Spiegelman's* Maus

1. Mary Mason made the case over a decade ago in a pioneering essay from which I have been quoting, "The Other Voice: Autobiographies of Women Writers," and her analysis has been important to the mapping of women's traditions, so often neglected in the formation of theories of cultural production. The essay is included in *Life/Lines: Theorizing Women's Autobiography*, ed. Bella Brodzki and Celeste Schenck (Ithaca: Cornell University Press, 1988).
2. In a revision of Mason's model, Susan Stanford Friedman has shown that women autobiographers tend to locate the self of their project not only in relation to a singular, chosen other, but also—and simultaneously—to the *collective* experience of women as gendered subjects in a variety of social contexts. ("Women's Autobiographical Selves: Theory and Practice," in *The Private Self*, ed. Shari Benstock [Chapel Hill: University of North Carolina Press, 1988.]) Here again—with the inevitable measure of asymmetry that gender comparisons always present—the men's texts echo the female paradigms. In *Maus* (and to a lesser degree in *Patrimony*) this collective identity—the other Other—plays a crucial, indeed constitutive role in the elaboration of the autobiographical subject. This socially situated identity, however, is not so much a generalized masculinity as a specified Jewishness. It could even be argued that the father/son relation, and more broadly the familial scenario, finds meaning primarily when plotted against the cultural figures of Jewish identity. This double

proximity may mean either that at the end of the twentieth century the auto-biographical model is becoming feminized, or that we need to reconsider the original theoretical assumptions of the canonical model itself. After all, one could easily see Augustine as constructing his autobiographical self in relation to his mother, Monica, and Rousseau elaborating his in relation to the other constituted by his imagined reader.

3. There is from the start a tension about whose story it is. On the cover of *Maus I* is the father/mother (mouse) *couple* whose joint destiny gets summarized in the singular "survivor's" tale. Although the son clearly distinguishes the two parts of the couple by asking specifically about his mother, he is limited finally by his father's plot.

 Maus also conforms to Catherine Portugues's account of recent auto-biographical film by contemporary women filmmakers (primarily post-war European directors). "These films share as a common gesture . . . the desire to create an intergenerational testimonial for the benefit of parents or children and to recount a story formerly repressed, silenced, or distorted. . . . It is the desire to make restitution for pain inflicted, real or imagined, and to see the other as a whole individual with a separate identity that infuses these films, rather than the 'manic defense' more typical of the work of male autobiograph-ical filmmakers" ("Seeing Subjects: Women Directors and Cinematic Autobi-ography," in *Life/Lines*, 343). I think we have to complicate these patterns of gender differentiation and to articulate them with the historical demands of postwar representation. See also in *Lear's* (June 1992) the striking photograph of TV news reporter Charles Stuart *with his mother* (the story is about her unsolved murder) and described as *a self-portrait taken by himself.*

4. Art Spiegelman, "Saying Goodbye to *Maus,*" *Tikkun* (September/October 1992): 16.

5. Elizabeth Pochoda, "Reading Around," *The Nation*, April 27, 1992, 560.

6. Ethan Mordden, "Kat and Maus," *The New Yorker*, April 6, 1992, 96.

7. In the upper left-hand corner of "Prisoner," in its title frame, a hand holds a summer snapshot of Anja and Art dated 1958. It's hard to make out the expres-sion on the mother's face, but her little boy is grinning at the camera. In the lower left-hand corner of the page in *Maus* on which "Prisoner" is reproduced, Spiegelman has drawn in the same hand, as if to mark the place of his own rediscovery of the earlier work. The repetition also ties the hand as signature to the mother/son bond. In the photo, Anja rests her hand on her son's head; the hand that a few panels later will hold the razor blade.

8. The tension between obsessional saving and impulsive throwing away is rehearsed earlier in *Maus*. After a session with his father on the pre-Auschwitz days in Sosnowiec, Art looks for his coat only to discover that Vladek has thrown it away: "It's such *shame* that my son would wear such a coat!" His father offers one of his old jackets as a replacement (having bought a new one for him-self at Alexander's). The chapter ends with Art verifying that his coat is indeed in the garbage, and walking home alone in shock (as in after his father's revela-tion): "I just can't believe it . . ."

9. The whereabouts of the diaries are associated with the saving of junk much earlier in *Maus*. Art interrupts a conversation with Mala about the roundup of

the Jews in Sosnowiec to track down a vague memory of having seen the note-books on Vladek's shelves in the den. He catalogues the kinds of things Vladek saved: four 1965 Dry Dock Savings Calendars, menus from cruises, hotel sta-tionery, etc. There's a question here about what part of this saving can be seen as a specific effect of surviving the Holocaust and what belongs more generally to a diasporic identity. I was struck by a remark in Susan Cheever's memoir of her father, John Cheever, the ultimate chronicler of *goyish* sensibility: "My father never saved anything. He scorned all conservative instincts" (*Home Before Dark*, 53). Like Vladek, my father always had tea bags drying on the stove (the degraded transformation of the perpetual samovar and the tradition of what he called "sens"—the essence, presumably, of tea) and saved rubber bands, jars, broken pencils, old flower pots, plastic containers, until the apartment overflowed from the hoarding. Was this the aftermath of the Depression? A way of always being prepared—the "you never know" of survivors?

10. In the scenes of Auschwitz following the therapy session Art has his father describe Birkenau (Auschwitz II) where Anja was interned. Here Vladek relates what he managed to learn of Anja's fate, including a letter reproduced in one of the panels: "'I miss you,' she wrote to me. 'Each day I think to run into the electric wires and finish everything. But to know you are alive it gives me still to hope . . .'" (*Maus II*, 53). Despite the "reproduction" of the letter—the only instance of Anja's written words—we are necessarily left as readers with the mother's voice in translation: into Vladek's English, into his idealized ver-sion of their couple, into Art's comic strip. Nonetheless, the disembodied voice delivers the message of despair that seems to have been hers from the start. At the beginning of her narrative we learn that Anja has a nervous breakdown after giving birth to Richieu and is sent to a sanitarium.

11. In *Holocaust Testimonies: The Ruins of Memory* (New Haven: Yale University Press, 1991), Lawrence Langer comments on the status of this phrase in sur-vivor interviews: "Asked to describe how he felt at the moment of liberation, one surviving victim declared: 'Then I knew my troubles were *really* about to begin,' inverting the order of conflict and resolution that we have learned to expect of traditional historical narrative" (67).

12. Toward the end of *Maus II* Vladek presents Art with a surprise, a box of snap-shots: "I thought I lost it, but you see how I saved!" This raises for the last time the matter of the memoirs: *"Mom's diaries?!"* (*Maus II*, 113). The snapshots—redrawn as photographs—mainly show other members of Anja's family, includ-ing a brother, a commercial artist Anja said he resembled and who like his sister killed himself. The photographs record what was left of her family after the war. Marianne Hirsch (in an essay reprinted in this volume) analyzes the role of photographs in *Maus* and their crucial role in the "aesthetic of postmemory" that Spiegelman elaborates. She also emphasizes the ways in which the *Maus* project represents an attempt to reconstruct the missing maternal legacy.

13. The epigraph to *Maus II* is drawn from a German newspaper article of the mid-1930s linking the "Jewish brutalization of the people!" to the miserable "Mickey Mouse . . . ideal."

14. In *Maus II* Vladek explains how in the camps he justified his boast that he had been a "shoemaker since childhood" (in reality he had watched his cousin

work in the ghetto shoe shop) (60). He describes repairing lace-up boots in need of resoling. Art illustrates this task with a complicated drawing. In the show above the comic drawings is mounted the technical drawing of shoemaking from which Art derived his cartoon version. Vladek draws the moral of his successful gamble: "You see? It's good to know to do *everything!*" Art's insistence on his impracticality—not knowing how to do anything—is undone by his accomplishment as an artist in figuring out how to *draw* everything. The survivor's skills honed in the camps pass on to the next generation as a matter of artistic survival.

15. It's the subtitle of his book.

16. A portion of the tape corresponds to the transcripted account of the march out of Auschwitz and thus becomes irresistible to compare the aural and written voices.

17. There's no escaping the effect of the frame since the taped passages are just as *chosen* (out of the twenty or more recorded hours) as the illustrated ones.

18. This book is coauthored with Shoshana Felman (New York: Routledge, 1992), 57–58.

MICHAEL ROTHBERG: *"We Were Talking Jewish":*
Art Spiegelman's Maus as "Holocaust" Production

1. A word on terminology: the proper name "the Holocaust" is problematic for a number of reasons. As Art Spiegelman remarks, "Holocaust" (and another alternative, "the Shoah") has religious associations which imply that those who died were a sacrifice or burnt offering, a clear mystification of senseless violence ("Conversation"). The word "Holocaust" also has a specific history and, according to Berel Lang, emerged as the term to describe the destruction of European Jews by the Nazis only in the late 1960s. I will be arguing that this moment is extremely significant for Jews in general and for *Maus* in particular. Lang proposes the more neutral "Nazi genocide" (xxi). I, however, am suspicious as a rule of the concept of neutrality, and even though I do not like the term "Holocaust" prefer to contest its production and meaning rather than ignore its power in popular imagination.

2. But see also Daniel Boyarin's subtle consideration of the complexities of Jewish relations to the image. Boyarin demystifies the "commonplace of critical discourse that Judaism is the religion in which God is heard but not seen" (532), and his essay has implications that go beyond this religious context and are important to secular Jewish representations as well.

3. In a 1937 anti-Semitic pamphlet, Céline wrote, "J'espere qu'a present vous savez lire 'juif'" [I hope that you now know how to read "Jewish"]. This sentence is cited in Kaplan, *Releve*, 25.

4. Apart from work cited elsewhere in this essay, two critics stand out for their theoretical sophistication in attempting to understand the Holocaust and Jewishness in an American context. On the Holocaust, see James E. Young, *Writing and Rewriting the Holocaust* and *The Texture of Memory*. On Jewish identity,

see Jonathan Boyarin, *Storm from Paradise: The Politics of Jewish Memory.* See also my review essay of Boyarin's book.

5. See also Marianne Hirsch's discussion of this self-portrait (reprinted in this volume).

6. See Adorno, *Negative Dialectics* 361–65; Blanchot, 66–69; Lang, 144–45. On Lang, see White, 44–48.

7. See, for example, Levi and Antelme. For more on this, see Rothberg, "Sites of Memory, Sites of Forgetting: Jewishness and Cultural Studies," *Found Object* 2 (1993): 111–18.

8. Alice Yaeger Kaplan wrote, for example, "Spiegelman gets the voices right, he gets the order of the words right, he manages to capture the intonations of Eastern Europe spoken by Queens" ("Theweleit and Spiegelman," 155).

9. The evidence for this alteration comes from the exhibit "Art Spiegelman: The Road to *Maus,*" at the Galerie St. Etienne, November 17, 1992–January 9, 1993. The phrase "talking Jewish" is one I heard my grandmother use, but which makes me (and, I would guess, Spiegelman) uncomfortable to hear. I suspect that the Jewish/Yiddish difference figures a generational divide.

10. Maurice Anthony Samuels, in a very fine unpublished essay, makes a similar point about the interplay between past and present in *Maus* and reads Art as "a parody of the traditional historian in what amounts to a parody of realist historiographic methods" (49–50).

11. Despite anatomizing a wide range of texts on Jewish themes, Gilman surprisingly makes no mention in *The Jew's Body* of Spiegelman or *Maus.*

12. This practice of revealing the creation of *Maus* has reached new heights (or depths) with the production of a CD-ROM version entitled *The Complete Maus.* As well as the complete text of both volumes, the CD contains interviews with Spiegelman, writings and sketches by the author, tapes and transcriptions of Vladek, and even a family tree which allows viewers to "access" pictures of the protagonists. Although it is a valuable resource, especially with the inclusion of Vladek's original testimony, I remain doubtful whether "*Maus* in cyberspace" (as I am tempted to call it) represents a qualitative artistic advance. Rather, it seems to me another step on the road to the Spielbergization of the Holocaust, something Spiegelman generally resists.

13. See Nancy K. Miller's and Marianne Hirsch's articles (in this volume) for readings of Anja's absence that have influenced my own.

14. In her 1992 performance piece about the struggles in Crown Heights between Hasidic Jews and Caribbean and African Americans, *Fires in the Mirror,* Anna Deavere Smith included a perceptive monologue on Hasidic women's wigs which she immediately contrasted with the Reverend Al Sharpton discussing his "James Brown" coiffure. I do not mean to imply that circumcision and the wearing of wigs are parallel phenomena, since only the former derives from a biblical injunction and since it holds more fully for different types of Jews (although Gilman does point out that assimilated German Jews in the nineteenth century questioned the need for circumcision [*Jew's Body,* 91]). Rather, I think more emphasis needs to be placed on the *heterogeneity* of Jewish bodies across various lines of sociosexual demarcation: not "the Jew's body," then,

but Jewish bodies. A full treatment of this question of Jewish women's bodies in *Maus* would need to consider the role of Art's wife, Françoise, and Mala, Vladek's second wife, whose marginalizations are not always treated as self-consciously as the question of Anja (see Hirsch on this topic).

A broader account of gender politics in Spiegelman's work would also consider his controversial Valentine's Day cover for *The New Yorker* (February 15, 1993), which featured a painting of a Hasidic man kissing a Black woman. A fairly direct reference to the same tensions explored by Smith in her performance, this "Valentine card" succeeded only in enraging Black and Jewish communities. Spiegelman's avowedly utopian wish that "West Indians and Hasidic Jews could somehow just 'kiss and make up'" (quoted in "Editors' Note," 6) was directed at racial tensions but did not take account of the intersection of race with gender and sexuality. The image of a white man with a Black woman connotes a whole history of sexual exploitation grounded in racial domination, while, on the other hand, a Hasidic man (as Spiegelman does acknowledge) is forbidden to touch a non-Jewish woman. With respect to the present context, I would also note the (not) accidental erasure of the Jewish woman (as well as the presumably threatening Black man) from this vision of reconciliation. The scenario effectively points to an ambiguity of Jewish "ethnicity": Jews will, depending on the context, appear as white, as other than white, or as both simultaneously (as here).

15. For an essay which situates *Maus* within a tradition of Jewish comics, see Buhle. For a consideration of *Maus* as part of the emergent genre of the comic-novel, see Orvell.

16. For information on Israeli torture in the Occupied Territories, see the report by the Israeli human rights group B'Tselem.

17. For a memoir by a Palestinian living in Lebanon which movingly addresses the latter side of this dialectic (among other issues), see Makdisi.

18. Unfortunately, this situation seems to remain true even after the recent mutual recognition of the Palestine Liberation Organization and Israel. I would hypothesize that this event will in the long run produce major changes in the parameters of Jewish identity configurations; however, it remains too early to tell what those realignments will look like (or what the political ramifications of this flawed agreement will be for Palestinians).

19. Spiegelman claims that the phrase "crystalline ambiguity" was his favorite description by a critic of *Maus* ("Conversation"). The only other place I've seen the phrase is in Spiegelman's own comments in *Tikkun,* where it appears unattributed. Talk about taking self-reflexivity seriously!

ALAN ROSEN: *The Language of Survival:
English as Metaphor in Spiegelman's* Maus

1. Sidra Ezrahi, *By Words Alone: The Holocaust in Literature* (Chicago, 1980), 12. Ezrahi's more recent views pertaining to language and the Holocaust can be found in several essays, including "'The Grave in the Air': Unbound Metaphors in Post-Holocaust Poetry," in *Probing the Limits of Representation: Nazism and*

the *"Final Solution,"* ed. Saul Friedländer (Cambridge, Mass., 1992), 259–76; and "Conversation in the Cemetery: Dan Pagis and the Prosaics of Memory," in *Holocaust Remembrance: The Shapes of Memory,* ed. Geoffrey Hartman (Oxford, 1994), 121–33.

Ezrahi is one of a procession of critics who have ventured a taxonomy of Holocaust languages. See, for instance, George Steiner, *Language and Silence: Essays on Language, Literature and the Inhuman* (Harmondsworth, 1969); David G. Roskies, "Scribes of the Ghetto," in his *Against the Apocalypse: Responses to Catastrophe in Modern Jewish Culture* (Cambridge, Mass., 1984); Sander Gilman, "The Ashes of the Holocaust and the Closure of Self-Hatred," in his *Jewish Self-Hatred: Anti-Semitism and the Hidden Language of the Jews* (Baltimore, 1986); Primo Levi, "Communicating," in his *The Drowned and the Saved* (New York, 1988); Shoshana Felman, "The Return of the Voice: Claude Lanzmann's *Shoah,"* in *Testimony: The Crises of Witnessing in Literature, Psychoanalysis, and History,* ed. Shoshana Felman and Dori Laub (New York, 1992).

2. Israel Knox, introduction to *Anthology of Holocaust Literature,* ed. Jacob Glatstein, Israel Knox, and Samuel Margoshes (New York, 1973), xiv. Though the anthology contains writing from 1942 to 1963, it was first published in 1968, with additional printings appearing regularly through the 1970s. The anthology thus came into circulation at approximately the same time Spiegelman was working on and eventually publishing his first cartoons representing the Holocaust.

3. It is, I think, fairly clear that by deploying the German word for the title, Spiegelman is asking the reader to view the Jews/mice through the Germans'/cats' eyes, a strategy that emphasizes Jewish weakness and vulnerability, on the one hand, and German power and ruthlessness, on the other. The strategy of the title parallels and reinforces the visual animal metaphor. The appropriateness of this metaphor has been the subject of substantial critical contention.

That said, I believe the reading that I give the title, emphasizing the interplay between English and German, can be further supported by noting that whereas Spiegelman's choice of the singular, *Maus,* enables the play between English and German, the choice of the plural, *Mice,* would not. And yet it is probably more fitting that the title (like the image of the mice on the cover) be in the plural. I therefore suggest that, at least in part, Spiegelman opted for the singular, *Maus,* to invoke the play between the two languages. I would like to thank Jorg Drewitz for drawing my attention to the singular/plural issue.

4. See, for instance, Marianne Hirsch, "Family Pictures: *Maus,* Mourning, and Post-Memory," *Discourse* 15, no. 2 (Winter 1992–93): 19–22 (reprinted in this volume).

5. By the phrase "language of survival," I am referring to the startling capacity of English as represented in *Maus* to determine survival during the Holocaust. This connotation is not synonymous with that of Sander Gilman's in *Jewish Self-Hatred.*

6. As Vladek makes clear in the transcripts, his English was merely good enough: "And I, I was a teacher in English. Here I couldn't be, of course. But there I gave lessons." Art Spiegelman, "The Working Transcripts," in *The Complete Maus,* CD-ROM (New York, 1994), 71.

7. Braj B. Kachru, ed., *The Other Tongue: English Across Cultures* (Urbana, Ill., 1992). The term refers to the English of nonnative speakers.

8. Vladek notes in the transcripts that "Willie" properly translates as the Polish "Vladek." Clearly, then, Willie was not a name chosen by the Americans simply in order to signal superiority. But since Spiegelman does not make the reader of *Maus* aware of the connection between the English and Polish names, the context, gestures, and language suggest the racial overtones.

9. It is important to note that, historically, the American army generally did not have as a military objective the liberation of concentration camps and of Jewish prisoners. The logic of this sequence in *Maus,* however, not only shows the actions taken on behalf of Vladek and his friend but also suggests that the rescue of the Jews was an aspect of the American army's mission. I wish to thank Alan Berger for drawing my attention to this issue.

10. As Alice Yaeger Kaplan phrases it, "One of the many extraordinary features of *Maus* is that Spiegelman gets the voices right, he gets the order of the words right, he manages to capture the intonations of Eastern Europe spoken in Queens." In "Theweleit and Spiegelman: Of Mice and Men," *Remaking History,* ed. Barbara Kruger and Phil Mariani (Seattle, 1989), 155.

11. See Nancy K. Miller, "Cartoons of the Self: Portrait of the Artist as a Young Murderer—Art Spiegelman's *Maus,*" *M/E/A/N/I/N/G* 12 (1992): 58 (reprinted in this volume).

12. To be sure, *Maus* represents a range of languages foreign to English: Hebrew, Polish, Yiddish, German, French. Whereas Vladek's Yiddish-English functions to estrange the reader, these other languages generally do not function so as to insist on their own foreignness; Spiegelman uses words so common to even nonspeakers that they do not need translation, or, in the case of Vladek's Polish, he subtitles it with fluent English. The Hebrew that appears in *Maus,* to my mind, has a more ambiguous status; I hope to address its significance in a longer version of this essay.

 Shoshana Felman uses a similar metaphor of "foreignness" in analyzing Lanzmann's *Shoah* in "The Return of the Voice," and I am indebted to her discussion therein. Yet Spiegelman and Lanzmann pursue this notion by means of contrasting strategies. Whereas Lanzmann foregrounds the foreignness of the Holocaust by making sure multiple survivors speak in languages (native or adopted) different from one another and different from the narrative language of the film itself (French), Spiegelman makes this foreignness palpable through the voice of a single survivor, whose testimony is in the same language as the narrative of the graphic novel.

13. While significant in its own right, Spiegelman's representation of Vladek's accent falls within the context and conventions of Yiddish voices in American literature, a point apparently overlooked by most critics. For a summary of this context and these conventions, see Kathryn Hellerstein, "Yiddish Voices in American English," in *The State of the Language,* ed. Leonard Michaels and Christopher Ricks (Berkeley, 1980).

14. "Art on Art" in *The Complete Maus.* In 1955, Alain Resnais employed this strategy in his film *Night and Fog.*

15. First published as "Maus," *Funny Aminals* 1 (1972); reprinted in *Comix Book* 2, ed. Denis Kitchen (New York, 1974); included in the appendices of *The Complete Maus*. In "Maus," Spiegelman also deployed accents unevenly. On the one hand, some adult Jews accent thickly ("Psst . . . you vant a potato to buy?") while Jewish children have no accent ("Next time I want to play the cat").

TERRENCE DES PRES: *Holocaust* Laughter?

1. Katerina Clark and Michael Holquist, *Mikhail Bakhtin* (Cambridge: Harvard University Press, 1984), 299.

2. Michel Foucault, *Power/Knowledge: Selected Interviews and Other Writings, 1972–1977*, ed. Colin Gordon (New York: Pantheon, 1980), 131.

3. Tadeusz Borowski, *This Way for the Gas, Ladies and Gentlemen* (New York: Penguin, 1976); Leslie Epstein, *King of the Jews* (New York: Coward, McCann & Geoghegan, 1979); Art Spiegelman, *Maus: A Survivor's Tale* (New York: Pantheon, 1986).

4. Mikhail Bakhtin, *Rabelais and His World*, trans. Helene Iswolsky (Cambridge: MIT Press, 1968).

5. Emmanuel Ringelblum, *Notes from the Warsaw Ghetto*, ed. and trans. Jacob Sloan (New York: Schocken, 1974). The three citations come, respectively, from pages 79, 55, and 216.

ANDREAS HUYSSEN: *Of Mice and Mimesis: Reading Spiegelman with Adorno*

1. An earlier German version of this essay was published in Manuel Koppen and Klaus R. Scherpe, eds., *Bilder des Holocaust* (Bohlau: Cologne, 1997), 171–90, and in English in *New German Critique* 81 (Autumn 2000).

2. Anson Rabinbach, *In the Shadow of Catastrophe: German Intellectuals Between Apocalypse and Enlightenment* (Berkeley: University of California Press, 1997). Central here is the chapter entitled "Elements of Anti-Semitism" in Horkheimer and Adorno's classic work *Dialectic of Enlightenment* [1947], trans. John Cumming (New York: Continuum, 1982).

3. As is to be expected, the discussion of signification, hieroglyphs, language, and image is pre-Saussurean, pre-semiotic in the strict sense. It remains indebted to Benjamin on the one hand, and through Benjamin also to a nineteenth-century tradition of German language philosophy. But it is precisely the non-Saussurean nature of this thought that allows the notion of mimesis to emerge in powerful ways.

4. See Gertrud Koch, "Mimesis und Bilderverbot in Adorno's Asthetik," *Die Einstellung ist die Einstellung* (Frankfurt/Main: Suhrkamp, 1992).

5. See Josef Frilchtl, *Mimesis: Konstellation eines Zentralbegriffsbei Adorno* (Wilrzburg: Kiinighausen & Neumann, 1986); Karla L. Schultz, *Mimesis on the Move: Theodor W. Adorno's Concept of Limitation* (Bern: Peter Lang, 1990); Gunter

Gebauer and Christoph Wulf, *Mimesis: Kultur, Kunst, Gesellschaft* (Reinbek: Rowohlt, 1992), esp. 374–422; Martin Jay, "Mimesis and Mimetology: Adorno and Lacoue-Labarthe," *Cultural Semantics* (Amherst: University of Massachusetts Press, 1998), 120–37.

6. Adorno, *Minima Moralia: Reflections from a Damaged Life,* trans. E. F. N. Jephcott (London: Verso, 1974), 154.

7. Adorno, Review of Roger Caillois, "La Mante religieuse," *Zeitschrift für Sozialforschung* 7 (1938): 410–11. See also Adorno's letter to Benjamin of September 22, 1937, and Benjamin's response in his letter of October 2, 1937, in *Theodor W. Adorno–Walter Benjamin: Briefwechsel, 1928–1940,* ed. Henri Lonitz (Frankfurt/Main: Suhrkamp 1994), 276–78, 286.

8. The literature on representing the Holocaust is by now legion. One of the richest and still influential collections of essays is Saul Friedländer, ed., *Probing the Limits of Representation: Nazism and the "Final Solution"* (Cambridge: Harvard University Press, 1992). See also, most recently, Dominick LaCapra, *History and Memory After Auschwitz* (Ithaca: Cornell University Press, 1998).

9. Art Spiegelman, *Maus I: A Survivor's Tale: My Father Bleeds History* (New York: Pantheon, 1986) and *Maus II: A Survivor's Tale: And Here My Troubles Began* (New York: Pantheon, 1991). The following publications were extremely helpful in preparing this essay. I acknowledge them summarily since my concern is a theoretical proposition rather than a new and differentiated reading of the text per se. Joseph Witek, *Comic Books as History* (Jackson: University of Mississippi Press, 1989); Andrea Liss, "Trespassing Through Shadows. History, Mourning, and Photography in Representations of Holocaust Memory," *Framework* 4, no. 1 (1991): 29–41; Marianne Hirsch (in this volume), "Family Pictures: *Maus,* Mourning, and Post-Memory," *Discourse* 15, no. 2 (Winter 1992–93): 3–29, reprinted in Hirsch, *Family Frames: Photography, Narrative, and Postmemory* (Cambridge: Harvard University Press, 1997); Miles Orvell, "Writing Posthistorically: *Krazy Kat, Maus,* and the Contemporary Fiction Cartoon," *American Literary History* 4, no. 1 (Spring 1992): 110–28; Rick Iadonisi, "Bleeding History and Owning His [Father's] Story: *Maus* and Collaborative Autobiography," *CEA Critic: An Official Journal of the College English Association* 57, no. 1 (Fall 1994): 41–55; Michael Rothberg (in this volume), "'We Were Talking Jewish': Art Spiegelman's *Maus* as 'Holocaust' Production," *Contemporary Literature* 35, no. 4 (Winter 1994): 661–87, reprinted in this volume; Edward A. Shannon, "'It's No More to Speak': Genre, the Insufficiency of Language, and the Improbability of Definition in Art Spiegelman's *Maus,"* *The Mid-Atlantic Almanack* 4 (1995): 4–17; Alison Landsberg, "Toward a Radical Politics of Empathy," *New German Critique* 71 (Spring/Summer 1997): 63–86. And most recently Dominick LaCapra, "'Twas the Night Before Christmas: Art Spiegelman's *Maus,"* in *History and Memory After Auschwitz;* James Young, "The Holocaust as Vicarious Past: Art Spiegelman's *Maus* and the Afterimages of History," *Critical Inquiry* 24, no. 3 (Spring 1998): 666–99.

10. For a discussion of the worst offenders, see Michael Rothberg, "After Adorno: Culture in the Wake of Catastrophe," *New German Critique* 72 (Fall 1997): 45–82.

11. The paradox is that when Adorno accused poetry after Auschwitz of barba-

rism, he deeply suspected the apologetic temptation of a poetic and aesthetic tradition, whereas much of the recent poststructuralist discourse of the sublime in relation to Holocaust representations does exactly what Adorno feared: it pulls the genocide into the realm of epistemology and aesthetics, instrumentalizing it for a late-modernist acsthetic of nonrepresentability. A very good documentation and discussion of notions of the sublime can be found in Christine Pries, ed., *Das Erhabene: Zwischen Grenzerfahrung und GroBenwahn* (Weinheim: VCH Acta Humaniora, 1989).

12. Paradigmatically in Shoshana Felman's much discussed essay, "The Return of the Voice: Claude Lanzmann's *Shoah*," in Felman and Dori Laub, *Testimony: Crises of Witnessing in Literature, Psychoanalysis, and History* (New York: Routledge, 1992), 204–83. For a convincing critique of Felman's work, see LaCapra, *Representing the Holocaust: History, Theory, Trauma* (Ithaca: Cornell University Press, 1994), as well as LaCapra, *History and Memory After Auschwitz*. The latter volume also contains a well-documented essay on Spiegelman's *Maus* that includes a critical discussion of much of the literature on this work.

13. This argument has been made very forcefully and persuasively in Miriam Hansen, *"Schindler's List* Is Not *Shoah:* The Second Commandment, Popular Modernism, and Public Memory," *Critical Inquiry* 22 (Winter 1996): 292–312. For the earlier debate on the television series *Holocaust*, a similar argument can be found in Huyssen, "The Politics of Identification: *Holocaust* and West German Drama," in *After the Great Divide: Modernism, Mass Culture, Postmodernism* (Bloomington: Indiana University Press, 1986), 94–114.

14. These were central topoi in the German debate about Holocaust memory. See the special issue on the *Historikerstreit, New German Critique* 44 (Spring/Summer 1988), as well as Charles S. Maier, *The Unmasterable Past: History, Holocaust, and German National Identity* (Cambridge: Harvard University Press, 1988).

15. Cf. the two-page prologue initiating volume I dated Rego Park, N.Y., c. 1958 when Art is only ten years old or the photograph of his dead brother, Richieu, that overshadowed his childhood, but is later used at the beginning of volume II to dedicate this part of the work to Richieu and to Nadja, Art Spiegelman's daughter.

16. The category of working through has been most thoroughly explored for this context by LaCapra in *Representing the Holocaust: History, Theory, Trauma.* LaCapra bases his approach on Freud, and he acknowledges that there cannot be a rigorous and strict separation between acting out and working through for trauma victims. While I feel certain affinities to LaCapra's general approach, I prefer not to engage the psychoanalytic vocabulary. While the psychoanalytic approach is certainly pertinent to the analysis of survivor trauma, it does have serious limitations when it comes to artistic representations of the Holocaust and their effect on public memory. The notion of "mimetic approximation" which I try to develop through my reading of *Maus* tries to account for that difference.

17. Significantly, the prologue to volume I that shows Artie roller-skating and hurting himself is also dated 1958, and when just a few pages and many years later Artie asks his father to tell his life's story, he is looking at a picture of his mother saying: "I want to hear it. Start with Mom . . ." (*Maus I,* 12).

18. With this insight and so much more, my reading of *Maus* is indebted to Marianne Hirsch's incisive essay (in this volume), "Family Pictures: *Maus*, Mourning, and Post-Memory." See also Hirsch, "Projected Memory: Holocaust Photographs in Personal and Public Fantasy," in Mieke Bal, Jonathan Crewe, and Leo Spitzer, eds., *Acts of Memory: Cultural Recall in the Present* (Hanover, N.H.: University Press of New England, 1999), 3–23.
19. See note 7.
20. See Homi K. Bhabha, "Of Mimicry and Man: The Ambivalence of Colonial Discourse," in *The Location of Culture* (New York: Routledge, 1994), 86.
21. Interview conducted by Gary Groth, "Art Spiegelman and Françoise Mouly," Gary Groth and Robert Fiore, eds., *The New Comics* (New York: Berkley, 1988), 190–91.
22. These are the terms Adorno uses in the first chapter of the *Dialectic of Enlightenment* where they discuss the irremediable splitting of linguistic sign and image. Horkheimer and Adorno, *Dialectic of Enlightenment*, 17–18.
23. Miriam Hansen, "Mass Culture as Hieroglyphic Writing: Adorno, Derrida, Kracauer," *New German Critique* 56 (Spring/Summer 1992): 43–75. Koch, "Mimesis und Bilderverbot in Adorno's Asthetik."
24. The original German reads: "Gerettet wird das Recht des Bildes in der treuen Durchführung seines Verbots." Adorno, *Gesammelte Schriften* 3 (Frankfurt/Main: Suhrkamp, 1983), 40.
25. Quoted in Joshua Brown's review of *Maus I* in *Oral History Review* 16 (1988): 103–4, reprinted in this volume.
26. "A Conversation with Art Spiegelman. With John Hockenberry," Talk of the Nation, National Public Radio, February 20, 1992.
27. An observation I owe to Gertrud Koch.
28. Klaus Scherpe, ed., *In Deutschland unterwegs, 1945–48* (Stuttgart: Reclam, 1982).

HILLARY CHUTE: *"The Shadow of a Past Time":
History and Graphic Representation in* Maus

1. Laura Frost recently argued that this connection is a weak point of *No Towers*. In my reading, however, the most interesting and politically useful, if risky, aspect of the book is its willingness to analyze a world-historical stage as opposed to keeping 9/11 local and specific, as Frost urges.
2. *In the Shadow of No Towers*, like the groundbreaking *Maus*, makes attention to interlacing temporalities part of its very form: Spiegelman's twenty-first-century comic strips are followed by reprints of old newspaper comic strips from the turn of the twentieth century. Spiegelman's own ten strips are followed by seven plates, lavish reproductions of the historical strips. *No Towers*, then, like *Maus*, offers no end that implies recovery or transcendence. Working specifically against any metanarrative of progress, it argues, through its narrative grouping of original and historical material, that the "end" is in fact a return to the old. Spiegelman says in an interview that the confusion that the combination of new and old work might induce is "exactly the point of the book" (Dreifus).

3. Other authors also note the persistence of the past in *Maus*. See for instance Sara Horowitz, Michael Rothberg (reprinted in this volume), James Young, and Andrea Liss.

4. The work of Marianne Hirsch and Michael G. Levine are two important exceptions. In "Family Pictures: *Maus*, Mourning, and Postmemory" (reprinted in this volume) and in "Collateral Damage," Hirsch discusses how the comics form "performs an aesthetics of trauma" ("Collateral Damage," 1213). Levine discusses bleeding as the hemorrhaging of visual images that break out of frames (71). Levine in places refers to the grammar of comics in terms of film language; he cites "Spiegelman's art of the 'slow motion picture'" (72). Deborah Geis also notes the "filmic" style of *Maus* (2). While *Maus* does make cultural references to film, I believe its form is best understood as specific to comics. For instance, as Scott McCloud points out about the crucial space of the gutter, comics' structural element of absence, "what's between the panels is the only element of comics that is not duplicated in any other medium" (13).

5. Rüdiger Kunow is correct to point out that a self-reflexive awareness of the limits of representation has become not only a specific problem germane to the Holocaust but more generally a *conditio sine qua non* of all representations in theory, history, and cultural texts (252).

6. Erin McGlothlin thoroughly dissects *Maus*'s temporalities through identification of its three diegetic levels and Genette's tripartite narrative classification system, but she does not consider the aesthetic issue of how time is represented spatially on the comics page.

7. Spiegelman rejected a certain woodcut style for *Maus* because it made the text "like a political cartoon" ("Jewish Mice," 116). He rejects the notion of a "graphic approach" as "a visual analog to the content" (Interview with Andrea Juno, 10).

8. See Shoshana Felman and Dori Laub's *Testimony*, especially the chapter "Education and Crisis"; and W. J. T. Mitchell's "The Commitment to Form."

9. Felman rightly believes this statement "has become itself (perhaps too readily) a cultural cliché, too hastily consumed and too hastily reduced to a summary dismissal" (33). This reading is affirmed by "Commitment," in which Adorno demands that art strive to resist the judgment of its uselessness in the face of suffering.

10. Spiegelman claims, "The page is the essential unit of information" and "I've considered the stylistic surface [of the page] a problem to solve" (*The Complete Maus*).

11. While many critics invoke *Maus*'s "hybrid form" (Miller, "The Art of Survival," 99) or "hybridized status" (LaCapra, 146) when elaborating the destabilizing work that the text performs, few analyze the graphic form of *Maus* that creates this hybridity. Although LaCapra goes beyond other critical invocations of *Maus*'s hybridity by explaining that "blurring and hybridization should not be conflated although they may at times be very close" (146n14), his frequent use of the term warrants further discussion; see 145, 146, 147, 149, 151, 152, 153. See also Huyssen (reprinted in this volume), Orvell, and Young for invocations of *Maus*'s hybridity. My own understanding of this term as apposite to comics is premised on the fact that in comics, the images do not necessarily illustrate

the text but can comprise a separate narrative thread; verbal and visual narratives do not simply blend together. This notion of hybridity is clarified in Lyotard's discussion of the *differend:* necessarily set into play by the nonunity of language, the *differend* represents the impossibility of bridging incommensurate discourses.

12. *Annotation* is Spiegelman's term for the procedure of comics; he describes comics pioneer Bernard Krigstein as "a philosopher of how time could be made visible and annotated in space" ("Krigstein"). For important theorizations of framing generally, see Derrida, Goffman, and Malina.

13. Friedman discusses location on page 20, multiplicity on page 24, and borders on pages 27–30. See also Mitchell, "Space, Ideology, and Literary Representation."

14. Spiegelman refers here to his dense comic strip "A Day at the Circuits," collected in his book *Breakdowns*. This obsession for packing and gathering took a more virulent form in Spiegelman's youth, when, reportedly, he hoarded string while hospitalized for a mental breakdown, as he knew Vladek had done at Auschwitz (Gerber, 168).

15. All emphases in quotations from *Maus* are Spiegelman's. I call *Maus*'s artist character Artie (as his father does) and the text's author Art Spiegelman.

16. The second volume of Spiegelman's 1980s magazine *RAW* evokes *My Father Bleeds History* in its subtitle, *Open Wounds from the Cutting Edge of Commix*. This connection emphasizes the *extraction* implied in Spiegelman's father "bleeding history" for his son's medium.

17. There is an important body of criticism that explores this rebuilding in terms of the absent mother, Anja Spiegelman. See Hirsch, "Family Pictures" (part of Hirsch's contribution in this volume); LaCapra; Levine; and Miller, "Cartoons of the Self" (reprinted in this volume) and an expanded version, "The Art of Survival."

18. *Maus* makes frequent use of the iris diaphragm, a technique often used at the end of silent films when the scene is viewed as if through a binocular and the image gradually diminishes into the darkness. This description is in Koch, 401.

19. Smoke also figures the presence of the past in *In the Shadow of No Towers,* where Spiegelman draws Art's cigarette smoke as the smoke coming from Ground Zero on 9/11. Art connects his father's inability to describe the smell of the smoke of bodies in Auschwitz with his own indescribable olfactory experience in Lower Manhattan in 2001, all the while himself smoking, as in *Maus,* Cremo brand cigarettes.

20. Hirsch writes: "I use the term *postmemory* to describe the relationship of children of survivors of cultural or collective trauma to the experiences of their parents, experiences that they 'remember' only as the stories and images with which they grew up, but that are so powerful, so monumental, as to constitute memories in their own right" ("Projected Memory," 8). See also Hirsch's "Family Pictures," "Surviving Images," and *Family Frames.*

21. Artie's therapist, Pavel, even suggests that Artie is "the *real* survivor" (*Maus II,* 44).

22. Spiegelman sees "Prisoner" and "Time Flies" as sequences that exist outside of the already complicated narrative structure of *Maus*. But, he notes, they "pull the narratives taut in different temporal and spatial directions" (Silverblatt, 35–36). Notably, Spiegelman's language here suggests a loose flow of historical narrative that is made more lucid—instead of more slack—by a complicating self-reflexivity.

23. The CD-ROM *The Complete Maus*, in which we hear portions of Vladek's narrative, suggests Spiegelman's attempt to represent Vladek's literal voice. It also shows how Spiegelman edited his father's speech to fit the format of *Maus*.

24. Spiegelman, while allowing his father's rejection of this "very well documented" fact, lets readers know which "version" is correct (*Maus II*, 54).

25. As Felman points out, testimony is composed of "events in excess of our frame of reference," and does not offer a completed statement, a totalizable account (5).

26. *Maus*'s representational ethic firmly rejects aesthetic mastery as inappropriate to Holocaust representation. Spiegelman says: "I wanted [the drawing in *Maus*] to be more vulnerable so that it wouldn't be the master talking down to whoever was reading" (Brown, 102 [reprinted in this volume]). This methodology would seem to figure itself against the mastery of subject implied in the project of an institution like the Holocaust Museum. Liliane Weissberg writes, for instance, that the Holocaust Museum is problematically "an object fully mastered by its creators" (19). For more on the Holocaust Museum and *Maus*, see Landsberg.

27. "Collateral Damage" is the first literary analysis I have read of any Spiegelman text besides *Maus*. Hirsch's cogent reading reinforces and clarifies my claim that the same fascinating formal procedures (the architectural structure of pages and the complex, layered panelization therein) drive both *Maus* and *In the Shadow of No Towers*.

28. See also Koch and Rothberg, *Traumatic Realism*. Hungerford reads *Maus* as a fundamentally strong moral text, claiming it seeks to "build a Jewish identity around the Holocaust" (93) and imagine a "healthy, true relation to the past" (94)—ideas that I read *Maus* as rejecting. Spiegelman comments on the question of Jewish identity in "Looney Tunes."

29. Fascinating work, however, is just now being published on historical comic books exactly because of their persuasive and didactic impulses. See Bert Hansen, "Medical History for the Masses: How American Comic Books Celebrated Heroes of Medicine in the 1940s," *Bulletin of the History of Medicine* 78.1 (2004): 148–91.

30. *Maus* also eschews the idea of an instructional morality by offering no model characters, refusing to sentimentalize or sacralize either the survivor or the artist.

31. Spiegelman came up with fifty to sixty ideas for the ending of *Maus;* we may understand that he wanted to make a significant, particular (graphic) point on this last page (*The Complete Maus*).

32. I use "breaking the frame" after Felman, and after Hirsch's "Family Pictures." *Maus*'s few photographs, such as one of Anja and Artie in *Maus I*'s "Prisoner"

and *Maus II*'s souvenir snapshot of Vladek in a concentration camp uniform, also literally, spatially break the frame by tilting out of their tiers at diagonal angles (*Maus I*, 100; *Maus II*, 134).

33. It is in a broad, affirmative sense that Spiegelman foregrounds the Magen David so powerfully on the last page of *Maus*. It would be incorrect to read the graphic prominence Spiegelman bestows the Magen David as a statement about Israel. Arguing that the world itself has become "the Diaspora Jew," Spiegelman was attached (before 9/11 compelled him to reconsider himself as a "rooted cosmopolitan") to the notion of the "rootless" and "ruthless" cosmopolitan, and also to the concept of the Diaspora Jew: "For me the romantic image of the Jew is . . . the pale, cosmopolitan, alienated, half-assimilated, International Stateless outsider Jew" ("Looney Tunes," 16). In *Maus II*, Spiegelman jokes that he would draw Israeli Jews as porcupines (42), and his attitude about Israel is ambivalent and evasive: "I am not anti-Zionist. I am Agnostic. But, maybe Israel was a bum steer, a quick-fix salve for the world's guilt that was an all-too-adequate response to the urgent and profound questions Auschwitz should have raised" ("Looney Tunes," 16).

34. See, for instance, Hutcheon, 121.

35. Friedländer's gloss, "Trauma, Transference, and 'Working-Through,'" 52.

PIERRE-ALBAN DELANNOY: *Spiegelman, in Nobody's Land*

1. Art Spiegelman, *In the Shadow of No Towers* (New York: Pantheon, 2004). Published in French with the title *À l'ombre des tours mortes* (Bruxelles et Paris: Casterman, 2004).

2. Art Spiegelman, *Maus II* (Paris: Flammarion, 1992), 41.

3. See Pierre-Alban Delannoy, "The Stylistic Instability of Art Spiegelman" (published in French with the title "L'instabilité stylistique d'Art Spiegelman"), *MEI* 26 (2007).

4. "Nervous Rex, the Malpractice Suite," in *Arcade* 6 (Summer 1976).

5. Anny Dayan-Rosenman, "Heirs of a Disaster Without Words," *Revue d'Histoire de la Shoah* 176 (2002): 147.

6. Edward Bond, *At the Inland Sea: A Play for Young People* (London: Methuen, 1996). Published in French with the title *Auprès de la mer intérieure: une pièce pour les jeunes gens* (Paris: L'Arche, 2000).

7. The below was published in another form in an article in *TSAFON, Revue d'études juives du Nord* 45 (2003), under the title "Richieu, the Survivor's Proper Name."

8. On the structure of *Maus*, see my study of the overall work in Pierre-Alban Delannoy, *Maus d'Art Spiegelman, bande dessinée et Shoah* (Paris: L'Harmattan, 2002).

9. "Rotten egg" is an expression that Judith Ertel translated as "chicken" in the French edition (2004).

10. Philippe Dubois, *The Photographic Act and Other Essays* (Paris: Nathan, 1990), 160.

11. Robert Storr, "Art Spiegelman's Making of *Maus,*" *Tampa Review* 5 (1995): 28, adapted from "Making *Maus*" (reprinted in this volume).

12. Alexis Nouss, "Speech Without Voice" (published in French as "Parole sans voix"), in *Dire l'événement, est-ce possible?* (Paris: L'Harmattan, 2001), 64.

13. "Remembering what they never knew," quoted in Dayan-Rosenman.

HANS KRUSCHWITZ: *Everything Depends on Images: Reflections on Language and Image in Spiegelman's* Maus

1. See Stephan Ditschke, "Comics als Literatur. Zur Etablierung des Comics im deutschsprachigan Feuilleton seit 2003," in *Comics. Zur Geschichte und Theorie eines populärkulturellen Mediums,* ed. Stephan Ditschke, Katerina Krouscheva, and Daniel Stein (Bielefeld: Transcript, 2009), 265–80, here 275.

2. Carter Scholz, "Comic Books: Philosophy in a Small Balloon," *Washington Post,* November 10, 1985.

3. Anja Lemke, "Bildersprache—Sprachbilder. Darstellungsformen der Erin-nerung in Art Spiegelmans *Maus,*" in *Anblick / Augenblick. Ein interdisziplinäres Symposion,* ed. Michael Neumann (Würzburg: Königshausen und Neumann, 2005).

4. On the images connected to Vladek's habitus, see the incisive discussion of "living masks" in Ole Frahm, *Genealogie des Holocaust. Art Spiegelmans Maus—A Survivor's Tale* (Munich: Fink, 2006), 51–90.

5. Sigmund Freud, *Beyond the Pleasure Principle,* trans. and ed. James Strachey. (New York: Norton, 1990), 36ff.

6. "Spiegelman's tale and the supernatural incidents in it seem to imply that Vladek and Anja were divinely chosen and encouraged to survive in order to give birth to Art Spiegelman. Only Art Spiegelman would create one of the most memorable monuments not only to his parents' travails and that of their generation, but to his, as a member of the second generation of Holocaust wit-nesses" (10). Stephen E. Tabachnick, "The Religious Meaning of Art Spiegel-man's *Maus,*" *Shofar: An Interdisciplinary Journal of Jewish Studies* 22, no. 4 (2004).

7. Sigmund Freud, *Moses and Monotheism,* trans. Katherine Jones (New York: Vin-tage, 1967). "With an unexampled power of resistance it [the Jewish people] has defied misfortune and ill-treatment [. . .] We know the reason for this attitude of theirs and what their precious treasure is. They really believe themselves to be God's chosen people; they hold themselves to be specially near to him, and this is what makes them strong and confident" (134).

8. Keith Harrison, "Telling the Untellable: Spiegelman's *Maus,*" *Rendezvous* 34, no. 1 (1999).

9. See Andreas Huyssen, "Of Mice and Mimesis: Reading Spiegelman with Adorno," *New German Critique* 81 (2000), 79 (a version of which is reprinted in this volume).

10. See Harrison, "Telling the Untellable," 63, 65; and Lemke, "Bildersprache—Sprachbilder," 233–35.

11. A classic example of this is Spiegelman's representation of the infamous Auschwitz prisoners' orchestra, whose existence Vladek cannot confirm (*Maus II*, 54).

12. See Richard De Angelis, "Of Mice and Vermin: Animals as Absent Referent in Art Spiegelman's *Maus*," *International Journal of Comic Art* 7, no. 1 (2005).

13. Michael Rothberg, "'We Were Talking Jewish': Art Spiegelman's *Maus* as 'Holocaust' Production," *Contemporary Literature* 35, no. 4 (1994): 661–87 (reprinted in this volume).

Works Cited

Abbott, Lawrence. "Comic Art: Characteristics and Potentialities of a Narrative Medium." *Journal of Popular Culture* 19, no. 4 (Spring 1986): 155–76.

Adorno, Theodor W. "After Auschwitz: Meditations on Metaphysics." *Negative Dialectics*. Trans E. B. Ashton. New York: Continuum, 1973, 361–65.

———. "Commitment." *The Essential Frankfurt School Reader*. Ed. Andrew Arato and Eike Gebhardt. New York: Continuum, 2000, 300–318.

———. "Cultural Criticism and Society." *Prisms*. Trans. Samuel Weber and Sherry Weber. Cambridge: MIT Press, 1981, 17–34.

———. *Minima Moralia: Reflections from a Damaged Life*. Trans. E. F. N. Jephcott. London: Verso, 1974.

———. *Negative Dialectics*. Trans. E. B. Ashton. New York: Continuum, 1973.

———. Review of Roger Caillois, "La Mante religieuse." *Zeitschriff für Sozialforschung* 7 (1938): 410–11.

Antelme, Robert. *L'espèce humaine*. Paris: Gallimard, 1957.

Arato, Andrew, and Eike Gebhardt, eds. *The Essential Frankfurt School Reader*. New York: Urizen Books, 1978.

Assmann, Aleida. "Re-framing Memory: Between Individual and Collective Forms of Constructing the Past." *Performing the Past: Memory, History, and Identity in Modern Europe*. Ed. Karin Tilmans, Frank van Vree, and Jay Winter. Amsterdam: Amsterdam University Press, 2010.

Assmann, Jan. *Das kulturelle Gedächtnis: Schrift, Erinnerung und politische Identität in früheren Hochkulturen*. München: Beck, 1997.

Bakhtin, Mikhail. *Rabelais and His World*. Trans. Helene Iswolsky. Cambridge: MIT Press, 1968.

Bammer, Angelika. *Displacements: Cultural Identities in Question*. Bloomington: Indiana University Press, 1994.

Barthes, Roland. *Camera Lucida: Reflections on Photography*. Trans. Richard Howard. New York: Hill & Wang, 1981.

Bhabha, Homi K. "Of Mimicry and Man: The Ambivalence of Colonial Discourse," in *The Location of Culture*. New York: Routledge, 1994.

Blanchot, Maurice. *Vicious Circles: Two Fictions and "After the Fact."* Trans. Paul Auster. Barrytown, N.Y.: Station Hill, 1985.

Bond, Edward. *At the Inland Sea: A Play for Young People*. London: Methuen, 1996. Published in French as *Aupres de la mer interieure: une piece pour les jeunes gens*. Paris: L'Arche, 2000.

Borowski, Tadeusz. *This Way for the Gas, Ladies and Gentlemen*. New York: Penguin, 1976.

Boyarin, Daniel. "The Eye in the Torah: Ocular Desire in Midrashic Hermeneutic." *Critical Inquiry* 16 (1990): 532–50.

Boyarin, Jonathan. *Storm from Paradise: The Politics of Jewish Memory*. Minneapolis: University of Minnesota Press, 1992.

Boyd, Brian. *On the Origin of Stories: Evolution, Cognition, and Fiction*. Cambridge: Harvard University Press, 2009.

Breines, Paul. *Tough Jews: Political Fantasies and the Moral Dilemma of American Jewry*. New York: Basic Books, 1990.

B'Tselem. "The Wrong Arm of the Law: Torture Disclosed and Deflected in Israeli Politics." *Tikkun* (September/October 1991): 13–14ff.

Buhle, Paul. "Of Mice and Menschen: Jewish Comics Come of Age." *Tikkun* (March/April 1992): 9–16.

Bukiet, Melvin Jules. "When the Holocaust Isn't News." *The New York Times*, May 3, 1995, 23A.

Caruth, Cathy. *Unclaimed Experience: Trauma, Narrative, and History*. Baltimore: Johns Hopkins University Press, 1996.

Chambers, Ross. *Untimely Interventions: AIDS Writing, Testimonial, and the Rhetoric of Haunting*. Ann Arbor: University of Michigan Press, 2004.

Cheever, Susan. *Home Before Dark*. Boston: Houghton Mifflin, 1984.

Chute, Hillary. *Why Comics?: From Underground to Everywhere*. New York: Harper, 2017.

Clark, Alan, and Laurel Clark. *Comics: An Illustrated History*. London: Greenwood, 1991.

Clark, Katerina, and Michael Holquist. *Mikhail Bakhtin*. Cambridge: Harvard University Press, 1984.

Connerton, Paul. *How Societies Remember*. Cambridge: Cambridge University Press, 1989.

Crouch, Stanley, interviewer. "Art Spiegelman." *The Charlie Rose Show*. July 30, 1996.

D'Arcy, David, narr. "Profile: Art Spiegelman's Comic Book Journalism." Transcript. *NPR Weekend Edition*, June 7, 2003, 1–3.

Dayan-Rosenman, Anny. "Heirs of a Disaster Without Words." *Revue d'Histoire de la Shoah* 176 (2002).

De Angelis, Richard. "Of Mice and Vermin: Animals as Absent Referent in Art Spiegelman's *Maus*." *International Journal of Comic Art* 7, no. 1 (2005): 230–49.

Derrida, Jacques. *The Truth in Painting*. Trans. Geoff Bennington and Ian McLeod. Chicago: University of Chicago Press, 1987.

Ditschke, Stephan. "Comics als Literatur. Zur Etablierung des Comics im deutschsprachigan Feuilleton seit 2003." In *Comics. Zur Geschichte und Theorie eines populärkulturellen Mediums*. Ed. Stephan Ditschke, Katerina Krouscheva, and Daniel Stein. Bielefeld: Transcript, 2009, 265–80.

Dreifus, Claudia. "A Comic-Book Response to 9/11 and Its Aftermath." *New York Times,* August 7, 2004, B9.

Dubois, Philippe. *The Photographic Act and Other Essays.* Paris: Nathan, 1990.

Duras, Marguerite. *Practicalities: Marguerite Duras Speaks to Michel Beaujour.* Trans. Barbara Bray. New York: Grove Weidenfeld, 1990.

Dwork, Debórah. *Children with a Star: Jewish Youth in Nazi Europe.* New Haven: Yale University Press, 1991.

Edelstein, Alan. "Will Eisner's Spirit." *Forward,* January 1, 1993, 1, 9.

Editors' Note. *The New Yorker,* February 15, 1993, 6.

Eisner, Will. *Comics and Sequential Art.* Tamarac, Fla.: Poorhouse Press, 1985.

Ellis, Marc H. *Beyond Innocence and Redemption: Confronting the Holocaust and Israeli Power.* San Francisco: Harper, 1990.

Epstein, Helen. *Children of the Holocaust: Conversations with Sons and Daughters of Survivors.* New York: Penguin, 1979.

Epstein, Leslie. *King of the Jews.* New York: Coward, McCann & Geoghegan, 1979.

Ezrahi, Sidra DeKoven. *By Words Alone: The Holocaust in Literature.* Chicago: University of Chicago Press, 1980, 12.

Felman, Shoshana, and Dori Laub. *Testimony: Crises of Witnessing in Literature, Psychoanalysis and History.* New York: Routledge, 1992.

"Forward Lauds Pulitzer for 'Maus.'" *Forward,* April 10, 1992.

Foucault, Michel. *Power/Knowledge: Selected Interviews and Other Writings, 1972–1977.* Ed. Colin Gordon. New York: Pantheon, 1980.

Fresco, Nadine. "Remembering the Unknown." *International Review of Psychoanalysis* 11 (1984): 417–27.

Freud, Sigmund. *Beyond the Pleasure Principle.* Trans. and ed. James Strachey. New York: Norton, 1990, 36ff.

———. *Moses and Monotheism.* Trans. Katherine Jones. New York: Vintage, 1967.

Friedländer, Saul. *Memory, History, and the Extermination of the Jews of Europe.* Bloomington: Indiana University Press, 1993.

———. *Reflections of Nazism: An Essay on Kitsch and Death.* New York: Harper & Row, 1984.

———. "Trauma, Transference, and 'Working-Through' in Writing the History of the Shoah." *History and Memory: Studies in Representations of the Past* 4, no. 1 (Spring/Summer 1992): 39–59.

Friedman, Susan Stanford. "Locational Feminism: Gender, Cultural Geographies, and Geopolitical Literacy." *Feminist Locations: Global and Local, Theory and Practice.* Ed. Marianne DeKoven. New Brunswick: Rutgers University Press, 2001, 13–36.

———. "Women's Autobiographical Selves: Theory and Practice." *The Private Self.* Ed. Shari Benstock. Chapel Hill: University of North Carolina Press, 1988: 34–62.

Frost, Laura. "The Twin Towers of Auschwitz and Hiroshima: Art Spiegelman, 9/11, and the Limits of Analogy." Address. Modern Language Association Annual Convention. Marriott Hotel, Washington, D.C., December 28, 2005.

Gaiman, Neil, and Dave McKean. *Black Orchid.* New York: DC Comics, 1991.

Geis, Deborah R. Introduction. *Considering Maus: Approaches to Art Spiegelman's*

"Survivor's Tale" of the Holocaust. Ed. Deborah R. Geis. Tuscaloosa: University of Alabama Press, 2003, 1–11.

Gerber, David A. "Of Mice and Jews: Cartoons, Metaphors, and Children of Holocaust Survivors in Recent Jewish Experience: A Review Essay." *American Jewish History* 77, no. 1 (September 1987): 159–75.

Gilman, Sander. *Jewish Self-Hatred: Anti-Semitism and the Hidden Language of the Jews.* Baltimore: Johns Hopkins University Press, 1986.

———. *The Jew's Body.* New York: Routledge, 1991.

Goffman, Erving. *Frame Analysis: An Essay on the Organization of Experience.* Boston: Northeastern University Press, 1986.

Groth, Gary. "Art Spiegelman and Françoise Mouly." *The New Comics.* Ed. Gary Groth and Robert Fiore. New York: Berkley, 1988.

Gussow, Mel. "Dark Night, Sharp Fears: Art Spiegelman Addresses Children and His Own Fears." *The New York Times,* October 15, 2003, E1ff.

Haidu, Peter. "The Dialectics of Unspeakability: Language, Silence, and the Narratives of Desubjectification." *Probing the Limits of Representation: Nazism and the "Final Solution."* Ed. Saul Friedländer. Cambridge: Harvard University Press, 1992.

Halkin, Hillel, "Inhuman Comedy." *Commentary* (February 1992): 55–56.

Hansen, Bert. "Medical History for the Masses: How American Comic Books Celebrated Heroes of Medicine in the 1940s." *Bulletin of the History of Medicine* 78, no. 1 (2004): 148–91.

Hansen, Miriam. "Mass Culture as Hieroglyphic Writing: Adorno, Derrida, Kracauer." *New German Critique* 56 (Spring/Summer 1992): 43–75.

———. "*Schindler's List* Is Not *Shoah*: The Second Commandment, Popular Modernism, and Public Memory" (on Spielberg, Lanzmann, and Spiegelman). *Critical Inquiry* 22 (Winter 1996): 292–312.

Harrison, Keith. "Telling the Untellable: Spiegelman's *Maus.*" *Rendezvous* 34, no. 1 (1999): 59–73.

Hartman, Geoffrey H. *The Longest Shadow: In the Aftermath of the Holocaust.* Bloomington: Indiana University Press, 1996.

Hilberg, Raul. "I Was Not There." *Writing and the Holocaust.* Ed. Berel Lang. New York: Holmes & Meier, 1988.

Hinz, Berthold. *Art in the Third Reich.* New York: Pantheon, 1979.

Hirsch, Marianne. "Collateral Damage." Editor's column. *PMLA* 119, no. 5 (October 2004): 1209–15.

———. *Family Frames: Photography, Narrative, and Postmemory.* Cambridge: Harvard University Press, 1997.

———. "Family Pictures: *Maus,* Mourning, and Post-Memory." *Discourse* 15, no. 2 (1992–93): 3–29.

———. *The Generation of Postmemory: Writing and Visual Culture After the Holocaust.* New York: Columbia University Press, 2012.

———. "Projected Memory: Holocaust Photographs in Personal and Public Fantasy." *Acts of Memory: Cultural Recall in the Present.* Ed. Mieke Bal, Jonathan Crewe, and Leo Spitzer. Hanover, N.H.: University Press of New England, 1999, 3–23.

———. "Surviving Images: Holocaust Photographs and the Work of Postmemory." *Yale Journal of Criticism* 14, no. 1 (2001): 5–37.

———. "Works in Progress: Sketches, Prolegomena, Afterthoughts." *WSQ* 48, nos. 1 and 2 (Spring/Summer 2020).

Hoberman, J., ed. and introduction. "*Schindler's List*: Myth, Movie, and Memory." *Village Voice*, March 29, 1994, 24–31.

Hoffman, Eva. *After Such Knowledge: Memory, History, and the Legacy of the Holocaust*. New York: Public Affairs, 2004.

Horkheimer, Max, and Theodor Adorno. *Dialectic of Enlightenment*. Trans. John Cumming. New York: Continuum, 1982.

Horowitz, Sara R. *Voicing the Void: Muteness and Memory in Holocaust Fiction*. Albany: SUNY Press, 1997.

Hungerford, Amy. *The Holocaust of Texts: Genocide, Literature, and Personification*. Chicago: University of Chicago Press, 2003.

Hutcheon, Linda. *A Poetics of Postmodernism: History, Theory, Fiction*. New York: Routledge, 1988.

Jameson, Fredric. *The Political Unconscious: Narrative as a Socially Symbolic Act*. Ithaca: Cornell University Press, 1981.

———. *Postmodernism or the Cultural Logic of Late Capitalism*. Durham: Duke University Press, 1991.

Kaplan, Alice Yaeger. *Releve des sources et citations dans "Bagatelles pour un massacre."* Tusson: Editions du Lerot, 1987.

———. "Theweleit and Spiegelman: Of Men and Mice." *Remaking History*. Ed. Barbara Kruger and Phil Mariani. Seattle, 1989.

Knox, Israel. Introduction, *Anthology of Holocaust Literature*. Ed. Jacob Glatstein, Israel Knox, and Samuel Margoshes. New York, 1973.

Koch, Gertrud. "'Against All Odds' or the Will to Survive: Moral Conclusions from Narrative Closure." *History and Memory* 9, no. 1 (Spring/Summer 1997): 393–408.

Kristeva, Julia. "The Pain of Sorrow in the Modern World: The Works of Marguerite Duras." *PMLA* 102 (March 1987).

Kruger, Barbara, and Phil Mariani. *Remaking History: Discussions in Contemporary Culture* 4. Seattle: Bay, 1989, 151–72.

Kuhlman, Martha. "Marianne Hirsch on *Maus* in the Academy." *Indy Magazine*, Spring 2005.

Kunow, Rüdiger. "'Emotion in Tranquility'? Representing the Holocaust in Fiction." *Emotion in Postmodernism*. Ed. Gerhard Hoffmann and Alfred Hornung. Heidelberg: Universitatsverlag C. Winter, 1997, 247–70.

LaCapra, Dominick. "'Twas the Night Before Christmas: Art Spiegelman's *Maus*." *History and Memory After Auschwitz*. Ithaca: Cornell University Press, 1998, 139–79.

Landsberg, Alison. "America, the Holocaust, and the Mass Culture of Memory: Toward a Radical Politics of Empathy." *New German Critique* (Spring/Summer 1997): 63–86.

Lang, Berel. *Act and Idea in the Nazi Genocide*. Chicago: University of Chicago Press, 1990.

Langer, Lawrence L. "A Fable of the Holocaust." *New York Times Book Review*, November 3, 1991.

———. *Holocaust Testimonies: The Ruins of Memory*. New Haven: Yale University Press, 1991.

Lanzmann, Claude. *Shoah: An Oral History of the Holocaust*. New York: Pantheon, 1985.

Lehmann-Haupt, Christopher. "Review of *Maus: A Survivor's Tale*, by Art Spiegelman." *The New York Times*, November 10, 1986.

Lemke, Anja. "Bildersprache—Sprachbilder. Darstellungsformen der Erinnerung in Art Spiegelmans *Maus*." In *Anblick / Augenblick. Ein interdisziplinäres Symposion*. Ed. Michael Neumann. Würzburg: Königshausen und Neumann, 2005, 227–46.

Levi, Primo. *Survival in Auschwitz*. Trans. Stuart Woolf. New York: Collier, 1961.

Levine, Michael G. "Necessary Stains: Spiegelman's *Maus* and the Bleeding of History." *Considering Maus: Approaches to Art Spiegelman's "Survivor's Tale" of the Holocaust*. Ed. Deborah Geis. Tuscaloosa: University of Alabama Press, 2003, 63–104.

Lipstadt, Deborah. *Denying the Holocaust: The Growing Assault on Truth and Memory*. New York: Plume, 1994.

Liss, Andrea. "Between Trauma and Nostalgia: Christian Boltanski's Memorials and Art Spiegelman's *Maus*." In *Trespassing Through Shadows: Memory, Photography, and the Holocaust*. Minneapolis: University of Minnesota Press, 1998, 39–68.

———. "Trespassing Through Shadows: History, Mourning, and Photography in Representations of Holocaust Memory." *Framework* 4, no. 1 (1991).

Lopate, Philip. "Resistance to the Holocaust." *Tikkun* (May/June 1989): 55–65.

Lyotard, Jean-François. *The Differend: Phrases in Dispute*. Trans. Georges Van Den Abbeele. Minneapolis: University of Minnesota Press, 1988.

Makdisi, Jean Said. *Beirut Fragments: A War Memoir*. New York: Persea, 1990.

Malina, Debra. *Breaking the Frame: Metalepsis and the Construction of the Subject*. Columbus: Ohio State University Press, 2002.

Mason, Mary. "The Other Voice: Autobiographies of Women Writers." *Life/Lines: Theorizing Women's Autobiography*. Ed. Bella Brodzki and Celeste Schenck, Ithaca: Cornell University Press, 1988.

McClintock, Anne. *Imperial Leather: Race, Gender, and Sexuality in the Colonial Contest*. New York: Routledge, 1995.

McCloud, Scott. "Understanding Comics." In *Comic Book Rebels: Conversations with the Creators of New Comics*. New York: Donald I. Fine, 1993, 3–15.

McGlothlin, Erin. "No Time Like the Present: Narrative and Time in Art Spiegelman's *Maus*." *Narrative* 11, no. 2 (2003): 177–98.

Miller, Nancy K. "The Art of Survival: Mom, Murder, Memory." In *Bequest and Betrayal: Memoirs of a Parent's Death*. New York: Oxford University Press, 1996, 97–125.

Mitchell, W. J. T. "The Commitment to Form; or, Still Crazy After All These Years." *PMLA* 18, no. 2 (March 2003): 321–25.

———. *Picture Theory: Essays on Verbal and Visual Representation*. Chicago: University of Chicago Press, 1994.

———. "Space, Ideology, and Literary Representation." *Poetics Today* 10, no. 1 (Spring 1989): 91–102.

Moore, Alan, and Dave Gibbons. *Watchmen.* New York: DC Comics, 1986.

Mordden, Ethan. "Kat and Maus." *The New Yorker,* April 6, 1992, 90–96.

Mulvey, Laura. "Visual Pleasure and Narrative Cinema." In *Visual and Other Pleasures.* Bloomington: Indiana University Press, 1989, 14–26.

Nehring, Neil. *Popular Music, Gender, and Postmodernism: Anger Is an Energy.* Thousand Oaks: Sage, 1997.

Nietzsche, Friedrich. *On the Genealogy of Morals.* Ed. Walter Kaufmann. New York: Vintage, 1969.

Nora, Pierre. "Between Memory and History: *Les Lieux de Memoire.*" *Representations* 26 (1989): 7–25.

Nouss, Alexis. "Speech Without Voice," published in French as "Parole sans voix" in *Dire l'événement, est-ce possible?* Paris: L'Harmattan, 2001.

Oksman, Tahneer. "Postmemory and the 'Fragments of a History We Cannot Take In.'" *WSQ* 48, nos. 1 and 2 (Spring/Summer, 2020).

Orvell, Miles. "Writing Posthistorically: Krazy Kat, *Maus,* and the Contemporary Fiction Cartoon." *American Literary History* 4, no. 1 (Spring 1992): 110–28. Reprinted and expanded in *After the Machine: Visual Arts and the Erasing of Cultural Boundaries.* Jackson: University Press of Mississippi, 1995, 129–46.

O'Sullivan, Judith. *The Great American Comic Strip: One Hundred Years of Cartoon Art.* Boston: Little, Brown, 1990.

Pekar, Harvey. *From Off the Streets of Cleveland Comes—American Splendor: The Life and Times of Harvey Pekar.* New York: Doubleday, 1986.

Pochoda, Elizabeth. "Reading Around." *The Nation,* April 27, 1992.

Pratt, George. *Enemy Ace: War Idyll.* New York: DC Comics, 1990.

Rabinbach, Anson. *In the Shadow of Catastrophe: German Intellectuals Between Apocalypse and Enlightenment.* Berkeley: University of California Press, 1997.

Raczymow, Henri. "Memory Shot Through with Holes." *Yale French Studies* 85 (1994): 98–106.

Reid, Calvin. "A 'Maus' That Roared." *Publishers Weekly,* January 31, 1994, 26–27.

Reidelbach, Maria, *Completely Mad: A History of the Comic Book and Magazine.* Boston: Little, Brown, 1991.

Riggenberg, Stephen. "Spiegelman: The Man Behind *Maus.*" *Forward,* January 17, 1992, 86–94.

Ringelblum, Emmanuel. *Notes from the Warsaw Ghetto.* Ed. and trans. Jacob Sloan. New York: Schocken, 1974.

Rosen, Jonathan. "Spiegelman, the Man Behind *Maus.*" *Forward,* January 17, 1992, 1, 9, 11.

Roth, Philip. *The Anatomy Lesson.* In *Zuckerman Bound: A Trilogy and Epilogue.* New York: Fawcett, 1986, 246–420.

———. *Patrimony: A True Story.* New York: Simon & Schuster, 1991.

Rothberg, Michael. "Sites of Memory, Sites of Forgetting: Jewishness and Cultural Studies." *Found Object* 2 (1993): 111–18.

———. *Traumatic Realism: The Demands of Holocaust Representation.* Minneapolis: University of Minnesota Press, 2000.

Said, Edward W. *The Question of Palestine.* New York: Vintage, 1992.

————. *The World, the Text, and the Critic.* Cambridge: Harvard University Press, 1983.

Samuels, Maurice Anthony. "Representing the Holocaust: Art Spiegelman's *Maus* and the Postmodern Challenge." Unpublished essay, 1990.

Schmitt, Ronald. "Deconstructive Comics." *Journal of Popular Culture* 25, no. 4 (1992).

Schwab, Gabriele. *Haunting Legacies: Violent Histories and Transgenerational Trauma.* New York: Columbia University Press, 2010.

Shohat, Ella. *Israeli Cinema: East/West and the Politics of Representation.* Austin: University of Texas Press, 1989.

Silverblatt, Michael. "The Cultural Relief of Art Spiegelman." *Tampa Review* 5 (1995): 31–36.

Silverman, Kaja. *The Threshold of the Visible World.* New York: Routledge, 1995.

Smith, Anna Deavere. *Fires in the Mirror: Crown Heights, Brooklyn, and Other Identities.* New York: Anchor, 1993.

Sontag, Susan. "Fascinating Fascism." In *Movies and Methods: An Anthology.* Ed. Bill Nichols. Berkeley: University of California Press, 1976.

————. *On Photography.* New York: Anchor Doubleday, 1989.

Spiegelman, Art. Address on *In the Shadow of No Towers.* Barnes & Noble, Union Square, New York, September 23, 2004.

————. *Be a Nose! Three Sketchbooks.* San Francisco: McSweeney's, 2009.

————. *Breakdowns: From Maus to Now. An Anthology of Strips by Art Spiegelman.* New York: Belier, 1977, unpaginated.

————. *The Complete Maus.* CD-ROM. New York: Voyager, 1994.

————. "A Conversation with Art Spiegelman." With John Hockenberry. *Talk of the Nation.* National Public Radio, February 20, 1992.

————. Cover painting (untitled). *The New Yorker,* February 15, 1993.

————. "Day at the Circuits." In *Breakdowns: From Maus to Now: An Anthology of Strips by Art Spiegelman.* New York: Belier, 1977, unpaginated.

————. "Drawing Pens and Politics: Mightier Than the Sorehead." *The Nation,* January 17, 1994.

————. "Ephemera Versus the Apocalypse." *Indy Magazine,* Autumn 2005.

————. Interview with Andrea Juno. *Dangerous Drawings: Interviews with Comix and Graphix Artists.* Ed. Andrea Juno. New York: Juno, 1997, 6–27.

————. Interview with Gary Groth. *Comics Journal* 180 (September 1995): 52–106.

————. Interview with Joey Cavalieri, Gary Groth, and Kim Thompson. *The New Comics:*

————. *Interviews from the Pages of the* Comics Journal. Ed. Gary Groth and Robert Fiore. New York: Berkley, 1988, 185–203.

————. *In The Shadow of No Towers.* New York: Pantheon, 2004.

————. "Jewish Mice, Bubblegum Cards, Comics Art, and Raw Possibilities." Interview with Joey Cavalieri. *Comics Journal* 65 (August 1981): 98–125.

————. "Krigstein: A Eulogy by Art Spiegelman." *Comics Journal* (February 1990): 13. Reprinted in *From Maus to Now to Maus to Now: Comix, Essays, Graphics, and Scraps.* Palermo: La Centrale dell'Arte, 1998, 90.

————. "Looney Tunes, Zionism, and the Jewish Question." *Village Voice,* June 6,

1989, 20–21. In *From Maus to Now to* Maus *to Now: Comix, Essays, Graphics, and Scraps.* Palermo: La Centrale dell'Arte, 1998, 14–16.

———. "Maus" (1972). Reprinted in *The Virginia Quarterly Review* 82, no. 4 (Fall 2006): 41.

———. *Maus. Die Geschichte eines Überlebenden.* Reinbeck: Rohwolt, 1989.

———. *Maus I: A Survivor's Tale: My Father Bleeds History.* New York: Pantheon, 1986.

———. *Maus II: A Survivor's Tale: And Here My Troubles Began.* New York: Pantheon, 1991.

———. "*Maus* & Man." *Voice Literary Supplement,* June 6, 1989.

———. *MetaMaus: A Look Inside a Modern Classic,* Maus. Assoc. Ed. Hillary Chute. New York: Pantheon, 2011.

———. "A Problem of Taxonomy." *New York Times Book Review.* December 29, 1991.

———. "Saying Goodbye to *Maus.*" *Tikkun* (September/October 1992): 44–45.

———. "The Working Transcripts." In *The Complete Maus,* CD-ROM. New York, 1994.

Spiegelman, Art, and Bob Schneider, eds. *Whole Grains: A Book of Quotations.* New York: D. Links, 1973.

Spiegelman, Art, and Françoise Mouly, eds. *Read Yourself Raw.* New York: Pantheon, 1982.

Spinrad, Norman. *Science Fiction in the Real World.* Urbana-Champaign: University of Illinois Press, 1990.

Storr, Robert. "Art Spiegelman's Making of *Maus.*" *Tampa Review* 5 (1995): 27–29.

———. "Making *Maus.*" New York: Museum of Modern Art, 1992.

Tabachnick, Stephen E. "The Religious Meaning of Art Spiegelman's *Maus.*" *Shofar. An Interdisciplinary Journal of Jewish Studies* 22, no. 4 (2004): 1–13.

Die Tageszeitung, January 2, 1988.

Tec, Nechama. *Dry Tears: The Story of a Lost Childhood.* New York: Oxford University Press, 1984.

Thakkar, Sonali. "Reparative Remembering." *WSQ* 48, nos. 1 and 2 (Spring/Summer, 2020), 138.

Theweleit, Klaus. *Buch der Könige, 1: Orpheus und Euridike.* Frankfurt: Roter Stern, 1989.

Van Alphen, Ernst. *Art in Mind: How Contemporary Images Shape Thought.* Chicago: University of Chicago Press, 2005.

Vidal-Naquet, Pierre. *Assassins of Memory: Essays on Denial of the Holocaust.* New York: Columbia University Press, 1993.

von Braun, Christina. *Die schamlose Schönheit des Vergangenen: Zum Verhältnis von Geschlecht und Geschichte.* Frankfurt: Neue Kritik, 1989.

Weissberg, Liliane. "In Plain Sight." *Visual Culture and the Holocaust.* Ed. Barbie Zelizer. New Brunswick: Rutgers University Press, 2001, 13–27.

Weissman, Gary. *Fantasies of Witnessing: Postwar Efforts to Experience the Holocaust.* Ithaca: Cornell University Press, 2004.

Weschler, Lawrence. "Art's Father, Vladek's Son." In *Shapinsky's Karma, Boggs's Bills.* San Francisco: North Point, 1988, 53–68.

———. "Pig Perplex." *Lingua Franca* 11, no. 5 (July/August 2001).

White, Hayden. "Historical Emplotment and the Problem of Truth." *Probing the Limits of Representation: Nazism and the "Final Solution."* Ed. Saul Friedländer. Cambridge: Harvard University Press, 1992, 37–53.

Witek, Joseph. *Comic Books as History: The Narrative Art of Jack Jackson, Art Spiegelman, and Harvey Pekar.* Jackson: University Press of Mississippi, 1989.

Young, James E. "Art Spiegelman's *Maus* and the After-Images of History." In *At Memory's Edge: After-Images of the Holocaust in Contemporary Art and Architecture.* New Haven: Yale University Press, 2000, 12–41.

———. *The Texture of Memory.* New Haven: Yale University Press, 1993.

———. *Writing and Rewriting the Holocaust: Narrative and the Consequences of Interpretation.* Bloomington: Indiana University Press, 1988.

Selected Further Writing on *Maus*

Baker, Steve. "Of *Maus* and More: Narrative, Pleasure, and Talking Animals." *Picturing the Beast: Animals, Identity and Representation.* Manchester: Manchester University Press, 1993.

Blume, Harvey. "Art Spiegelman: Lips. Interview by Harvey Blume." *Boston Book Review*, 1995.

Bosmajian, Hamida. "The Orphaned Voice in Art Spiegelman's *Maus I & II.*" *Literature and Psychology* 44 (1998): 1–22.

Buhle, Paul. "Of Mice and Menschen: Jewish Comics Come of Age." *Tikkun* 7.2 (1992): 9–16.

Cavna, Michael. "Why 'Maus' Remains 'the Greatest Graphic Novel Ever Written,' 30 Years Later." *Washington Post*, August 11, 2016.

Chute, Hillary. "Meta*MetaMaus.*" *e-misférica* special issue, On the Subject of Archives, Summer 2012 (online). http://hemispheric institute.org/hemi/en/e-misferica-91/chute.

Delannoy, Pierre-Alban. *Maus d'Art Spiegelman: Bande Dessinée et Shoah.* Paris: L'Harmattan, 2002.

Elmwood, Victoria. "'Happy, Happy Ever After': The Transformation of Trauma Between the Generations in Art Spiegelman's *Maus: A Survivor's Tale.*" *Biography* 27, no. 4 (2004): 691–720.

Ewert, Jeanne. "Reading Visual Narrative: Art Spiegelman's *Maus.*" *Narrative* 8 (2000): 87–103.

Frahm, Ole. *Genealogie des Holocaust: Art Spiegelmans* Maus: A Survivor's Tale. Munich: Wilhelm Fink Verlag, 2006.

Friedman, Elisabeth R. "Spiegelman's Magic Box: *MetaMaus* and the Archive of Representation." *Studies in Comics* 3, no. 2 (2012): 275–91.

Geis, Deborah R., ed. and introduction. *Considering Maus: Approaches to Art Spiegelman's "Survivor's Tale" of the Holocaust*. Tuscaloosa: University of Alabama Press, 2003.

Glaser, Jennifer. "Art Spiegelman and the Caricature Archive." In *Redrawing the Historical Past: History, Memory, and Multiethnic Graphic Novels*. Ed. Martha J. Cutter and Cathy Schlund-Vials. Athens: University of Georgia Press, 2018, 294–319.

Halkin, Hillel. "Inhuman Comedy" (review of *Maus II: A Survivor's Tale*). *Commentary* (February 1992).

Hansen, Miriam Bratu. "*Schindler's List* Is Not *Shoah*: The Second Commandment, Popular Modernism, and Public Memory" (on Spielberg, Lanzmann, and Spiegelman). *Critical Inquiry* 22 (Winter 1996): 292–312.

Harrison, Keith. "Telling the Untellable: Spiegelman's *Maus*." *Rendezvous* 34, no. 1 (1999): 59–73.

Hathaway, Rosemary V. "Reading Art Spiegelman's *Maus* as Postmodern Ethnography." *Journal of Folklore Research* 48, no. 3 (2011): 249–67.

Hungerford, Amy. "Surviving Rego Park." *The Holocaust of Texts: Genocide, Literature, and Personification*. Chicago: University of Chicago Press, 2003, 73–96.

Hutcheon, Linda. "Literature Meets History: Counter Discursive 'Comix.'" *Anglia* 117 (1999): 5–14.

Iadonisi, Rick. "Bleeding History and Owning His [Father's] Story: *Maus* and Collaborative Autobiography." *CEA Critic Official Journal of the College English Association* 57, no. 1 (Fall 1994): 41–55.

Kakutani, Michiko. "Rethinking the Holocaust with a Comic Book." *New York Times*, October 29, 1991.

Kaplan, Alice Yaeger. "Theweleit and Spiegelman: Of Men and Mice." *Remaking History*. Ed. Barbara Kruger and Phil Mariani. New York: The New Press and Dia Art Foundation, 1989, 150–72.

Koch, Gertrud. "'Against All Odds' or the Will to Survive: Moral Conclusions from Narrative Closure" (on *Maus* and *Schindler's List*). *History & Memory* 9, no. 1 (Spring/Summer 1997): 393–408.

Kuhlman, Martha. "Marianne Hirsch on *Maus* in the Academy." *Indy Magazine*, Spring 2005.

LaCapra, Dominick. "'Twas the Night Before Christmas: Art Spiegel-

man's *Maus.*" In *History and Memory After Auschwitz.* Ithaca: Cornell University Press, 1998.

Langer, Lawrence L. "A Fable of the Holocaust." *New York Times Book Review*, Nov. 3, 1991.

Lehmann-Haupt, Christopher. "Review of *Maus: A Survivor's Tale*, by Art Spiegelman." *New York Times*, Nov. 10, 1986.

Leith, Sam. "Graphic Artist Art Spiegelman on *Maus*, Politics, and 'Drawing Badly.'" *The Guardian*, October 17, 2020.

Levine, Michael G. "Necessary Stains: The Bleeding of History in Spiegelman's *Maus I*" and "The Vanishing Point: Spiegelman's *Maus II.*" In *The Belated Witness: Literature, Testimony, and the Question of Holocaust Survival.* Palo Alto: Stanford University Press, 2006.

Liss, Andrea. "Between Trauma and Nostalgia: Christian Boltanski's Memorials and Art Spiegelman's *Maus.*" *Trespassing Through Shadows: Memory, Photography, and the Holocaust.* Minneapolis: University of Minnesota Press, 1998, 39–68.

Mandaville, Alison. "Tailing Violence: Comics Narrative, Gender, and the Father-Tale in Art Spiegelman's *Maus.*" *Pacific Coast Philology* 44, no. 2 (2009): 216–48.

McGlothlin, Erin. "No Time Like the Present: Narrative and Time in Art Spiegelman's *Maus.*" *Narrative* 11, no. 2 (2003): 177–98.

Mikics, David. "Underground Comics and Survival Tales: *Maus* in Context." In *Considering* Maus: *Approaches to Art Spiegelman's "Survivor's Tale" of the Holocaust.* Tuscaloosa: University of Alabama Press, 2003, 15–25.

Orvell, Miles. "Writing Posthistorically: *Krazy Kat, Maus*, and the Contemporary Fiction Cartoon." In *After the Machine: Visual Arts and Erasing of Cultural Boundaries.* Jackson: University Press of Mississippi, 1995.

Schuldiner, Michael. "Writer's Block and the Metaleptic Event in Art Spiegelman's Graphic Novel, *Maus.*" *Studies in American Jewish Literature* 21 (2002): 108–15.

Silverblatt, Michael. "The Cultural Relief of Art Spiegelman: A Conversation with Michael Silverblatt." *Tampa Review* 5 (Fall 1992): 31–36.

Smith, Graham. "From Mickey to *Maus*: Recalling the Genocide

Through Cartoon" (Interview with Art Spiegelman.) *Art Spiegelman: Conversations.* Ed. Joseph Witek. Jackson: University Press of Mississippi, 2007, 84–94.

Smith, Philip. *Reading Art Spiegelman.* London: Routledge, 2018.

Spiegelman, Art. *MetaMaus: A Look Inside a Modern Classic, Maus.* Assoc. Ed. Hillary Chute. New York: Pantheon, 2011.

Staub, Michael. "The Shoah Goes On and On: Remembrance and Representation in Art Spiegelman's *Maus.*" *MELUS* 20, no. 3 (1995): 33–46.

Tabachnick, Stephen. "The Religious Meaning of Art Spiegelman's *Maus.*" *Shofar* 22, no. 4 (2004): 1–13.

Urdiales-Shaw, Martín. "Between Transmission and Translation: The Rearticulation of Vladek Spiegelman's Languages in *Maus.*" *Translation and Literature* 24, no. 1 (Spring 2015).

Van Biema, David. "Art Spiegelman Battles the Holocaust's Demons— and His Own—in an Epic Cat and Mouse Comic Book." *People,* October 27, 1986.

Weschler, Lawrence. "Art's Father, Vladek's Son." In *A Wanderer in the Perfect City: Selected Passion Pieces.* Chicago: University of Chicago Press, 2006.

———. "Pig Perplex." *Lingua Franca* 11, no. 5 (July/August 2001).

White, Hayden. "Historical Emplotment and the Problem of Truth." *Probing the Limits of Representation: Nazism and the "Final Solution."* Ed Saul Friedländer. Cambridge: Harvard University Press, 1992.

Wickerson, Erica. "Beyond Vision: Myth, Catharsis, and Narration of Absence in Art Spiegelman's *Maus* and W. G. Sebald's *Austerlitz.*" *Comparative Critical Studies* 17, no. 1 (2020).

Wilner, Arlene Fish. " 'Happy, Happy Ever After': Story and History in Art Spiegelman's *Maus.*" *Journal of Narrative Technique* 27, no. 2 (1997): 171–89.

Witek, Joseph. "History and Talking Animals: Art Spiegelman's *Maus.*" In *Comic Books as History: The Narrative Art of Jack Jackson, Art Spiegelman, and Harvey Pekar.* Jackson: University Press of Mississippi, 1989.

Young, James. "Art Spiegelman's *Maus* and the After-Images of History." In *At Memory's Edge: After-Images of the Holocaust in Contemporary Art and Architecture.* New Haven: Yale University Press, 2000.

Contributors

DORIT ABUSCH was born and grew up in Tel Aviv. She has published five books of fiction in Hebrew, and is currently working on a new one. She is Professor of Linguistics at Cornell, concentrating on the semantics of natural language. Her recent research focuses on the semantics and pragmatics of visual narratives such as comics. Her passions include travel, art history, ethnic jewelry and textiles, and reading comics.

JOSHUA BROWN is Professor of History Emeritus and former Director of the CUNY Graduate Center's American Social History Project. Author of *Beyond the Lines: Pictorial Reporting, Everyday Life, and the Crisis of Gilded Age America*, he has written widely about visual culture history. He is visual editor of the noted print and online textbook *Who Built America?* and has served as adviser and produced documentaries, exhibitions, and award-winning digital projects. Brown's cartoons appear online and in print—including the novella *Ithaca* on the *Commonplace* website. A Guggenheim fellow and NEH and American Council of Learned Societies grantee, Brown is writing a history of the Civil War's visual culture.

PIERRE-ALBAN DELANNOY holds an *agrégation* in French Modern Letters. Former lecturer at the University Charles de Gaulle Lille 3, he is the author of articles on images in children's books and comic books, and a comic book writer. He is also the author of *The Rule of Saint Benedict: A Path of Life for the Laity,* published by Albin Michel

in 2015. His book *Maus d'Art Spiegelman: Bande Dessinée et Shoah* was published by L'Harmattan in 2002.

TERRENCE DES PRES (1939–1987) was a renowned Holocaust scholar and Professor of English at Colgate University, where he held the Crawshaw Chair in English Literature. Prior to his arrival at Colgate, he was a Junior Fellow at the Harvard Society of Fellows. He is the author of *The Survivor: An Anatomy of Life in the Death Camps*, published by Oxford University Press in 1976, and two books published posthumously, *Praises and Dispraises* (1988), and *Writing Into the World: Essays 1973–1987* (1991).

THOMAS DOHERTY is a cultural historian with a special interest in Hollywood cinema and a Professor of American Studies at Brandeis University. He is also the film review editor for the *Journal of American History*. His books include *Show Trial: Hollywood, HUAC, and the Birth of the Blacklist* (2018) and *Little Lindy Is Kidnapped: How the Media Covered the Crime of the Century* (2020).

RUTH FRANKLIN is a book critic, a biographer, and a former editor at *The New Republic*. Her work appears in many publications, including *The New York Times Magazine, The New Yorker, The New York Review of Books*, and *Harper's Magazine*. Her books include *A Thousand Darknesses: Lies and Truth in Holocaust Fiction* (Oxford University Press, 2011), which was a finalist for the Sami Rohr Prize for Jewish Literature, and *Shirley Jackson: A Rather Haunted Life* (Liveright/W. W. Norton, 2016), which won the National Book Critics Circle Award for Biography and was named a *New York Times* Notable Book of 2016, a *Time* magazine top nonfiction book of 2016, and a "best book of 2016" by *The Boston Globe*, the *San Francisco Chronicle*, NPR, and others.

ADAM GOPNIK has been writing for *The New Yorker* since 1986. During his more than thirty years at the magazine, he has written more than a million words throughout hundreds of essays, from personal memoirs to reviews and profiles, along with much reporting from abroad, and including fiction, humor, and art criticism. His books include *Paris to*

the Moon; *The King in the Window*; *Through the Children's Gate: A Home in New York*; *Angels and Ages: A Short Book About Darwin, Lincoln, and Modern Life*; *The Table Comes First: Family, France, and the Meaning of Food*; *Winter: Five Windows on the Season* (Fiftieth Anniversary Massey Lecture); *At the Strangers' Gate: Arrivals in New York*; and most recently, *A Thousand Small Sanities: The Moral Adventure of Liberalism.* Gopnik has won the National Magazine Award for Essays and for Criticism three times, as well as the George Polk Award for Magazine Reporting.

MARIANNE HIRSCH writes about the transmission of memories of violence across generations, combining feminist theory with memory studies in global perspective. Her recent books include *The Generation of Postmemory: Writing and Visual Culture After the Holocaust* (2012); *Ghosts of Home: The Afterlife of Czernowitz in Jewish Memory* (2010) and *School Photos in Liquid Time: Reframing Difference* (2019), both co-authored with Leo Spitzer; and the coedited volumes *Women Mobilizing Memory* (2019) and *Imagining Every Life: Encounters with Vernacular Photography* (2020). Hirsch teaches Comparative Literature and Gender Studies at Columbia University and is a former President of the Modern Language Association of America as well as a member of the American Academy of Arts and Sciences.

ANDREAS HUYSSEN is the Villard Professor Emeritus of German and Comparative Literature at Columbia University, where he served as founding director of the Center for Comparative Literature and Society (1998–2003). He is one of the founding editors of *New German Critique*. His books include *After the Great Divide: Modernism, Mass Culture, Postmodernism* (1986), *Twilight Memories: Marking Time in a Culture of Amnesia* (1995), *Present Pasts: Urban Palimpsests and the Politics of Memory* (2003), the edited volume on the culture of non-Western cities entitled *Other Cities, Other Worlds: Urban Imaginaries in a Globalizing World* (2008), *Modernismo después de la posmodernidad* (2010), *William Kentridge and Nalini Malani: The Shadowplay as Medium of Memory* (2013), and *Miniature Metropolis: Literature in an Age of Photography and Film* (2015).

HANS KRUSCHWITZ studied German literature, history, and political science at RWTH Aachen University and wrote his doctoral thesis on Franz Kafka. From 2005 to 2007, he served as a research associate for a German critical edition of the writings of Paul Celan. Since 2009, he has been a research associate in European-Jewish Literary and Cultural History at the Institute for German and General Literary Studies at RWTH Aachen University. In 2011, he was a substitute professor at the Facultés Universitaires Notre-Dame de la Paix in Namur, Belgium. He has been a board member of the International Heiner Müller Society since 2017.

NANCY K. MILLER teaches cultural criticism and life writing at The Graduate Center (CUNY), where she is Distinguished Professor of English and Comparative Literature. Her most recent books are *My Brilliant Friends: Our Lives in Feminism* (Columbia University Press, 2019) and *What They Saved: Pieces of a Jewish Past* (University of Nebraska Press, 2011). Nancykmiller.com

PHILIP PULLMAN was born in Norwich, England, in 1946. His first children's book was *Count Karlstein* (1982, republished in 2002). That was followed by *The Ruby in the Smoke* (1986), the first in a quartet of books featuring the young Victorian adventurer Sally Lockhart. His most well-known work is the trilogy *His Dark Materials*, beginning with *Northern Lights* (*The Golden Compass* in the United States) in 1995, continuing with *The Subtle Knife* in 1997, and concluding with *The Amber Spyglass* in 2000. These books have been honored by the Carnegie Medal, the Guardian Children's Book Award, and (for *The Amber Spyglass*) the Whitbread Book of the Year Award, the first time in the history of that prize that it was given to a children's book. He was the 2002 recipient of the Eleanor Farjeon Award for children's literature.

ALAN (AVRAHAM) ROSEN is the author or editor of fourteen books on Holocaust literature, testimony, history, and topics of traditional Jewish concern. He is most recently the author of *The Holocaust's Jewish Calendars: Keeping Time Sacred, Making Time Holy* (Indiana University Press, 2019), awarded the 2020 Yad Vashem International Book Prize for Holocaust Research. He lectures regularly at Yad Vashem's

International School for Holocaust Studies and other Holocaust study centers. Born and raised in Los Angeles, educated in Boston under the direction of Elie Wiesel, he lives in Jerusalem with his wife, children, and grandchildren.

MICHAEL ROTHBERG is the 1939 Society Samuel Goetz Chair in Holocaust Studies and Professor of English and Comparative Literature at the University of California, Los Angeles. He is the author of *The Implicated Subject: Beyond Victims and Perpetrators*, *Multidirectional Memory: Remembering the Holocaust in the Age of Decolonization*, and *Traumatic Realism: The Demands of Holocaust Representation*.

DAVID SAMUELS is a writer of fiction and nonfiction. His journalism has appeared in *The New York Times Magazine*, *The New Yorker*, *The Atlantic*, and *n+1*. He was a longtime contributing editor at *Harper's Magazine* as well as the literary editor of *Tablet*. He is also the author of several books, including *Only Love Can Break Your Heart*, a collection of his journalism, and *The Runner: A True Account of the Amazing Lies and Fantastical Adventures of the Ivy League Impostor James Hogue*, based on a profile originally published in *The New Yorker*. He lives in Delaware County, New York.

KURT SCHEEL (1948–2018) grew up on the Elbe island of Altenwerder, where his parents ran the only cinema far and wide. He studied German literature and language, political science, and sociology in Hamburg, Munich, and Berlin. From 1977 to 1980, on the prestigious DAAD German research scholarship, he worked as a lecturer in German literature and language at the University of Hiroshima, Japan. Upon his return to Germany, he served as an editor of *Merkur*, Germany's leading intellectual review. In 1991, he became *Merkur*'s editor in chief, alongside Karl Heinz Bohrer. A lover of film, he wrote film reviews throughout his career.

ALISA SOLOMON is a Professor at Columbia University's Graduate School of Journalism, where she directs the MA concentration in Arts & Culture. A longtime theater critic and political journalist, she has written for *The Nation*, *The New York Times*, NewYorker.com, Public-

Books.org, Howlround.com, the *Forward, American Theater*, and *TDR*, among other publications, and *The Village Voice*, where she was on staff for two decades. Her books include *Re-Dressing the Canon: Essays on Theater and Gender* and *Wonder of Wonders: A Cultural History of* Fiddler on the Roof. As a dramaturg, her most recent project was Anna Deavere Smith's *Notes from the Field*.

ROBERT STORR is an artist, curator, and critic who was formerly Senior Curator of Painting & Sculpture at MoMA in New York, the first American Director of the Venice Biennale, the first Rosalie Solow Professor of Modern Art at the Institute of Fine Arts, NYU, and a Professor of Painting and Dean of the School of Art at Yale University.

STEPHEN E. TABACHNICK retired in 2020 after having served as a Professor of English at the University of Memphis and several other universities in the U.S. and abroad. He is the author or editor of thirteen books, including the 1988 Lawrence of Arabia centenary volume published by Lawrence's publisher in the U.K., and five books about the graphic novel.

KEN TUCKER has written about comics and books for *The New York Times, The Washington Post,* the *Los Angeles Times, New York Magazine*'s Vulture, *Rolling Stone, Slate, The Village Voice,* and *Entertainment Weekly.* A finalist for the Pulitzer Prize in criticism, he is the pop-music critic for NPR's *Fresh Air with Terry Gross.*

Credits

Philip Pullman's "Behind the Masks" originally appeared in *The Guardian*, October 17, 2003.

Joshua Brown's "Of Mice and Memory" originally appeared in *Oral History Review* 16, no. 1 (Spring 1988).

Ken Tucker's "Cats, Mice, and History: The Avant-Garde of the Comic Strip" originally appeared in *The New York Times Book Review*, May 26, 1985.

Adam Gopnik's "Comics and Catastrophe: Art Spiegelman's *Maus* and the History of the Cartoon" originally appeared in *The New Republic*, June 22, 1987.

Kurt Scheel's "Mauschwitz? Art Spiegelman's 'Geschichte eines Uberlebenden'" originally appeared in *Merkur* 43 (1989).

Part 1 of Dorit Abusch's "The Holocaust in Comics?" originally appeared in *Studio* no. 2, December 1997.

Thomas Doherty's "Art Spiegelman's *Maus*: Graphic Art and the Holocaust" originally appeared in *American Literature* 68, no. 1, Write Now: American Literature in the 1980s and 1990s (March 1996).

Stephen E. Tabachnick's "Of *Maus* and Memory: The Structure of Art Spiegelman's Graphic Novel of the Holocaust" originally appeared in *Word & Image* 9, no. 2 (April/June 1993).

Parts of Marianne Hirsch's "My Travels with *Maus*, 1992–2020" originally appeared in *The Generation of Postmemory: Writing and Visual Culture After the Holocaust* (New York: Columbia University Press, 2012), *Family Frames: Photography, Narrative and Postmemory* (Cambridge: Harvard University Press, 1997), and "Works in Progress: Sketches, Prolegomena, Afterthoughts," *WSQ* 48, nos. 1 and 2 (Spring/Summer 2020). An earlier version of the chapter in *Family Frames* appeared as "Family Pictures: *Maus*, Mourning, and Post-Memory," in *Discourse* 15, no. 2 (Winter 1992–93).

Nancy K. Miller's "Cartoons of the Self: Portrait of the Artist as a Young Murderer— Art Spiegelman's *Maus*" originally appeared in *M/E/A/N/I/N/G* 12 (1992).

Michael Rothberg's "'We Were Talking Jewish': Art Spiegelman's *Maus* as 'Holocaust' Production" originally appeared in *Contemporary Literature* 35, no. 4 (1994).

Alan Rosen's "The Language of Survival: English as Metaphor in Spiegelman's *Maus*" originally appeared in *Prooftexts* 15, no. 3 (September 1995).

Terrence Des Pres's "Holocaust *Laughter?*" originally appeared in *Writing and the Holocaust*, ed. Berel Lang (Holmes & Meier, 1988).

Andreas Huyssen's "Of Mice and Mimesis: Reading Spiegelman with Adorno" originally appeared in *Present Pasts: Urban Palimpsests and the Politics of Memory* (Stanford: Stanford University Press, 2003). An earlier version of the chapter appeared in *New German Critique* 81 (Autumn 2000).

Robert Storr's "Making *Maus*" originally appeared as the brochure essay for Projects 32: Art Spiegelman, Museum of Modern Art, New York (1991).

Hillary Chute's "'The Shadow of a Past Time': History and Graphic Representation in *Maus*" originally appeared in *Twentieth-Century Literature* 52, no. 2 (Summer 2006).

Ruth Franklin's "Art Spiegelman's Genre-Defying Holocaust Work, Revisited" originally appeared in *The New Republic*, October 5, 2011.

Pierre-Alban Delannoy's "Spiegelman, dans le pays de personne" originally appeared in *Revue d'Histoire de la Shoah* 191 (2009).

David Samuels's "Q&A with Art Spiegelman, Creator of *Maus*" originally appeared in *Tablet*, November 2013.

Hans Kruschwitz's "Alles hängt an Bildern: Sprach- und Bildreflexion in Spiegelmans *Maus*" originally appeared in Bettina Bannasch and Hans-Joachim Hahn, eds. *Darstellen, Vermitteln, Aneignen. Gegenwärtige Reflexionen des Holocaust* (Vienna University: Poetics, Exegesis and Narrative. Studies in Jewish Literature and Art 10). Göttingen: V & R unipress, 2018.

Alisa Solomon's "The Haus of *Maus*: Art Spiegelman's Twitchy Irreverence" originally appeared in *The Nation*, August 27, 2014.

A NOTE ON THE TYPE

This book was set in Hoefler Text, a family of fonts designed by Jonathan Hoefler, who was born in 1970. First designed in 1991, Hoefler Text was intended as an advancement on existing desktop computer typography, including as it does an exponentially larger number of glyphs than previous fonts. In form, Hoefler Text looks to the old-style fonts of the seventeenth century, but it is wholly of its time, employing a precision and sophistication available only to the late twentieth century.

Composed by North Market Street Graphics,
Lancaster, Pennsylvania

Printed and bound by Berryville Graphics,
Berryville, Virginia

Designed by Cassandra J. Pappas